landmarks

niki de saint phalle

robert irwin

richard fleischner

terry allen

nam june paik

ian hamilton finlay

bruce nauman

william wegman

landmarks

sculpture
commissions
for
the stuart
collection
at the
university
of california
san diego

jackie ferrara

michael asher

alexis smith

jenny holzer

elizabeth murray

kiki smith

john baldessari

Mary Livingstone Beebe
James Stuart DeSilva
Robert Storr

Interviews by Joan Simon

R

LANDMARKS:
Sculpture Commissions for the Stuart Collection at the
University of California, San Diego

Published on the occasion of the 20th anniversary of the Stuart Collection

Major support for this publication has been provided by UCSD Office
of External Relations, the Stuart Foundation, Joan and Irwin Jacobs and
the Friends of the Stuart Collection. Additional support has come from
the UCSD Office of the Dean of Arts and Humanities, the Good Works
Foundation, the Lucille and Ronald Neeley Foundation, the Bobo
Foundation, the Redducs Foundation, the Paul Mahalik Trust, Peggy
and Peter Preuss, Susan Caldwell and Elly and Carl Kadie.

First published in the United States of America in 2001 by
Rizzoli International Publications, Inc.
300 Park Avenue South, New York, NY 10010

Library of Congress Cataloguing-in-Publication Data

Beebe, Mary Livingstone, 1940-
 Landmarks: sculpture commissions for the Stuart Collection at the
University of California, San Diego/Mary Livingstone Beebe, James Stuart
DeSilva, Robert Storr;
 interviews by Joan Simon.
 p.cm.
 Published on the occasion of the 20th Anniversary of the Stuart Collection.
 ISBN 0-8478-2399-7 (hard cover: alk. paper)
 1. Stuart Collection (San Diego, Calif.) 2. Site-specific sculpture—California—
San Diego. 3. Outdoor sculpture—California—San Diego. 4. University of
California, San Diego—Art Collections. 5. Sculptors—Interviews. I. DeSilva,
James Stuart. II. Storr, Robert. III. Simon, Joan, 1949- IV. University of
California, San Diego. V. Title.

NB30. S78 B43 2001
735'.238'074794985—dc21

 2001019974

Publication Director: Lynda Forsha
Design: Simon Johnston @ praxis
Editor: David Frankel

Printed and bound in Singapore

Cover: Terry Allen, *Trees*, 1986
Photo by Philipp Scholz Rittermann

contents

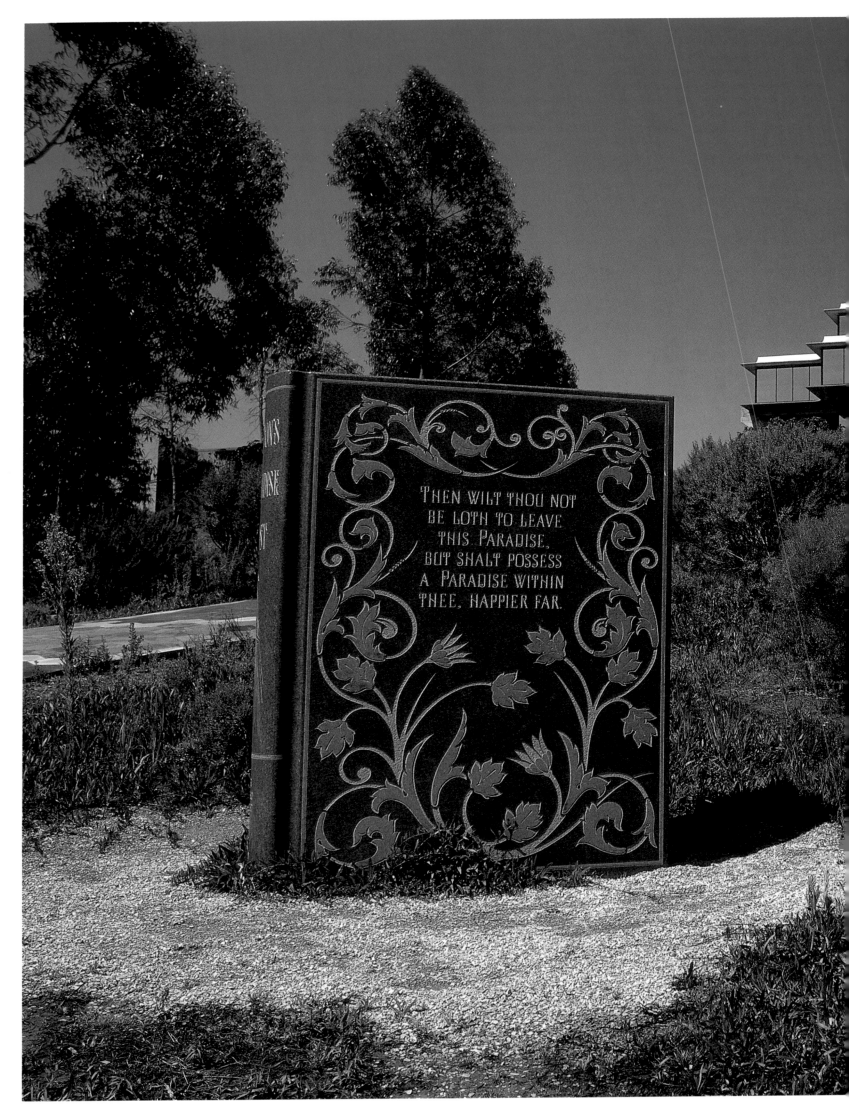

THEN WILT THOU NOT
BE LOTH TO LEAVE
THIS PARADISE,
BUT SHALT POSSESS
A PARADISE WITHIN
THEE, HAPPIER FAR.

founder's statement

James Stuart DeSilva
President, Stuart Foundation

PEOPLE OFTEN ASK ME HOW I BEGAN to think about starting a public sculpture collection.
It's a good question because, astonishingly, many of its permutations weren't clear to me until
I began to write for this book. The beginning was that my mother was an artist (nonprofessional)
and a classics scholar. The room I studied in during my high school days had most of her books
and supplies—I particularly recall her Odilon Redon lithographs, a book on color, and some
pictures of Greek and Roman sculpture. My wife too was a painter, a knowledgeable and enthu-
siastic supporter of the arts, and the one who provided the initiative for starting our personal
art collection. Even the untutored works our son put together with found objects while he
was still in prep school, before he enrolled at the Museum of Fine Arts School, Boston, had an
impact on me.

As an undergraduate I somewhat reluctantly attended the School of Business at the
University of Chicago, and for years afterward I felt unfulfilled for lack of serious exposure to
the liberal arts. After we moved to New York City, in 1961, our museum visits became less intim-
idating and more meaningful. I made the effort to go to The Museum of Modern Art and the
Whitney Museum of American Art, both quite close to my office. I also started to join evening
curator-led tours at MoMA and to attend lectures at the Metropolitan Museum of Art. Around
1967, I experienced what might be called an epiphany at one such MoMA event, learning to be
in touch with my feelings in looking at art, rather than focusing on it only with my eyes and
brain. This modest insight was difficult for me at first and required constant effort, but it turned
my life around, to the extent that I sold my business and enrolled at Columbia University full-
time, primarily to dig deeper into the history of art.

Among a host of positive experiences at Columbia, I took a course in Italian Renaissance
art in 1970, at first a little unwillingly. I found, though, that learning about the explosion of
creative genius in the Quattrocento excited all aspects of my being. This proved to be another
life-altering turning point, and was arguably an early step in a complex course of becoming
an arts activist. I developed a passion to become involved with the artistic genius of our time
(with the questionable proviso that I had the ability to recognize it). So, in the early '70s, pretty
much without preparation, I jumped into the world of contemporary art, searching out leading
living artists.

At some point my so-called activist focus narrowed to sculptors, with whom I felt a kinship;
I seemed to relate most readily to three-dimensional art. Also, living in Manhattan at the time,
I saw new works being sited so inappropriately as to reflect badly on the artists' skills. It grieved
me that most sculptors lost control over their works—a far more serious matter for a sculptor
than for a painter. So, over time, I started to fantasize about a perfect world where sculptors

might be offered a choice of sites until they found one that inspired them, and then would receive the assurance that their work and site would be maintained and preserved. At this stage, though, I had neither the time nor a clear enough vision to do anything concrete in this direction. And it was a wonderful idea, but would have no meaning to the world at large unless, in the course of living a normal, hectic modern life, I could act on it. So I was haunted by seemingly endless hours of soul-searching. It wasn't until the late '70s that things began to coalesce and I was finally able to start working toward a plan. After the uncertain and confusing early years, I was now treading more familiar ground, doing what came naturally: organizing something tangible and putting it into place. During this period my friend and attorney Norman J. Laboe ardently assisted in the foundation's birth. Our son, daughter, and her children also graciously joined in the initial funding.

It became clear to me that a spacious, parklike setting would be ideal for what I had in mind. I wanted art to be accessible for casual visitation, without any hint of an obligation to the passerby to look at or think about it, let alone treat it with reverence. My personal experience told me that living with art, casual repetitive exposure to it, can lead to understanding and appreciation, if not passion and possessiveness, even among those who profess to dislike art. I was confident that over time passersby would respond each in their own way to the objects, perhaps even ignoring them for a time. Any given piece might elicit a strong response—either positive or negative. For me that would be all well and good. Also, I knew that most observers' original feelings would likely change, probably several times—they might experience a sense of discovery one time, then later passion, or boredom, or even rejection. My perspective was and is that the entire process is healthy, and a wonderful part of being alive—to experience new feelings, and to escape for a moment from one's routine. My feeling was that it was alright even to ignore a work, to make fun of it, or to criticize it. The important thing was to interact with it over time.

All along, I've been insistent on creating a situation where each work would have breathing room and would neither detract from nor be disserved by a neighboring work. The road to site-specific works also seemed to involve commissioning, which art world professionals warned was inordinately risky; I was undeterred, because I felt that with care and patience, commissions would yield rare rewards that would far exceed the risks. Some of these thoughts gelled in response to the sculpture parks I visited in the U.S. and Europe during the fall of '78, in the late stages of creating the Stuart Foundation (the vehicle for funding the collection). To my disappointment, I found no model in my travels for what I wanted to do. Instead I discovered that the only way for me to go was to invent something new in partnership with those who might join me along the way.

While my mind was still restlessly pondering how to create a meaningful sculpture project unlike any other, our family moved to San Diego, where I planned to start a new business venture. Fortuitously, we landed in an area of La Jolla close to the campus of the young and vibrant University of California, San Diego, where I frequently walked and bicycled. I say fortuitously, because by the time the foundation had been started and funded, in late December 1978, it was becoming clear that this campus was the ideal place for the type of collection I envisioned. The appeal of a generous-sized university campus was that it not only met the site criteria but also offered the exciting bonus of an educational role, both formal and informal. I was overjoyed to think of a captive audience of ongoing generations of students (largely scientists who might never otherwise have such an experience) informally exposed to a variety of sculptural objects.

In early February 1979, I wangled an invitation to dinner with then Chancellor William McElroy, the top officer of the school, to present my ideas. There was essentially no response until late May of that year, when various meetings ensued. John Stewart, then Provost of Muir College, Assistant Chancellor Patrick Ledden, and Visual Arts Professor Newton Harrison expressed the most interest, and Dr. Ledden was enthusiastic and confident enough to start work on a draft agreement and other necessary spadework. So when a new chancellor, Richard C. Atkinson, was appointed, Ledden was ready, took the initiative to brief Atkinson on the matter, and managed to arrange a meeting with Atkinson where I could make my pitch.

Considering the university's leisurely pace during the previous fifteen months, we came to an incredibly speedy decision. Dr. Ledden must have done a very convincing presell, because Chancellor Atkinson was enthusiastic about the concept almost immediately, and seemed to accept me on faith right then and there. Further, he offered to put his weight behind obtaining contract approval from the Regents, who oversee the entire University of California system.

In addition to my Western European tour and my shorter jaunts in the U.S., even before the Stuart Foundation was set up I sought advice in lengthy conversations with a number of people, including the sculptor Henry Moore; Franklin Murphy, former chancellor of UCLA and father of that school's sculpture collection; and Fred Wight, long-time chair of the UCLA Art Department. Murphy and Wight shared valuable tips about public art, about their own startup, and about the view in hindsight. Moore, among other things, charged me to move forward and trust my own instincts. A ten-year agreement was negotiated with the university and ratified by the Regents in 1982. In a naïve and futile stab at remaining anonymous I decided to use my middle name, Stuart, for the foundation. The agreement with the university has been extended and slightly amended twice. Appreciation and support for the Stuart Collection seems to have grown exponentially.

Jim and Marne DeSilva in
France during the fabrication
of Niki de Saint Phalle's
Sun God, 1982

An Advisory Committee was set up to include the Stuart Foundation's chair, and at least
one notable international representative from each of the four categories of museum director,
art critic, artist, and UCSD faculty. Newton Harrison chaired the first three Advisory
Committee meetings. Harrison later served as faculty representative, a post that has rotated
several times among Visual Arts professors and is expected to continue in that fashion. An early,
serious concern of mine was to avoid repeating a problem I'd seen too often elsewhere: the lim-
iting of a collection by the taste and expertise of its patron. This partially explains the purpose of
the Advisory Committee, and my relatively low profile in its meetings. In view of the constella-
tion of experts on the committee and the direction the collection has taken, it has proved a
wise decision.

It is impossible to say enough about the vision and the support we have enjoyed at crucial
moments from former Chancellor Richard C. Atkinson, former Vice Chancellor Bruce
Darling, former Interim Chancellor Margery Caserio, our present Chancellor Robert Dynes,
Senior Vice Chancellor Marsha Chandler, and Muir College Provost Patrick Ledden. Each
has been a good and constant friend, both personally and of the collection.

Mary Beebe, who became director of the Stuart Collection in 1981, is an unbelievable tal-
ent. I dare not think what the collection would be today had Patterson Sims not recommended
her to me, and had she not agreed to leave her beloved Oregon those many years ago. One of
Mary's greatest achievements was foreseeing the need for a person of the rare genius of Mathieu
Gregoire, and persuading him to join her early on.

Imagine if you can how rewarding the formation of the collection has been, given an indus-
trious and gifted staff and artists, loyal and generous supporters, and a supportive university, to
be able to allow untold generations of bright, eager young people the opportunity to find art
even when they weren't looking for it.

Mary Livingstone Beebe
Director, Stuart Collection

FLYING INTO SAN DIEGO, I knew this was unfamiliar territory—a whole new horizon. Although I was still on the West Coast, it was not the Pacific Northwest, where I'd spent most of my life. For me, Southern California triggered thoughts of palm trees, Hollywood, and sun-drenched beaches, of a culture unfettered by tradition, where anything can happen—and can happen overnight. From the air the ocean was spectacular, but San Diego looked dry and somewhat desolate; no sign of a fir tree anywhere. Little did I suspect what lay ahead.

It was June 1981, and I had been invited to the University of California, San Diego, to be interviewed by the Advisory Committee for a new sculpture project. Not looking to leave the Portland Center for the Visual Arts, where I had been director for nearly ten years, I was somewhat reluctant, perhaps diffident, but the Committee was distinguished and impressive. Artist and committee member George Segal wondered what the first thing I might do would be; since the excursion still seemed something of a lark, I rather flippantly suggested making friends with the grounds-keepers, who are often the ones with the ability to make things happen—or to sabotage the most well-intentioned effort.

The campus was beautiful and the interview was enjoyable and informative. James Stuart DeSilva had persuaded the university that the installation of sculpture throughout the relatively new campus would enliven and enrich the community and play well against the rather stark concrete buildings that had gone up in recent years. He had set up a foundation, assembled an Advisory Committee of world-renowned professionals in the field of contemporary art to guide it, and committed funds to get the endeavor up and running. The Committee was obviously enthusiastic about the belief that inserting contemporary art into the campus would enhance the university's central mission of open and provocative inquiry; yet it was also free of arcane campus politics and pressures. A significant group was getting behind a great idea. Clearly Jim had set forth a real challenge for the university and the Advisory Committee. I was slowly coming to see the job as a worthy adventure.

That night I had dinner with Jim and his wife, Marne, beginning a warm and rewarding relationship that has endured and grown through the years. Jim is tall and slender with a stately demeanor and grace warmed by a prankish sense of humor. He is a man of conscience, dedication, and extraordinary patience. Marne is quietly observant and playful—warm and generous. She plays down her role as a partner, but as I was to find out, she is a strong force for art and an artist herself. We had a delightful time. I began to see the DeSilvas not just as patrons but as friends, people who could easily become engaging and thoughtful long-term comrades.

As assistant chancellor at the time, Patrick Ledden was the university's main link to the project that was to become the Stuart Collection. Both a James Joyce scholar and a mathemati-

The University of California, San Diego

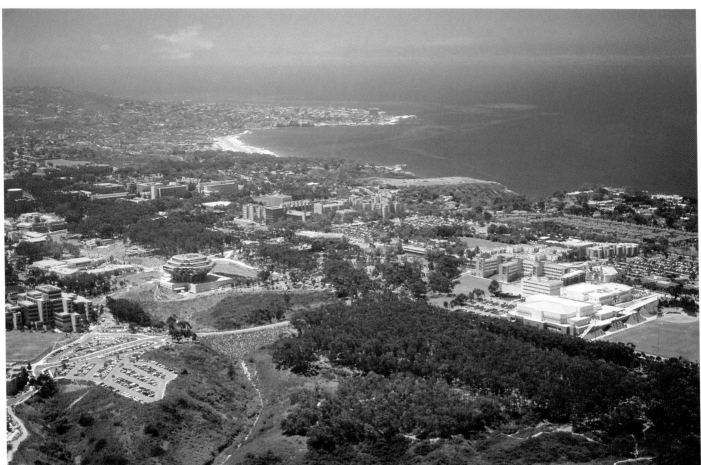

cian, Ledden showed an early enthusiasm and support that were absolutely instrumental in shepherding the idea through to the UC Regents' approval. He became the provost of Muir College in 1987 and has remained a guiding force through the years. A persuasive advocate on many levels, Pat made a convincing case for the university's commitment. My reluctance faded. When I returned to Portland the idea began to take root that perhaps it was time for a change. Art is about taking risks; I decided to act like an artist and dive into the unknown. The daunting first impressions of San Diego turned into exciting possibilities. When offered the job, I accepted immediately and started work on October 15, 1981.

At first the widely varied terrain of the 1200-acre campus seemed an impossible maze. It is a breathtaking setting, located in La Jolla, San Diego's northern edge, on a dramatic mesa above the Pacific Ocean. The university's founding core is the Scripps Institution of Oceanography, which was founded in 1906 and is tucked in along the shore and up the hillside toward the mesa. Throughout the campus, chaparral-filled canyons and eucalyptus groves contrast with the built environment of urban plazas and green lawns. The canyons are wild, Mediterranean-like areas with native growth, including sage, artemesia, buckwheat, grasses, scrub oak and toyon. They

are inhabited by red-tailed hawks, owls, mourning doves, birds of all kinds, foxes, coyotes, rabbits, and snakes. Deer and the occasional bobcat used to roam here, but seem to have retreated in the face of new construction.

Eucalyptus groves are a defining aspect of the campus: the trees, native to Australia, were planted in orchardlike rows by the Santa Fe Railroad and other investors at the turn of the century as fast-growing specimens to be harvested for wood products, especially railroad ties. As it turned out, the wood did not live up to expectations and the groves of evenly planted trees (eight feet apart at UCSD) were abandoned, remaining a distinct legacy in different parts of California. As the UCSD campus grew in the 1980s, parts of the groves were removed for new construction, but people missed them. The university eventually decided that they were a part of the campus identity and should be preserved. Large lone trees are sometimes brought down by wind, and droughts and beetles have caused considerable damage, but the trees are slowly being replaced. The groves soften the harsh California light, and in hot weather or after a rainfall have a refreshing, pungent, almost medicinal aroma—a result of the oil in the leaves, which fall and cover the ground, preventing nearly anything from growing under them. The soft subtle tones of the eucalyptus—pale green leaves, smooth gray trunks—provide a respite, a sense of relief.

The campus architecture ranges from California cottages and World War II barracks through larger, newer buildings from the 1950s and '60s on to recent structures by well-known contemporary architects. When Richard C. Atkinson became chancellor of UCSD, in 1980, he was to lead the university through a period of rapid growth; extensive construction was underway and has continued, with only a slight lull during the recession of the early 1990s. We have seen the addition of major buildings, residence halls, hospitals, recreation centers, a faculty club, parking lots, bridges, an entire minicampus for the Graduate School of International Relations and Pacific Studies, research labs, library expansions, and an aquarium. The present enrollment is just over 20,000. An estimated 35,000 people are on campus every day.

UCSD is the third largest employer in San Diego and has spawned over 150 companies. There is academic tranquillity, but there is also the energy and activity of Southern California, which is undergoing rapid development. Today, looking east from the campus as far as the eye can see, the rolling hills have flattened tops and are virtually covered—or are being covered—with commercial development and condominiums. In peak periods, San Diego can grow by over 1,000 people a week. UCSD expects to add 10,000 new students in the next decade.

When I arrived, the Advisory Committee was discussing directions the collection might take. There was some talk of documenting the history of sculpture with examples throughout

the campus. My experience in Portland had been with contemporary artists (some of whom later did works for the Stuart Collection), and I saw myself as more a catalyst or "production manager" than a curator of a historical collection, so buying art to place around didn't quite fit. This notion also seemed ambitious given the funds available.

The university was young and research oriented—on the cutting edge in many fields. The campus's varied terrain seemed an invitation to do something other than a traditional sculpture garden. Also, there seemed to be no need to repeat or compete with the marvelous Franklin D. Murphy Sculpture Garden at UCLA to the north. At the time, too, a number of artists were thinking about work outside the studio—about how work could be influenced by or have an effect on the surrounding territory. "Site-specific," "site-generated," "site-related," were terms in the air. We could imagine artists making work in this vein—art that was experiential, sensory, kinetic; art that involved moving through space rather than static contemplation; art that asked for an intimate engagement, despite its public scale; art that could be experienced viscerally and intellectually in any variety of ways; art that was conceptually taut as well as precisely crafted. This seemed an opportunity to do something that wasn't happening anywhere else that we knew of—to integrate sculpture with the fabric and life of the campus.

The Advisory Committee had invited Niki de Saint Phalle to create the first work for the collection, and had begun to develop a wish list of other artists. We soon expanded the list to include artists who had not worked in sculpture, or done site works, or made outdoor projects. We wanted artists who thought in interesting ways. It was determined that I would invite these artists to the campus and, keeping university priorities and long-range construction plans in mind, help them choose a site and develop a feasible proposal and budget that would be presented to the Advisory Committee for consideration. Since the beginning, over forty artists have agreed to come and develop proposals; fourteen of those proposals have been executed, and a fifteenth will be realized before this book is published.

We are still working with a number of the artists who have visited, as well as inviting new proposals. Projects have gone unbuilt for reasons as varied as can be imagined: some ideas were ambitious and fascinating but financially impossible; some sites in the mesa's cliffs and canyons were found to be unstable; a few artists wanted larger fees than we were able to offer. To a certain measure, an unpredictable chemistry and karma come into play. Some ideas were more interesting than others: choices had to be made. All of the artists, however, have contributed greatly to the pleasure and challenge of the process.

From the beginning, we felt that we should have a standard proposal fee and commission fee for every artist. As well as paying these fees, the foundation has paid for all travel and

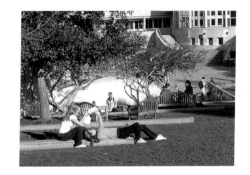

production costs. It also seemed right to let each artist find a site that would not conflict with other proposals or projects, and perhaps might even dovetail with university plans.

Once the Advisory Committee approves a proposal, we take it through a university process. This always involves site and safety issues, but there have also been other considerations. Two successive chancellors have been very supportive of us. They have also, on occasion, had to be willing to stand up to criticism, and the university constituency can be understandably territorial. We don't expect everyone to love every work, and if they did, we probably wouldn't be doing a very good or enlightened job; but it is still necessary to build consensus and support for a project within the immediate community. The chancellor has final approval, but constituency building is guided by the reality that it's not in anyone's interest to place him at odds with his faculty and administrators. Once all approvals are obtained and the agreement with the artist is signed, we start production and construction.

It has been important to recognize that art is not the primary mission of the university and to have a clear picture of UCSD's long-range plans. It would be futile to lead artists into territory earmarked for other purposes. I have learned that each project involves a complex journey of partnership, brainstorming, persuasion, conflict resolution, passion, and friendship. The endeavor requires a driving force, a strategic planner, a political ombudsman, a persistent and cheerful advocate, a consensus seeker, a collaborator, an interpreter of artists, a fundraiser, and, certainly, a sense of humor. Our small staff has developed into a cadre that has covered all of these roles. They have more than occasionally guided me in knowing which role I should be playing at particular times.

In Portland I had worked with a student, Mathieu Gregoire, and found him an inspired artist, an enlightened problem-solver, and a knowledgeable, intelligent, good-humored, and highly responsible professional. Arriving in La Jolla, I discovered that among those at the university who were dubious about putting sculpture throughout the campus was a key person in the university's Design and Construction office. He was convinced that our work would be an exercise in frustration and folly, that students would destroy the artworks, and that the whole effort would come to a grinding and embarrassing halt. This was not helpful, and I requested permission to hire Mathieu. Our first project, with Niki de Saint Phalle, required coordination with the artist's crew in France. Mathieu, fluent in French in addition to his other talents, seemed a perfect solution. He was then, and has been again and again.

At first Mathieu worked by commuting from Portland, vowing that he would work only on Niki's project. Soon, however, he was working on the next, and then the next. Eventually he moved to San Diego as an independent contractor and our project consultant. His sensitivity to

other artists' works and desires, his ability to understand and articulate, his forceful voice, and his willingness to engage in the ideas as well as the process have been extraordinary. Mathieu is widely recognized as an artist, sculptor, and teacher who has not only exhibited but worked collaboratively across the country and abroad on installations both permanent and temporary. He has been absolutely essential in the conception, fabrication, installation, and conservation of every work in the Stuart Collection.

In 1991, Julia Fuller Kindy came to work for the Stuart Collection fresh out of UCLA, where she had just received an MA in art history. As my first full-time assistant, Julie added real vivacity to the team, and eventually came to be assistant director. She expanded our community of friends both on campus and off, and also enhanced our education efforts by overseeing the production of a thirty-minute film about the collection. Resilient, energetic, and astute, Julie's spirited optimism buoyed us through triumphs and transitions for nearly a decade.

The transitions began in the early '90s. The collection had been launched by the initial funds that Jim DeSilva had placed in the Stuart Foundation and in the UCSD Foundation. This had given us the confidence we needed to forge our way. We had all along applied for grants and donations to augment Stuart Foundation funds, and had been reasonably successful. (The National Endowment for the Arts was particularly supportive and helpful in the early years.) It wasn't until 1997, and Kiki Smith's fountain *Standing*, however, that we were really on our own financially.

Robert C. Dynes became UCSD's sixth chancellor in 1996. He and Marsha Chandler, Senior Vice Chancellor, Academic Affairs, have continued and even augmented the university's strong administrative support for the Stuart Collection. Along with Pat Ledden, they were instrumental in convincing Joan Jacobs and Peggy Preuss, both great friends and patrons of the university, to serve as cochairs in setting up a major support system. We launched the Friends of the Stuart Collection in the summer of 1998. The Friends has an International Advisory Board that includes collectors, museum directors, and curators from around the world. With these blessings, the Friends now stands at over 120 members (and growing) who are committed to the long-term preservation of existing works and the support of new projects. It was the Friends who enabled the completion of Smith's *Standing* and the conservation of de Saint Phalle's exuberant *Sun God*. In 2000 the renovation of Alexis Smith's "Garden of Eden," and minor restorations of her *Snake Path* itself, were underwritten by the Friends. The current John Baldessari project is almost entirely funded through contributions from the Friends.

By 1998 the Stuart Collection had become world renowned, and a distinguishing asset for UCSD. Jim DeSilva's early vision had become a reality worthy of the support of new philan-

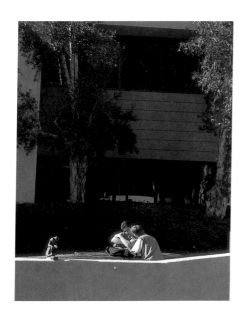

thropists. Jim is an inspired patron who could serve as a model around the world. In several ways his vision for the Stuart Collection suggests a difference not so much in degree as in kind from other, seemingly similar philanthropic acts: there is the public nature of the endeavor, directed toward a public university and its community of students and faculty. There is the uncertainty of the outcome; the Stuart Collection, after all, involves a risky commitment to an ongoing process, not simply the purchase of individual sculptures. The ongoing nature of the commitment points up the breadth of the risk and the extent of the philanthropic effort required to underwrite multiple works. There has also been Jim's steadfast self-removal from any decisions that might create even the appearance that he had steered the outcome to suit his own artistic sensibilities, or to enhance the value of his own collection. Finally there is the venture itself: could anything be more risky than public art, a field littered with Sturm und Drang, stormy protest, compromise, and failure? One could search the field of artistic philanthropy and find few parallels in commitment, artistic trust, or true generosity.

That UCSD has supported the operational side of the collection from the beginning, and has stood by without interference, is also remarkable and laudable. The risk has been theirs as well. The university is to be further commended for its courage in refusing to accept gifts of sculpture that the Advisory Committee feels to be of lesser quality than the works in the collection. This is part of the agreement between the Regents and the Stuart Foundation. Nonetheless, it is not an easy road to follow.

Although we have not been able to realize as many projects as we might have wished, and the work has gone more slowly than was originally projected, time has been on our side: projects have not been rushed; artists have had time to think; we have paid careful attention to detail. We have tried to honor the creative process. We have made the point that the mission of the Stuart Collection is not only to provide sculpture for the campus but to give artists the opportunity to do things they would not otherwise do. We are clearly not decorating the campus in a cosmetic sense; the Stuart Collection is not about taste but about memorable experiences. Assumptions and perceptions are challenged. One of the joys has been in watching people change their minds about particular works, and realizing that this can be a legitimate part of the process of thought and response.

By the time this book is published, we will have fifteen unique and impressive works. It is our staunch belief that the images and experiences of these and future works will be firmly planted in the minds of many people—people who may or may not have thought that art could play any role in their lives. Not only can this art give them a more acute sense of their own time, it can open up new vistas and connections that will matter to them in unforeseen and

meaningful ways. Art is about paying attention. Perhaps, in some way, it can alert those who are paying attention, as well as those who aren't, to the wide view that was my father's mantra: "Broaden your horizons." That has happened here in San Diego, on the western shore of the American continent—a corner where many have come in pursuit of their dreams, a once-small naval outpost that has become one of the nation's ten largest cities. I never lost the ring of my father's words, but neither did I ever dream I would be living out his mantra a thousand miles from Portland. Nor could I ever have dreamed of patrons and friends like the DeSilvas, or of the extraordinary artists, colleagues, and all the others who have helped make the Stuart Collection a reality.

Robert Storr
Senior Curator of Painting and Sculpture,
The Museum of Modern Art, New York

A PARK OVERLOOKS THE PACIFIC. Atop wind-carved, sea-gouged bluffs, its grassy expanse is stapled along the outer perimeter by a strictly utilitarian fence. At irregular intervals the lawn is anchored by hunchback evergreens with twisted lateral branches and braided roots that seem to be fleeing the salt spray in any direction they can. The people who cohabit the park with these sinewy outposts of vegetation are, by contrast, the picture of unconstrained vitality. A solitary thirty-something walker in ultramarine Spandex leggings cuts a limber profile against the grayer blue of the ocean; a cluster of teenagers swagger and tease, baggy boxers for the boys, bikinis for the girls; off to one corner a group of late-middle-aged men and women sit in a tight semicircle, taking turns to jump up, speak to the assembly, and receive applause. Over the heads of all, surfers paddle out to the swell, scramble in the cresting foam, then ride it in as the sound of the breakers absorbs the applause of the self-help group and the muffled voices of the teenagers. All is lit by a rich yellow light that throws shapely though often eccentric shadows on the verdant ground and picks out the designer hues of tank tops, hair bands, and brand-name sneakers with a hyperreal precision that simultaneously dazzles the eye and slows its scan. Optically the effect is as if one were watching a wide-screen-television sportscast programmed with little pauses so that one could take it all in. Or imagine Seurat's *Sunday Afternoon on the Island of la Grande Jatte* in contemporary attire, with palms and Torrey pines added for local color and athletic pantomime for local zest. Here is middle-class America at play, in a place most hospitable to its twenty-first-century forms of recreation.

Almost the only thing truly immobile in this slow-motion panorama of rolling sea, swaying trees, and people in leisurely flux is a small rock near the base of one of the park's less contorted evergreens, flanked by a solid-concrete wastebasket with an aqua plastic top. A modest bronze plaque has been bolted to the rock; it reads "Abraham Lincoln centennial memorial—February 12, 1809–1909. Erected by the people of La Jolla." One is hard put at first to say why this unobtrusive civic landmark seems so strange. Monuments to dead presidents and politicians are the standard furniture of municipal parks throughout the nation, so why should one seem out of place here? Nor is there any reason to think that the sentiments expressed on the plaque are any less deeply felt by the population of La Jolla than they would be elsewhere, even though the fashions of today's residents of the town are as different from those of the sober citizens who must have commissioned the memorial as they are from the decorous pleasure-seekers in Seurat's stately tableau. No, the monument's uncanny aspect has nothing to do with such discrepancies, but rather with the arbitrary and curiously ephemeral presence of the stone itself. Apparently unchanged since it was first plunked down, and by all evidence the oldest thing in view, it still looks temporary, making everything else around it seem even more so.

Keep this rock in your mind's eye as you move up the coast a couple of miles to the north of

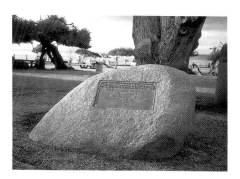

Abraham Lincoln Centennial Memorial,
La Jolla, California.

downtown La Jolla. There, stretched inland from the bluff that rises to a height above the water, you will catch glimpses of buildings nested in among eucalyptus groves or flush up against the dry chaparral that creeps in around their foundations from neighboring hills and ravines. Bark hangs loose from the trunks of the eucalyptus trees like the flayed skins in one of Vesalius's anatomical engravings, and the scrub growth of the chaparral resembles a threadbare Persian carpet with sun-bleached textures and occasional bursts of floral color. Architecturally the buildings are a hodgepodge. Imperial modern rubs shoulders with "your-tax-dollars-at-work" functionality, cantilevered monoliths suggesting science-fiction lamaseries commingle with freshly painted wooden barracks recalling the days when the site was a vast military base. Presently it is the grounds of a major university of some 20,000 students. Yet for all their number, generally large size, and occasional grandeur, these buildings cling tenuously to the land, their foothold apparently no more permanent than that of the brittle, shallow-rooted flora that crowd them. On the outermost edge of California—land of brushfires, mud slides, and earthquakes—the huge campus projects the oddly evanescent aura of an ideal future perpetually under construction, such that the differences among the buildings represent the changing incarnations of a utopian vision no single expression of which is likely to last all that long.

Most of the men and women who swarm around and through these buildings are just passing through. Nothing about their clothes or demeanor clearly distinguishes them from vacationers by the beach: the dress code is casual and the pace generally measured. Work and play can of course have much the same appearance, but appearances may be deceiving, and are in this case, since the students and faculty are exceedingly hardworking people. In the East and Midwestern United States, institutions of higher learning commonly mimic the old academies of Europe, ivy-covered Gothic halls and all. In the West, educational centers of comparable importance more often hew to the line set by other manifestations of urban or suburban sprawl, which means dormitories like housing developments and libraries and laboratories like corporate offices. Only a snob would be bothered by this, and only a confirmed postmodern ironist would prefer that a big, spanking-new state school on the Pacific Rim be the simulacrum of a quaint academy on the Thames. Rather than an ivory tower establishment, the University of California, San Diego, is a horizontal collage of wood, cement, steel, and glass. Rather than a period theme park for the bookish, it is a well-laid-out subdivision for the adventurously brainy.

Wandering through this maze of structures, visitors unaided by a map may be confused about the location of the university's true center, but near what seems from the traffic to be its main drag is another stone marker. This one features a bronze plaque dedicated to the thousands of soldiers who, between 1917 and 1964, learned how to shoot straight at this training-

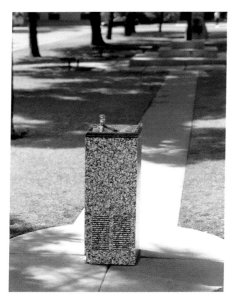

Michael Asher
Untitled, 1991

camp-turned-campus. Like a glacial erratic, the boulder seems to have been dropped by history with the same arbitrariness as the Lincoln-centennial stone downtown, and like that rock it sits undisturbed and generally unremarked upon. In the middle of the sodded strip of which it occupies one end is a flagpole, and at the other end is a nondescript drinking fountain, equivalent in its way to the garbage bin with which the downtown memorial is paired. The symmetry between this polished granite fountain and the rough granite lump is natural enough, until one considers that drinking fountains do not usually have the same status as military monuments. Nor is the style of the fountain—the style of the standard-issue stainless steel model found in thousands upon thousands of office buildings—commonly reproduced in this expensive material or with this tombstone finish.

The truth is that the fountain is anything but ordinary and its placement is anything but routine. Instead, with bland thoroughness, the Conceptual artist Michael Asher has seen to the fabrication of a ringer amenity that stands out over time in inverse proportion to the degree that it begs to be overlooked on first inspection. The back of the fountain is the tipoff; designed to hug the wall, in this case it is left in the open like a hospital patient unable to hide the nakedness exposed by an open robe. The granite button that releases the flow of water is the next giveaway, being too neat, and too luxurious a detail, for such a utilitarian thing. And when the fountain's sentinellike rigidity is aligned with the flagpole and the intractable monument, the absurdity of the triad is revealed, as if an SAT question asking which of three objects did not belong to a given set had been posed by the Surrealist mischief-maker René Magritte. The longer one considers the problem, the more what one initially assumed to be the least significant of the three objects eclipses the two most aggressively symbolic ones, and the more what would normally have seemed the most expendable of them becomes the defining element of the ensemble. Such is the fine art of not quite fitting in.

Asher is a past master of this kind of gamesmanship, which might appear frivolous if one's notion of art were marble fountains with gesticulating statuary rather than granite fountains surrounded by men and women in jeans and T-shirts. But Asher's medium is not so much the materials at hand as the ideas he juggles by means of formal substitutions and dislocations. Chief among them are the unexamined ideas about art that nearly everybody starts with and too many otherwise sophisticated people hold on to as if their lives depended on them when, to the contrary, intellectual growth and artistic pleasure depend on getting rid of just such received opinion. Universities, oddly enough, have frequently shown themselves the last bastions of such conservatism. Paradoxically, places devoted to thinking about the sciences, social sciences, philosophy, history, and other weighty disciplines tend to spin off hostile attitudes toward art, like organisms genetically susceptible to a particular virus that selectively attacks aesthetic sen-

sibilities and aesthetic speculation. Alternatively, universities may smother the artistic imagination by treating its products as mere epiphenomena of truly important scientific, social-scientific, philosophical, or historical developments—in short, as if they were illustrations of big ideas best understood by specialists in other fields, rather than big ideas best approached on their own terms.

Taking those two extremes into account, it is heartening to see Asher's fountain so at home at UCSD, as if faculty, alumni, and students matter-of-factly assumed that all schools had a comparably peculiar artwork in their midsts, which of course they don't but should. On the other hand, it is also good to see people of all kinds striding right up to the fountain to quench their thirst, rather than stepping up to it warily or shying away, as if it were reserved for art majors in pursuit of a thesis topic. Indeed, I have been told that just before exams students come to take a sip of what they call "smart water," a benign superstition demonstrating that sooner or later Conceptual art's much vaunted austerity yields to the common-sense uses of the surrounding culture, and that by that mysterious process some of its subtler lessons are subliminally learned.

If all this strikes readers as an awfully roundabout way to introduce the Stuart Collection, consider that one of its guiding principles has been what art writers term "site-specificity." To use such jargon is to run the risk of shutting many minds off with a definitive "click." Yet the idea is indispensable, and we have no better word for it. Practically speaking the problem is not so much the basic notion that some works of art are created in response to their environment and require interaction with it to be meaningful, but that once that notion is invoked in the abstract, far too little attention is usually paid to the significant givens of the particular place, such that most things said about work and site remain annoyingly nonspecific. However, the qualities that Asher's physically intransigent but semiotically ambiguous sculpture plays with and off are qualities that most if not all of the other artists who have contributed to the Stuart Collection have had to contend with, namely the bigness, scatteredness, heterogeneity, multipurposeness, instability, and uncontrollably metamorphic potential of almost every situation in which they have been asked to work. Site-specificity at UCSD must reckon with all of this, but can also count on a community that is culturally mixed and open enough to let artists keep coming up with surprises that make the standby challenge "But is it art?" seem stale by comparison to Asher's more enjoyably provocative question "OK. So what is art?"

Although not among the first pieces commissioned for the Stuart Collection, Asher's fountain is physically and conceptually the cornerstone of the project. Like the boulder with which it brackets the media strip, it will not budge. Unlike that boulder it is open to multiple readings. Ian Hamilton Finlay's UNDA, installed in 1987, is if anything still more obdurate than the foun-

Ian Hamilton Finlay
UNDA, 1987

tain, but just as ambiguous in its situational meaning. An experimental poet turned environ-
mental sculptor and theorist of deliberately anachronistic utopias, Finlay is a stubborn anti-
modernist who dreams lapidary dreams of classical formality against the backdrop of urban
spread and the fragmentation it brings. The remote enclave in rural Scotland to which he
retreated in 1966 to cultivate his own garden and develop his aesthetic and social ideology is
named Little Sparta—not Little Athens, as some denizens of a liberal-arts institution or of the
art world might have preferred. The choice is a signifier of his intransigence, for in his fashion
Finlay the Scottish recluse is a kind of militiaman of the arrière-garde, a holdout contrarian who
turns the formal and conceptual weapons of the avant-garde against it so as to remind those liv-
ing in delirious flux that in Arcadia, order once prevailed. But there is always a twist to Finlay's
evocations of the Golden Age.

In *UNDA*, five roughly quarried limestone blocks are engraved with this single word, in
roman capital letters. The contrast between the solidity of the blocks and the sense of transfor-
mation that the word—Latin for "wave"—undergoes as it is adjusted by editorial markings
indicating differing sequences of its four letters casts language loose on tides of ambiguity. The
visual cadences of this simple, subtly but repeatedly dislodged text carry the eye (and the mind's
ear) along in a scanning motion that animates this otherwise emphatically static piece.

Finlay's work is not the only one to evoke antiquity in this manner. Richard Fleischner's *La
Jolla Project* (1984), composed of seventy-one rectangular units of pink and gray granite, plays
similar games with standardized shapes and antique motifs. Resembling a miraculously clean-
cut ruin with its columns, gates, and portals, Fleischner's multipart sculpture is a fractured
mini-Acropolis on a shallow slope. The formal vocabulary of the piece is that of Minimalism.
Robert Morris set the parameters for such work in 1969 with his *Untitled (Three L-Beams)*, three
identical L-shapes of painted plywood that he deployed in three distinct positions: one lay flat
on its "side," one was poised on its ends like a giant circumflex, and one was placed squarely on
the ground as if it were an archetypal chair. The point of Morris's exercise was to show how
easily one could reveal the different sculptural possibilities inherent in a basic form simply by
altering its orientation. Taking off from this precedent, as well as from the explicitly yet ambigu-
ously architectural sculptures of Tony Smith, the point of Fleischner's recourse to modular
elements is to build, and by building claim exterior space on terms that suggest but never com-
pletely enclose interior space. The result is a play with insides and outsides, of masses of stone
being used to frame volumes of open air.

Where *La Jolla Project* lends itself to casual use—students with books in hand drape them-
selves over its scattered parts like wandering bards in a Poussin painting—*UNDA* contradicts its
surroundings even as it translates into graphic terms the rhythm of the breakers that were once

Richard Fleischner
La Jolla Project, 1984

visible in the distance from where it sits but are now lost from view behind trees along the bluff over the ocean. Positioning his sculpture at the edge of a sports field where bleachers might stand, Finlay may seem to set his verbal play at odds with the games of soccer, softball, and ultimate Frisbee that are played on the grass—unless one thinks of those games as the modern equivalents of the physical contests of ancient Greece, in which case mischief-mindedness suggests that to make the wave in the sculpture occupy the place of the contest's spectators might be interpreted as a parody of the human waves that sweep crowds in American stadiums. But that is perhaps too whimsical a leap of the imagination. What is plain is that Finlay's work is a monument to language's mutability and to its ludic potential, rendered in a material that is all but immutable and in a form that is almost absurdly straight-faced and antiquarian. Meanwhile one wonders whether the buildings already skirting the playing field will give way to new and larger ones. Whatever the case, Finlay's anomalous limestone blocks with their follow-the-bouncing-ball—or follow-the-typographer's-sign—message will endure. And centuries hence when travelers come across these stones—be they set in the midst of the megalopolis or stranded in some future desert by the sea—they will find that in the waning years of the twentieth century the California surf had its Apollonian praise-singer.

In its material (granite) and its typography (boldly incised capital letters), Jenny Holzer's *Green Table*, completed in 1992, has correspondingly classical overtones. From a distance, given the nature of philanthropic "naming opportunities" on university campuses, one might expect Holzer's texts to be dedications of some sort, for example, "Gift of the Class of 1936 in Memory of Professor Backwards." But the professor in question is not an academic but an artist, and what she professes are conflicting truisms of her own invention that individually and collectively have the ring of George Orwell's 1984. A sampling: "A lot of professionals are crackpots." "At times inactivity is preferable to mindless functioning." "Money creates taste." "Much was decided before you were born." "Raise boys and girls the same way." "Sloppy thinking gets worse over time." And her signature sentence: "Abuse of power comes as no surprise."

Jenny Holzer
Green Table, 1992

What better idea for a pedagogical institution than a didactic art teaching basic moral and practical lessons? The deadpan manner of Holzer's aphorisms invites this naive response, but the hard-edged logic of the propositions themselves, and the compound contradictions they dredge up from the sediment of the "good advice" that this culture dumps on young minds, turn passive acceptance of Holzer's barbed adages into active doubt about the conventional wisdom on any subject. Thus the initial nod won from the passerby who reads that "alienation produces eccentrics or revolutionaries" is checked by the question an unassimilated twenty-year-old might then ask him- or herself: "Well, if I feel so out of it, which one am I, and if I am neither, what then?" For Holzer's implicit challenge is not only to the status quo, which alienates most

people with a critical intelligence, but to the romantic myths that describe the road ahead of them in simplistic either-or terms, as if the only choices were a business suit, beads, or a guerilla's beret. And what of those who flock to universities intent on joining the society's elites after completing their education—the nation's future doctors, scientists, social scientists, and lawyers? One afternoon I watched a group of students huddle around Holzer's table preparing for an exam. They could not have been more "normal" in appearance, more eager, or, I would like to presume, more optimistic of their chances of success in both the short term and the long. But as they scanned their notes, their gaze necessarily fell on Holzer's words, and I wondered how the idea that "a lot of professionals are crackpots" registered, or whether they considered that as they moved up from apprentice experts to figures of authority, their relation to the statement "Abuse of power comes as no surprise" would fundamentally alter. Across campus stands the Ché Café, which is emblazoned with the political slogans of a bygone era when, for many, counterculture beads and revolutionary berets really did seem the only viable alternatives to a buttoned-down existence. It is good that the cafe survives as a part of the variegated social and architectural fabric of UCSD, but in truth it is a relic. The sit-ins of the 1960s and the culture wars of the 1980s are things of the past; the social and political choices of the moment are not so much a matter of "them and us" as of individuals in disagreement with themselves. Nowadays campus "radicalism"—and by that I mean all questioning that cuts to the root of things—has a different, less rhetorical, but no less demanding tone: the even but unsettling diction of Holzer's relentless probing followed by the pregnant silence of private reflection.

Ché Café, UCSD

Bruce Nauman's neon frieze *Vices and Virtues* (1988) harmonizes with Holzer's compendium of sayings, if harmony is the right word for two works that employ visual and intellectual dissonance as their basic device. Nauman is a pioneer of the textual art that Holzer so eloquently practices, and his own early experiments in this area bear directly on his piece for the Stuart Collection. In 1967 Nauman took over a former grocery store in Mill Valley for use as a studio—he graduated from UC Davis the year before—and there in the window he found a neon beer sign that inspired him to make his own replacement. Set against a spiraling red filament, Nauman's illuminated message reads "The true artist helps the world by revealing mystic truths." Nauman's rationale for this substitution emphasized ideas of aesthetic camouflage current at the time: "I had an idea," he said, "that I could make art that would kind of disappear—an art that was supposed to not quite look like art. In that case you wouldn't really notice it until you paid attention. Then when you read it, you would have to think about it." The object of this game of hide-and-seek was still more subversive: to insert a spiritual dimension into the discourse of commerce. At that time Nauman's message was only a hypothesis. What remained for the young artist was to see if his experience as an artist bore out this

Bruce Nauman
Vices and Virtues, 1988

idealistic credo, and if the public that passed his window would subscribe to an old concept of the artist as seer when that concept was delivered in a new medium on behalf of other equally unprecedented forms of artmaking.

Vices and Virtues is prime evidence of Nauman's evolution as an artist. One of his most commanding works of any kind, anywhere, it occupies the upper reaches of all four sides of a block-like building that overlooks the center of the campus. This neon, unlike its predecessor, is by no means a purloined letter in its given context. Quite the contrary, the brilliant overlays of colored tubing that flash in a repeated progression from single words, to pairs, to groups, to the whole series all at once, and then back to evening glow or nocturnal blackness are as visually assertive as anything could be. (And as far as that goes, there is scarcely anything more beautiful in the modern landscape than watching the buzz of tinted neon in the fade from dusk to darkness.) Claiming the technology of selling for the cause of ethical inquiry in a uniquely declarative manner, Nauman nevertheless refrains from pronouncing on the application of these moral categories. In a period when voices from many quarters call out for a return to fundamental values, Nauman declines to pass judgment, and with the utmost probity and aesthetic rigor alerts the public to the weaknesses they must live with, the principles to which they aspire, and the choices they will make. Nauman does not preach to the converted, he advertises the difficulty of decision-making in a world given to binary systems of thought, underscoring in illuminating bursts the confusing, sometimes inextricable linkages among symmetrical rights and wrongs.

It may be hard for some to reconcile the image of the free-thinking avant-garde artist with such a work without assuming that the whole endeavor is an ironic gesture. But Nauman's work is not a big Dada joke at the expense of traditional beliefs. His art is never that glib or that coy. In this instance he plainly means what he says, in the sense that by naming the cardinal virtues and vices he is recognizing the power they represent. The only ironies that apply are those we introduce when we think of the inconsistent conduct of people who affirm simple truths in the face of the complexity of modern existence. The ambiguity of Nauman's piece is therefore intrinsically humanistic, acknowledging as it does the distance between what should or should not be and what is, the things we ought to do and the things we actually do. Offering little comfort to those with reflex answers, while refusing to cast the first stone, Nauman sheds light on the soul's dilemmas.

Alexis Smith's *Snake Path*, completed in 1992, is funny—and agreeably knowing. Rising from the plaza below Nauman's piece to the buttressed library up the hill, the serpentine walk Smith has laid down, and the way-station garden she has created along it, are a kind of Edenic cloverleaf or roller-coaster in the traffic patterns of the university. Climbing the path takes effort and care—an ascent to knowledge?—and descending its steep curves requires attention as well,

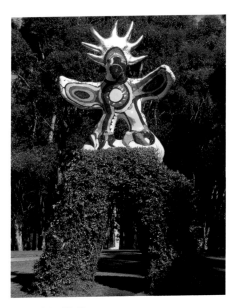

Niki de Saint Phalle
Sun God, 1983

because Smith has so ingeniously accentuated the swelling of the land, and so subtly suggested the volumes of the snake (in slightly rounding out the mosaic of stones), as to make you feel as if you were navigating the back of a giant sidewinder in motion.

While you do, there is much to see: the patterning of the intricate, shifting stone scales (trompe l'oeil on a grand scale), the scrub and indigenous flowers that grow beside it, and the two texts on the subject of Paradise found, lost, and regained—one on a giant marble book a quarter of the way up from the bottom, the other on a bench a quarter of the way from the top—that punctuate the trajectory. The first is Thomas Gray's admonition to ignore, so long as we are able, the unhappy reality that awaits us as we acquire knowledge, the second Milton's lofty promise that even after the expulsion from the Garden of Eden, true contentment lies within.

Once again, it may be somewhat startling to discover a contemporary artist embracing biblical themes and paradigms, but rather than otherworldly the paradise Smith has in mind is pretty obviously the sacred precincts of the university. Given the nature of youthful attachment to alma mater, the separation anxiety her dialectical quotations pinpoint is the commonplace, commonsense fear of the "real world" bred by the pleasures and protections of ivory tower education. The good humor and material splendor she devotes to her teasing meditation on the trade-off between blissful ignorance and inner wisdom ease the pain of knowing that students are for the most part privileged transients who must figure out for themselves how to preserve their curiosity, their critical capacity, and their hard-won sense of integrated understanding once they leave the communities in which such ideals are fostered and enter into the realms of "practical" specialization and expediency. In the best possible way, the *Snake Path* is a giant environmental cartoon narrating the passage from innocence to experience, but the upbeat ambience of the project as a whole—imagine hitting this twisting, eye-catching, off-kilter course while pondering Foucault, the greenhouse effect, or unpaid college loans—seems to hold out the hope that innocence, and if not innocence then a mature capacity for play, will somehow survive the worst punishments for original sin. Life is full of rude awakenings, but Smith's heads-up land art is altogether benign and intelligently charming.

Niki de Saint Phalle's *Sun God*, installed in 1983, has some of the same antic quality as Smith's installation. The first work in the collection, and a mascot for several generations of students, it is half archaic deity, half comic book monster. I say this with no disrespect. One of the most important figures in early European Pop art, de Saint Phalle was long ago instrumental in breaking down the barriers between high culture and mass culture. Her "Nanas"—pneumatic sculptures of women, ranging from tabletop Venuses of Willendorf in striped and polka-dotted bathing suits to a supine odalisque as big as a house that could be entered through a door opening between her legs—are icons of this aesthetic sea change. Her public sculptures in

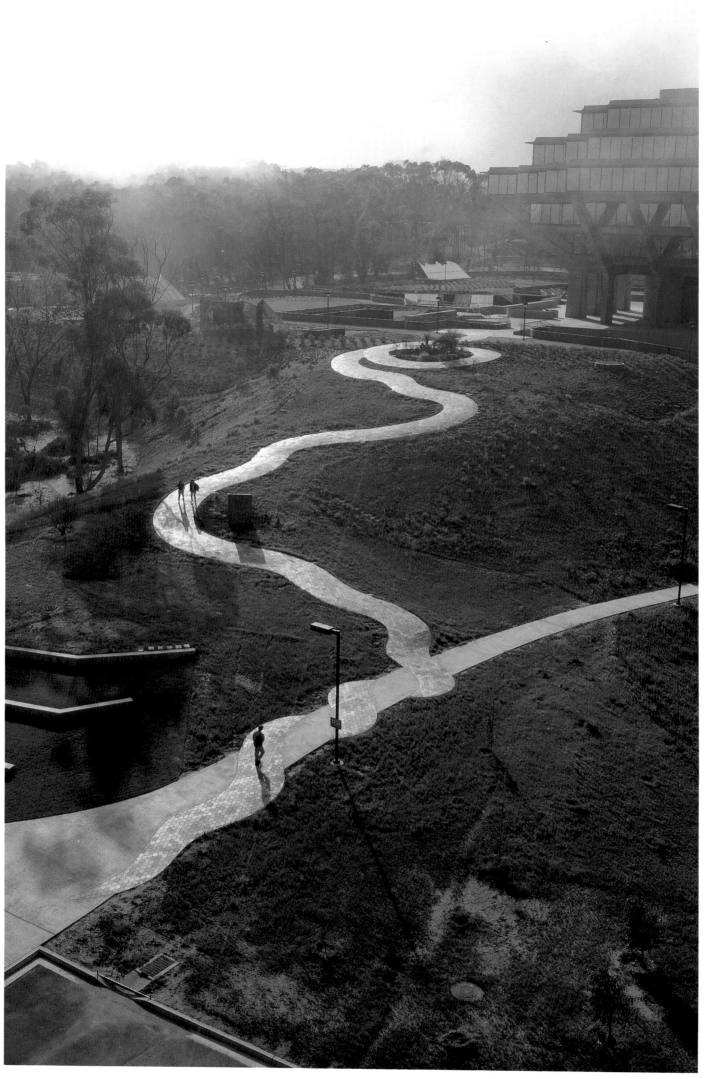

Europe, in particular the fountain extravaganza next to the Centre Pompidou in the old market quarter of the French capital, invite the general populace to meet the creative vanguard on an equal footing—and let go. A contemporary expression of the carnivalesque aesthetic that is as old as medieval Paris, in an American context de Saint Phalle's amiably awkward figures seem like crazy cousins of the featured players in early animated movies, and by virtue of that craziness and awkwardness the antithesis of the codified and endlessly repackaged caricatures currently churned out by animation factories a few miles up the thruway from UCSD. That inexpungeable measure of anarchy saves de Saint Phalle's images from the committee-born cuteness that makes their mass-media counterparts so numbing, and it is no doubt the trace element that has inspired generations of students to celebrate their rites around it, or amend it with their own rude inventions.

De Saint Phalle is not alone in benefiting from this proximity to Hollywood; Elizabeth Murray too has taken on the heritage of Disney Studios and Looney Toons. Coming of age as an artist in the heyday of Pop art, Murray made her own experiments with direct formal quotation and indirect iconographic borrowing from the comics and cartoons. Of all the leading figures of the movement, Claes Oldenburg was probably the most important to her during this phase, which she went through not in New York but in Chicago—where the weirder dimensions of commercial graphic culture were more highly prized than in Manhattan, at Mills College in Oakland, where she received her MFA, and in Buffalo, New York, where she taught for two years after graduation. In other words, Murray worked through her influences at a distance from the place where the styles she was testing were already fully developed and widely accepted, giving her a crucial margin of freedom to reinvent them for her own use. For a number of years this process saw the virtual disappearance of the caricatural aspect of her work into a chromatically rich and uniquely physical form of patterned abstraction with affinities to the work of early modernist Stuart Davis and Patrick Henry Bruce, and to New York School painters of the 1950s and '60s such as Ron Gorchov, Al Held, and Frank Stella. When a cartoon quality reemerged in the late 1970s and early '80s, it had been so thoroughly assimilated that it was at first almost unrecognizable as such. Indeed, what Murray had latched onto was not a cartoon look but the metamorphic principles that underpin cartooning, and, not at all incidentally, had also underpinned the systematic formal distortions of Surrealist art.

Murray's greatest innovation came in the mid-1980s, when she began to make shaped-canvas paintings that tipped or bowed out from the wall, sometimes as relatively low reliefs, sometimes as all but fully three-dimensional objects. The radicality of this formal gambit consisted not only of pushing the picture plane out into the room, but of complex spatial puzzles such that the image depicted on the surface of the canvas might imply perspectival depth even as the

Elizabeth Murray
Red Shoe, 1996

surface upon which it was described thrust toward the viewer in the opposite direction. This convoluted dynamic of illusionistic inwardness and volumetric projection marked the first time that the biomorphic character of Surrealist art was simultaneously applied not simply to the painted shape but to the shape on which it was painted.

Having staked this territory out for herself, Murray has occupied herself with flat or near flat painting formats for most of the past decade, and it was this self-imposed restraint, perhaps, that precipitated *Red Shoe* (1996), her only freestanding sculpture as a mature artist, as if the contraction of her pictorial universe had somehow forced into the world the independent entity it had previously contained. Like cups, glasses, and tables, shoes have been lead players in Murray's nonstop painterly narratives, owing as much to the bulbous footwear of Mickey Mouse as to the forlorn clodhoppers of van Gogh. Usually they come in pairs, but *Red Shoe* stands alone among the trees—a magic forest in miniature?—surrounded by lumpy gems. A cross between Cinderella's glass slipper, Dorothy's ruby slipper, and the nursery rhyme shoe housing the woman with too many children, Murray's sculpture recalls any number of stories but fits none precisely. Evoking childhood fantasies without anchoring them in an easily remembered and thus easily circumscribed specific one, Murray's initially appealing but over time increasingly disorienting work is an object lesson in what Bruno Bettelheim called the "uses of enchantment," meaning the ways in which fairy tale reality sublimates anxiety, allowing us to confront inchoate fear and unacceptable desire in a vivid but fictionally remote form. Thus dense psychological shadows quickly gather around this seemingly bright and friendly ensemble, as each visitor penetrating the wood brings their own. Among these pilgrims one hopes will be not only the students of art and art history, but students of Freud and Lacan. Reason presides over universities; it remains for artists to give substance to those areas of consciousness that reason has not and perhaps cannot articulate.

Both in form and in feeling, Kiki Smith's *Standing* (1998) is figurative sculpture of a wholly different kind from that of Murray and de Saint Phalle. In many ways it appears to be a contemporary example of traditional statuary, and in a couple of ways it is. A nearly life-size female nude on a pedestal, its stiff organic contours are sharply defined against the hard geometries of the surrounding architecture, in a manner familiar to us from antiquity, through the Renaissance, and on down the various branches of the classical style. That Smith intentionally evokes this heritage is plain, but she does so not so much to insert herself snugly into a conservative lineage as to transform it from the inside by subtle deviations from the norm. Thus while academic sculptors mimic the conventional attitudes and attributes of the ideal body handed down to us from Greco-Roman times—that body being a kind of collage of the most beautiful parts of many bodies, reassembled according to preconceived mathematical proportions—

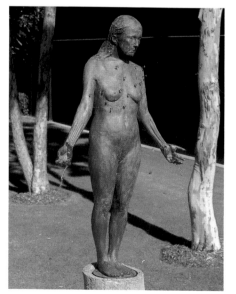

Kiki Smith
Standing, 1998

Smith has made a direct cast of a unique woman, who, though beautiful in her overall being, is not a model of perfection. In this respect one may contrast Smith's approach to the type of modern-day neoclassical sculpture that idolizes the "hard body" physique of Olympic athletes, and of the health-club addicts who haunt machine-age gymnasiums. With cold eroticism, such over-muscled grotesques represent a desperate quest for invulnerability in a world beset by dangers. Smith's statue, by contrast, is an emblem of a basic human fragility; hers is a body that things can happen to, and will.

In that context it matters a great deal that we are looking at a facsimile of a real woman, not at an abstract or generic semblance of Woman. Her uneasy carriage (like someone standing naked under the gaze of strangers, which is in fact the case), the blurring of her facial features (like a flesh beginning to dissolve), the exposure of the muscles of her arms (like a flayed cadaver), all reinforce this basic impression of contingency and mortality. The tree upon which she stands—also a direct cast—extends this awareness to nature at large: it too is displaced and isolated, it too is worn. Yet in their way both of these sculptural elements continue to manifest a life force—one that takes death properly into account as a part of life—and their vivid particularity is enhanced by the sustaining sound, sparkle, and cooling effects of the water that flows from her hands into the encircling pool, from which, one can almost imagine, the desiccated tree might somehow be replenishing itself. The constellation of stars arrayed across the nude woman's chest gives this otherwise matter-of-fact composite a symbolic aspect, if not an explicitly transcendentalist one, which in turn lends her open-armed gesture an aura of cosmic embrace, as if she were the Virgin in glory, or an incarnation of one of the many deities, demiurges, and earth mothers to whom religion and mythology have assigned the role of protector and nurturer. In this regard it is doubly important that Smith has resisted the temptation to create a goddess or "heroine" for our times but has instead given us an ordinary person to look upon. Located in front of the School of Medicine, the statue is not there to promote any specific creed or to revive any ancient superstition but simply and eloquently to point out what science, philosophy, and religion grapple with in common: the all-encompassing connectedness of things, and the poignant finiteness of the individual in an infinite though perishable universe.

In the ongoing discourse between nature and culture, some artists choose to represent natural forms—or in the case of Smith to make natural forms represent themselves—while others have chosen to draw attention to nature by highlighting or framing phenomena as they exist in actuality. Robert Irwin belongs to this latter group. Trained as a painter, whose abstractions came to consist of broad areas of uninflected color divided by impasto bars of pigment in variously dissonant or harmonious hues, Irwin then became known as a sculptor preoccupied by light—first by how light fell on or reflected off minimal shapes, and second by how light played

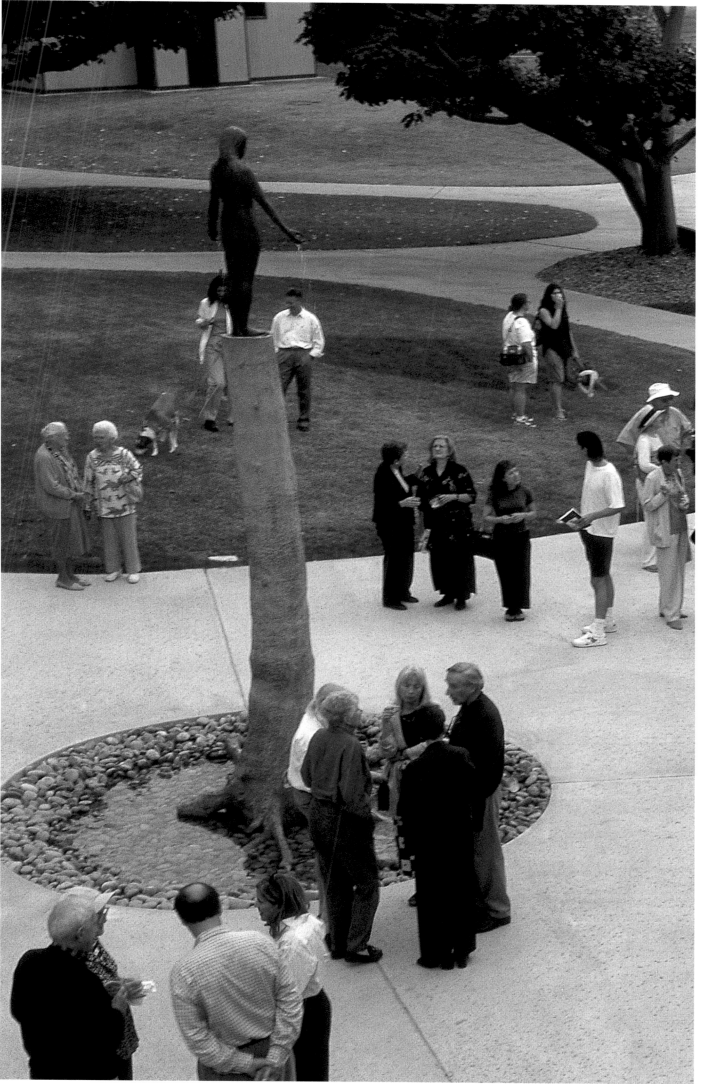

Robert Irwin
Two Running Violet V Forms,
1983

across walls and penetrated or was diffused by scrims, in the deep architectural mazes that he created in white-cube galleries around the country. Irwin's experiments thus led him away from imitating the effects of spectral or tonal light in another medium (painting) to using light itself as his primary medium. Meanwhile he expanded his scope by undertaking projects in public spaces both indoors and out. One of these, from 1980, was a low-running strip of highly polished steel, jigsaw-cut with the silhouettes of leaves, that crossed a lawn at Wellesley College, Massachusetts, casting shadows that changed their shape as the sun changed its angle of projection and the ground undulated in relation to the always plumb metal line. On spring or summer days the piece scatters the ground with "leaves" that have yet to fall; in autumn and winter it adds ghostly specters to the leafy husks lying all around—and all these seasonal transitions are accented by a simple prismatic manipulation of natural light.

Two Running Violet V Forms (completed 1983) is a similarly self-effacing, similarly surprising intervention. This time the material carving a slice out of the environment is not in itself elegant or eye-catching but standard chain-link fencing. In several ways it rhymes perfectly with its situation. First, despite the fence's inexplicable location in a eucalyptus grove and the unusual height of the mesh—it begins nearly nine feet above the ground—the materials have a temporary, construction-site look, as if they had been left behind from a previous phase of the campus's metamorphosis. Second, Irwin chose a mesh coated in a rich blue-violet plastic, which, depending on one's vantage, may resemble a brilliant chromatic plane against the subdued gray-browns of the trees, may fade to a silvery tint that blends with the tattered bark hanging from their trunks, or may dissolve altogether into the visual crackle of branches and leaves. From no position and under no atmospheric conditions, though, does the mesh have a consistent appearance all along its length. Rather, variations are visible from any perspective, giving the whole band a sense of movement through space, like a ray of color refracted through the vegetation. The fact that this band passes above one's head—leaving one free to walk among the trees without impediment—increases the sweep of that illusion, while the black and yellow monarch butterflies that congregate in the grove flutter like lazy sparks spun off by the optically streaking chain link. In the history of land art—Michael Heizer's *Double Negative* (1969–70), Christo's *Valley Curtain* (1970–72), Richard Serra's *Shift* (1970–72)—Irwin's permeable membrane of metal stands out by not standing out, being instead among the comparatively few works that integrate themselves so completely into their surroundings that once having seen them one must still keep finding them again. This game of hide-and-seek, and the gently mutable pleasures it affords, are the essence of Irwin's art.

In the context of UCSD's overall layout, Irwin's *V Forms* might be thought of as an antiquadrangle or anticloister, a spatial volume within the campus's grid that is neither enclosed

Jackie Ferrara
Terrace, 1991

nor enclosing yet establishes its own perimeters and through them fosters quiet alertness or quiet thought. Jackie Ferrara's *Terrace* (completed 1995), on the other hand, would seem to be a linear descendant of the traditional quadrangle or cloister, though it too opens out rather than shuts away the precincts that the sculptor has discreetly but strikingly reconfigured. To be sure, the buildings that overshadow Ferrara's terrace are the work of other hands, though over her long career Ferrara has often conceived complex sculptural ensembles including architectural or quasi-architectural elements such as the walls, screens, steps, pyramids, ziggurats, and other modules that occupy or frame similar patio or plaza designs. These freestanding elements and the "vacant" but densely patterned intervals between them hark back to precedents in ancient Egypt, Persia, Rome, Renaissance Italy, and Moorish Spain, as well as throughout the Islamic Middle East and Southeast Asia, and they have their modern echoes in the paintings of Giorgio de Chirico, master of expectant urban emptiness.

This time Ferrara has restricted herself to reshaping a given space with paving blocks and gravel alone, but the effect of this restriction has been to increase the intricacy of the terrace's patterning. Large red, black, and gray squares of slate make up an arrowlike path that dominates the central axis of the piece. They are laid down in bands that tilt now to the left, now to the right, or run parallel at uneven distances from each other in a visually accelerated Fibonacci sequence, while other smaller squares stitch a seam down the center of the path's trajectory, corresponding to the wider checkerboard seam that stretches out alongside the main path, separated by the comparatively "silent" gravel. If I choose this term to refer to the ground between these two walkways, it is because the interruptions and broken symmetries that result from these graphic counterthrusts lend the overall composition a crisp syncopation, as if a jazz riff were being played off the cadences of a Monteverdi madrigal, and the two distinct genres had wondrously fused. The metaphor is not so far-fetched. Ferrara is of the artistic generation of Philip Glass, whose music has fed on models—pre- and postclassical, Eastern as well as Western—that assiduously avoid the lush orchestration and expressive vibrato of the nineteenth-century repertoire, and with it any sort of ornamentation that would obscure the clear articulation of the sound. Ferrara does the same in visual terms. No matter how elaborate her sculptures may be—and within its strict horizontality, *Terrace* is quite elaborate—Ferrara belongs to the party of aesthetic clarity and precision. The rigor with which she adheres to this basic faith has enabled her to harness the decorative impulse behind this work, and to maximize the impact of her minimal means.

The minimalist grid is Nam June Paik's template as well. In his case, whatever musical analogies his work may suggest are not merely speculative: Paik began his career as a composer and performer, in the early 1960s in the avant-garde circles of John Cage. At the heart of Cage's

aesthetic was the use of chance operations as ways of deconstructing or bypassing conventional musical formats. Random correspondences, unpredictable pauses, the independent unfolding of the different parts played by different players, and the predetermined duration of those parts, which could at any point truncate a section of the whole, became the ruling principles of Cage's art. All this was in the spirit of liberating music, musicians, and listeners from the auditory regimens imposed by canonical modes, so as to concentrate their attention on the act of listening and the serendipitous discoveries the ear may make when not obliged to follow a score, or when simply unable to anticipate what that score might dictate. These are principles that Paik transposed to video art, of which he is a founding father.

We are accustomed, of course, to thinking of TV as a primarily narrative medium, whether the stories being told are fictional or documentary. With the scheduled hours and half-hours that fill the TV day, standard shows have beginnings, middles, and ends regularly subdivided by commercial breaks, with each part of that day given over to a specific variety of programming that establishes its own progression from kids' fare to adult entertainment. Beyond that the genres—news, drama, cartoons, variety shows, talk shows, the MTV cavalcade of pop stars— all have their own familiar formats, such that the average American who watches eight hours of TV daily knows them all by heart. Paik's genius in *Something Pacific* (1986) is to turn the prerogatives of the sound-booth engineer who ordinarily manages the smooth transmission of these TV staples over to the random viewer, on terms that guarantee the scrambling and semichaotic reimaging of the original broadcast material. Thus anyone who chooses can change the quality of the signal, or toy with the kaleidoscopic combinations that Paik has programmed into the wall-size matrix of monitors installed in the lobby of the UCSD Media Center. It is simple fun— a common practice of playing with the dials, or talking back to the talking heads—but in a country mesmerized by the tube it is an anarchistic declaration of independence that is especially appropriate for those studying how the media work.

If the indoor component of Paik's piece entices the normally passive viewer to become an active one—giving the title *Something Pacific* an added twist in its already loaded play on the importance of California's ocean link to Asia, and to the artist's culture of origin—then the outdoor component of the installation pokes gentle fun at the spectator as contemplative couch potato. In what amounts to a graveyard of vintage televisions neatly summarizing the sculptural history of "the box," weather-beaten sets are grouped near the entrance to the Media Center and stare blankly outward at passersby. In front of three of them Paik has placed offbeat bronze Buddhas, and atop a little Sony Watchman he has affixed a small cast of Rodin's *Thinker*. The humor is seemingly offhand, but it has staying power. Anyone retreating along this path to their dorm room or office to indulge in private in the nation's favorite pastime may do a mental

Nam June Paik
Something Pacific, 1986

double-take as they sink into their chair and press the on button, for what may look like a dumb art joke is in reality a visual koan for a technological age that habitually tunes out by tuning in.

With Cagean, not so say Zen, cheerfulness, Paik thus lays an ambush for media-savvy generations present and future. Terry Allen's *Trees* (completed 1986) are also booby traps for the mind, but the audio collages Allen has created and the mixed messages they transmit are moodier than Paik's basically optimistic play with technology. A musician and multi-discipli-nary artist who had never undertaken a commission for public sculpture before his work for the Stuart Collection, Allen chose as his site an area close to the university's intellectual nerve cen-ter, the main library (now named the Geisel Library), but it is not until one is well away from that space-age building that the full effect of Allen's subversive project is felt. The trees in ques-tion are eucalyptuses that were cut down during a campus building expansion. Allen salvaged three of these trees, wired two of them for sound, and covered them in patches of lead, which are patiently nailed down with thousands of common nails whose color is just a shade different from the warm dull gray of the metal. In its irregular tone and texture, this covering from a dis-tance mimics bark, so that one can easily walk by one of the trees without noticing anything peculiar about it—until it speaks, or sings, or emits some other uncanny sound. By the time one has found the source, the disorienting impact of the disembodied words and music causes one to question just how many other trees in the vicinity might be similarly wired. The harder one looks for another, the more the untouched trees begin to resemble Allen's metal-clad one, while, reversing polarities, Allen's themselves become "alive" as a result of his ventriloquism through the dead wood.

One is reminded in this context of the opening lines of Charles Baudelaire's poem "Correspondence": "Nature is a temple in which living pillars utter a Babel of words; man traverses it through a forest of symbols, that watch him with knowing eyes." In our semiotics-sensitive period, Baudelaire's notion of a forest of symbols has gained widespread currency, but the verses whispered or growled by Allen's trees have little in common with Baudelaire's sinuous prosody and a lot more to do with all-night honky-tonks and the hard feelings and tender mer-cies of the morning. Thus guitar licks and country twangs alternate or elide with intimate mono-logues and the occasional rant, while from time to time Philip Levine and other poets read their own stanzas. The composite is no ordinary public-radio potpourri but a carefully orchestrated blend of work by collaborators chosen by the artist. No wonder that students, their heads full of the library's book-learning, drift among the trees where Allen's two noise-making ringers are hidden; the draw of the music and the alternatively introverted and extroverted texts are an irresistible stimulus to the imagination as one heads toward or away from that vast repository of knowledge. And it is no wonder either that the third tree, the one closest to library, is silent, a sentinel of inwardness on the approach to the printed cacophony of ideas that the library hosts.

41

William Wegman
La Jolla Vista View, 1988

To some, such silence can be frustrating: "Talk to me," an anonymous hand had written in chalk around the base of the third tree on one of the days I visited. Perhaps this was meant as a gag, perhaps it was a genuine plea; in either case the tree's implicit reply was "Listen to your own voices."

William Wegman's *La Jolla Vista View* (completed 1988) is as close to the periphery of the campus as Allen's is close to the center. Wegman, now world famous as the whimsical master of a troupe of weimaraners that masquerade as men and women in all their strange posturings, is also a painter of landscapes. Not exactly traditional landscapes—they contain all sorts of visual and logical anomalies—these are landscapes all the same, and it was the terrain on and around which UCSD was constructed that caught Wegman's fancy when he was invited to make a work for the Stuart Collection. Under other circumstances the location he chose, on a promontory overlooking the university's outskirts and the beginnings of suburbia with which it merges, would have made an ideal lovers' lane. (In all probability young lovers who find their way there take full advantage of this potential even now—at least one hopes so.) In any case, what seems to have attracted Wegman to the panorama one sees from that spot was its expanse and its splendid banality. Turning away from the open, picturesque Pacific horizon, and in doing so making one aware that the westward migrations and the myths they have propagated reach their terminus just over his shoulder, Wegman, a connoisseur of everyday absurdities, looks back on the America that fills in the parentheses between the two coasts, an America ever more homogeneous as it radiates from the core of its old cities. UCSD is just barely within the circumference of the outermost of these circles, and Wegman savors the vertigo of its slack orbit.

So, like a surveyor mapping a development, he has etched the rolling contours of the land on a mounted brass plate that one can consult when gazing at the view. And like an eager tour guide he proudly indicates the points of interest, items that are in fact of no special interest at all but for their archetypal Americanness, or that are temporary and evanescent or even the pure products of his quirky inventiveness. "Rare bird," an inscription says, though of course the bird Wegman claims to have seen at that exact location is no longer there. "Rare plane," says another inscription, but what might have prompted the artist to write that down?—other than a lovely linguistic slide that creates an image needing no verification by the actual appearance of a Concorde or Spad. The details, all rendered in a loose notational hand, accumulate but do not quite add up, in precisely the way that the topsy-turvy growth of industrial parks and subdivisions unfolds but never really coalesces to become a permanent place. Some structures, one quickly sees, have cropped up since Wegman made the chart, most conspicuously the Mormon temple, as specific a shrine to Manifest Destiny as anything conceivably could be, and, had it been built early enough, a perfect subject, with its massive Oz-like spires, for Wegman's benign

graphic weirdness. The truth is that the land stretching out from *La Jolla Vista View* will continue to change, making his modest portrayal of it in the year 1986 less a description of what is there than a reference against which to measure what is to come. But even then, with its rare birds, rare planes, and quick glimpses over fences and into back yards, it is less a document than a pictorial parable of flux.

As Wegman shows us, we are filling up the American sublime, but just at the point when that realization might cause us to despair, the landscape, natural and manmade, undergoes another metamorphosis, and we must look again and relearn our surroundings. In doing so there is always pleasure, especially when art responsive to such flux is there to focus our attention and make sense of the ambient confusion, or the confusions we bring to the situation. Generations ago, art's function was to embody eternal verities. Such verities may still tug at our consciousness as Nauman, Alexis Smith, Holzer, and many of the other artists who have contributed to the Stuart Collection have demonstrated, but the manner in which they are evoked no longer resembles a rock of ages, or if it does, as in Finlay's or Asher's case, the stone no longer speaks in simple declarative ways.

Instead, artists today have learned to exploit the ephemeral, and to make more durable things seem ephemeral in order to speak to their contemporaries in the clear, emphatic present tense. How long that present tense will echo, and how long the works these artists create will last, is unknowable, but we do know from the early history of modernism that the significance of works made for a fully experienced "now" is generally more enduring than that of those made for a speculative "forever." The comfort artists currently feel with impermanence, and the wit they often bring to their task, may strike some people as indicating a lamentable loss of ambition on the part of those dedicated to a noble profession. To them I would recall a phrase of Lawrence Sterne's quoted by Ezra Pound in his *ABC of Reading*: "Gravity, a mysterious carriage of the body to conceal the defects of the mind," to which Pound added his own admonition: "Gloom and solemnity are entirely out of place in even the most rigorous study of an art originally intended to make glad the heart of man." That goes for study generally, and might usefully be emblazoned on the stones of many another university. Fortunately on the campus of UCSD—where Nobel Prize winners walk upright and wear casual clothes, melding easily with crowds of skateboarding students—art that eschews gloom and solemnity, but is serious in every way that matters, has found a home. May the rare artistic birds of which the Stuart Collection can already boast so many examples attract still others with the will to carry on this come-as-you-are conversation of ragged nature, heterogeneous buildings, more or less itinerant scholars, and multifarious works of art that do their job perfectly by occupying positions in the midst of all the rest but at odd angles to expectation.

niki de saint phalle

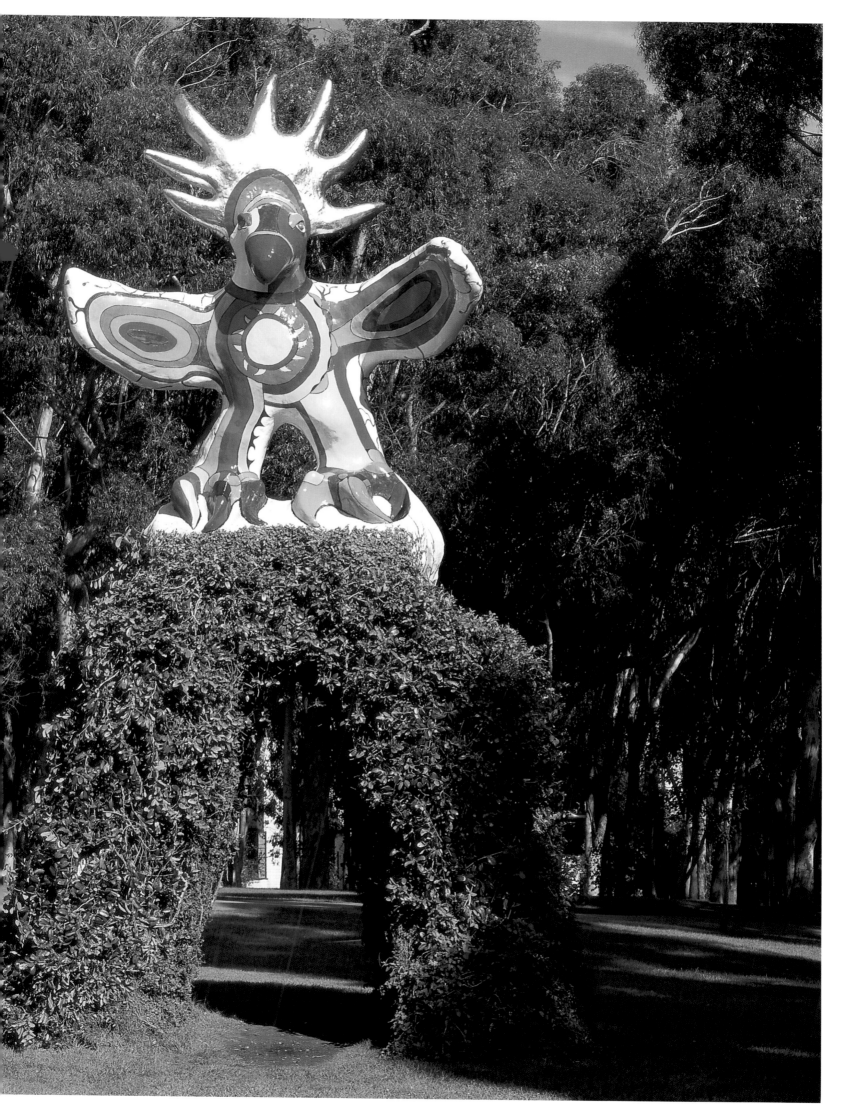

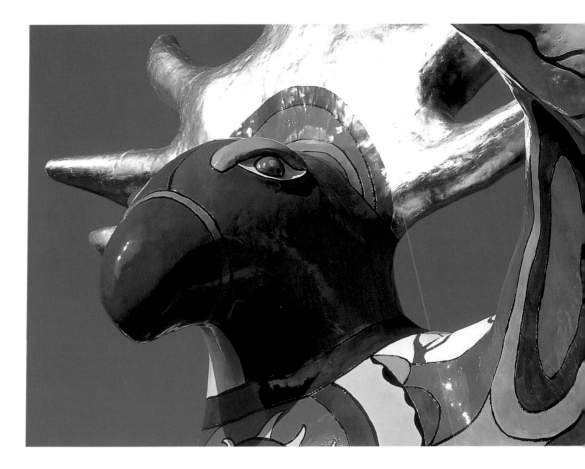

niki de saint phalle

SUN GOD
1983

WHEN I ARRIVED IN SAN DIEGO, the agreement between the Stuart Foundation and the Regents of the University of California had not been completely defined, but the Advisory Committee had invited Niki de Saint Phalle and Jean Tinguely to make proposals. (The two of them had collaborated frequently.) Niki visited first and then they visited the campus together in early 1981. Tinguely wanted to create a fountain. Concerned about droughts and the long-term cost of maintenance, the university, sadly, was not predisposed to encourage this idea, and after considerable deliberation the Committee chose Niki to make the first work on campus.

Niki was best known at the time for her "Nana" works, large, colorful female figures that played on ancient traditions of feminine deities while celebrating feminism's revaluation of the bodies of women. Whatever she might do was likely to elicit both delight and outrage, and she would surely bring a burst of color to the gray concrete of the campus, something opposite to the solemn monumentality of traditional public art. The project promised to be shocking yet friendly enough, beginning to get everyone's attention. It would also be Niki's first major outdoor work in America.

Niki was born in France but grew up in both Europe and the United States. She discovered art while young, and found it a salvation for her sometimes delicate psyche. She has described working as a "fruitful trauma." By the early 1960s she was achieving respect and notoriety for her "shooting paintings," the products of public events that she orchestrated: having made a kind of collage with bags of paint embedded in it, she would shoot at it with a gun, making the paint splatter and drip. Niki became known as a member of the Nouveau Réalistes, a group of artists including Tinguely, Pierre Restany, Arman, César, and Christo, among others. In 1961, Pontus Hulten, then the director of the Stedelijk Museum in Amsterdam, gave the group their first exhibition. His support continued through subsequent years. Niki also soon gained the

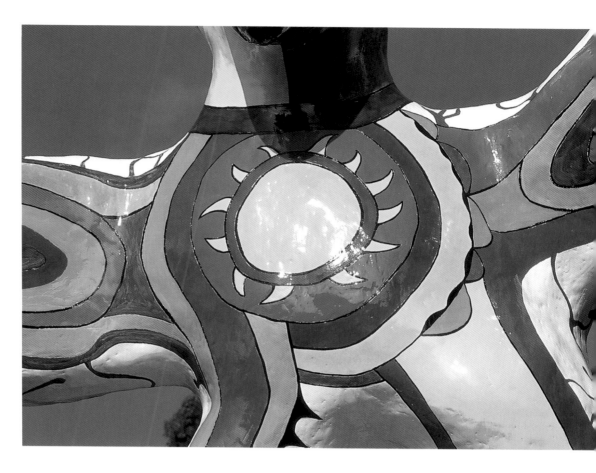

attention and friendship of American artists Allan Kaprow, Robert Rauschenberg, Jasper Johns, Merce Cunningham, and John Cage, whose interest in spontaneity and chance she shared. Ed Kienholz assisted at one of her "shootings."

Niki's influences include Matisse and Picasso, Klee and Rousseau, ancient and so-called primitive art, fairy tales and gargoyles, magic realism, carnivals, folk art, and the architecture of Antoni Gaudí. But she always marches independently, inventing her own values and almost flaunting her freedom from societal constraints. The force of her personality is clear in her sculpture, which has an irrepressible humor and innocence in tension with an underlying seriousness. Bold, accessible, playful, idiosyncratic, and brilliantly colored, her work takes on the opposing forces of pleasure and terror: monsters and beasts become playgrounds, and fantasy and nightmare are equal sources. Conquering fear with humor is a recurring theme. Terror and difficult memories are subdued, suffused with comedy and joy.

Niki proposed three possibilities for the Stuart Collection, a *Life Savior*, a *Nana House*, and *Sun God*. The latter was her preference, and eventually the Committee's as well. Niki saw this giant colorful bird with outstretched wings as "an homage to the Southwest." She sent a maquette for the Committee's consideration and the project was set in motion.

Niki returned to the campus in the fall of 1981, choosing a lawn area near the Mandeville Center as the site. The visit inspired her to lighten the work's colors in recognition of the California sun. Her original archlike base, to be constructed in concrete on site at UCSD, was felt to be somewhat awkward, so Tinguely collaborated on reconfiguring it. The fiberglass bird itself would be made in France, at the studio of Robert Haligon, longtime fabricator of Niki's large-scale works. Meanwhile, in collaboration with the UCSD Mandeville Gallery (now the University Art Gallery), we planned an exhibition, "Niki de Saint Phalle: Monumental

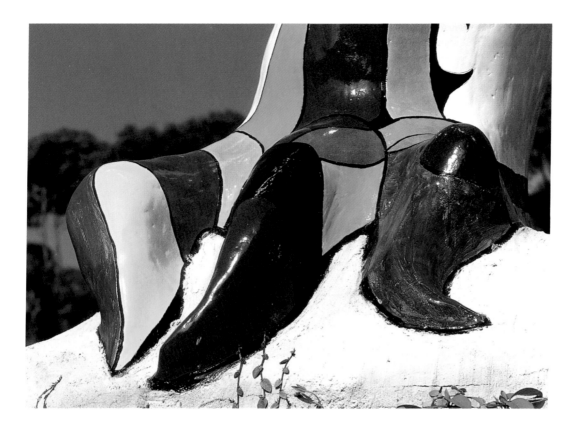

Projects," to run in October–November 1981. Some of the amazing models that Niki had creat-ed for her fanciful architectural projects were shown, along with small Nanas and a maquette for *Sun God*. We received the maquette for the base, a chunk of carved Styrofoam in the form of an arch a little over two feet high, with instructions from Niki to "just make this six times as big." This was quite a challenge: Mathieu set about figuring out the molding and construction of a solid concrete arch over fifteen feet high.

There were many reasons to go to Europe in the summer of 1982, and seeing the progress on *Sun God* was high on the list. Mathieu Gregoire, Jim and Marne DeSilva, and I drove from Paris into the French countryside to Haligon's studios, Niki's fiberglass "foundry," not far from her house in Soisy-sur-École. Here we saw the giant mold for *Sun God*. The production process was fascinating, and Mathieu was able to discuss details of fabrication, the fit of the bird with the base, and shipping. We went on to Niki's house and then, with her, to Jean Tinguely's, where Pontus Hulten and Pierre Restany joined us for dinner. Tinguely lived in one end of a four-teenth-century convent, a huge place where exceptional cobwebs had accumulated over many years, becoming tangled specters on the ceiling. It was a wonderful and memorable evening.

In the twilight we journeyed out to a nearby wood to see a giant outdoor sculpture that Tinguely, Niki, and other artists had been working on sporadically since 1969. This was *Le Cyclops*, an eighty-foot-high mechanized head—a composite assemblage of industrial by-prod-ucts, furniture, and even a real boxcar cantilevered out from the back of the "skull." A large pool of water on the top was an homage to Yves Klein. Inside there were living and cooking facilities, and even a theater. With some ado, Tinguely and his assistants started the generator. The head groaned and ground into action: chairs went up and down, couches back and forth, "eyeballs" rolled out of "sockets" and down a giant trough and were taken back up to repeat

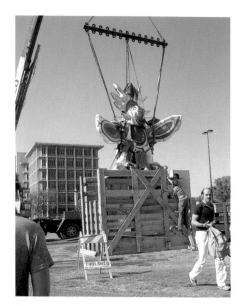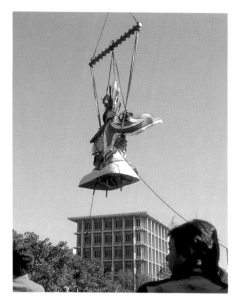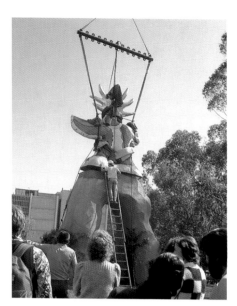

Sun God installation, 1983

their descent. It was spooky and awesome. Later Pontus Hulten suggested that the Stuart Collection buy this extraordinary construction, but it was obviously at home in its forest. The idea of taking it apart, moving it, and reassembling it was so overwhelming and probably destructive that its acquisition was never pursued. Eventually, and appropriately, it was included in the national collections of France, ensuring its preservation on the original site.

By fall we were getting ready to begin building the base. Niki, still back in France, hadn't determined the exact and final siting, and her schedule and her health weren't going to permit a visit for some time. We were eager to proceed with the work on the site and foundation, so Niki suggested we go ahead and fix the location ourselves. Mathieu went out to survey the territory. A couple was lingering in the general area; the woman had a large parrot on her shoulder. *Sun God*, a birdlike creature, was to be in bright parrot colors. The couple wandered and talked, and suddenly the woman took the parrot off her shoulder and set it on the ground. Mathieu marked the spot. The site was fixed.

The foundations were laid in the ground and then the arch was begun. For some weeks there was scaffolding and wire mesh and concrete mixers. The bird itself would not arrive for several months, and the finished arch alone was a strange sight. Rumors circulated on campus that it was Gumby's legs. Nothing like this had ever been seen at UCSD before. Mystery was in the air.

The bird was shipped from France in a slatted crate, arriving in the port of Long Beach in late January 1983. After customs clearance it was put on a flatbed truck and driven down the freeway, visible through the slats—another strange sight. We had arranged a celebration for the joining of the bird with the arch. People flocked to the site. A huge crane lifted *Sun God*, wrapped in packing garb, and "flew" it to the base. It was cemented in and the Stuart Collection really had begun: our bird was here to stay.

This zany object was met with a flamboyant mixture of delight, dismay, and distress. There had been pessimistic forecasts in some quarters about the physical fate of sculpture on campus, so I was very nervous about *Sun God*'s well-being on its first night. I slept fitfully, and hurried to school early in the morning to make sure all was well. The bird was still there, and I

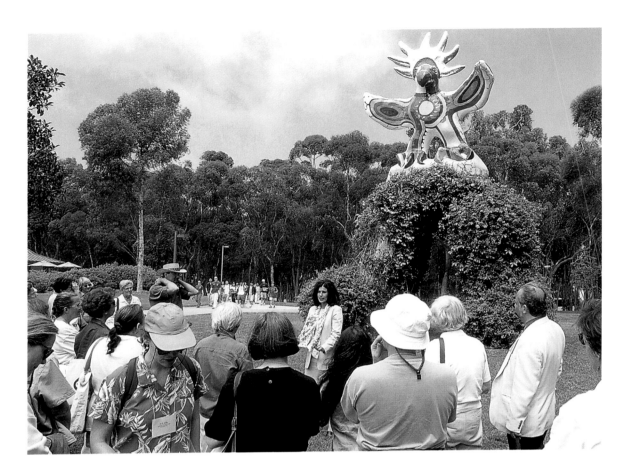

saw no graffiti, but on the ground at the base there was something strange—which, as I got closer, emerged as a very large handmade paper egg. The unknown artists had written greetings: "Happy Birthday," and, since this was an egg, "Happy Easter." A mascot was born.

Less than a year later, the Associated Students of UCSD, the undergraduate student government, began the process of organizing a Sun God Festival, their first such activity. Even the doubters had to admit that this was a successful beginning—such a success, in fact, that the students immediately decided to make it an annual event. It is now the biggest undergraduate event of the year, taking place in May to celebrate the end of classes and to offer an excuse for revelry before the start of exams. A student team works all year to plan a huge array of food, music, and games. It's a whole day of gaiety crammed onto the lawns surrounding the joyful bird.

Right away *Sun God* became a landmark, a place where people arrange to meet, or leave notes for each other. It has really never been damaged, but is often the target of fun: it has worn a cap and gown for graduation; cardboard sunglasses; earphones and a box hanging from one wing saying "Sony Walkbird"; and a bandolier, a machete, and a headband saying "Rambird." Offerings have been found at the base, as if some, perhaps even many, had invested this awesome creature with otherworldly powers. Druidlike ceremonies have been known to take place. Clearly these are responses to a campus character, a mascot.

Sun God can be interpreted as a phoenix risen from an ancient civilization, an enlightened presence, or an advertisement for the toys on sale at the Tijuana/San Diego border. Its sex has been widely debated. One day a large straw nest appeared at its base, filled with chicks made from found wrappers, wires, and other cast-off junk, making the bird a mother. On another occasion this great figure became distinctly male, donning a huge yellow penis with testicles in the form of two orange basketballs. A newspaper reporter called to ask if we were waiting for

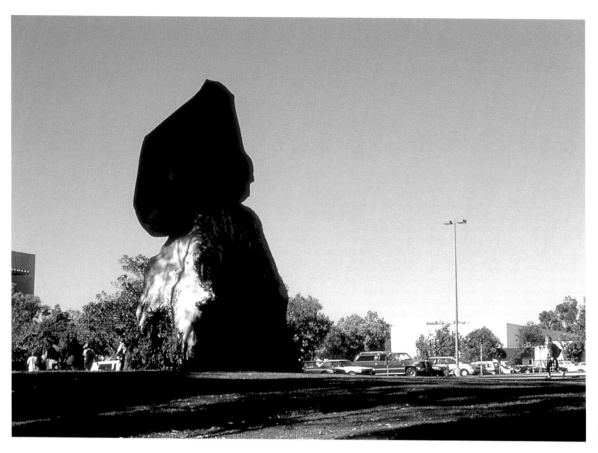

Sun God shrouded for
A Day Without Art, 1989

help from the School of Medicine to take this new appendage down. I asked if he were going to publish a picture of it: "Oh no, we're a family paper." These are only a few of the pranks that have occurred over the years.

In 1989, on a more somber note, a graduate class made a giant black shroud to cover or "take away" the bird on that year's Day Without Art, the annual commemoration of the devastating losses to the creative community from AIDS. The effect was stark and powerful and moving. Clearly *Sun God* made its way almost immediately into the life and traditions of the campus, and remains a participating citizen. There have been countless photographs, weddings, parties, and surely nighttime trysts. *Sun God* has graced T-shirts and sweatshirts, key chains and coffee mugs, student recruitment brochures and posters. In the memories of graduates and visitors, it is a standout. A number of alumni have reported that whether or not they paid much attention to the Stuart Collection when they were students, they carry the images with them, and when they've encountered Niki's work in particular elsewhere (such as the Stravinsky Fountain, her collaboration with Tinguely in Paris), they feel a great sense of recognition, pride, and ownership.

Sun God incorporates many opposing forces, and so, true to form, its audacity belies its fragility. The color is vulnerable to the ultraviolet rays in sunlight, and the surface has twice undergone conservation to restore the original brilliance of the palette. In September 1999, the sculpture was sanded back to pure white before the reapplication of resin. It was a shock—for a day or two it had become a Snow God! When students returned for the new semester they were greeted by a freshly sparkling creature, familiar but new.

—*MLB*

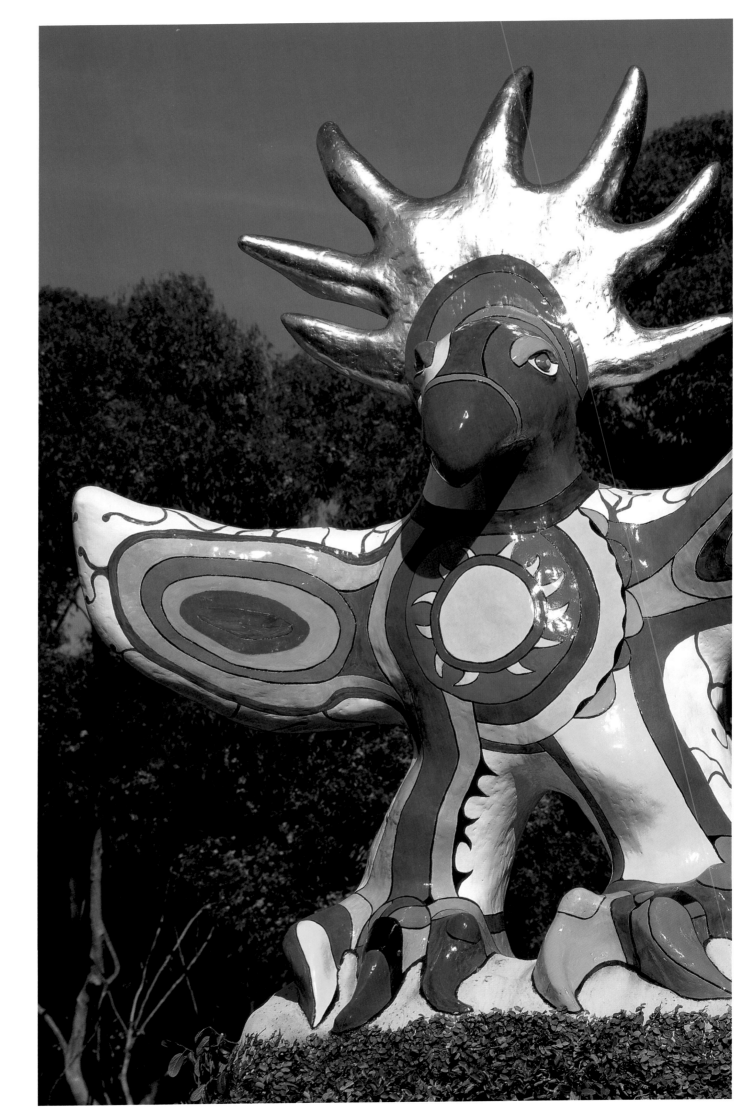

interview

niki de saint phalle

JOAN SIMON: You were the first artist commissioned to make a work for the Stuart Collection.

NIKI DE SAINT PHALLE: When I came to UCSD, Jim DeSilva rented a helicopter to go around the campus for me to choose the place for my piece—and I was scared to death. I thought a lot about the roots of California, which were Native American and Mexican. I wanted something that would mean something on a spiritual level. And I chose an eagle.

The sculpture was contested a bit at first, and then it became the mascot. The students like it. It's a place where they meet. The thing that matters for me is that the students really use it, it's a place of rendezvous: "Meet you at the Sun God."

JS: When you were first contacted [to do a work for the Stuart Collection], what do you remember of the process?

NdSP: I know that Pontus Hulten, who has been a lifetime supporter of my work, was on the committee. I know that Pierre Restany, who is a French critic, was on it. I think it was an international board. They also wanted Jean Tinguely to do something, but he proposed a fountain, and they said, There's not enough water. It's too bad it didn't happen, Jean had chosen his spot, but somehow it didn't work out.

JS: Might you and Tinguely have collaborated on the fountain?

NdSP: No, it was just going to be by him.

JS: The Sun God *seems to relate to two other bird sculptures of yours—the one in the Stravinsky Fountain, your collaborative work with Tinguely near the Centre Pompidou, Paris [1982–83], and the one in your Tarot Garden at Garavicchio in Tuscany, the complex of monumental sculptures and architectural works that you began in 1979 and that opened to the public in 1993. There the motifs are based on the twenty-two cards of a tarot deck.*

NdSP: The one in Italy is similar to this one, but it is done in tile instead of being painted. The one at the Stravinsky Fountain is smaller, it's different, but it's in the same family.

JS: Were they conceived at the same time?

NdSP: The *Sun God* was first, then came the one in Italy, and later the one in Paris—from a Stravinsky opera, *The Firebird*. Birds have been a major theme in my work; I think they're free and spiritual. I hope if I get reincarnated I'll get turned into a bird. I love their magic, their freedom. Where I live, I can see pelicans flying by.

JS: When you talk of the bird in tile, I'm reminded of your interest in the Catalan architect Antoni Gaudí and the French postman Ferdinand Cheval, a kind of architectural folk artist. You have called them both heroes of yours.

NdSP: I first encountered Gaudí's work when I was twenty-five, when I was living in Majorca with my husband Harry Mathews. We were living like hippies before their time.

Jean Tinguely and
Niki de Saint Phalle
Stravinsky Fountain, 1982–83
Paris, France

Walter Auerbach, a very intelligent man and a friend from New York, said "Niki, you have to go to Barcelona and see Gaudí. It's going to change your life. I feel it already in your work." So I took a trip, and I really had the feeling that [Gaudí's Parc Güell] was a message sent to me—that I too must do a garden of joy to give people happiness. It took years and years before I started the Tarot Garden.

JS: And Raymond Isidore, and his Maison Picassiette in Chartres? And Cheval?

NdSP: He was totally great, the Facteur Cheval. I don't know how many times I've gone down there. Jean was really involved with these outsiders. He saw the terrific freedom of being an outsider that people don't have when they're enveloped in the art system.

JS: You have spoken of how important Gaudí and Cheval were for you. Cheval worked on his Palais Idéal, in Hauterives, France, for over thirty years; Gaudí worked on Parc Güell for ten. You say that this work had no intermediary—no galleries or museums—that it had a direct kind of beauty. You also say that although Tinguely changed his opinion, he was initially against this type of work because he thought art needed to be within society, not outside it.[1]

NdSP: That's what he thought. Then when he saw the Facteur Cheval's work and the Watts Towers, he totally changed his mind, and he built his own "outsider" sculpture—the Cyclops in the forest [1970, Milly-la-Forêt, France].[2]

JS: What do you think made for the change of mind?

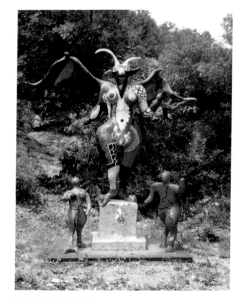

Niki de Saint Phalle
Tarot Garden, 1979
A public outdoor sculpture
park in Italy

NdSP: He was overwhelmed by the savage beauty of these artworks. Jean was at heart a rebel, and most outsiders are rebels. Gaudí was very lucky; he had a benefactor who financed Parc Güell. Sometimes I used to curse him, my master, when I was doing the Tarot Garden. I was really jealous—he had all this help and I had to find the money. The Facteur Cheval did it all on his own too. I also felt it was my karma to have to finance and build this garden to show that a woman was capable of taking on such a task.[3]

JS: How did you finance it?

NdSP: By doing a perfume, by making vases. I thought if I made art objects to embellish the home I could make money, and I did, probably because I made them with the same love and care that I do my sculptures. My multiples have done extremely well. People like to have a chair or a vase, it makes their house gay—and that helped to support my other work. I managed the Tarot Garden, but sometimes it was very tough.

JS: How is it maintained now?

NdSP: The artisans who helped me make the garden now run it. We have visitors. There is also a boutique where I do selected work. The museum shops have become too important. I have a small shop, designed by a young artist, Pierre Marie Lejeune, where we sell books, scarves, posters, postcards, T shirts. We do quite well between the shop and the visitors. It's a private foundation.

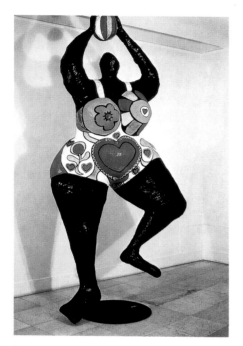

Niki de Saint Phalle
Black Venus, 1965–67
Painted polyester
110 x 35 x 24"
Collection Whitney Museum of American Art,
New York, Gift of the Howard and Jean
Lipman Foundation, Inc.

JS: Was there a moment when you felt you had really come into your own as an artist?

NdSP: I loved doing the shooting paintings. I was of course a scandal then. I had this great dealer, Alexandre Iolas, who bought all my early work, and let me survive by giving me enough money to live and work—not very much, because he didn't sell anything, but enough. Rauschenberg bought a shooting painting; Jasper [Johns] was enthusiastic; [Ed] Kienholz was a big supporter—all of which was very important to me. This was about 1961.

Then afterwards I went on to different things, but as I moved on, my early work got lost. Nobody would show them or buy them. They were ignored. That's why I'm very happy with the major donation I made to the Sprengel Museum [in Hannover], because they concentrated on the early work. I feel, at last I'm being seen as a complete artist. For years it was as though they wanted to take off your legs or something and only show the trunk—nothing but the Nanas. It was just Nana, Nana, Nana. It got kind of boring. I got sick of them, but I needed to do them to help finance other projects. I tried always to do them the best I could.

JS: In 1987, in collaboration with Silvio Barandun, you wrote and illustrated an important and accessible AIDS awareness book, AIDS—You Can't Catch It Holding Hands.[4]

NdSP: The book was published by Sam Francis's Lapis Press. He didn't want people to know it was his publishing company. He never wanted to show all the good things he did. But I came out and said, "Sam, I'm sorry, I'm going to say you did it. I want people to know." I thought it was a great thing he did.

JS: More recently you published the first volume of your autobiography, Traces.[5] *Why now?*

NdSP: I see all the lies about Tinguely after his death, and two books have come out about me that have many things wrong. I don't believe in truth, I believe in perception—I may offer things that are distorted also—but at least it will be there, for my family. It gives them a reference.

JS: In the period of that early work, in Paris in the late '50s, you were part of an important community of artists—Yves Klein—

NdSP: —Joan Mitchell, Riopelle—

JS: Giacometti, Tinguely, Saul Steinberg, all involved with each other's work. In your autobiography you say that when Mitchell treated you as the wife of a writer [Mathews]—

NdSP: —I think she was provoking me—

JS: —it charged you to work very hard to—

NdSP: Not to work very hard; I was already working all day long, as hard as I could. But I didn't want to be taken for an amateur, I couldn't stand that, and I decided to impose myself on the art world. She did me a favor. I wanted to be recognized, and I wasn't recognized by the art world, though I was by my fellow artists, and by Iolas.

JS: You were born in New York to a French father and an American mother. You lived in France for

Restoration of *Sun God*, 1999

three years with your grandparents while your parents were back in New York, then returned to America. As an adult you lived in France, Majorca, Italy, and now in the U.S. again. Is there a particular place you would now call home?

NdSP: I'm glad I feel part of many cultures. It has given me liberty, freedom.

JS: I think it may surprise people to learn that you live in La Jolla.

NdSP: I love living in La Jolla. It's been seven years. I was in such bad health, I told my doctor I wanted to join the Hemlock Society—I didn't want to go on—and I asked my doctor if he could give me another option. After a few minutes he said, "Move to San Diego." He said it had the best asthma climate in the country—no big weather changes, no storms—and my asthma would improve right away. And it did.

JS: What are you working on now?

NdSP: I'm doing a garden in Escondido on Calafia, the legendary Queen of California. Soon after moving here, because of the incredible diversity of California landscape my work and materials changed. In the Tarot Garden I used ceramics and both handmade and bought mirrors and glass. Here I'm using stones. I used them first for a project I'm doing for the Jerusalem Foundation, the Noah's Ark Project. The pieces were here in La Jolla for a year. I can find the stones here—at a big fair in Tucson, and many other places. I've also found new kinds of glass and mirror here, and the best collection of rocks in the country.

JS: In the last month or so you've been on the road—to Germany, and before that I heard you might have gone to Japan?

NdSP: I won the Imperial Prize in Japan. I couldn't go, because my health wasn't good, but I was pleased. I didn't think I'd win something like that. I'd never wanted to go to a major art gallery, so I don't have that support, and I know this means not many reviews, not much writing, and I really didn't think an international jury would pick me. I was very pleased.

JS: Did you make it to Germany in November [2000]?

NdSP: I made the donation to the Sprengel Museum, which is famous for its incredible Kurt Schwitters collection. The Sprengel is really wonderful. They go into depth in showing an artist, not just one of this and one of that. It's more of a classical museum and they chose the pieces very well. They also made me an honorary citizen of Hannover, and that made me very proud—the first woman to be an honorary citizen. In Germany a third of the parliament is women, a much bigger representation than here.

JS: Do you feel part of a community of artists in San Diego?

Restoration of *Sun God*, 1999

Construction of arch base
for *Sun God*, 1983

NdSP: I'm known as a recluse here. They probably think I'm a little crazy, but I don't care. They're probably right. I like discovering new things. I'm always for new experiments. I'm interested in learning. There's always something new to discover. I don't go to any art balls. It's too boring. I have met quite a few scientists here.

JS: Is there anything specific you'd like me to record about the Sun God*?*

NdSP: That I liked the way it looked so much it influenced other works. You've seen the Tarot Garden book; that *Sun God* looks different, but there are big similarities. It's a piece I feel very good about. And here I am back in the same place, working with Calafia, the legendary queen of California.

1. Niki de Saint Phalle, "Printemps 90/Cher Jean/qui est le monstre toi ou moi?," in "Lettres," *Niki de Saint Phalle*, exh. cat. (Paris: Musée d'Art Moderne de la Ville de Paris, 1992), p. 153.

2. Sometimes called La Tête [The head] as well as the Cyclops, this monumental sculpture, over seventy feet high, was built with the participation of Eva Aeppli, Bernhard Luginbuhl, Giovanni Podesta, Jean-Pierre Raynaud, Jesus Rafael Soto, Daniel Spoerri, and de Saint Phalle. The facade, of mosaic mirrors, is by de Saint Phalle.

3. See John Maizels, "Fantasy Worlds: Introduction," in Deidi von Schaewen and Maizels, *Mondes Imaginaires* (Cologne, London, Madrid, New York, Paris, and Tokyo: Taschen, 1999), p. 14.

4. De Saint Phalle, with Silvio Barandun, *AIDS—You Can't Catch It Holding Hands* (San Francisco and Santa Monica: Lapis Press, 1987). Also published in French, Italian, and German editions.

5. De Saint Phalle, *Traces*, vol. 1 (Lausanne: Acatos, 1999).

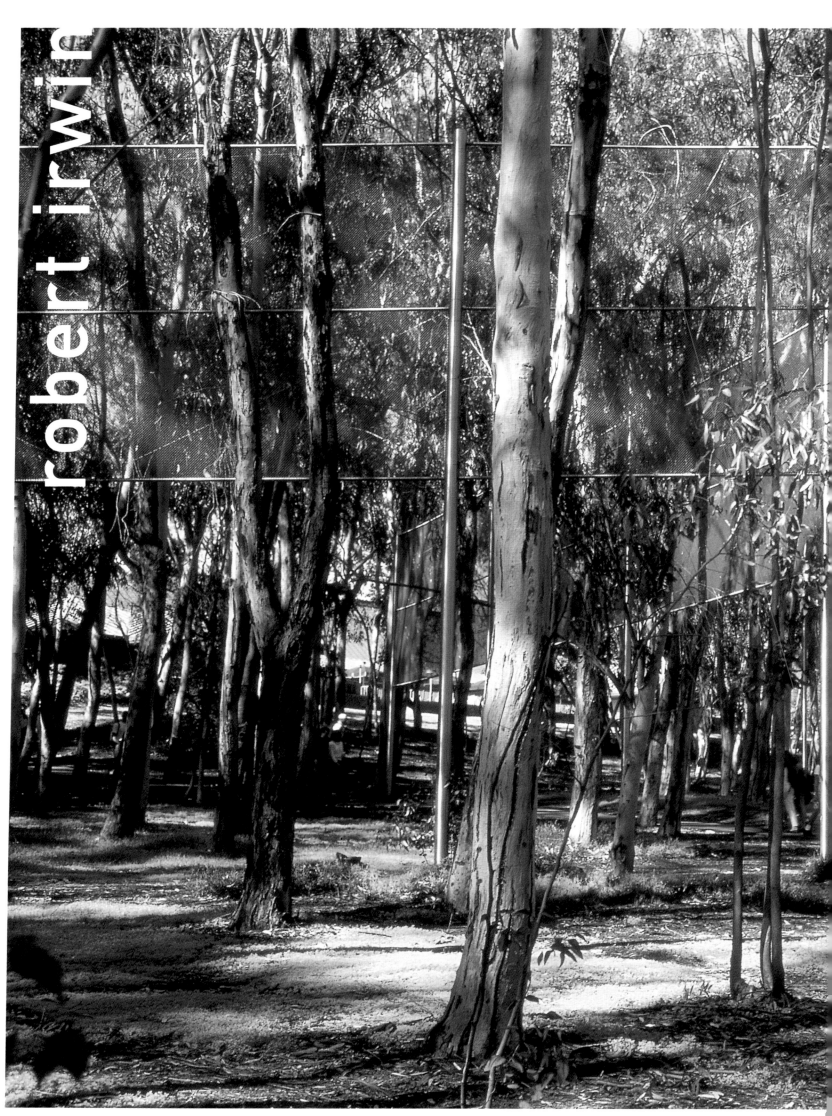

robert irwin

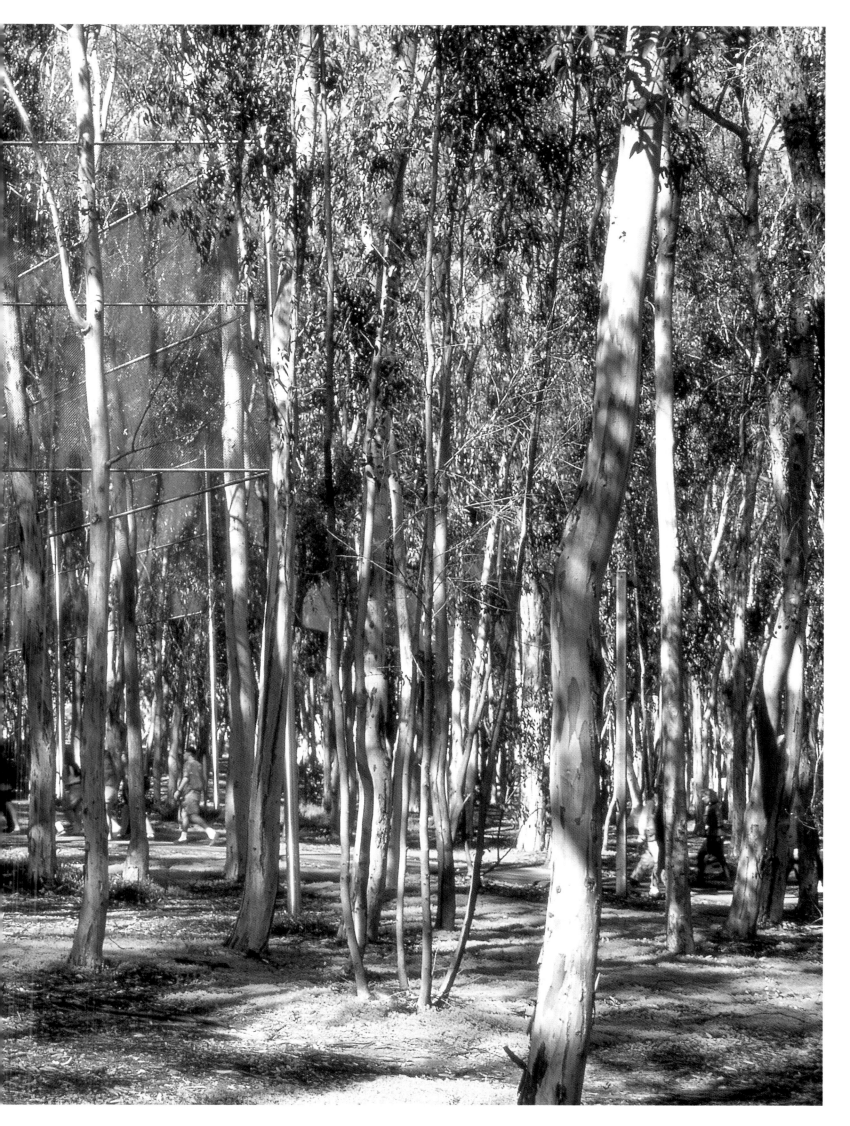

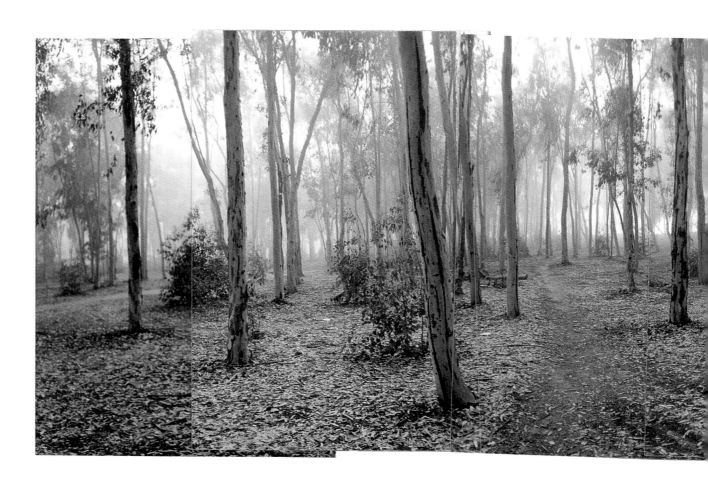

TWO RUNNING
VIOLET V FORMS
1983

OUR DISTINGUISHED ADVISORY COMMITTEE held Robert Irwin in high esteem, and from Day One his work seemed the perfect choice to follow Niki de Saint Phalle's *Sun God*. We wanted to demonstrate right away the wide range of possibilities for commissioned work using the campus as a canvas. Although Bob had won a number of commissions, for a variety of reasons none had come to fruition. He had never built a permanent work in his home state. (This was notable since in 1984 he was to become one of the first artists to receive a MacArthur Fellowship, the so-called "genius award.") Yet Bob is the quintessential California artist. Born and raised in Los Angeles, growing up immersed in car culture and swing dancing, he made an early decision to be a painter. But his interest in both the act and the results of painting waned; and as it did, his fascination with everything going on outside the picture frame grew. Compelled by inquiry on the nature of perception, light, and space, he began to address place. Moving away from the realm of the object, he began taking the viewer—and himself—into new territory.

Bob first visited the USCD campus in November 1981, a month after I arrived as director. He was immediately enthusiastic about the possibilities. Bob is an energized presence, a friendly, forceful personality. At the Portland Center for the Visual Arts, he had created one of his transforming scrim installations, visually and perceptually extending a 5,000-square-foot gallery space with very few gestures. I was excited about working with him again, and especially interested in what he might do in this new context.

Bob went right to work exploring the campus, sensing it as territory and watching the way people moved through it. He responded particularly to the many eucalyptus groves scattered around, and to the relief they offered from the more corporate aspects of the campus landscaping. Their shade, their fresh aroma, their play of light and shadow, and their soft color all appealed to him greatly, as did their geometric arrangement. These groves were among the many that were planted at the turn of the century by the Santa Fe Railroad and other investors

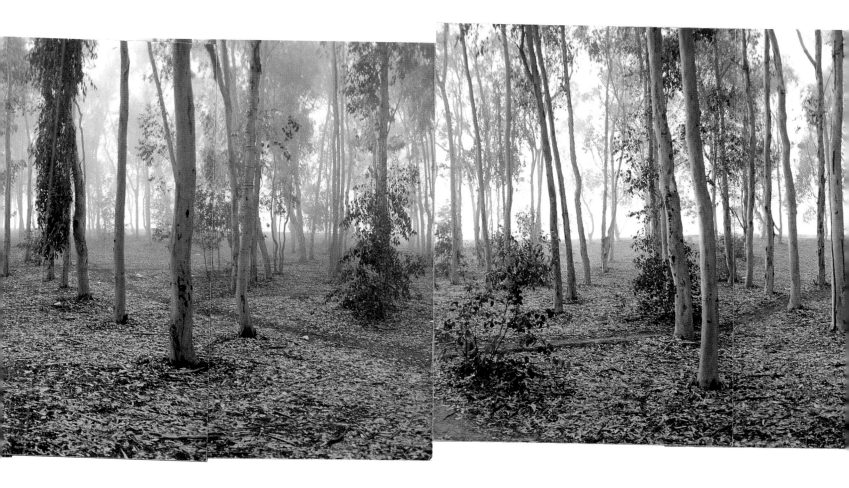

Robert Irwin site photo, 1981

for use in wood products. Since the particular species planted around San Diego didn't have the durability for railroad ties and other hardwood uses, the trees were abandoned as a crop. Many of them survive to this day, evenly planted eight feet apart in rows, an orchardlike grid. They are a dominant feature of the UCSD campus, giving it a sense of place unique among the ten University of California campuses.

By 1981, the university was launching a period of serious expansion, and to make room for new buildings some of the eucalyptus groves were being cleared. Somewhat later the destruction of these groves became an issue, but Bob noticed it early. He envisioned a work that would be a catalyst for thinking about the sensory qualities of the space and the light in the groves, and that would invite people to experience these places. This in turn, he felt, would propel both their appreciation of the groves and their awareness of their own powers of perception—an enduring Irwin subject.

Bob chose a centrally located grove with several major pathways running through it, a natural place for a confrontation with people walking through in their daily course of activity—when art was likely far from their thoughts. These asphalt pathways are especially heavily trafficked in the minutes between classes, with a surge of students and faculty making their way along them hourly. Just as quickly, the paths become quiet again. Irwin liked the fact that people traversed the grove when they weren't necessarily thinking about art, encountering the place in a casual way.

In January 1982, Irwin presented a proposal to the members of the Advisory Committee who lived nearby and could gather on the grove site: Jim DeSilva, Patrick Ledden, Newton Harrison, and myself. He planned a high fence of small-gauge, blue-plastic-coated chain link stretched between five-inch-diameter stainless steel poles with a brushed finish, the height of the poles varying with the slope of the hill to keep the fence level. The fence would be installed in

Plastic-coated fencing

two separate lengths, each in the shape of a V. Not designed to keep anybody out, it would begin a minimum of nearly nine feet above the ground, obstructing no one's passage. Below it would be planted a scattering of iceplant, which flowers in lavender blue.

The review group's considerable enthusiasm led to a telephone canvas of other members of the Advisory Committee, and the proposal was approved before the group's next meeting, which would not be until March. Irwin's energy and attention were entirely focused on the project. He engaged Jack Brogan, a master technician and friend with whom he had worked on other projects, to handle engineering and construction. Bad weather and late shipments of steel from Korea caused delay, but in time eleven-foot-deep holes were drilled and filled with concrete and rebar as supports for the poles. Not a single eucalyptus branch was damaged during construction, and the installation was completed by November—that is, the first version was.

This was not a work that could be assembled and built in the studio, then assessed and adjusted before installation. In late 1982 Bob called Jim DeSilva, Pat Ledden, and me to meet at the site. Feeling that the pair of V forms felt too much like two separate works, one on each side of the path, he had decided he wanted to extend each section by about fifty feet, one across the path, the other farther into the grove. Although the work looked fantastic as it was, and we were very pleased and excited with it, we agreed that additional lengths would take it to a new dimension, substantially intensifying the experience and further integrating the work with its context. We were committed to realizing the artist's concept and making the work as good as it could possibly be. My only concern was that extending the fence over the path might tempt someone to swing from the bottom horizontal bar, about nine feet above the path; but we went ahead anyway, and it has never been a problem. Right after the entire work was installed but before the opening, the fence started sagging badly because of the distance between the poles. Jack Brogan designed a solution using sail-rigging-type wire stays, which have held up for nineteen years without even minor modification. Told that it would be impossible to grow anything beneath the eucalyptus trees because of the eucalyptus oil, we installed a watering system and went ahead with the plantings of purple-flowering iceplant. It still blooms from January until about April, becoming part of the ever-changing scenario in the grove.

Two Running Violet V Forms was completed and celebrated at an opening in May of 1983. Some months later a notable intervention occurred on the site of another campus eucalyptus

grove—which, without any public warning, was cleared for the construction of new buildings. All that remained was a field of perhaps 100 stumps about eighteen inches high. Responding immediately, students made visible their concern: the next morning, each stump had a white Styrofoam cross set upright on it. Since the trees had been planted in the railroad's regular rows, these suggested a ghostly cemetery. The statement was short-lived but moving. We aren't sure if it was related to Bob's piece or not, but clearly an interest in the eucalyptus groves had been nurtured, and UCSD's Long Range Development Plan now recognizes the importance of preserving them.

The work is man-made of industrial materials. It is juxtaposed with nature, albeit a nature arranged for purposes that were originally commercial, and it gently integrates itself with the grove. Here, humanity and nature coexist, not competing, not dominating one another, each playing off the other. The fence is not static—it is a living, breathing part of the grove. It does not announce itself as art, but exists, sometimes waiting quietly to be noticed, sometimes softly saying "Look at me." As visual experience, it is abstract, but underplays connections to any pre-existing body of knowledge one might have.

The response has been mixed from the start. The work has been mistaken for scientific apparatus and for athletic equipment. One group of students made a very large shuttlecock and left it nearby, as if the fence were a badminton net for giants. Some accused it of being a crime against nature; it was thought to have killed innocent birds (though with nary a shred of evidence). Those objections have died. Bob is pleased by all this, and the university is well served by the dialogue, conversation, and even classroom assignments generated by *Two Running Violet V Forms*.[1]

The piece has no formal beginning or end, but walking on the path that passes under it allows perfect entry into the experience. As one walks and looks, the blue changes, whether dramatically or softly. The open mesh of the chain link can appear opaque at moments or in stretches and transparent at others. As one looks up, the shadows of foliage play on the blue in the sunshine. One sees branches through it and around it. Sometimes it seems that a ribbon of sky has been woven through the grove. It sparkles after a rain, becomes poetic and mysterious in fog, and on a bright day it can be positively operatic. In February and March, monarch butterflies flutter about from their brief winter-nesting spots in the closest trees. We think the color attracts them. The poles are in scale with the trees, and gray like their bark. As one walks through the grove, they appear and disappear in the trees, just the way people do.

Every artistic decision in this work is based on qualities that preexist and continue to exist. The place has stayed the same, but now, season to season, day to day, moment to moment, a heightened awareness of light, birds, flowers, a cloud, a shadow, a breeze, all participate in—and contribute to—the pleasure and beauty and awakening one can find here.
—*MLB*

1. The work was originally untitled, but it became *Two Running Violet V Forms* when Irwin applied the term descriptively for an exhibition at the San Francisco Museum of Modern Art and Pace Gallery, New York, in 1985. He hopes the term is too long and too awkward to actually be a title.

interview

robert irwin

JOAN SIMON: I guess a good place to start is, how did you start developing the ideas for the Stuart Collection project?

ROBERT IRWIN: I walked the campus, which is what I always do. I just walk around and spend a lot of time there. And I don't try and do a project in my head while I'm there, I basically just look at the site and try and get a feel for the place. And after I go away, then I think about how I feel about the place and so forth. And then I go back.

In this particular case, I felt the architecture and the layout of the campus, there was nothing really special about it—nothing except the stands of eucalyptus trees. To me, that's what you remember. It's the one thing that distinguishes the campus. They're quite beautiful. You spend a little time in them and they really evoke an interesting mood. So the first thing was, if I do something on the campus, I'd like to do something in relationship to those trees.

Also, everybody passes through them. They're not hidden away, or some place you'd take a trip to; you go through them every day going back and forth from classes. And there is a bit of habituation that goes on, naturally; not everybody pays too much attention, they've got a lot of things on their mind. So the initial part of the idea was to somehow take what is going on there and just sharpen it into focus a little bit. Also in the back of my mind was the idea that if I did something in those trees, it could point up their importance. It might remind everybody that they've something special here.

So then I came down with the question of, OK, what can I do in this space? And the first thing was—it's not at ground level, it's not at eye level, it's up in the air. It's a soaring kind of thing, and it's happening up above you. And the idea of coloration was quite interesting—that every time you walk through those stands of trees at different times of day, they are a different color. They go from almost a nondescript gray to violet and to green, and they get a kind of golden quality at certain times of day, from the sunlight. So the idea was also to sort of heighten that experience of the color.

It was the first time I used that chain link fence material, which I didn't know about when I got involved in the project. I did some research, looking for something that had the ability to affect a lot of space but was not something you focused on, was not a thing in itself, and that fence material from a little bit of a distance becomes just a visual haze of color. It was a terrific material to find. The color is quite quixotic. I say that because the day I was finishing it up, I was looking at it, and it was almost not there. I mean no color at all. And I thought, oh Jesus, I've screwed up. But that's the funny thing about it. Sometimes the color is intense, really strong, and then sometimes it's not there at all. Which is fine. It sort of does the same thing that the color in the trees does.

And so everything else was really how to articulate all that space, and to get it up in the air, and to play with the quality that was already there, and really to add as little as possible. The stainless steel poles worked well because they wear well. They're going to last, I don't know about forever, but for a very long time. And they patina with being in the space, and get a kind of comfortable look in there. And they're not all that visible—I don't think they're that demanding in and of themselves. And the idea was working out how to do all that in the simplest, most economical way.

The plant material at the bottom was an idea that came at the end. I thought it would be nice—the piece could live without it, but it would be nice if it could be there, which it is, on occasion. And it's sort of like the color falling down on to the ground, and gives the whole area a bit more life.

It's really a simple piece and it was really a simple process.

JS: The idea of working outdoors relates to several projects and exhibitions of 1977: the photo piece New York Projections, Rectangle—Mercury-Vapor Lamps, Central Park, *and unrealized proposals of the same period like the one for seeding vacant lots with wildflowers in a ten-block area in L.A. Were these the beginnings of your garden/park situations?*

RI: Maybe, but not in a causal sense. First of all, when I did the discs in the late '60s I realized that what I was really interested in was phenomena. At that time I had an extra room in the studio, and I painted the whole thing white, I covered all the corners, and I made it as close to a Ganz field as possible. And then I started putting just a single light in there—a fluorescent light or an incandescent light, a floodlight or a spotlight. I borrowed or rented basically everything that was being made at the time, and I put them all in there one at a time, looking at the quality of the light. What I was looking for was in some way to try to engage the phenomena, and the problem is we are very object-oriented. Every time I put a fixture there, it did a lot of interesting things, but for someone just walking in, the presence, the phenomenon, was very subtle. You're preconditioned to look at the object as the thing.

I was also looking for other materials, and it was then I found the scrim, quite by accident.

I was in doing an exhibition in Amsterdam, and this material was on almost every window. It was fascinating what it did with the light. I thought, that's beautiful stuff. The amazing thing was that it came fourteen feet wide instead of three feet or four feet, which is what most material comes in, and so suddenly I'm like, wow! Again I'm going back to light, to some way to affect space without it being a thing, without having any objectness to it. So that's how the scrim came into play. I wish I could have found five things that would do that.

JS: The chain link fence at that scale does it.

RI: Exactly. For that outdoor situation it worked perfectly. It's called nonclimbable fence—it was made as a security fence, because you can't get your fingers or toes into it. Normal chain link fence has two-and-a-half-inch apertures, this has three-quarters of an inch, or five-eighths. That makes all the difference in the world.

JS: So it's closer to a fabric in structure. It's closely woven but has an open weave, to get that glimmer.

RI: Given the distance, it starts to generate that same sort of quality. Regular chain link fence will do it to some degree, but not nearly as effectively.

JS: And the finish?

RI: It's regular wire fence that has been electrostatically coated with a plastic coating. You'll find things in your kitchen done that way: they put a charge through the metal, and the plastic wraps it totally. So it's a perfectly coated finish, which also protects the metal so that it lasts.

JS: At which point did the purple-flowering iceplant come into the project?

RI: Near the end. It was a refinement, the piece would work without it. You have a major limitation: basically nothing grows under eucalyptus except iceplant. It takes some doing to get

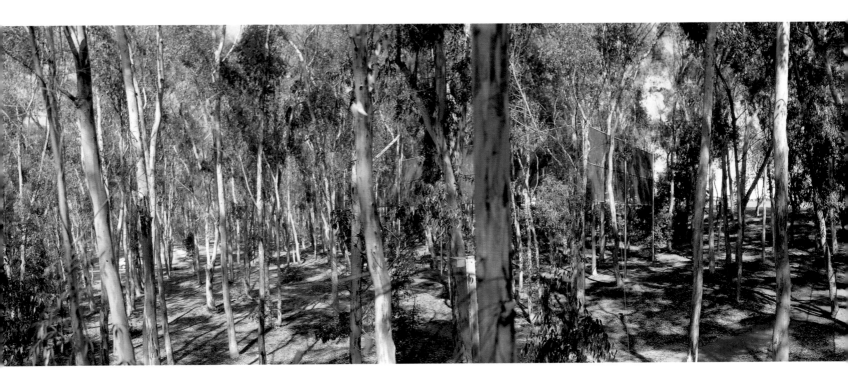

it to grow, but it will. So I just looked at all the iceplants that were available.

JS: A number of unrealized proposals from the same time as this piece used plantings.

RI: The easiest way to explain that is: you're outdoors, you're trying to affect this large space, and you have $1.95 to work with, which is how it always is. Per square foot, the amount of money is minuscule. One thing that's important outdoors is scale. Something big enough to engage the space—that's certainly one strategy. So the idea is that for $500 you can buy a full, mature, beautiful tree, a great tree really. And for $5,000 you can buy a really great tree, something forty-five feet tall and thirty-five feet around, and it has a tremendous effect on the space. And scale being my first cognition, I thought, my God, if I build something as big as that tree in any other material it'll cost $150,000, and here I can do it for $5,000.

Of course, having done that, you start being affected by color. I had wanted color back in my work for a long time, I just didn't know how to legitimately get it in there. As a painter, I'd loved the way color is when it's made up of five thousand points of light, as opposed to a couple of strokes of paint. It's simply not the same. The color in nature is so much more complex, and when you start to get into the phenomena of color, each single point of color goes through a shading from light to dark, from violet, say, to its opposite, and that's what really makes it. In a painting, if, for example, you want an important element of red, you have to put green in somewhere, because the eye habituates to red in less than twenty seconds and mutes it. So if the eye isn't reenergized by the green, the red painting is never really red. But in nature that's there all the time. When you see orange in nature, with all the ambient blue around that orange, it is just whammo.

JS: You said that one of the key aspects of the eucalyptus grove was its crisscrossing paths—

RI: Yes, I loved the fact that people come upon it naturally. It's not like going to a museum, it's not being channeled or focused, there's no ritual involved. You just walk through and say, "What the hell is this?" The idea in a sense is that you pass through the piece in your normal movement through the campus. If somebody had to go find it, like a trek to Mecca or something—for some people those things are additions, ceremony and ritual and so forth, but for me

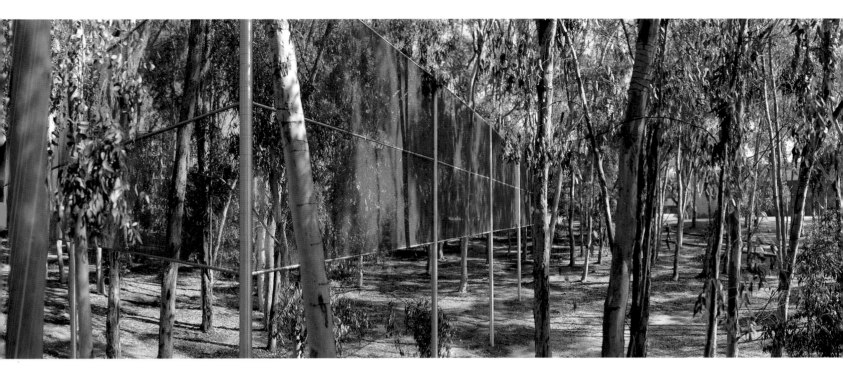

they're distractions. I'm interested in that "Aha" moment that probably every one of us has had, and which is why we're interested in art in the first place. We've experienced something that knocked our socks off. And from that point we want to know. We seek it out. We find it. We pursue it. What I try to do is create an uncluttered moment where you can have that little confrontation with yourself.

JS: At other times you've called it "wonder."

RI: "Wonder" is a great word, because in philosophy, wonder is what allows you to deal with the unknown.

JS: You have written of attending as the equal of discovery.[1] That seems crucial.

RI: It is crucial, just in terms of how the mind works: we see what we seek to see. So that moment of attending the world is probably the single most important force in the world. How you enter in is by essentially doing just that—opening yourself up and attending it. And if you don't allow yourself that moment, if you just bring all the baggage with you, then you never actually know what's literally there. You're always structuring it, or prestructuring it, or having ambitions for it. The rationales we have as we function in the world are important, but they obscure the individual moment of understanding. The only act in a sense that puts you in that position is to attend directly to the nature of things.

JS: Talking to Lawrence Weschler about "the historic relationships between a sculpture and its site," you began by discussing site-dominant works and followed through to site-generated pieces.[2] This idea is important not only to your own process but to the Stuart Collection.

RI: While my painting was going down to, as someone else coined the phrase, "point zero"—down to less and less things—people were saying, Where will you go from here? And I didn't have any idea. At one point I thought the term "nonobjective" was going to translate to nonobject, this idea of the phenomenon, but all of a sudden I discovered that it had nothing to do with object/nonobject at all; it had to do with relationships, and the whole idea of conditioned relations. Everything exists as a set of conditions. Everything. There's nothing that's isolated in a vacuum. Everything is acting on and in a context. When I move an object from one

Robert Irwin
Installation, 1978
Portland Center for the Visual Arts

Facing west

Facing east

point to another point, everything is changed. So that became the development of this idea that the key in classical thought was how the object was understood in a meaningful context.

In site-dominant sculpture, the object was in a sense the content or the container of a meaningful idea or personage, and on the basis of that it dominated, and was therefore placed in the center of the plaza. It was given this hierarchical position of power. And the whole history of modern art has been the deletion of that power, disseminating the whole hierarchical structure.

JS: You give as an example of site-dominant work the sculpture of Henry Moore. You also talk about site-adjusted works, by people like Mark di Suvero.

RI: Simply, that is when the object loses its immediate meaning context. When we made a so-called "abstract" painting, a lot of people still wanted to Rorschach or psychoanalyze it, reading meaning context into it. Docents in museums say to kids, "What do you see in there? Is there a cloud, a cow jumping over the moon?"—you know. But the whole point was, content was giving way to presence. The work was not about content; it was not about a referential process at all. It was an immediate presence that you were being asked to attend. And once you do that you have someone like Mark di Suvero, an abstract sculptor. He's still an object-maker, still making a thing, but he's not making it in quite the same sense, because he will begin to deal with scale or color as independent elements. When you first did an Abstract Expressionist painting, when a dot was not a molehill but a dot, and a splash was not a mountain but a splash, then you started dealing with a whole different issue of scale and relationships. So di Suvero starts making a sculpture that has some understanding of the physicality of the space that it's in, but it's still an object, still made in the studio and transported to the site, still having a style or a defined character. So that's what I meant by site-adjusted.

And then there's site-specific, which is really where the crucial step happens. Richard Serra speaks of site-specificity. He does, on occasion, move a sculpture from one place to another, but they're made for a particular place. The crucial thing is, though, when you come to reference a work you still reference it in the old way, by referring it not to the experience, the moment of attending, but to the historical construct within which it stands—the history of artists, the history of art, the history of art objects, and what have you. So fundamentally there's still this abstraction going on in terms of how we actually process it. What I'm saying about conditional relations is, if I did it properly, if I made a thing—it could be an object or not an object—but if I did something in a particular set of circumstances that was perfectly resonant with those circumstances, then as you come along you don't have to know anything about me, and you don't

David Antin, Jack Brogan and Robert Irwin during installation of *Two Running Violet V Forms*, 1983

have to know anything about art. You have all the same cues that I had, you have all the same references that I had, and you can essentially go through the same immediate processing as an immediate phenomenological process. You and the moment of attending.

JS: And those are the ones you would refer to as site-generated.

RI: I've been trying to find a word for it. Everybody loves "site-specific"; I've suggested two or three others. There was a great one in a quote from Mondrian.

JS: The one in the MoCA catalogue?[3]

RI: I wouldn't doubt it. I use Mondrian as a font. It's amazing, going through all this and one day running across that quote, it's like the guy, by 1912 or something, had predicted the whole damn thing in a way. He talked about the end of art as a thing isolated, and about conditioned relations. Here it is: "Nonfigurative art brings to an end the ancient culture of art... the culture of particular form is approaching its end. The culture of determined relations has begun."[4]

JS: Do you think your work has opened up questions for other artists, not only in the present but in the future?

RI: To predict the future is hard for me to do. But for me, I have posited in the world three or four questions. That show at the Whitney [Museum of American Art, New York, in 1977]— that whole thing was done to ask one question.

JS: Which was?

RI: Which was, if you take the words "experience" and "phenomena" and "aesthetics" as bearing directly on the dialogue of art, then can we take art to be the equal of making? And the answer in my mind is obviously no. If you accept that proposition, that changes everything: if art isn't about making, it's not about objects. It's about perception, it's about awareness, it's about consciousness. Without being mystical-twistical about it, what art is really about is constantly extending the human potential to perceive and know and understand the world with an aesthetic bias.

JS: One way you've done that is by teaching. You've taught at Chouinard, at UCLA, and at UC Irvine; your students have included Larry Bell, Ed Ruscha, Vija Celmins, and Alexis Smith.

RI: The nice thing is that none of them work like me.

JS: Smith, in her interview for this book, talks about how important that time at Irvine was for her.

RI: Her *Snake Path* is terrific. She really pulled it off.

JS: How do you see the Stuart Collection as a whole, and how do you see it functioning in the future?

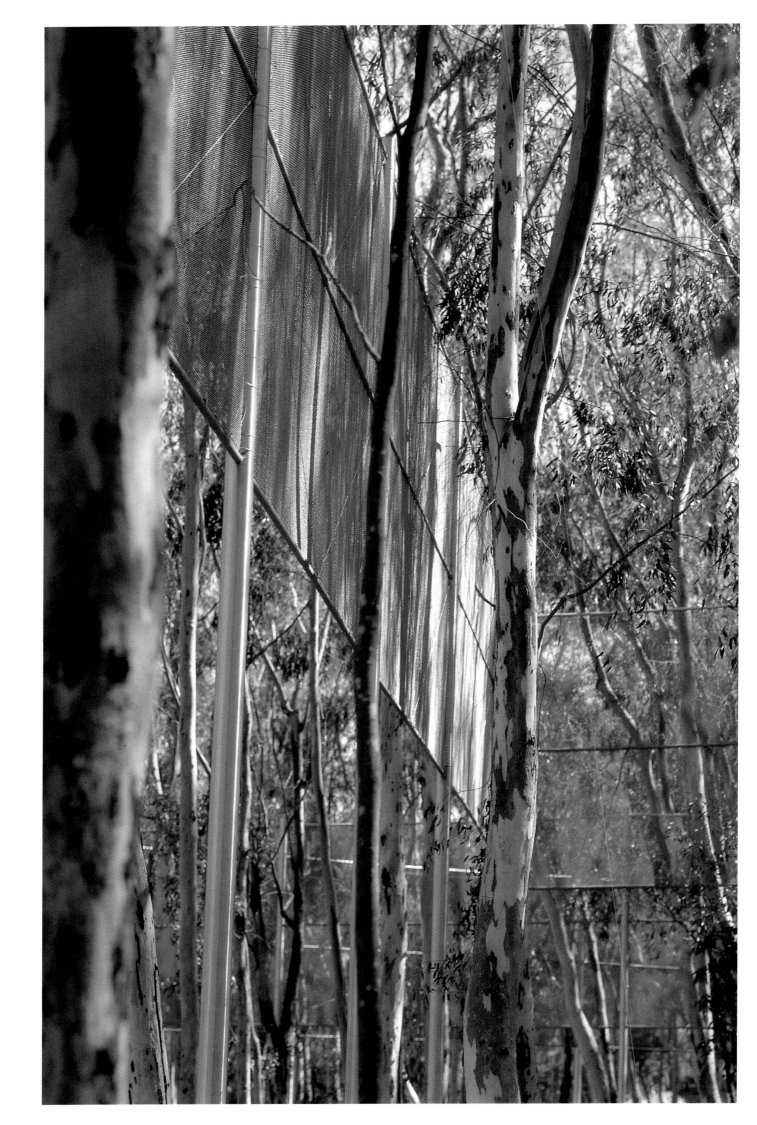

RI: This is the closest to a really good twentieth-century collection, or twenty-first-century collection, whatever you want to say. Basically it's not a sculpture garden in the old sense of the word. A few pieces may be, you know, but they're really integrated into the campus. Alexis's is a good example, the flow of the whole campus moving into it. I haven't seen a collection that is as good a forum as the Stuart Collection for taking up the questions of what is art or sculpture. I haven't seen anything that approximates it.

JS: I guess the last thing I'll ask you about is something you have said about San Diego, describing the sight—or actually the total experience—from the terrace where you now live. You talk about the distance and scale of ships coming into the bay, and the overwhelming lack of sound.[5]

RI: When I played the horses at Del Mar I used to stay in a hotel on the bay. There's a moderate amount of activity on the bay and I can't put my finger on it, I have no idea why, but it just swallows sound. It's absolutely silent here most of the time. So the whole bay has a kind of magical quality for me. I decided I could live in San Diego if I could live on the bay. So that's where I'm living.

I'm perfectly happy here. I tried New York, and you know, it's the first time I realized something about the light up there. I was in the Hudson Valley, a marvelously historical place, very beautiful in a lot of ways, but very, very melancholy and for me depressing after a while. And I suddenly realized one of the reasons why I have this total optimism, this kind of Pollyanna sort of view of the world, is that the light encourages it. And San Diego's definitely got that.

1. "We do not invent our consciousness. Here attending is the equal of discovery, since by the time we can conceive of a change the grounds for it are already in us." Robert Irwin, "The Myth of the Art World," in Irwin, "The Hidden Structures of the Art," published in *Robert Irwin*, exh cat. (Los Angeles: The Museum of Contemporary Art, and New York: Rizzoli International Publications, New York, 1993), p. 27.

2. Lawrence Weschler, *Seeing Is Forgetting the Name of the Thing One Sees: A Life of Contemporary Artist Robert Irwin* (Berkeley, Los Angeles, and London: University of California Press, 1982), p. 194.

3. Sally Yard writes, "Irwin's thinking pursued that of Mondrian, who had suggested to no avail that the colors must be painted in the precise place where the work is to be seen,' since setting and light affect everything. In this theoretical break with the idea of the timeless, immutable object, Mondrian had laid the grounds for a conditional art of presence." Yard, "Deep Time," in *Robert Irwin*, p. 58 and note 28 (quoting Mondrian's "The New Plastic in Painting").

4. Piet Mondrian, "Plastic Art and Pure Plastic Art" ("Figurative Art and Nonfigurative Art"), 1937, in Herschel B. Chipp,

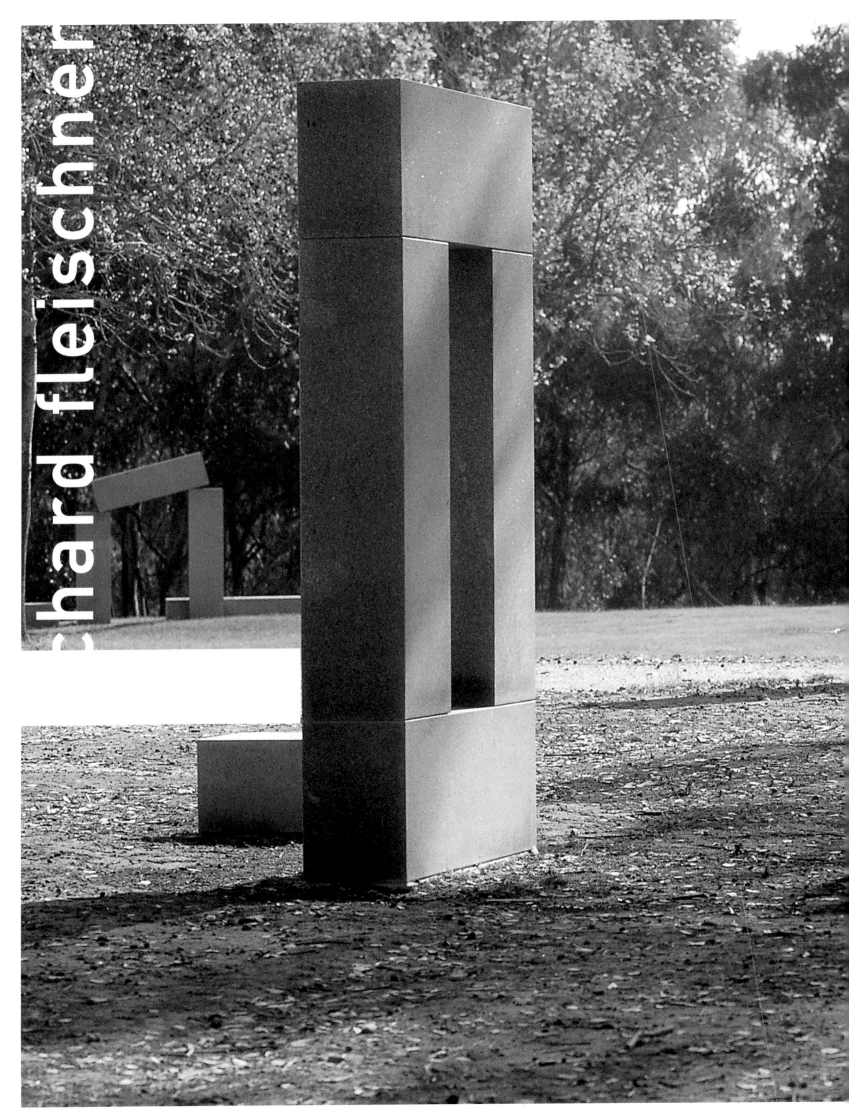

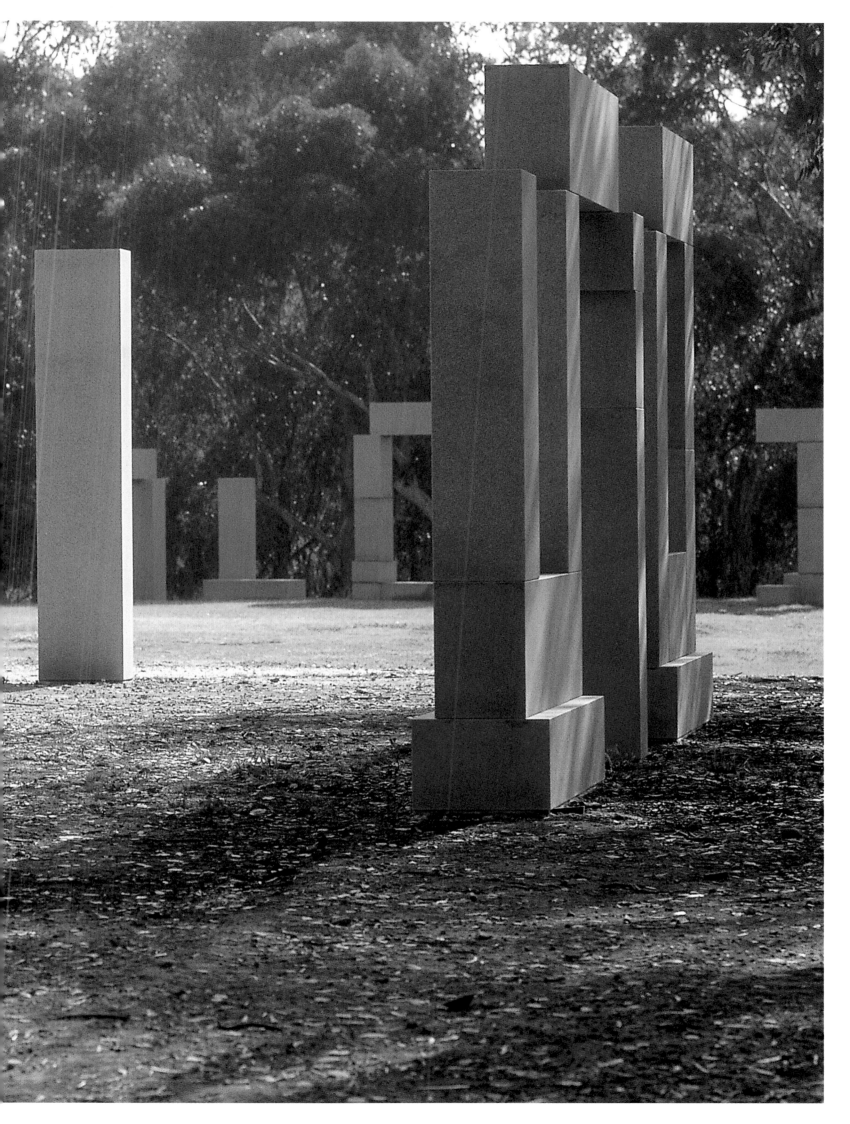

LA JOLLA
PROJECT
1984

PLACE-MAKING IS RICHARD FLEISCHNER'S MÉTIER. He thinks about architecture in terms of environment—of how people move through space, and how that space feels. In the 1970s, he began to practice outside the studio, using hay, tufa (a sandy, porous rock), sod, and other materials as sculptural elements in mazes, corridors, and lines that redefine and enliven the territory in which they appear. Fleischner works to create engaging destinations that draw people in for a variety of purposes.

Faculty members in the Department of Visual Arts had recommended Richard early on, and the Advisory Committee liked the idea. He first visited the campus in 1982, seeking a place with "definable boundaries whose presence didn't limit that site." The perspectives and viewpoints he could establish in such a place, in other words, would extend beyond its boundaries.

Richard's immediate choice was at a beautiful chaparral-filled canyon above the Scripps Institution of Oceanography, near an area of housing for married graduate students. Here a large flat area funneled toward the canyon, which dropped rather steeply down to the Scripps campus and then to the ocean. Another area Richard liked was a large eucalyptus grove in the northeastern quadrant of the campus, a territory set aside as a preserve in the university's long-range plan. Rough trails pass through this dense forest area and then out to open canyons and scrub terrain. Preliminary drawings for these two sites were presented to the Advisory Committee, which received them enthusiastically.

Subsequent examination of the university's long-range plans revealed that the Scripps canyon area was destined to be a parking lot and road after an expansion of the institution's aquarium. Richard returned with his assistant, Lane Myer, and began developing a proposal for the eucalyptus grove, which, after extensive inquiry, I believed we had permission to use. When Richard was staking out the work, however, he discovered recently dug post-holes—

Richard Fleischner
Study for *La Jolla Project*, 1983
Pencil and chalk over diazo print
28" x 66"

clearly for some structure. It turned out that exercise stations were being built here for a run-ning course. Our investigations hadn't revealed this because the project had been given the go-ahead ten years earlier, and was now all but forgotten by everyone except the staff of the Athletics and Recreation Department, who had finally raised the money and were going ahead without the usual bureaucratic notifications. This was early in the life of the Stuart Collection; we had much to learn.

Even so, the importance of choosing our battles wisely was always evident, and it became clear that we shouldn't challenge this use of the site, which was, in fact, well suited for the *par-cours*. The idea of a collaboration was considered briefly and dismissed. We asked Richard, now a bit perturbed, to proceed with a search for yet another potential location. He rediscovered— and was very pleased with—a large lawn on the campus of Revelle, one of the six colleges into which UCSD is divided.

We shook hands over this new site, relieved to finally settle on one. Now Richard set about thinking through his concept, both spending time on the site and working with photographic blueprints in his studio in Providence, Rhode Island. He planned to keep the lawn's open spaces but to define its perimeters with elements formed out of stone blocks in two sizes, an idea that came out of playing with his two small children. (He subsequently used this gamelike system in a number of projects around the country.) The configurations of these elements would refer to the vocabulary of architecture: posts, lintels, columns, arches, windows, doorways, thresholds. The whole area would become an activated field, its allusions ranging from ancient ruins to a con-temporary construction site, and its verticals and horizontals generating complex spatial and historical relationships.

Richard debated the relative merits of different stones. Marble was a little precious, but a

La Jolla Project during construction, 1984

beautiful green variety was available from one of the Carolinas. Limestone was warm and unpretentious, but probably too soft and vulnerable for the use it would get here. Granite was hard, and although Richard felt that it perhaps had too finished a look, it was the durable choice. Leaving the surface unpolished would eliminate any preciousness. A proposal was developed, and the Advisory Committee approved it in January 1983.

Work began immediately. Richard laid out each arrangement of stones in his studio by using a large set of particle-board blocks that he had assembled for the purpose of working out the basic masses. Then he and Lane Myer returned to the campus, where they worked with a set of plywood mock-ups, moving them around in various configurations and combinations in order to determine exact locations for all of the elements. It was of course critical that the work should establish relationships to the existing trees and slopes, and to many other aspects of the place, both natural and built. Human scale was a key consideration. The viewpoints and planes experienced on site played an integral role. An old asphalt road on one side of the lawn was kept as a transition from grass to dirt, making a kind of dirt island for one set of elements.[1] The work was to be inseparable from the place in relation to which it had come into being. It was to be as integral to that place as rooms are to a house.

Richard chose granites in two colors, a cool gray and a warm, soft pinkish brown. One senses that these colors could have been selected to reflect the hues of sky and ground, or the gray and brown bark of the area's large eucalyptus trees. Seventy-one pieces of stone were cut into precisely measured blocks, each in one of two sizes, or multiples of those. A six-foot-round slab was to become the top for a Brancusi-like table in the site's northwest corner. Since the layout had been determined, the foundations for all the stones could be laid in advance. Then the stones arrived on two flatbed trucks from Richard's Providence studio. A team—including Tzanko Chakuroff, Richard's stonemason and construction supervisor, and Sully Sullivan, his handpicked rigger from Boston—worked closely for a week, unloading, placing, and securing each stone, with Richard overseeing and participating at every stage. Each stone was meticulously plumbed and leveled. The flat sod plane was leveled at an angle across part of the middle of the space. Although barely discernible, this plane, or floor, is integral to the concept of the work. A place was created: one can't be in front of, behind, or on top of it. One can only be in it.

The project was completed in time for the graduation ceremony of June 1984. The former stage area still serves as a focal point and a perfect performance platform or stage for such events. The main "window" of this grouping frames the trees behind. Lone students can frequently be seen sitting on these stones reading, with sometimes a bicycle propped nearby. Like other works in the Stuart Collection, Richard's piece has taken on its own life, or lives, in the minds of the students, who have dubbed it "Stonehenge." This may be a little inappropriate, since the work reflects an abstract sensibility, and has nothing to do with celestial occurrences or the calendar. But it does, like Stonehenge, have vertical and horizontal stones, and a visceral

sense of place. The project's real title is simply *La Jolla Project*.

Also, if the work's similarities to Stonehenge spark the imaginations of students taking introductory art history classes, its site and materials call up other sacred uses unintended by the artist. After several years, memorial plaques with inscriptions mysteriously began to appear in the general area of the work. Somewhat pleased that the site had been chosen for such personal and meaningful purposes, we weren't overly concerned at first. By 1995, however, there were five of these plaques, some of them close enough to the sculpture to intrude on its sensibility. After all, the artist hadn't meant it as a burial ground. Our efforts to deal with this issue instigated a new formal campus policy regarding memorial possibilities. Most of the plaques on the site were moved to other locations, with the cooperation of the friends and families involved.

Later campus expansion required some alterations: a road was planned along the southern edge of the lawn, and an adjacent parking lot was to be replaced by a theater building. Our main concern was preserving Richard's sight lines and edges. The planners made important concessions: the building's footprint was moved back some twelve feet, and a design for a concrete retaining wall was abandoned. The theater is a handsome, planar gray building. The architect, Antoine Predock, created an arched walkway along its side that somewhat mirrors the arches and colors of *La Jolla Project*.

Richard spent significant time coming to understand the site. He wanted to punctuate and articulate existing viewpoints, and then, without defining the use of the lawn, make it a place people would set out to visit. That, we can safely say, has happened: the lawn has been chosen for weddings, memorial services, festivals, dances, concerts, and picnics. It is a frequent gathering place, formal and informal, for reverie and study. It has also been the subject of academic assignments. I once discovered a young man sitting on the round table, apparently deep in study of a group of the stones beyond. He told me he was writing a play, its action to be determined by the stones—this was his professor's assignment. Clearly these granite blocks have accomplished what the artist intended. They have drawn people in. They have seen play and relaxation. They have shaped or influenced many and diverse dramas, from the workaday drama required in academia to the moving drama of ceremony, sanctuary, and remembrance.
—*MLB*

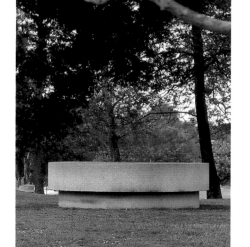

1. Some on campus have periodically suggested that this road "remnant" be removed, but Fleischner has been steadfast in his desire that it remain.

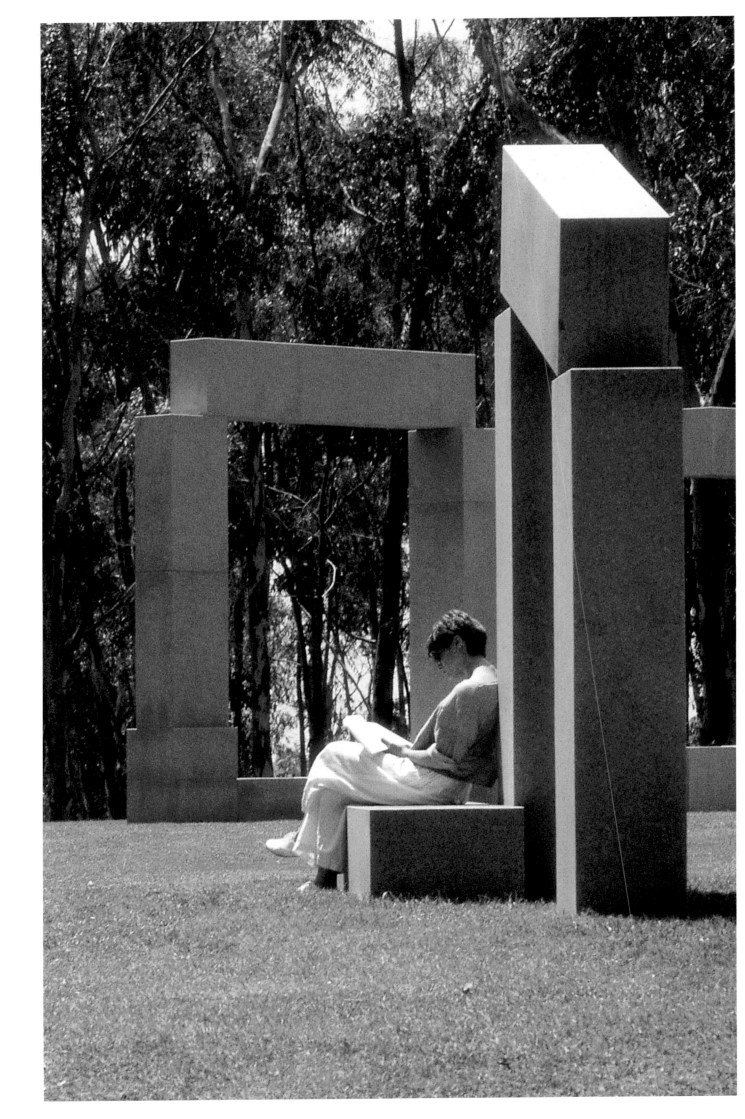

richard fleischner

JOAN SIMON: *Yours is one of the earliest pieces in the collection. I think it's the third, following Niki de Saint Phalle and Robert Irwin.*

RICHARD FLEISCHNER: I was asked to do a proposal by the committee, and made several trips out. I had originally picked a site that was near the big library, the one that looks like it's a spaceship, and it was totally in the woods, in a eucalyptus grove. We actually went fairly far on the project. Then on a trip to continue laying the project out, we found the site had already been committed for another university use. After several more trips looking for other sites, I finally fixed on the one that was next to Galbraith Hall. It was a much more open site. These two sites couldn't have been more different. Although I continue to work with the same set of issues, their hierarchy is subordinate to the givens of the site.

My work is about dimensioned space, and addresses one's perceptions based on experiencing distinctions within it—placement, form, scale, color, and light. I work with combinations of sculptural markers, plantings, furniture, landscaping, as well as architectural components; and through a dialogue with both the site and the project's parameters I find the edges, axes, and points from which the rest of the work develops. Considerations for the physical and psychological effect of vistas, borders, pathways, outdoor rooms or defined spaces, seating areas, and their relationship to the natural or built context all influence the way I resolve my sited works. They are integrated into the larger overall context through the definition and articulation of boundaries, site lines, and destinations.

What intrigued me about the site I finally chose, what drew me to it, was that there was already an almost archaeological presence—there were existing markers in the terrain. In the lower area there had been a stage or bandstand. It was a place that had a flattened area, and a kind of edge. There was a very low railing on the back corner: it suggested an architectural corner. I spent a long time looking at that. The trees existed for me as markers as well.

Pretty much the way I work is going from point to point within a site, in a sense almost visualizing myself as the element that might go there. And as all that begins to take dimension, I come up with a scale: you know, it can't be any smaller than, or any bigger than; this is going to be a point; this is going to be very axial; this is going to be planar. And then using two-by-fours, or sheets of plywood, I begin to give it some rough dimension.

JS: *On the site?*

RF: All on site. Then I come back here to the East Coast, to Providence, and I work in the studio full scale on those elements. So the Stuart Collection piece was mocked up full-scale in these particle board blocks. At the time I did several projects that had a modular block construction.[1] I was doing a lot with these blocks.

Richard Fleischner
Hay Interior, 1971
temporary installation
Rehoboth, Massachusetts

JS: There's a photograph in your studio showing the modular blocks that goes back to I think 1980. Working with the blocks followed on from earlier working more typically with grass or hay—with organic materials.

RF: Yes. The hay was blocks or bales of hay. When I did *Hay Interior*, in '71, a bale of hay was a buck. So for $300, I had 300 bales of hay. That's a lot of blocks. And with one assistant who was working with me, we would retie them. For *Hay Interior*—

JS:—which is based on a below-ground room-sized tomb, one of those at the ancient Etruscan necropolis Cerveteri, near Rome—

RF:—we built the beams out of hay bales. When my children were really little I was playing a lot with them, and they had blocks. So I made a substantial, heavy set of blocks, like children's wooden blocks made to a big scale. In the blocks I used for the Stuart Collection piece, the biggest ones were something like ten feet long. A lot of the concept came from Froebel's blocks, which Frank Lloyd Wright used to play with as a child: they were German, and they were a sequence of gifts for children that with each set got more and more complicated. It started with a basic cube, then a cube cut into four cubes or into two rectangles, and then it started to get more complex, with the pieces getting more numerous and smaller. Later it got into spheres and triangles.[2]

JS: How do these relate to the Stuart Collection project?

RF: I had all these blocks, and on some levels I was looking for ways to use them. I would never be so literal again.

JS: I think you used something like seventy stone blocks for the Stuart Collection piece. You seem here to be dealing specifically with post and lintel, column and passage.

RF: That was what I was really interested in. It became a ruin.

JS: A ruin that is used in a very vital way.

RF: The fact that it's used is great—the fact that it's inhabited, and there are events there. That's funny and nice.

JS: Part of the reason the piece seems so architectural is that it is furnished as well as framed.

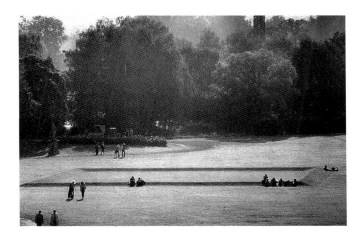

Richard Fleischner
Floating Square, 1977
temporary installation
for Documenta 6
Kassel, West Germany

RF: That's a good expression, "furnished as well as framed." That's excellent. If you look at some of the earlier hay pieces—

JS: —oh yes, the interior benches lining and structurally part of the room in Hay Interior, *and also the bedlike form in* Hay Maze.

RF: I later did a version of *Hay Maze* in stone [*Tufa Maze,* 1973, Rockefeller Collection, Pocantico Hills, New York]. What I love about ruins is they show you everything, in a sense, the most significant information in terms of scale and layout and structure, the most significant relationships—inside/outside, the sequence of destinations or rooms, the distinction of parts, all without ornament or detail.

JS: Your piece is particularly hard to photograph.

RF: My intent was for the piece to be experiential. What I mean by that is, I was taking what I thought were the major gestures of the area that I was working in and amplifying them. There was the lower stage or bandstand area, a flat rectangular plane coming out of the slope of the larger landscape. Working with the blocks, I built a vertical backdrop perpendicular to the bandstand plane at its back edge. The next group of stones was an attempt to reinforce a boundary parallel to and across the site from Galbraith Hall. Third was the round table, which basically becomes a point rather than a plane, but it's cornerlike. It's almost a stake. The fourth element was a large recessed plane cut into the lay of the land.

I regret not making that sod plane more visible. I did it so subtly that it's invisible [laughter]. My idea that it was to be like a sunken plane literally derived from a Bedouin I came across in Jordan. He lived on the side of an olive orchard that he took care of, and all of the parts of his life were very quietly laid into this orchard. Where he slept, he'd taken a broom and really just swept out the stones, and tried in the subtlest way to put what read as a flat level plane into this hill. In reality it was neither flat nor level, but its subtle contrast to the existing topography when the light hit it in a certain way was beautiful. It was just quite something.

JS: What you're saying reminds me of what William Jordy wrote of your 1977 piece for the Documenta exhibition in Kassel. Quoting you, he said, "Fleischner's Floating Square *interrupted the slope of a park lawn by a sod-covered embankment shaped as a square to create a place defined by the minimal gesture needed to establish a distinction between inside/outside."* [3]

Do you primarily now work on public commissions? And do you also make studio works?

RF: I've always done a lot of gouaches and drawings; I've also always done photography. Right now I'm working more in gouaches and photography. A year ago I was in Kosovo for five weeks, photographing and working on issues of the simplest elements that define home. It was very much along the lines of what we were talking about [the Bedouin]: what are the special gestures that focus home life. They are more visible in areas of total upheaval. It's trying to see the human dimensioning and refining of things on the basis of how we physically relate to

Richard Fleischner and Mathieu
Gregoire working on-site with
plywood mock-ups, 1983

things in the body politic, and so forth. And it's really the lines on which I want to work more. I no longer think the only way to make these things accessible is through large-scale public commissions. All of my work is about acting on, for, and in reply to a site. It's about perceiving, then acknowledging, then demonstrating an understanding.

None of this is really new. Historically it goes back to Bernini and then to the Greeks and Romans and Egyptians. In my mind, it wasn't that any of us who were making these public commissions were introducing any revolutionary ideas. But there seemed to be an opportunity to work pretty uncompromised. This kind of work really broke into two separate groups: the conceptualists like Walter de Maria, who did the *Lightning Field*, and even Michael Heizer, who did *Double Negative*, would conceive of a project, and the plasticity or refining of it was not as major a factor as the concept in that gesture. The other group ended up having the concept developed through the manipulation of the space, and the becoming acquainted with the space, so that the physical fit took on an incredible importance.

JS: Now you're more involved with the photography and gouaches?

RF: I'm interested in vernacular architecture, which is so connected to its source intellectually and emotionally. It's not overly cerebral. I'm interested in something simple and elegant, not a spectacle. A lot of big projects, and what one goes through to get them realized, don't allow those passions. I would agree with John Hockenberry, who wrote, "If design is the act of defying forces of conformity, then the elemental gestures of the world's refugees to defy forces of international chaos, traumatized people in living spaces, are a fitting component of the decade's design legacy."[4]

JS: How does this relate to what you are trying to do with the photographs?

RF: What I'm trying to do in the photographs is find any workable situation that right now

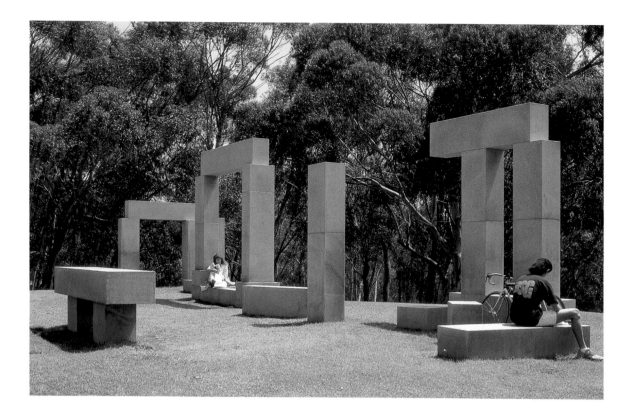

reinforces these ideas, given the nature of everything else that's going on—the pressure to compromise, and the lack of reasonable sensibility either in the name of expedience or of art, or cost or time. I think there are things that one needs to be responsible to, and so I guess I've become focused on acknowledging things that I look to as examples of excellence. These are the issues that become my issues. I'll read you one other quote, by Ezra Pound. He wrote this in 1921:

> But if we are ever to have a bearable sculpture or architecture it might be well for young sculptors to start with some such effort at perfection rather than with the idea of a new Laocöon or a triumph of labor over commerce. This suggestion is mine and I hope it will never fall under the eye of Brancusi but then Brancusi can spend most of his time in his own studio surrounded by the calm of his own creations whereas the author of this imperfect exposure is compelled to move about a world full of junk shops, a world full of more than idiotic ornamentations, a world where pictures are made for museums, where no man has a front door that he can bear to look at let alone he can contemplate with reasonable pleasure, where the average house is each year made more hideous, and where the sense of form which ought to be as general as the sense of refreshment after a bath, or the pleasure of liquid after a drought, or any other clear animal pleasure is the rare possession of an intellectual aristocracy.[5]

Quite a quote, huh?

1. Among related block projects are Richard Fleischner's commissions *Alewife Station Project*, Cambridge, Massachusetts (1981–85), and *Dallas Museum of Art Courtyard Project* (1981–83).
2. The "Froebel Gifts" were a series of ten toys designed and developed in Germany in the 1830s, by Friedrich Froebel.
3. William Jordy, "Richard Fleischner: Projects," *Richard Fleischner: Projects* (Providence: David Winton Bell Gallery, List Art Center, Brown University, 1995), p. 6.
4. John Hockenberry, "Dwellings That Left Incredible Marks," *New York Times*, December 30, 1999.
5. Ezra Pound, in *The Little Review Quarterly Journal of Art & Letters*, Autumn 1921.

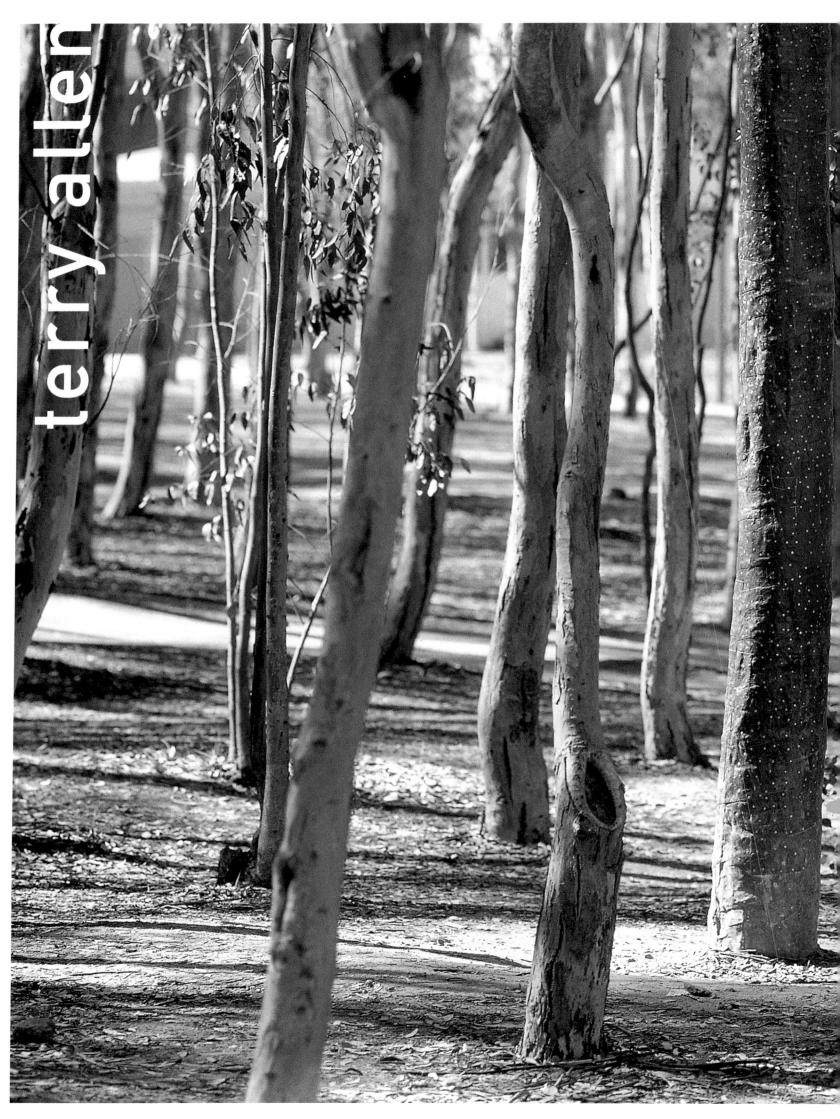

terry allen

JUNE 1983

MARY...

JUST A NOTE TO TELL YOU NOT TO DESPAIR OVER MY SLOWNESS...THE PIECE IS
DIFFICULT FOR ME...RUNNING INTO A LOT OF BRICK WALLS (MAYBE I'LL PROPOSE
ONE OF THOSE)? THE PROBLEM IS...WHICH I TOLD YOU BEFORE...I NEVER MUCH
CARED FOR OUTDOOR SCULPTURE (AND IF YOU CAN UNDERSTAND IT, THAT'S ONE OF
THE MAIN REASON THE PROJECT IS SO INTERESTING TO ME...ABOUT THE ONLY
THINGS 'OUTSIDE' I LIKE ARE THE BUDDY HOLLY STATUE IN LUBBOCK, THE LITTLE
BRONZE KID LIFESIZE ON THE SIDEWALK EATING A HAMBURGER IN FRONT OF MAC-
DONALDS IN KANSAS CITY, THE EYE-FULL TOWER, THE LINCOLN MONUMENT, THE
MEMORY OF MY 1953 GREEN CHEVROLET HALF SUNK IN BUFFALO LAKE IN LUBBOCK,
THE GREAT PLAINS LIFE BUILDING IN LUBBOCK...STUFF LIKE THAT. I THINK MY
AVERSION TO IT HAS USUALLY BEEN BECAUSE OF INBRED RESENTMENTS TO HORIZON
OBSTRUCTION...USUALLY WANT ANYTHING THAT 'STICKS UP' TO DO SO JUST UNDER
EYE LEVEL...I DID HOWEVER PROPOSE A PIECE ONCE IN TEXAS...IT REGARDED
DIGGING UP ALL THE TEENAGERS FROM A PARTICULAR TOWN THAT HAD BEEN KILLED
IN CARWRECKS IN THE 50's , ENCASING THEM IN CLEAR PLASTIC AND STACKING
ALL OF THEM UP THEN COVERING THE WHOLE THING WITH BUBBLE GUM...NEEDLESS
TO SAY, MY XXXX PLAN DIDN'T MAKE IT OUT OF THE COMMITTEE) BUT I AM AT
IT...SCRAWLING AND SCRIBBLING...AND THOUGH MY STUDIO IS PRETTY EMPTY, MY
GARBAGE CANS ARE BECOMMING FULLY REALIZED IN SPADES. XXXXSXXX
I ALWAYS GO THROUGH KIND OF A DEATH KNELL OF ENERGY AND GOOD SPIRITS
AFTER A SHOW...GUESS MOST PEOPLE DO. SO I'VE BEEN READING ALOT...FOCUSING
ON MORE A CRAVING FOR INPUT THAN OUTGO...ALSO TRYING TO FULLFILL DEADLINE
STUFF I COMMITTED TO EVEN BEFORE I COMMITTED TO YOU...JO HARVEY'S BOOK
JACKET FOR 'CHEEK TO CHEEK' AND MY ALBUM COVER FOR 'BLOODLINES'...BOTH OF
WHICH ARE FINALLY AS FINISHED AS I CAN GET THEM.
ANYWAY...YOU HAVE BEEN VERY PATIENT AND I SINCERELY APPRECIATE IT...I WANT
TO PROPOSE SOMETHING I FEEL REAL GOOD ABOUT SO AM GOING TO KEEP HAMMERING.
I JUST WANTED TO WRITE YOU AND SAY I'M NOT JUST SITTING ON MY THUMB...
WELL, WHEN I AM...I AM ALSO CONSIDERING IF I MIGHT BE ABLE TO USE THE
POSITION AS A VIABLE WORK.
ALL OF OUR MACHINES KEEP FALLING APART TOO. THE MOON I FIGURE. EVERY
CAR WE OWN IS BROKEN DOWN AND JUST TODAY THE FAN IN MY STUDIO STARTED
DISPERSING ITS' PARTS AROUND THE SPACE IN A MANNER EVEN THE MOST IMMAGI-
NATIVE XX WARRANTY WOULDN'T CONSIDER. BUT I'M NOT WHINEY...I
PROMISE THAT. JUST KIND OF SLIMEY AND MENTALLY INEPT...BUT GRADUALLY,
I CAN SMELL A LITTLE LIGHT COMING IN...CAN'T SEE ANY YET...BUT DO SMELL
IT. I'LL CALL YOU ABOUT ANOTHER JAUNT DOWN THERE...WILL HAVE TO BE AFTER
THE 4th...BUT I FEEL LIKE I NEED IT...ESPECIALLY IF 'THE LOST HIGHWAY'
SITE MIGHT RUN INTO A XXXXX SNAG.
I'M SORRY ABOUT YOUR XXXXXX FRIEND...THOSE ARE MEAN HOURS NO MATTER HOW
GOOD YOU FEEL ABOUT THE PERSON'S LIFE. WE'VE BEEN THINKING ABOUT YOU
AND LOVE YOU.

 T

**TREES
1986**

Terry Allen grew up in Lubbock, Texas, to become a dramatic story-teller and
pithy aphorist, tossing out lines like "Art is the shortest distance between two question marks"
and "Talking about art is like trying to French-kiss over the telephone." A true ornery Texan
with a quick and irreverent wit, he has a devoted following. Terry is a multidisciplinary artist in
the truest sense of the term. He paints. He draws. He sculpts and makes installations. He plays
the piano, and occasionally other instruments. He composes music and writes songs. He sings as
the lead vocalist with his own Panhandle Mystery Band. He is well known for his installation
and performance projects of the 1980s. One series, "Youth in Asia," reflected on the experience
of the Vietnam War, and on the Amerasian children left in the war's aftermath. Terry has
explored American value systems through a variety of means, ranging from mass-culture
heroes, to fairy tale protagonists like Snow White and the Seven Dwarfs, to the ethos of road-
houses in the American Southwest.

Terry first visited the campus at the time of his exhibition "Rooms and Stories," at the
Museum of Contemporary Art, San Diego (then the La Jolla Museum of Contemporary Art),
in April 1983. The museum produced his opera/theater piece *Anterabbit/Bleeder* to coincide
with the show, and the Panhandle Mystery Band played for an evening. The city got a
significant dose of Terry Allen and responded with wild enthusiasm.

Although Terry was not on the Advisory Committee list, and had never made outdoor
sculpture, I found his work compelling and talked with him about making a proposal for the

PROPOSAL FOR OUTSIDE PIECE, UCSD

To find a <u>dead</u> <u>or</u> <u>dying</u> <u>tree</u> in a grove of trees where people walk
and cover the entire outside surface of the tree with pieces of
sheet lead...nailed directly to the tree. Hollow out an area high
up in the branches and conceal an audio speaker (or speakers...stereo)
beneath the lead (with holes to let the sound come out) which would be
connected to a tape deck in an appropriate nearby location and pro-
grammed to play original music and/or poetry compositions written by
various selected composers and poets specifically for this piece. The
recordings could be looped to play continuosly (including periods of
'silence')...but would probably make more sense for them to be scheduled
for play at different time intervals during the day, week, etc.

More than one of these trees could be made (one for music, one for
poetry, one just to look at, etc.) and placed in different groves
on the campus. If practical, the school radio station might be a
good central location to play the recordings from...but I wouldn't
want them to broadcast any of their shows out of the trees...unless,
of course, a circumstance came about that made this a good idea.

Every effort will be made to select recorded works that will be pleasing
to the casual walker-by or student on the rush...whatever race, creed or
color or relegious affiliation...even whatever major. (As you well know,
however, you just can't please everybody)

One of my own ideas for a group of musical recordings would be a series
of solo instrumentals written for different instruments...i.e. piano,
violin, cello, pedal steel guitar, steel drum...each lasting approx.
two minutes with longer intervals of silence (or the reading of poems)
in-between...nothing harsh, but something that would hopefully sound
beautiful comming out of a lead tree...even creating a place where a
person might like to just sit, look, listen and relax after a rough
day (or even a good one). In other words, a pleasant place (or places)
where people can enjoy what is going on...nothing obnoxious, because
God knows, school can be obnoxious enough.

The recordings could be made into record albums and cassettes and sold
to generate funds for further projects, making new recordings by more
poets and musicians, etc. ad infinitum...possibly, after the original
expenses for making the physical piece and recordings, the piece would
be able to pay for its own regeneration...maybe even pay for itself in
the long run. The feasibility of this would depend on how it was im-
plemented, but I think it provides some unique possibilities for con-
sideration.

Regarding lead: it is a beautiful soft malleable material that is in
 a state of constant physical surface change...durable
 and mysterious. It is different everyday. I am in-
 cluding some samples (the weight of the sheet lead for
 the project would probably have to be heavier than
 these samples...but not much.) Wash your hands after
 you handle it.

I underlined <u>dead</u> <u>or</u> <u>dying</u> above, because I would not want to kill a
healthy tree or trees to do this project. I had rather build a tree
myself...though a real one would be preferable.
 © Terry Allen, 1984

Terry Allen proposal letters

Stuart Collection. This led to more serious correspondence back and forth between San Diego and his home in Santa Fe. At first Terry kept insisting he wasn't interested; he didn't feel comfortable in a university setting. "Outdoor art is for the birds, Mary. When I go outside I don't want to look at art, I want to look at nature." With some cajoling he returned to the campus in late 1983, and just before leaving on a trip to Thailand he sent a long letter, filled with his usual puns and witty associations, outlining several ideas: a large hollow metal heart with interior speakers; a buried car, again with speakers, to be used as a get-away place; other variations on the car theme; and trees placed in a grove, also with speakers concealed in them. The university discourages shelters where someone could hide out, or take up residence, so that pretty much eliminated the heart and car ideas. The trees, however, seemed a possibility. After some discussion we resolved to focus on them.

Terry first sent a drawing of one tree but eventually there would be three trees, two of which had speakers and "talked." The third was to be silent. Terry was using sheet lead extensively in his work and decided that the trees would be covered with it, a kind of protective skin that would be similar in color to the subtle and faintly iridescent smooth dove-gray bark of the live eucalyptus throughout the campus. We developed the proposal and a budget, which were approved by the Advisory Committee. The university in turn approved sites in front of the library and in the adjacent eucalyptus grove on the condition that the sound be confined to a fifty-foot radius and that the trees be relocated if necessary in the event of an expansion.

As it happened, the university was preparing to erect several buildings at the time, and had to clear a eucalyptus grove. Three doomed trees were chosen, carefully cut down, and stored near the Stuart Collection shed, slightly off the main campus. Each of them was around forty feet high. On several return trips to campus, Terry decided that the two sound trees should be "planted" in a large grove just south of the library, in a spot where a real tree had once stood. Here, he felt, the work would summon thoughts both of displacement and loss and of new life. Wanting to associate the silent tree with the library, he found a site for it near the entrance. The university librarian approved heartily but pleaded, "Couldn't our tree say something too?" Terry wryly replied that perhaps it could say "Ssshhh" to people entering the building. She didn't want the library to be seen as a place of hushed seriousness—in any case she knew he was joking—and the library tree remained silent.

After some months of consultation with engineers, it became clear that we would have to arrive at solutions for the fabrication of the sculpture ourselves; the challenge of preserving and stabilizing a forty-foot tree was new to them. Thus it was Mathieu who figured out how these smooth, spindly, but often elegant trees could be made both to stand firm and to "talk" while retaining their grace and integrity over time. Once again he came up with practical and ingenious solutions. Like all Stuart Collection works, the trees were fabricated to stringent structural requirements, including those for earthquake readiness. As a result, it is sometimes said that in the event of some sort of disaster, Terry's are the only trees in the grove likely to remain standing, still singing and reciting away for generations to come.

The engineering was tested and the contract was signed (after a copyright agreement for the audio material had been approved by all parties). After considerable consultation with the UCSD Media Center, installation of utility lines and conduits began. Special speakers were designed to go into the trees at several high spots; the trees were prepared for joint and base fittings, and metal forms were forged in the UCSD Scripps Institution of Oceanography Nimitz Marine Facility at Point Loma. The trees had to be stripped of their bark and cut in several places before San Diego Wood Preserving could take them for treatment. They were reassembled with metal pipe sleeves at critical junctures in the trees, and with wires for added stability.

Electrical wiring was installed from the Media Center (where a tape deck was installed to provide the trees' soundtrack) through utility tunnels and underground to the trees. Terry and several graduate students went to work nailing squares of sheet lead onto the trees, protecting their hands with gloves. Twelve-foot-deep footings were drilled and filled with cement and rebar. The first tree, which recites poetry and stories, was craned in and installed in January 1986. Some adjustments, no problems—not one branch broken. Rain. A week later the second tree, which "sings," was placed, bolted, welded, and connected. We had sound. Very loud sound. It was quickly adjusted, much to some people's relief.

Although these trees ostensibly represent displacement or loss, they offer a kind of compensation: one emits a series of recorded songs and the other a lively sequence of poems and stories created and arranged specifically for this project. To make the tapes, Terry solicited material from friends, relatives, and artists he admired. The result is a vast range of music, stories, and poems. For the music tree, William T. Wiley, known for his paintings filled with literary puns and eccentric maps, sings "Ghost Riders in the Sky," accompanying himself on a homemade instrument; West Texas singer Joe Ely sings "Mona Lisa Won't You Squeeze My Guitar"; the Maines Brothers work pedal-steel guitars; a Thai band plays; and the musician David Byrne sings a song he composed especially for the project. For the literary tree, Bale Allen delivers his poem about scabs, the poet Philip Levine recites, plus there are Navajo chants, translations of Aztec poems, duck calls, and many other contributions. This is a truly participatory and collaborative project. There are currently about six hours of material on each tree, and Terry and others are at work on future contributions.

There are periods of silence between songs and poems—pauses of up to five minutes on the music tree, longer on the literature tree. As a result, people just passing by can be truly surprised when a tree starts to talk. The trees meet the ground just like the live trees around them and the lead absorbs the light and the surrounding color. A person could walk right by one of Terry's trees without noticing it among the live trees in the grove, or be right next to it before being startled by its subtle difference. One might hear the sounds before realizing their source. Once encountered, however, the trees are alluring. The mysterious lead beckons: it is soft—and often warm—to the touch. People find themselves patting a tree; children climb on the one low "branch" or hold hands and dance to the music.

The carving of initials into a tree is a long tradition, even if now considered a damaging one. A participatory aspect of Terry's trees is that students and others are welcome to scratch their initials into the lead bark, incising a shiny silver mark in the surface of the lead—that is, until the scratch oxidizes and returns to dull gray. Then others can make their own marks over existing initials, forming layers of "history," seen and unseen, none lasting forever.

In 1988, plans for expanding the library began to become real. Some considered the original 1972 William Pereira building, a six-story diamond-shaped structure rising from a vast terrace, the centerpiece of the campus. It had become an icon for the university, so that the expansion and all matters related to it were sensitive subjects. At the same time, the removal of eucalyptus groves for nearby building construction had already been controversial; support for trees was increasing, but not for dead ones. We were entering delicate territory.

Terry Allen
Study for *Trees*, 1984
Ink and watercolor on paper
29¼" x 22¼"

The silent tree near the library was moved into storage during the expansion. The plan included an important new access route to the library, a kind of spine for this part of the campus, to be called Library Walk. It would extend nearly a quarter of a mile, from the library to the School of Medicine, creating a long vista—perfect, we thought, for viewing the tree from a distance in front of the enormous concrete library. In 1992 Terry returned to determine the site. The new library entrance was in mirrored glass and concrete, with no lawns; Terry decided that the tree should be "replanted" right in the middle of this "denatured" site, rather than being disguised somewhere else.

A few months later I had lunch with a second, newly appointed university librarian and brought up the subject of the silent tree, the most graceful and elegant of the three. We were planning, I told him, to put it back in front of the library. "I thought we'd nixed that idea," he declared. I took a deep breath and tried to explain how meaningful and even inspiring the tree could be in this new site. The library behind it could provoke one to think of it in many different ways: it could represent a tree of knowledge, or the presence of nature in front of a geometric form, or the importance of silence. The extended branches could be seen to invoke dance. Perhaps the tree would remind us that trees must be cut down to print books and build buildings, or to point out that knowledge can be acquired through the observation of nature as well as through research and study. The librarian was persuaded, but warned that I would have to convince the deans, who had adamantly opposed this placement. He offered help. I asked to be on the agenda for the next deans' meeting.

There the tree was again and again declared an "ugly dead tree." I tried to suggest that ugliness, like beauty, is in the eye of the beholder, and that although some people might find the tree ugly, others certainly would not. I acknowledged that the tree was indeed dead, but said that there are many ways to describe things, and that perhaps a university's job was to expand those definitions. Ask people to your house for roast chicken or Thanksgiving turkey, for example, and you'll get an entirely different response than if you invite them for dead bird. Exasperated, the deans capitulated. The dean of arts and humanities, in good humor, threw up his hands and said that he could think of no reasonable objection and felt that they could no longer oppose the idea.

The Campus Community Planning Committee also approved the proposed new site, though not without stipulation. A two-year probation period was agreed upon, in case of a violently negative response when the tree went in. June 1993 was set as the reinstallation date. The

hole was dug and the foundations set. Terry and his wife, the actress and artist Jo Harvey Allen, arrived in town, and the CBS reporter Betsy Aaron came to film a segment on the Stuart Collection for *Sunday Morning with Charles Kuralt*. It was fairly dramatic watching the crane lift the long delicate branches from horizontal to vertical, and the first reaction was immediate: a woman passing by muttered something to the effect of what a crazy thing to do, in reply to which the crane operator suggested that she just go read a book. Most observers were delighted, though, and the general response was very positive. We have heard no further complaints.

A thick lead square was inlaid at the base of the silent tree to serve as a flush plinth, integrating the cement ground plane with the tree. This plinth also serves as the label. Terry has pressed the names of everyone who contributed to or worked on the trees into the lead at eye level.

There have occasionally been creative interventions in Terry's trees, presumably done by students. One year a large nest, made of eucalyptus branches with their leaves painted silver, was placed high in the silent tree, and from atop the stairs going up to the library terrace one could see three golden eggs snugly resting in it. A "sand painting" of pebbles was once installed at its base; and the trees in the grove have "sprouted" baby metal trees.

In 1995, when the construction of Library Walk took place, the area around the silent tree was torn up for some time. When this major campus artery was complete, however, it proved the perfect site: from afar the gray tree seems a bare but powerful tracery against the huge form of the library. From Terry's initial proposal drawing a world has been created that entrances, dumbfounds, and delights visitors to UCSD twenty-four hours a day every day. The trees can be rather ghostlike. Not only do they reinvest a natural site with a literal sense of magic, they implicitly make connections between nature, death, and the life of the spirit. The idea of trees talking is an ancient one, but expectations are not tuned to the reality of such a possibility. It is not surprising that students have dubbed this eucalyptus grove the "Enchanted Forest."

—*MLB*

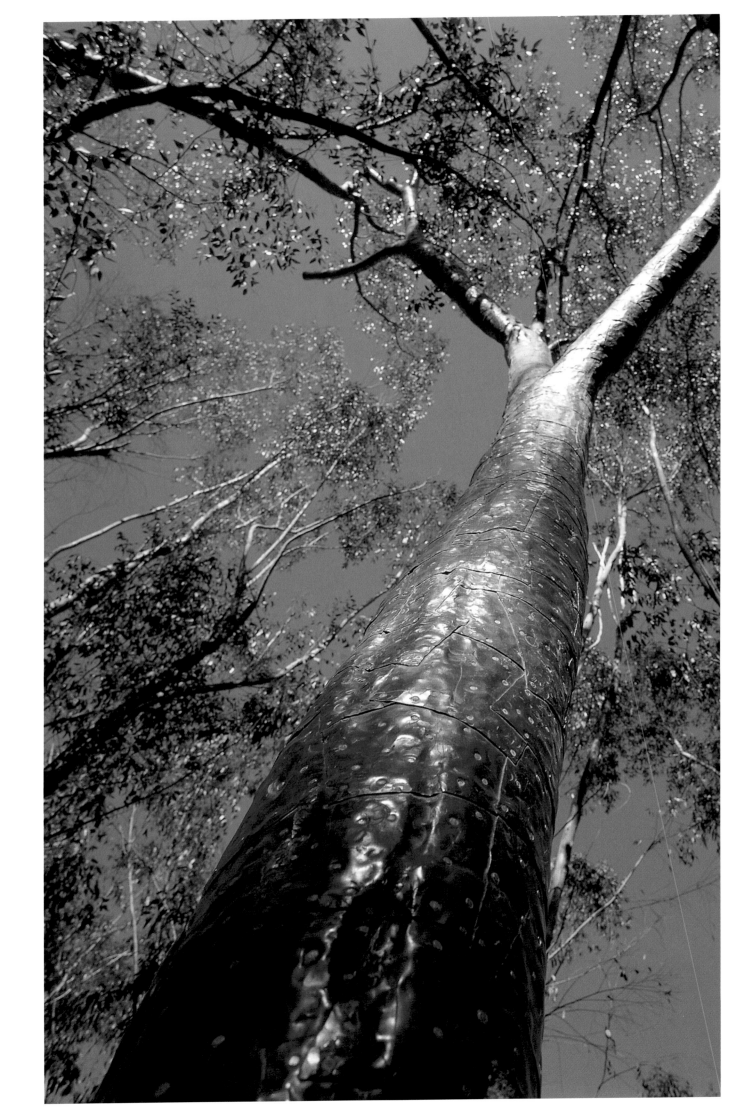

interview

terry allen

TERRY ALLEN: I wasn't interested in "public art." I thought of it mainly as large heavy metal objects stuck out in front of corporations and institutions to show how rich they were. Big pretentious baubles. And sculpture parks seemed like graveyards full of tombstones of this stuff that hadn't made the corporate or institutional "cut." So it was ironic and somewhat unsettling when Mary invited me to make a proposal—to face my own music, as it were, my own prejudices. Without her enthusiasm and persistence, I would've never considered such a thing.

I made about four trips down there over two or three years, trying to get some idea of what I might do. I walked and drove all over the campus, but always came back to the eucalyptus groves.

JOAN SIMON: Why?

TA: Probably some kind of refuge, some kind of breath of fresh air in the desperation of all that architecture that just keeps on coming at you. Also, I liked the idea of people walking through the woods to get to their classes. Those pathways are the campus's main foot-traffic thoroughfares. The groves aren't really "nature"—this is, after all, Southern California—but at least the illusion of nature.

Mary was getting nervous because after all these visits, I still hadn't made a proposal. I was getting ready to go to Asia for six weeks to do music for a film. The day before I left, I had the idea of finding a dead tree in the groves, covering it with sheet lead, and putting a sound system in it. I did a quick drawing of this and sent it to her. I sent her several ideas actually, but she liked the tree idea and thought it would be the most feasible to do, so I later went back to La Jolla for our first serious discussions on how to proceed. Mathieu [Gregoire], who was instrumental in implementing and supervising the fabrication of the piece from start to finish, was in on these talks. It wasn't as simple as just finding a dead tree, sticking a speaker in it, and putting lead on it. A eucalyptus tree has shallow roots; nail ten tons of lead on that and it would probably fall over and kill somebody. The piece had to be engineered, earthquake-proofed, preserved, meet every standard in California and everywhere else on the planet, et cetera. So, after the proposal went through all the necessary channels and was accepted, this whole world was set into motion.

Instead of one tree I could do three: two with sound systems in the groves, and a silent one near the library. All three were selected from a grove earmarked to be cut down for future construction. I invited musicians I know to do songs—songs they would like people to hear coming out of a tree. I did the same thing with writers and poets, imagining a music tree and a storytelling tree—or a music tree and a "poetree."

These two trees are placed about a hundred yards apart so soundwise they don't conflict

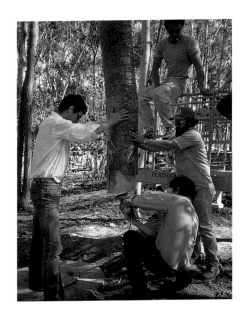

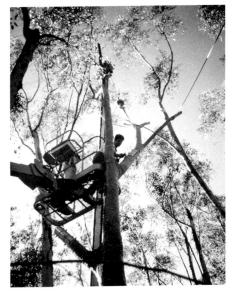

Trees during installation,
1986

with one another. Each has a radius of sound of about fifty feet out from the base of the tree. Due to the nature of the light in the groves, the lead surfaces kind of blend in and disappear. It's possible to walk by and never see the lead trees, never notice them. It's also possible to miss the piece because the sound isn't constant. It's not like Muzak; maybe a song will play for three minutes and then there will be ten minutes of silence, then another song or two, then more silence. Same with the storytelling tree. So, with the light and the silences, it is probable to miss the two trees entirely. I like this aspect of the piece, that it can scream at you, literally, and at the same time be very subtle, not even there.

JS: Tell me about some of the songs and some of the people on the music tree.

TA: Well, both of the trees go from state-of-the-art studio recordings to stuff people did in their bathrooms with cheap tape recorders. So there's a real variety in the types of sound that come out. On the music tree, Bill Wiley [William T. Wiley], Mike Henderson, and I used to play music together off and on, and Bill was making instruments as well, so I asked him to do a song for the tree, and he twanged out a great version of "Ghost Riders in the Sky." Mike, who is a wonderful slide guitar player, did his song "Movin' On/Fly Away." David Byrne wrote a song specifically for the trees called "I Know Sometimes a Man Is Wrong." He recorded flies buzzing all over the song. Since it was for an "art deal," Joe Ely thought he'd do something with the Mona Lisa, so he made a song called "Mona Lisa Won't You Squeeze My Guitar?" My son Bukka wrote a song called "To Be Okay." Lloyd Maines sent a pedal-steel instrumental he wrote called "A Tree in Trouble." Jacki Apple sent a cut from her piece *Mekong Delta*. Dave Hickey's song "Put It Out of Your Mind" is on it. On and on.

Zuzu and the Robot Slave Boys from Washington State—Zuzu is a fiddle player named Jim Hockenhull—do a song called "Leaving the Galaxy" which is about the "master plan." This was appropriate because UCSD has a Master Plan, and one of the big problems in finding a site for your work on campus was that you kept running into it. Nearly every spot you chose, fifty years down the line, was projected to have a building sitting on it. Including the groves—the future is going to be pretty tough on the groves. My trees may end up being the only ones left. (Or the next to go?) It's hard to figure how sculpture might fit into any Master Plan. Or trees.

JS: Which of your own songs are on there?

TA: I put on a couple of pieces from *Pedal Steal*, a soundtrack I had just finished for the Margaret Jenkins Dance Company. I sing on one called "Loneliness" and Jo Harvey does narration over another.

JS: And the poetry or story-telling tree?

TA: It's everything from my son Bale, who was eleven or twelve at the time, doing a poem about scabs, to National Book Award winner Philip Levine. My friend Roxy Gordon, who was an Indian activist, poet, and writer, read a hilarious piece about jogging and the Mothers Against Drunk Driving group. His wife, Judy, did a stunning poem about picking cotton to pay for her first store-bought dress. Dorothy Wiley sent a series of sound effects from different wild animals. Joan Tewksbury read a piece called "Movie People." Peter Everwine did a couple of poems; his voice sounds like the voice of God. I taped a number of writers in my studio; some sent tapes later. It was all kind of a crapshoot, I never knew what I was going to get, but everything I did

get I liked and used. One of my favorites was by David Dowis, a friend of mine who is a doctor. He just sat down in his backyard with a tape recorder and told a story about a big tree he was looking at.

JS: You plan to add new material over time?

TA: I've collected more pieces. I've got a tape of Bruce's [Bruce Nauman's] that I plan to put on there. It's a sound piece he did, I believe it's connected with something in São Paulo. It's in Portuguese, I think.

JS: It's a video work he did for the 1998 São Paulo Bienal, revisiting his 1968 work The True Artist Is an Amazing Luminous Fountain.

TA: Mary wants to have an open submission with some work chosen to be added to the trees. I like the idea. We've also talked about producing a compilation CD of selected works from both trees to fund more works for the Stuart Collection.

JS: Where these trees are designed to lose themselves among the other eucalyptus in the groves, the silent tree is a distance away, in a prominent position on campus.

TA: It's now in its second location—it was initially at the side of that spaceship library, but construction took out the area where it originally was.

It's the largest of the trees. It sits right in front of the library. Every person's name who had anything to do with the trees, from making the recordings to fabricating or installing, is pounded into the lead surface—it's the table of contents for the whole piece.

JS: In addition to your multimedia sculptures, you do theater, stories, radio works, drawings, and installations that draw on all of these. You have your own band—you're the singer. You're a composer.

TA: I think it's all the same. The common denominator, if there is one, is your own curiosity. I'm working right now with stories I heard growing up. My mother was a professional piano player, my dad was a professional baseball player. They were both quite old to have kids by the time I came along, so I grew up hearing these incredible stories from them, which in the context of "now" seem like science fiction, totally of another world. Initially I wrote the piece as a radio drama; that generated drawings and a music theater piece. The piece, which is presently called *Dugout*, may end up being any and all of this or none of it. It's just the way I work.

Another thing I'm interested in, which happens with the trees, is offering a platform for other people to make work—play music, read poems, even come up and carve a drawing on the surface of one of the trees, which has happened a lot. The trees have a whole patina now of graffiti.

JS: You went to school at Chouinard, and while you were there, Marcel Duchamp and Man Ray

Terry Allen nailing lead to tree trunk, 1985

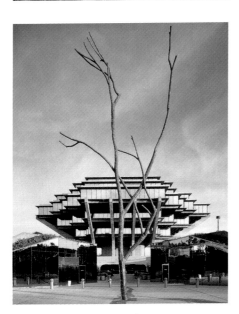

Above: *Silent Tree* in 1986 location
Below: Relocated in 1992 to new entrance of
Geisel Library

both lectured there. Did you hear them speak?

TA: Yeah, I met them both. There was an art history teacher, the first art history teacher I ever had, Miss Watson, and she had been a nun, or so the story goes, and had spent time in a convent in France, where she had met André Breton and a bunch of the Surrealists. Later she dropped the cloth and moved back to the States. And I'll never forget, one day she said, "Today we're going to show slides and discuss the work of Mr. Marcel Duchamp, and we're very fortunate to have Mr. Duchamp here to talk with you about his work." He was there for his first museum show, at the Pasadena Art Museum, and Miss Watson, who knew him, asked him to visit the class.

JS: Do you remember what he said, or anything about the show?

TA: I really wish I could say I did, but I don't. It's funny, in retrospect that encounter has become important, rather than thinking at the time that it had any significance at all.

Man Ray was different. I believe he lived in L.A. off and on then, and he came to Chouinard a lot, usually around lunchtime. He liked to shoot the breeze with the students down in the courtyard. He was also a pal of Miss Watson. I remember he once said, "There's nothing wrong with being a bad artist because a bad artist doesn't hurt anybody. It's not like a bad doctor or a bad lawyer who kills people." Another one I remember was, "The great thing about being an artist is that you can do anything you want to do, any time you want to do it. You want to draw your dog? Go draw your dog. You want to make a giant sculpture? Make a giant sculpture. Take a break? Take a break. If you're an artist you have complete carte blanche." And I loved that.

JS: Talk about rock 'n' roll.

TA: Permission. Just like what Man Ray said, it gave you permission. Rock 'n' roll hit like the atom bomb, especially in isolated rural areas across America. It opened this huge door of possibilities that was never there before. It gave voice to every secret yearning you ever had and a whole lot you didn't even know you had. The whole Beat thing too—Beat and rock 'n' roll were the same thing. Jack Kerouac and Chuck Berry—all that language! For me, the door that opened was the way out of there. Going somewhere else and doing something, anything, even if you didn't know what it was, but something different from what was going on where you were. It had a huge impact. For the first time you could think about making something—art, music, words, whatever—as a way of life.

JS: Where did you get into doing visual work as well as music?

TA: I've always made pictures, I don't know why. I grew up around music, but nothing much that was visual. Maybe that's the reason! The Texas Panhandle is so flat and empty that on a clear day, if you look hard in any direction, you can see the back of your own head [laughs]. That's a joke, but not too far off the mark. There was one museum where I grew up, but it was full of farm implements. There was a picture of a sailing ship on our living room wall, my mother had a collection of painted-bird plates, and I knew who Norman Rockwell was. That was about it. My mother's side of the family was heavily tattooed, and I loved comic books, so I'm sure that was an influence. Also, the music was visual, in the lyrics. So were the amazing stories you heard at the supper table. I guess, really, the most visual thing was what you imagined.

There was only one tree in my town, in front of the courthouse; it had a brass plaque embedded in the trunk that just said, "A Tree." Farmers would come in from hundreds of miles around with their kids and point at it and say, "Look! See? That's what they look like!" Maybe, ultimately, that's where the idea for the La Jolla piece comes from.

JS: Is there anything you'd like mentioned about that project that we haven't discussed yet?

TA: One question, because it's lead, has come up: Is it toxic? What about putting that in nature? I think if a test were made on the real trees in the groves, they would probably have as much toxic lead on them as my lead ones because of the accumulation from car exhaust over the years. Just a speculation, but you might note that.

JS: You were making other lead works at the time of your Stuart Collection proposal.

TA: I made a body of work called "Youth in Asia," dealing with the aftermath of the Vietnam War. Lead seemed to make sense in those works. Humidity, anything in the air, can change its coloration; it's also malleable, like a skin. So more than any other metal, it's like some kind of weird flesh. The fact that bullets are made out of it also made sense. And that it's poisonous seemed appropriate for works about Vietnam.

JS: Have you gone back to the campus and just hung out and watched people listening to your trees?

TA: For the first time in a long time I went back I guess last April [April 2000]. I was on a concert tour that passed through La Jolla, so I walked out there late one afternoon.

JS: What was that like?

TA: Odd. I mean, I was really glad to see them, but the thing that got me was how settled in the project is, how really part of that environment it is, while in my memory it was still all new. That's another reason I like the patina of graffiti scrawl and scratches. Because when I saw that, it was like "Ah!"—a weird relief that it was actually part of the world.

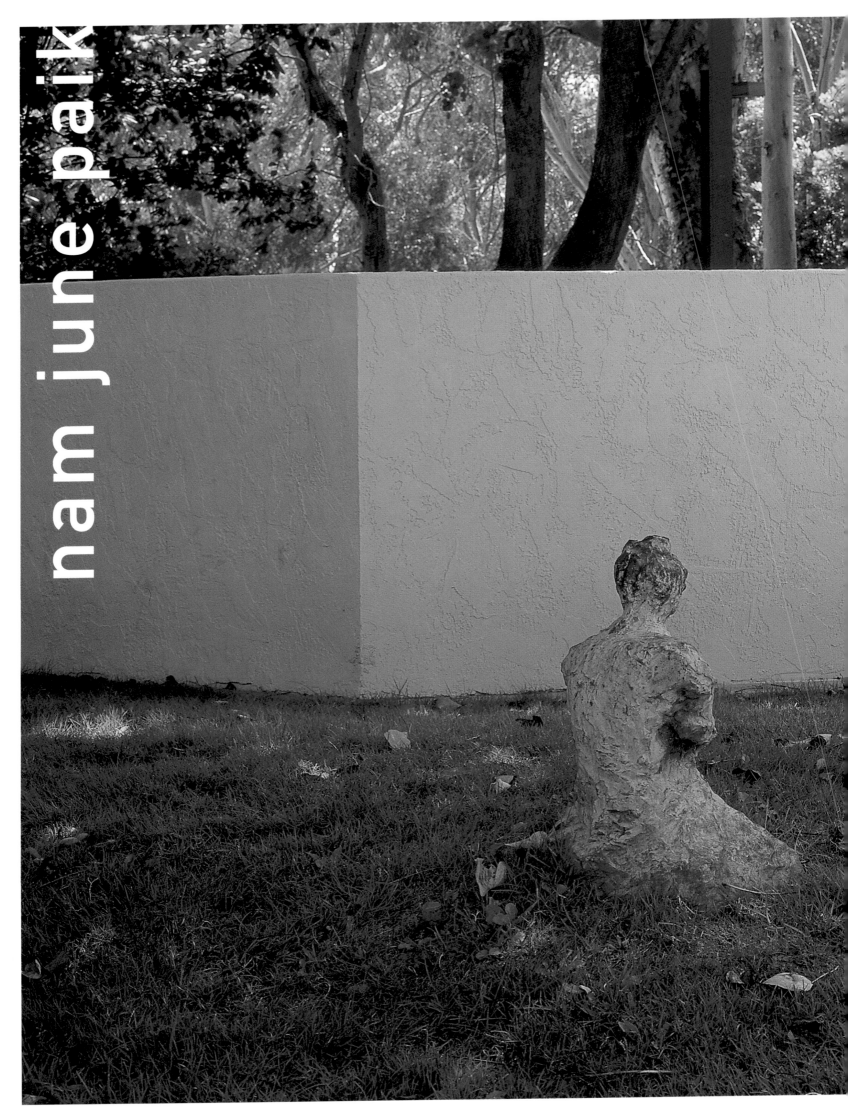

nam june paik

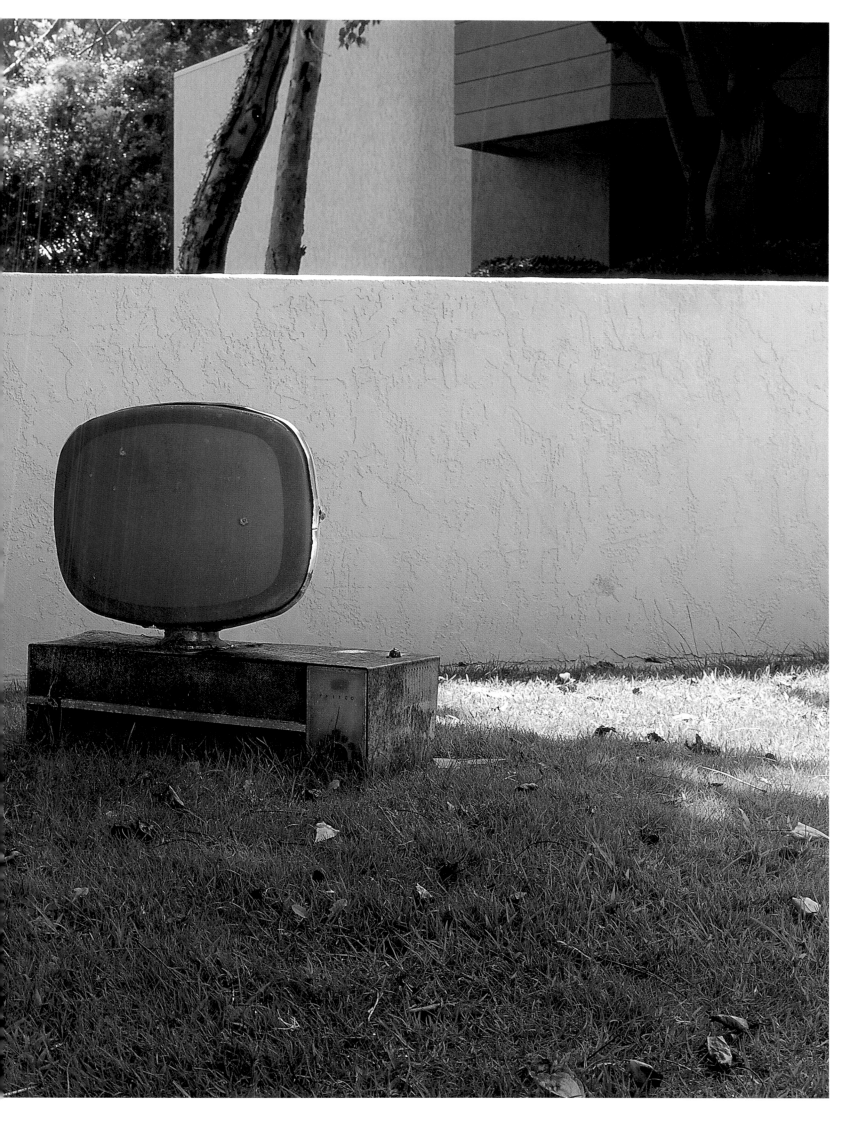

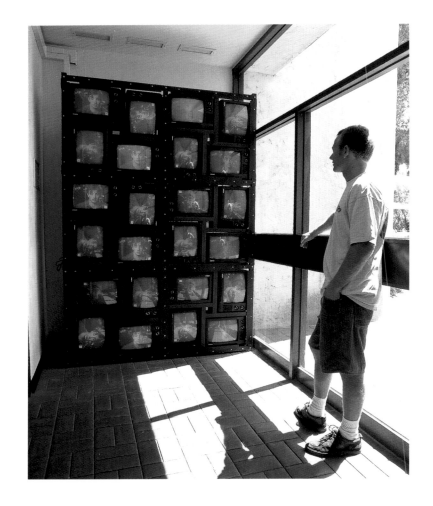

SOMETHING
PACIFIC
1986

WHEN THE UNIVERSITY'S REGENTS AGREED to the idea of creating a sculpture collection
on campus, I suspect that none of them had rusting television sets in mind, and if they had, those
minds might well have been changed. The Advisory Committee, however, decided that Nam
June Paik would be an important contributor to the Stuart Collection. Nam June was born in
Korea and began his career as a composer and musician studying in Tokyo, Munich, and
Freiburg before moving to New York in the 1960s. Influenced by the composer John Cage, Paik
came into the orbit of Fluxus, an international postwar movement of artists—many of them
interested in the earlier work of Marcel Duchamp and the Dada artists—who sought to break
down the barriers between high art and everyday life. Fluxus is often considered "anti-art" in its
sometimes violent renunciation of conventional definitions of the art object. Nam June had
invented the use of video in art, not just as a subject but as media and material. In the 1960s,
when he was known as a "cultural terrorist," he had helped to transform the whole notion of
sculpture—and of music, and of painting. He had made a banal, even ugly thing, a television
set, into an ingenious art object. In the 1980s he imagined a global communications network
and coined the phrase "information superhighway." He has been and continues to be a vision-
ary nomadic art ambassador with a great wit.

I contacted UCSD'S Media Center, where the academic pursuits of the students include
the history of communication and television, from sociological as well as technical and produc-
tion perspectives. The center's faculty and director, Sherman George, of course knew Nam
June's work, and were pleased at the prospect of hosting the first outdoor permanent installation
by the "grandfather of video art."

Nam June came to the campus in September of 1985, and responded right away to the
Media Center site. To illustrate his belief that television has served as the American landscape

since World War II, he proposed old television sets, or skeletal remains of them, scattered about in the landscape around the Media Center. Some of these would be combined with small bronze sculptures. Nam June also envisioned a bank of live interactive televisions in the interior lobby.

The building itself is a bland, boxy, two-story structure built on a slope. There is an entrance at the lower level. Large handsome trees of several kinds grow around this entrance, and lampposts, a fireplug, utility boxes, and a kiosk for posting information are also scattered about. Nam June wanted to put his work in amongst all this. Instead of creating a monumental public sculpture, he would insert objects similar in scale to the things already there, and seemingly no more—or less—important. Adding these objects to the general picture, he intended to provoke some thought as to their meaning and their relationship to the function of the building. He proposed three small Buddhas, each paired with a television; a miniature reproduction of Rodin's *Thinker*, also staring down into a television, in this case a very small Sony Watchman; a cast-concrete television covered with live passion flower vine; a television sinking into the lawn; and a hillside strewn with television "remains," looking rather like an archaeological dig. These would not be monuments: they would be positioned almost incidentally, like furniture, without a hint of public-sculpture grandeur, or of the sense of permanence and placement that has been the traditional experience of sculpture. The relationship between viewer and work would be analogous to the way people watch television while simultaneously doing other things around the house. One can see TV as a barren wasteland, a humorous playground, a part of everyday life, a source of information—or all of these.

For the lobby of the building, and in sharp contrast to the silence of the outdoor elements, Paik proposed a bank of twenty-four active television sets. Half of these sets would be wired

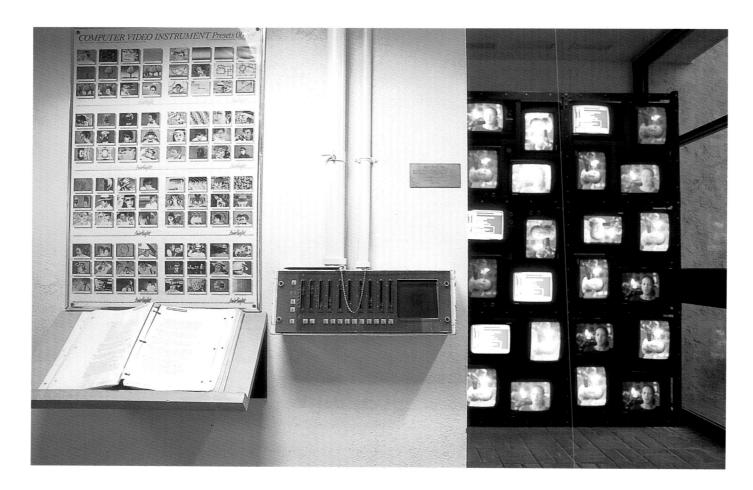

through a video synthesizer, enabling the viewer to manipulate the images playing on them and thus to use television no longer passively but actively. We discussed placing additional Buddhas and televisions indoors, in stairwells and halls, but in the end decided against this. An installation and maintenance proposal was developed that could be handled by the Media Center staff. Their enthusiasm was a great help in making the project happen, and their continuing vigilance in making sure it runs properly have been key elements in the success of this work since its installation, in 1986.

When the project was discussed at the Advisory Committee meeting in January of that year, the reactions were very positive. At the time, the UCSD Music Department was preparing for a major festival, Pacific Ring, to which they had invited John Cage and numerous prominent musicians. Cage and Nam June were old friends and collaborators; to have the two projects coincide would make for a perfect match and a great opportunity. It was agreed that we should concentrate on finishing the installation in order to have the opening take place in conjunction with the festival, which was to be in May, five months later.

The accelerated approval process continued at the Campus Community Planning Committee. Serious misgivings were expressed here, but strong support from the Media Center allayed them and the project was approved. When word got around, however, one faculty member was heard to declare that "if the Stuart Collection is allowed to put disintegrating television sets on the campus, it will destroy the reputation of the university." The alarm had been sounded but other voices prevailed: so far, esteem for the university remains intact.

In the bank of interactive televisions, the sets were to be placed in pinwheel formations of four, so that their screens would alternate between right side up, sideways, and upside-down, upsetting any "normal" viewing. Nam June would make a tape that could run on the televisions some of the time, but for everyday use he wanted to broadcast live MTV. This required not only

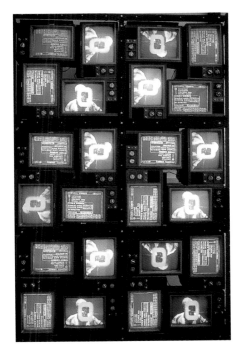

a satellite dish for decent reception but permission from MTV. I met with officials of the company in New York and secured a licensing agreement; no fee was charged. We acquired a Fairlight synthesizer for the interactive part of the television "wall." Nam June obtained a supply of Samsung TV sets, including a small reserve of spares.

Nam June returned in March with his longtime friend and dealer Carl Soloway. There were details and adjustments to be worked out, but Nam June was traveling between America and Seoul, Korea, where he was working on another large commission, so Carl oversaw the casting and shipping of the bronze Buddhas.

Nam June always has a twinkle in his eye, and likes to tell the story of how, as a child in Korea, he did well in every subject but handicraft and art. He made a painting in 1976, but claims that he was never bold enough to make sculpture. Then, for an exhibition, he combined a television and a valuable bronze Buddha that he had borrowed for the purpose. When someone wanted to acquire the work, he decided that instead of spending a lot of money to buy this or another Buddha, he would simply make one. Necessity turned him into a sculptor, and then he found that he actually enjoyed the physicality of casting. He liked working with clay, the sense of going back to earth and to the past. He made several Buddhas, shaping the classic form himself rather than casting it from existing Buddha statuary. For the Stuart Collection installation, *Something Pacific*, he made a long-necked "ET Buddha," which he positioned to stare into a 1947 Predicta TV set that also has a "neck" holding up the mirrorlike screen; another Buddha looks into an old TV that has been reduced to a shell.

Nam June found old, broken televisions more interesting than new ones. Perhaps the sense of a TV graveyard evoked by *Something Pacific* seemed to him to reflect our fascination with death. The form of the Predicta made him think of a vanity mirror; grass growing in the TV shell evoked Niagara Falls; the *Thinker* gazing into the Watchman may be thinking about universal philosophic questions, but also about Sony, or about television. When the old TV sets disintegrated enough to be considered dangerous, Nam June's plan was that they would be replaced with "new" old TV's. The elements would age and change, just as people age and change, and thus the definition of the piece could change with each generation.

Having worked out most of the details, Nam June and Carl Soloway left La Jolla. Mathieu went to work on making the installation happen. Foundations were poured, old television sets were gutted and reinforced, frames for the bank of televisions were designed, passion flower plants were planted to cover the concrete TV—the jungle taking over the

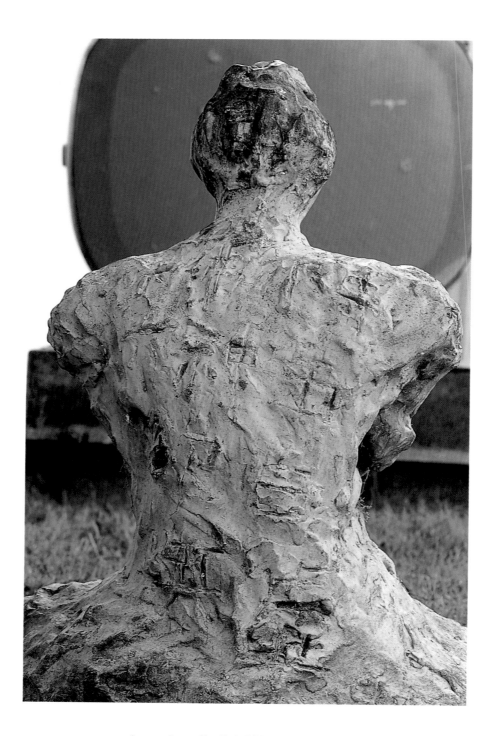

ruins, perhaps. Rodin's *Thinker* and a tiny Sony Watchman were secured to a low wall. The title, *Something Pacific*, came easily to Nam June and seemed so perfect with its obvious double reference: both something peaceful, and something of the territory here on the Pacific Ocean and the Pacific Rim.

The installation was completed just in time for the opening of the Pacific Ring Festival. Accompanied by his wife, Shigeko Kubota, Nam June arrived from New York to meet with a group of eager and serious students, some of whom were somewhat puzzled by his offhand humor and underlying sense of the ridiculous. An afternoon reception on the site drew a very large crowd. John Cage gathered a basket of mushrooms.

Since that spring, grass has grown in and around the outdoor televisions, which have occasionally been repaired or replaced as they have weathered and aged. Response has been interactive and introspective. One student blackened his skin so he would look like a sculpture, then sat cross-legged in front of a working television on the lawn alongside one of Nam June's TV-watching Buddhas for an entire day. A computer keyboard was placed in front of another

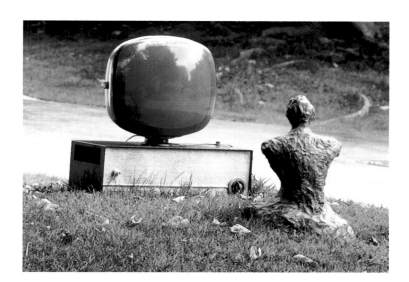

Buddha, as if the statue were surfing the Net. The synthesized TVs indoors have been scrambled, programmed, demonstrated, and studied. The original Fairlight synthesizer has not been replaced, and is rather dated by now, but it remains user friendly and provides plenty of provocative play for users of all ages. Nam June was right in thinking that the combined educational and artistic purposes of this work would change with time but would outlive us all.

Nam June uses many references, including the figure, to ask us to think about our relationship with television and its influence on culture, our own and every other. The "dead" TVs outside contrast with the very-much-alive TVs inside, which anyone can actively influence by manipulating the synthesizer. Is the timeless contemplation of the Buddhas passive in our contemporary world? Or is their wisdom lost to us—do we think in half-hour segments, or even in thirty-second sound bites? How has television affected our experiences of time and of space?

In the reduced reproduction of *The Thinker*, a tiny man sits on top of a tiny TV on a human-scale wall. *The Thinker* has become another Paik antimonument. It is his premise that public art doesn't have to be monumental, although when it isn't seen as grand, it can be controversial, as the history of Rodin's *Thinker* reminds us. When the work was first proposed, in 1880, it was embroiled in contention. People in the Paris neighborhood for which it was intended felt it looked unfinished and crude, like a man sitting on a toilet; they didn't want it. There were cartoons in the papers and vehement protests. Yet today *The Thinker* is an icon of Western civilization, a world favorite, the symbol of humanity contemplating the meaning of the universe. It is certainly not an object of ridicule or contempt.

It has become almost a cliché, but the story of much public art is a story of slow acceptance and eventual reverence. This is true of the Chicago Picasso, Alexander Calder's *Grande Vitesse* in Grand Rapids, the Saint Louis Gateway Arch—works that now are objects of civic pride. Perhaps not everyone at UCSD takes pride in Nam June's TV landscape, but some do, and others are provoked, amused, or even befuddled by it. *Something Pacific* is yet another example of the way art can incite the mind into a kind of thinking that is not always or only about "beauty."
—*MLB*

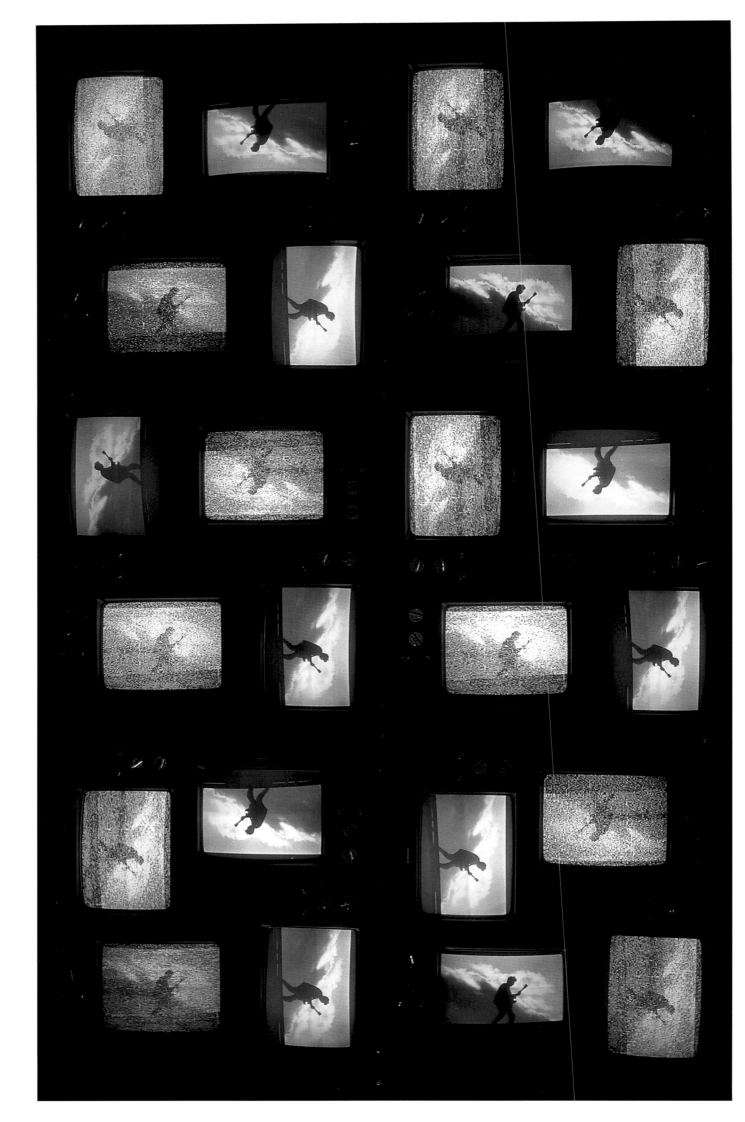

interview

nam june paik

NAM JUNE PAIK: This is a very happy day. I have these glasses that let me read the *New York Times* for the first time in three years. So finally I was able to read the *Times* review of my Guggenheim show.

JOAN SIMON: And you're happy with what you read?

NJP: I'm very happy. Grace Glueck is my very good friend, and she understood the whole history and spirit of my work. It is not just a good or bad review but a very penetrating, understanding review.[1]

JS: I'm glad to be here on such a happy day, a day we picked over a month ago to talk about your piece Something Pacific *in La Jolla. It was your first permanent work outdoors; how did it come about?*

NJP: Somebody called me. And at that time there was Roger Reynolds in the music department. I think he was doing a festival.

JS: Your sculpture for the Stuart Collection has two parts: one outdoors in front of the university's Media Center, and one indoors, near the building's entry.

NJP: Yeah, yeah. I'm very proud that both parts have survived.

JS: How did the concept develop?

NJP: The thing is that I was already a '60s kid. We always hoped for participation by many people. We wanted freedom for the people to create. That was John Cage's idea: everybody is artist. And at that time the first computer came out where anybody could make something using a synthesizer. The synthesizer was made in Australia, and it was a very high-tech thing—very high-tech then, especially at the price that the Stuart Collection could afford.

JS: This synthesizer, a Fairlight, was described to me by a professor at the Media Center as affording the kind of manipulation of a computer image that is now widely accessible with, for example, programs like MacPaint, but in 1986 it was a state-of-the-art, high-tech device.

NJP: Since then the company collapsed.

JS: Any visitor to the Media Center can use the synthesizer to alter and abstract the images on twenty-four monitors that fill a wall in the entry lobby. For imagery, your original idea was to have only live broadcast television—specifically MTV—on all of the monitors.

NJP: With the synthesizer you can make changes, make your own variations, using computer manipulation. In San Diego, the smart kids there made very good pictures from the first day. And still the machine is alive. And the concept is alive.

JS: In addition to the live MTV, which still plays there, you have added a taped component. These images too the students can alter with the synthesizer. Why did you decide to make a video that would play some of the time instead of the MTV broadcast?

NJP: Maybe it is that tape is safer. Kind of like time-sharing.

JS: John Hanhardt has grouped certain of your pieces sharing "formal and conceptual interests."
Something Pacific can be seen as a member of one such group, which begins with Zen TV *in 1963 and*
includes recent pieces like Crown TV *of 1998, in which, Hanhardt notes, you "realized the power of the*
pure electronic image to create an abstract shape and participatory experience"[2]—

NJP: —where people can make them.

JS: The "live" component of Something Pacific *inside the building is changeable by any passerby;*
the "dead" TVs outside the building, set into the landscape, are changeable too, but now by forces of
weather and natural decay.

NJP: Yeah, yeah. Also I love the beauty of ruins. The broken. The decadent. I made a kind
of cement TV with vines coming out of it [part of Paik's *Waiting for UFO*, 1992, at the Storm King
Art Center]. Still alive, that. I'm glad about that.

JS: The shells of the TVs in Something Pacific *are individual sculptures in the sense of being found*
objects chosen to function in a different context, and some of them are also paired with traditional-looking
three-dimensional sculptures—the small replica of Rodin's Thinker, *for example, with a Sony Watchman*
television.

NJP: *TV Buddha* variations.

JS: I read that you began to make sculpture out of necessity. For the first video Buddha, you borrowed
a bronze Buddha figure and placed it facing a video monitor. A live feed from a video camera mounted just
behind and above the sculpture transmitted an image of the Buddha onto the monitor, generating a self-
reflexive continuum of creation and contemplation. Following this work, TV Buddha *[1974], with its*
appropriated, treasured bronze sculpture, you began to make Buddha figures yourself.

NJP: To make money. Because people buy one, which they can resell. You know, Arthur
Miller said the only thing you own in this world is something you can sell.

JS: Was there pleasure in making the sculpture yourself?

NJP: Sometimes. Thinking about it. I made one Buddha by myself, the thing called *Ugly Buddha*. I wanted to hide it. In the Guggenheim, I did hide it inside the Mongolian tent.

JS: Why did you put the reproduction of Rodin's Thinker *in the Stuart Collection piece?*

NJP: At that time the Watchman was kind of a new thing from Sony. I know the guy who is the chief designer at Sony. He's a personal friend. It was his personal work. I wanted to make him eternal.

JS: That reminds me of words of yours from 1976: "Video art imitates nature not in its appearance or mass but in its intimate time structure which is the process of aging. A certain kind of irreversibility." One often thinks of the "live" aspect of time in video, whether in live broadcast, the "real time" of closed-circuit transmission, or the perpetual present of single-channel tapes being looped continuously. You have used all of these modes, and each in its way seems more about a continuity than an irreversibility.[3] *What did you mean by the time structure?*

NJP: Aging. You cannot survive. Everybody ages. Especially when I got the stroke, suddenly then aging becomes a daily struggle.

JS: That process of time taking its toll is explicit in the broken-down TVs outdoors in Something Pacific, *but less so in the indoor video component.*

NJP: I think that for some reason I like tragedy. Tragedy is a breaking down, a ruin. Great negativity.

JS: Why do you think you like tragedy?

NJP: I think I'm born a negative guy. I like negativity more than positivity.

JS: What don't you like about positivity, to put it in the negative?

NJP: I think it's in my character. I like bits of defeat. I like to be beaten. Maybe that is a spiritual pursuit. Spiritual pursuit means you don't know what you're doing.

JS: Symphony for 20 Rooms, *of 1961, was the first of your pieces where the audience could take part. Previously you would perform your actions for music, and then with this piece—*

NJP: —people made their own music.

JS: The audience activated the piece in a number of ways: by playing audiotapes, for example, or kicking objects. What was the change for you between making something by chance, by an action, by determination, and—

NJP: I think that's the John Cage influence..

JS: Do you make music now?

NJP: Yeah. I think I may even make one record before I die. We discovered 1958 audiotapes. Still very good. I was startled how good.

JS: Hanhardt has written of you as making "postvideo" now. What's postvideo?

NJP: For me it is laser. The reason I like laser is the character is transcendent. It has a kind of Hindu character.

JS: You have sometimes used video outdoors. Isn't video odd outdoors, or at least hard to use?

NJP: It's not odd. But video breaks down when it rains. In sunshine you can't see it too well. Now we're working on two outdoor projects that may work. One is in Korea, in the Olympic Museum.

JS: Why did you pick the title Something Pacific?

NJP: I'm Korean. It was like Pacific Rim, very close to us. Although we live at rim of Pacific.

JS: Was there anything you wanted to do in San Diego that you didn't do?

NJP: No. I lived there one week and expressed myself 100 percent. The San Diego piece became the base for the later Storm King project.[4] It is a very important work. I am very satisfied.

JS: Are there things you would particularly like noted about the piece?

NJP: The fact that I love ruins, for some reason I don't know. I loved ruins from the beginning. There are ruins of television in many ways in *Something Pacific*, so I am very happy. My destructive tendency is finally expressed well. Already in my past performances I broke pianos. I remember this guy came and said, You are small guy! He thought because I broke piano I must be giant guy. He was quite big guy. And he said [laughs], you are small guy.

JS: There is a nice contradiction if not irony in the fact that to maintain the TVs as outdoor ruins for this site sculpture on the UCSD campus, the "ruins" have already been replaced, renewed [laughter].

NJP: The San Diego piece is in my heart, so I am very happy to talk about it. This one I made with my own hands. I dug up the hole and put television inside. This time I not only designed the piece but I made the hole myself. The piece is very popular.

JS: It's in a Media Center.

NJP: It's the best place to be. I'm glad people are using the Fairlight computer.

JS: As you said, the company is out of business. What happens one day when the Fairlight equipment used in this installation doesn't work?

NJP: Now we have similar stuff.

JS: Similar stuff to maintain it to the same level of now "low" but then "high" tech?

NJP: To be the next generation. Like human genes. When people die, they make their own babies and they educate the babies.

JS: Are you saying that for conservation purposes, if it were no longer possible to fix the original Fairlight synthesizer the piece should be maintained using state-of-the-art synthesizers? Or should Something Pacific *be repaired to maintain the level of technology circa 1985–86, the original Fairlight standard?*

NJP: No, I think it should be made better. Every young kid expects more now from media. So they should go with the progress of industry.

JS: Who should make the decisions of what technology to use?

Nam June Paik, John Cage and Shigeko Kubota at inauguration of *Something Pacific*, 1986

NJP: The right curator. Who educates the kids? The teachers are the public's will.

JS: So the teachers in the UCSD Media Center, let's say, could be the voice of the public, advising on the technology.

NJP: It's like a symphony. When you write a symphony each new generation comes along and changes it and that way it becomes better and better. We got the Ormandy, and Toscanani, and they all make the work. They all make the conductor's work. Curators make good work now.

My most favorite piece—if I had to pick three of my most favorite pieces in my life—the San Diego Piece is one of the three.

JS: Which are the other two?

NJP: I never thought yet [laughter].

1. Grace Glueck, "Vast Wasteland? Fast-Paced Land!," *New York Times*, February 11, 2000, pp. E33, 38. The exhibition was "The Worlds of Nam June Paik," curated by John G. Hanhardt, at the Solomon R. Guggenheim Museum, New York, February 11-April 26, 2000, and tour.

2. Hanhardt, *The Worlds of Nam June Paik*, exh. cat. (New York: Solomon R. Guggenheim Museum, 2000), p. 119.

3. Paik, "Input-Time and Output-Time," in Beryl Korot and Ira Schneider, eds., *Video Art: An Anthology* (New York: The Raindance Foundation, 1976), p. 98. Quoted in Hanhardt, *The Worlds of Nam June Paik*, p. 15, note 6.

4. Paik's *Waiting for UFO* (1992), in the permanent collection of the Storm King Art Center, Mountainville, New York.

UNDA
1987

IAN HAMILTON FINLAY came up as a possible artist at the Advisory Committee meeting in August 1984. The objects he made were beautiful as sculpture; his roots in poetry, his interest in inserting language into the landscape, and his references to literature, history, and mythology seemed ideal for a university setting. They were especially relevant because the UCSD University Libraries contain an outstanding collection of poetry manuscripts, including many from the "concrete poets" who emerged in the 1960s and '70s—one of these being Ian Hamilton Finlay. In May 1985 I visited Ian's home, "Little Sparta," a farm in the Scottish Lowlands outside Edinburgh.

Since 1966, Ian, working with his wife Sue, had been developing an extraordinary garden and sculpture park. They had created temples from farm buildings and had distributed architectural fragments, fountains, and commemorative plaques among plantings throughout the property. Many of the works they had placed in the landscape were collaborations with other artists and craftspeople. Sometimes a single work appears in a variety of designs and media. Many sculptures contain quotations and references to artists, revolutionaries, and classical or mythological heroes and tales. The viewer is called upon to have or find knowledge and to discover layers of meaning.

One of the largest sculptures at Little Sparta, from 1983, is a grouping of eleven large stone slabs, thick and flat, each with a word deeply incised: THE / PRESENT / ORDER / IS / THE / DISORDER / OF / THE / FUTURE / SAINT / JUST. The French Revolution, of which Saint-Just was a leader, is a particular interest of Ian's. These stones lie on a gentle slope looking across a large pond to the hills beyond, so that as one stands reading the words, the landscape is very much part of the view. Elsewhere a stone vase, fluted like a classical column, sits on a square pedestal carved with the words "Wildflower: A Mean Term Between Revolution and Virtue." An ordi-

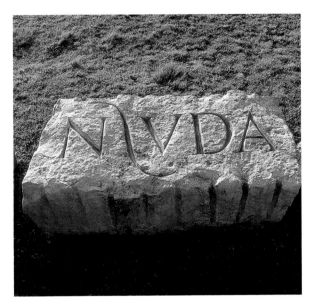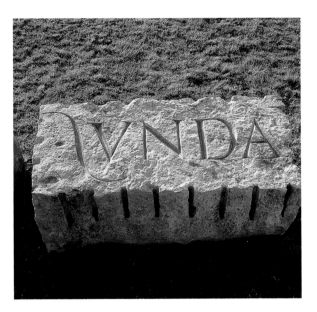

nary galvanized watering can bears the words of Gertrude Stein, "a rose is a rose is a rose," painted beautifully around the top while Gertrude Jekyll, the eminent English gardener, is named across the front.

When Ian was younger he was primarily known as a writer of short stories and concrete poems. In 1961 he founded the Wild Hawthorn Press, which produced works by a number of poets and today still publishes his own extraordinary small books and other manifestations of his creative endeavors. Little Sparta, like all of his work, explores the complex relationship between the wildness of nature and of revolution and the attempts of culture—particularly literature, painting, and other forms of classical knowledge—to control and contain it. There are many references to war, warships, and armaments in the garden, a microcosm of the world that casts the poet in the role of social thinker. Little Sparta is a philosophical, lyrical place where the intellect meets nature and addresses it in many ways. I spent a wonderful day there with Ian, talking enthusiastically about a multitude of subjects. We agreed that the Stuart Collection would be a fine place for his first permanent work in America.

Ian rarely travels, Edinburgh has been the farthest he will go, so a visit to the campus was out of the question. Sue agreed to come for a week in early December, although she was not in good health. It was a strenuous trip for her, but we traveled around in an electric cart and her spirits were high. She had never been to California and found it entrancing and energizing. Returning to Scotland with a massive amount of information and photographs, she had a site in mind.

What she had seen was a grassy area with a sliver of ocean view, lying between Sequoia Hall, a Humanities building, and student apartments of Thurgood Marshall College—between art and life. Ian pored over her material and agreed with her: "If the Humanities building had

Ian Hamilton Finlay and
Gary Hincks
*Sea Coast, After Claude
Lorrain (Liber Veritatis,
1667)*, 1985
Hand-colored etching
(Wild Hawthorn Press)
18″ x 21¾″

not already existed," he declared, "we would have had to invent it." The site looks out across a playing field, over the trees on the far side of it, and then to the ocean in the distance. These horizons step out beyond the university into the real world of nature.

Ian would make a one-word poem. Because a poem must infer relationships he felt that a one-word poem wouldn't work on the page, but would be possible outdoors, where a single word would relate to its setting in the landscape and there would be a relationship between landscape and mind. He also felt that the California views he saw in Sue's photographs were reminiscent of the seventeenth-century French painter Claude Lorrain, known for poetic scenes of the Roman countryside featuring classical ruins set in spacious panoramas. The illustration Ian made (in collaboration with Gary Hincks) for his proposal is a beautiful pen-and-ink drawing with a blue-and-gray wash—a Claude-like scene with five stones in the foreground.

The stones would end up as rough thirty-inch-high blocks of Guiting stone, a limestone with the light honey color of the cliffs that rise from the La Jolla beaches. The word Ian chose for them was *unda*, Latin for "wave." He added to it the wavy typographical sign that proofreaders use to indicate that two adjacent letters should be transposed. One stone has the wave sign alone; each of the other four bears a single word incised in Roman letters, the Roman "U" being a V shape. *UNDA* itself appears only once; in its other appearances the letters are slightly reordered as the wave sign activates the letters, moving sequentially as one reads, through different configurations of the word. Ian sees this as a typographical representation of the way a natural wave advances and spins on itself. He also wrote in his proposal that he sees "a kind of double movement within the work, for, while the wave sign moves (in the sequence) to the left, the letters have a necessary movement to the right." Combining the wave sign, the word for wave, and the actual physical wave, Ian has made a challenging and beautiful work of which the landscape is an essential part. He had used the word *unda* in earlier pieces, but wrote that this site was perfect for a new version and is "so obviously the right choice—so obviously as really to preclude choice."

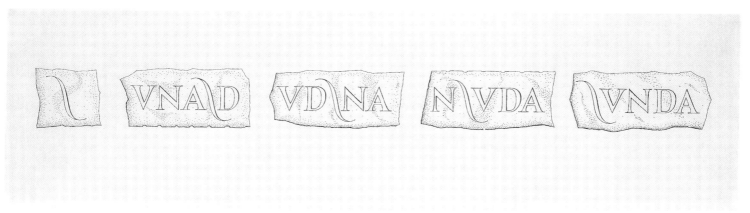

Ian Hamilton Finlay
Study for *UNDA* (detail), 1986
Ink on paper
8⅞" x 29⅞"

The Advisory Committee expressed considerable enthusiasm for the project, though the members regretted the fact that Ian would not come to La Jolla for the installation. They had previously seen the artist's presence on-site as essential to the Stuart Collection's process. But he was very clear: he absolutely never flies, and Sue oversees the execution of all overseas commissions. She was happy to come back to California, and the committee approved the proposal.

The stones were quarried in southern England, near the Cotswolds, and were carved by Nicholas Sloan, an expert mason and Ian's frequent collaborator. Put in a large container and shipped to arrive in February 1987, they were stored in our shed until Sue arrived a few weeks later. A crane carefully placed the gorgeous stones on a sand foundation; we planted several eucalyptus and Torrey pine trees to make a connection to the distant trees, to frame the view, and to create the sense of a special enclave. The campus has many Torrey pines, beautiful tall trees known only along the coast of San Diego County and on nearby Santa Rosa Island. There was some concern, though, that these trees would eventually grow large enough to obstruct the view to the ocean, so they were later replaced by smaller Japanese black pines. Ian's work as a poet was well known to many in the university's Literature and Visual Arts departments; they and others turned out for a delightful noon reception on the site. Sue returned to Scotland to give a happy report to Ian. Their son, Eck, has visited UCSD several times since, where he has given talks about his father's work.

Now it seems as though the stones have been in place forever, perhaps the only "classical" ruins in California. They present us with a word puzzle, engaging both intellect and knowledge. Students can come here to witness human play in the adjoining field or the spectacle of nature in the nightly sunset, a sensual experience as important as the knowledge and the intellect. Some wanted to know if they could sit on the stones and drink beer. I said that they could, and if they wanted to contemplate the roots of language, they could also try undulating. Evidence of late-night occupation, such as candle wax, has been found. Games are played and graduations held on the field. Birds visit. Joggers run over the stones' tops.

Even from a distance, Finlay's sensitivity is strong enough to make this place powerful and memorable, connecting the landscape with history and politics and touching on philosophical and moral implications specific to the site. The cliffs and sea are far off, but the waves that the work refers to roll in and out beneath them, unseen but known. The carving flows over the uneven stones. Water from the rare rains and frequent sprinklings sits in the recesses of the letters. Storms pass through. Green and gray lichen has grown. Grass sprouts up the vertical hollows made by the quarriers' drills on the sides. More than pleasant seating, these scenic stones provide a place imprinted with thought.

—*MLB*

121

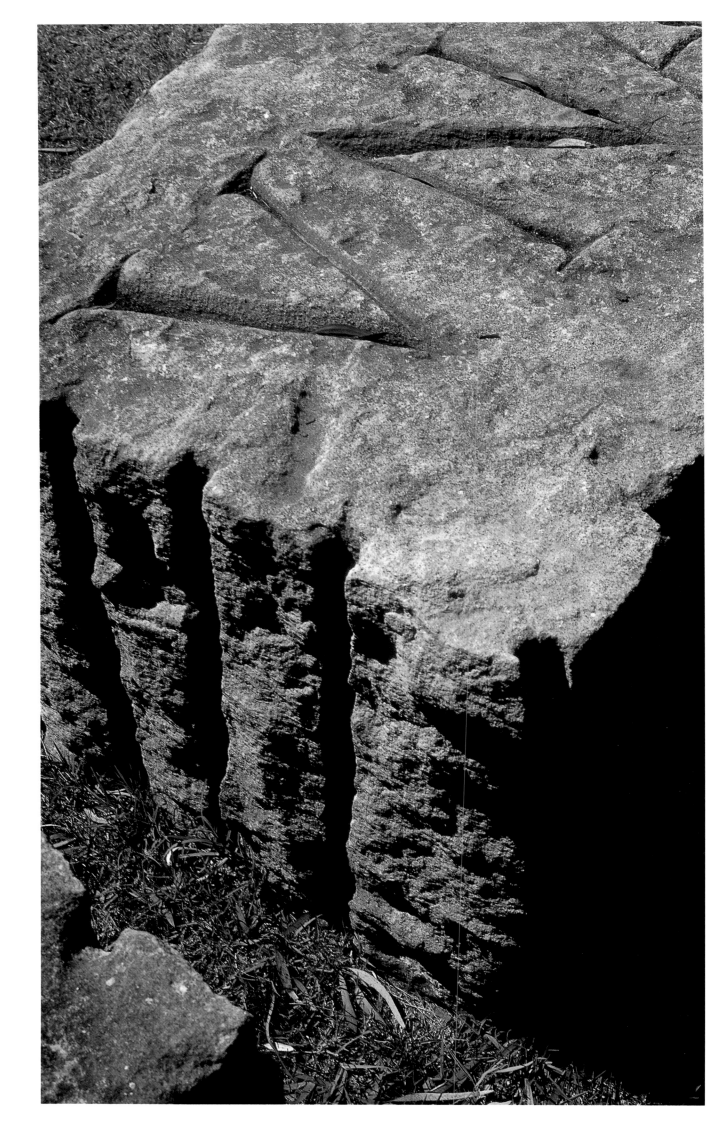

interview

ian hamilton finlay

JOAN SIMON: *Why don't we talk about being a poet-gardener.*

IAN HAMILTON FINLAY: I don't know what to say about that. It comes naturally to me. I feel very good about siting works in landscape.

JS: At what point did you move off the paper page?

IHF: I think really when I came to stay here [at "Little Sparta," Scotland], and had the ground with which to make a garden.

JS: Was that 1966?

IHF: I don't know—a long time ago, thirty years ago.

JS: How did you choose this place, in the Southern Uplands of Scotland?

IHF: Well, where I was before, there was no running water, and I had a wee baby, a wee boy. This space had running water so it was a very good idea to come here. It was much easier with a baby.

JS: UNDA, at the Stuart Collection, is your first public outdoor piece in America, I think.

IHF: I think that's probably correct.

JS: How did it come about?

IHF: I think because Mary Beebe came to see my garden, and invited me to do it.

JS: Your situation is a bit unusual for a person who makes site works: am I correct in that you didn't go visit the site?

IHF: No, I didn't. No, no, I didn't like traveling then.

JS: How did you approach the problem? How did you get a sense of the site, and of what work you wanted to put there?

IHF: It's not such a big problem as you might think. I had lots of photos. I don't see it really as a problem.

JS: The reason I ask is that a site visit is an integral part of the process for many artists who work outdoors on commissioned works. They are involved with specificity to site, and the particularities of a site.

IHF: I too. I think, actually, that's important. But I don't see why it's a problem.

JS: There are many ways to experience a site, and learn about it. Being there is one—taking a measure against the physical self.

IHF: If you're used to working out of doors in a garden, it's not hard to imagine what another site is like.

JS: Did you send anybody in your stead?

IHF: Yeah. My, you'd say, partner [Sue Finlay] went.

JS: The proposal in the form of a drawing at the Stuart Collection details a number of aspects of the

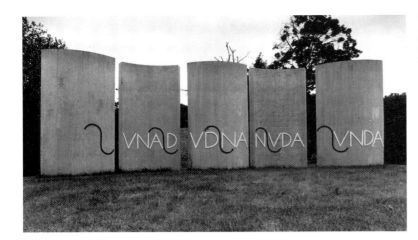

Ian Hamilton Finlay
UNDA, 1975
Cast concrete and neon
Collection Max Planck Institute
Stuttgart, Germany

*project. There's a quote from Xenophanes, "The mighty sea father of clouds and of winds and of rivers"; there's mention of the presence of the ocean, and of the proximity of a Humanities building. Then you talk about "*UNDA,*" the Latin word for "wave."*

IHF: Yeah.

JS: How did these come together for you?

IHF: Well, that was what was there. The ocean was there. The Humanities building was there.

JS: One of the things I noticed when I was reading about and looking at photographs of your earlier work is that a condensation of "unda," with the wavelike typographical sign meaning "transpose these letters" is an important motif, sign, or image for you.

IHF: Yes, I've used that sign a number of times. It's a very harmonious one.

JS: In one project from 1975, in the garden of the Max Planck Institute near Stuttgart, there are five cast-concrete steles, freestanding wall panels. Reading from left to right, the first, vertical panel isolates only the typographical sign, and then each of the next panels uses the sign to transpose pairs of letters within a four-letter word, so that on four of the five panels the "scrambled" letters making up the word will in fact be "read" as unda. In Frankfurt, as part of the 1995 project for Schröder, Münchmeyer Hengst & Co, six words are seen in sequence. Reading from left to right, the first three are each the word "wave," the sixth is the word "rock," and the fourth and fifth words are superimpositions in a single word-space of "wave" and "rock." What does it mean for you to revisit ideas? How does it work when you use variations on the same idea—on vertical concrete panels for Stuttgart, fabricated in steel and positioned on an interior wall for Frankfurt, or cut in five massive blocks of stone for the outdoor piece at the Stuart Collection?

IHF: The blocks of stone have a kind of a—maybe you would say—archaic presence, which the other settings don't have.

JS: How did you come to choose this particular stone—guiting, a limestone quarried in England, in the Cotswolds—for California?

IHF: Well, I suppose you could have used lots of different stones, but it seemed to me that that particular stone was very nice in a hot country.

JS: I read a beautiful passage in the catalogue Works in Europe 1972–1995: Ian Hamilton Finlay, *discussing your* Improvements, *1991, at Stockwood Park, Luton, England: "Permutations and change continue. If Ovid's errata took us from Degas's poetry of 'ideas' to Mallarmé's sterner poetry 'made of words,' we now move to a more atomistic poetics of the letter."* [1] *How do you deal with each letter in terms of building the poem?*

IHF: I don't think it would be true to say that I use each letter, really, usually.

JS: Could you describe a bit the process of how you create a text?

IHF: It's hard to explain. I can't answer that really.

JS: In the introduction to Works in Europe 1972–1995, *John Dixon Hunt writes of gardens, "They are refuges from the business of negotium of the world; yet—as Ian Hamilton Finlay long ago advised us—these retreats are 'really attacks,' rebukes, admonitions or challenges to the world around them."* [2]

IHF: Often.

JS: What does this mean?

IHF: Well, I suppose that my own garden has been the scene of a long war with the surrounding political region. Because the region wanted to put taxes on my garden center as an international art gallery. But I said no, it was a religious building.

JS: And what happened?

IHF: What happened was they launched an attack on the building, and we repulsed them. A lot of things happened over fifteen years.

JS: The situation now?

IHF: The situation now is that there's a sort of stalemate. And they are not at the moment attacking us. And I am much older, and more into the ways of peace than I used to be.

JS: And in terms of making gardens elsewhere. When you are invited to a public place, how do you address those issues? Might your gardens in those places also be seen as admonitions? Or do they have a different relationship to the surroundings?

IHF: Well, I should think in the case of each work it is different. Sometimes I've done works that are connected to the French Revolution. Not always.

JS: The text in the Stuart Collection brochure notes that your work explores "the complex relationships between the wildness of nature and revolution, and the attempts of culture—particularly literature, painting and other forms of classical knowledge—to control and contain it." [3] *Zdenek Felix, in his preface to* Works in Europe 1972–1995, *writes of the kind of perfection you demand of the craftsmen with whom you work: "This drive for perfection, an urge which also mirrors Finlay's Classical inclinations, is evidenced in a broad field of reference which delves back to antiquity and culminates in Neo-Classicism's precepts of beauty, harmony and moderation."* [4] *References to antiquity and classicism are ever present in your work.*

IHF: Yes, I'd hope so.

Carved stone ready for
shipment to California

JS: In approaching a particular site, are you reaching into the readings that you are doing each day, or things that have stayed with you for a long time?

IHF: Things that have stayed with me for a long time.

JS: In terms of the texts, do you keep these in notebooks, and then work, depending on the site, on translating the text to the support—a boulder-size stone, or a wall, or a plaque for a tree? Or does it go the other way around—only when you have a site in mind do you find a text, or write one anew, and consider its presentation?

IHF: It's fair to say I first write texts. But usually when I would write texts, I also found ideas as to how they should be realized—in what form. And thinking of words for a tree plaque, I would think of the form of the tree plaque, and I realized these things. The concept comes to me probably at the same time as the words.

JS: When the concept and words come together, do you then draw, or go immediately to three dimensions?

IHF: No, I draw it. Describe it.

JS: Describe it in words on the page? Or out loud.

IHF: In scribbles and in words.

JS: Then what happens?

IHF: Then I work with a collaborator to actualize it.

JS: The stone carver?

IHF: Yes, the stone carver.

JS: And do you work with different ones?

IHF: Yes, seven or eight different ones.

JS: How do you choose which one you will work with on a particular project?

IHF: Usually stone carvers have—they can't do everything. They do sort of limited sets of things. And I would choose whoever seemed the natural person to do that particular work.

JS: Nicholas Sloan was your collaborator on UNDA. *What is his particular skill or approach?*

IHF: One thing is working with large pieces of stone, which not all letter-cutters like to do, but he particularly likes to do. He's also a very good letter-cutter—I think possibly the best letter-cutter in this country. He has no objections to working on a fairly large scale.

JS: What would he do as you begin working together on a project? Would you show him a sketch, or talk to him about an idea? Does he bring anything to the project at an early point, before the cutting stage—does he ever talk about the text itself with you?

IHF: No, never. Never.

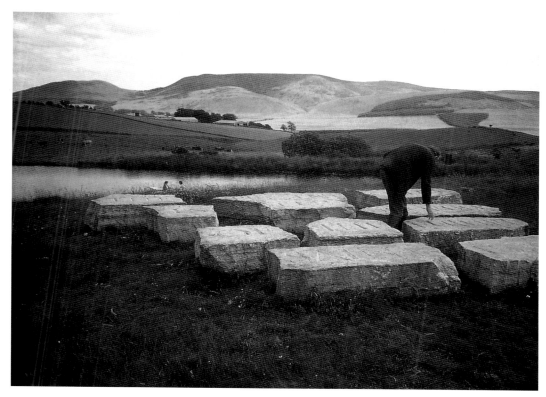

Ian Hamilton Finlay at
Little Sparta, Dunsyre,
Lanark, Scotland, 1985

JS: Would he ever suggest a different font, for example, than you would choose, or have chosen?

IHF: Style of letter you mean? I don't have that experience with him, no.

JS: Let's talk about that wave-shaped mark, the typographer's or editor's mark linked around two letters or characters, indicating that they should be transposed. It has a specific function within each stone in the Stuart Collection piece.

IHF: Transposing the letters is because the wave itself, if you put that around the word, it would turn over, as a circle. We're suggesting the sand turns over.

JS: The repetition. The wave itself continues, the "same" word continues (even if the letters are in different nonsequential orders), the wave keeps coming back on itself, correcting the sequence, allowing us to read the words as the same.

IHF: It does, it revolves. It suggests that allegorically.

JS: Is there anything you'd particularly like to see included in documentation for this piece?

IHF: The lettering seems to run from left to right, and the wave sign from right to left, which is very nice visually, and which suggests the ebb and flow of the wave. I find it a very satisfactory work. I don't get tired of it.

JS: Hunt writes that gardens should be "playgrounds of paradox, where the play is always serious (but not solemn) territories of both nature and culture, of both physical pleasure—sights, sounds, smells, textures, taste—and metaphysical insight."[5] His comment seems particularly relevant for a work, like UNDA, *on a college campus. In creating* UNDA, *how much did you think about the fact that this field, with the ocean beyond, was on the grounds of UCSD? That is, as compared with others works of yours that have appeared on the wall of a bank, or in public or private gardens?*

IHF: Well, I think I would have thought that it's nice to be on a college campus, because nobody is going to say you shouldn't use Latin.

1. "Stockwood Park" entry, *Works in Europe 1972–1995: Ian Hamilton Finlay*, ed. Zdenek Felix and Pia Simig (Ostfildern: Cantz Verlag, distributed in the USA by D.A.P., 1995), n.p.

2. John Dixon Hunt, "Introduction," ibid., n.p.

3. *Ian Hamilton Finlay: UNDA*, 1987, brochure (La Jolla: The Stuart Collection, n.d.), n.p.

4. Felix, "Preface," *Works in Europe 1972–1995*, n.p.

5. Hunt, "Introduction," n.p.

bruce nauman

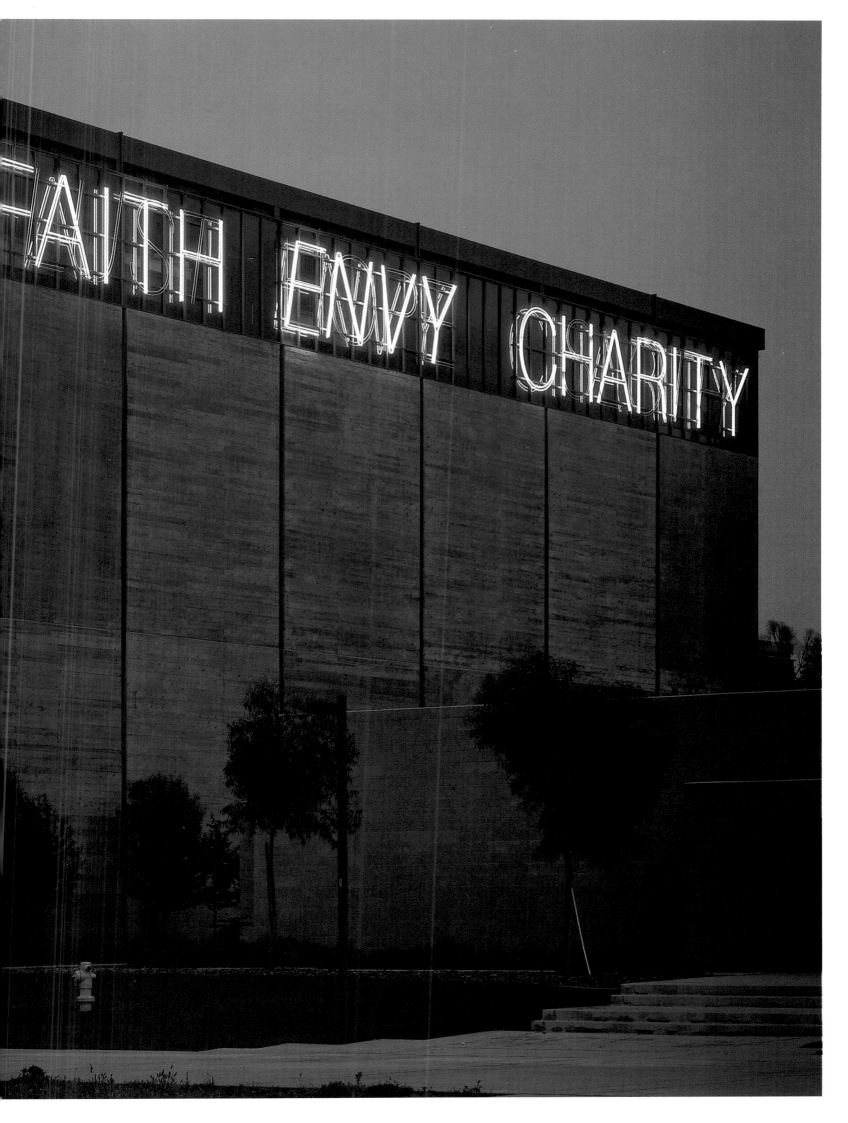

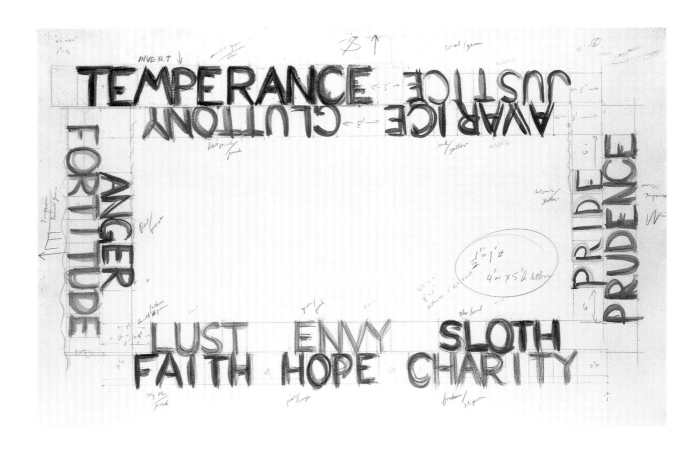

bruce nauman

VICES AND VIRTUES
1988

Bruce Nauman
Proposal drawing for
Vices and Virtues, 1983
Watercolor and pencil on paper
37″x 53″

ART AND IMAGES HAVE LONG BEEN TIED TO LANGUAGE, but more at some moments than others. The use of text in art came into prominence again in the late 1970s and early '80s, and the Advisory Committee definitely wanted this approach represented in the Stuart Collection—which is, after all, based at a university, a place where words and writing are primary concerns. Bruce Nauman was a clear choice and he was able to come to La Jolla for a few days in March of 1983. Mathieu and I had worked on a great corridor project of his in Portland, and I had visited him in Pecos, New Mexico, where he lived quite removed from the art world. My admiration for him and my desire for an important Nauman work in the Stuart Collection filled me with anticipation and a little trepidation. Would he propose for us something obtuse and discomfiting, stark and provocative, hinting of violence or madness? All were quite possible. Then what about my responsibility to the university? What kind of stands would I have to take to defend the art and the artist, while still ending up with something both true to the artist and suitable for a public place? Further, Bruce's work is so diverse in its media that there was absolutely no predicting what physical form he might propose.

We toured different parts of the campus. Bruce had been thinking about the lists of words and names that can be found on the facades and cornices of traditional banks, libraries and other public buildings, and what he might do to conjure a list of moral qualities for a similar situation. He had thought of the seven vices and seven virtues, and the possibility of provoking new ways of thinking about them and about their relationship to each other. While we walked, we tried to remember what the vices and virtues were, but couldn't come up with fourteen certainties. As we approached the southern edge of campus, we neared a low but substantial building, and Bruce asked what it was. I told him it was a new theater, the Mandel Weiss Theatre— a perfect place for the vices and virtues, the very stuff of drama.[1] Bruce immediately suggested

130

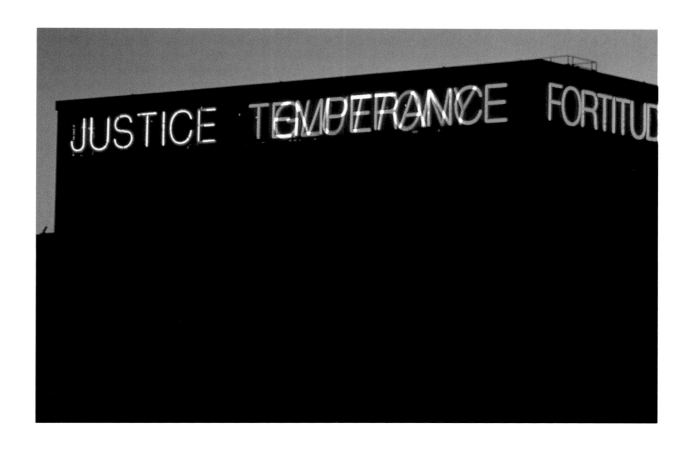

naming these qualities in neon around the top perimeter of the building. It seemed a great idea—a version of a theater marquee.

We examined the building from all sides and went straight back to the office to look up the vices and the virtues. They weren't so easy to unearth. Enlisting the help of a graduate art student, we found ancient and modern variations on a basic group: faith, hope, charity, prudence, justice, temperance, and fortitude on one side of the scales, and lust, envy, sloth, pride, avarice, gluttony, and anger on the other. Bruce imagined these forces of human nature balancing the world, in silently glowing letters. The notion was particularly seductive in that a well-known early neon work of his from 1967 had involved the phrase "The true artist helps the world by revealing mystic truths." The artist simply reveals these truths, he doesn't create them, and indeed the lists of vices and virtues are ages old. Their origins are unclear, but it seems they developed as a religious attempt to categorize and remind humanity of its own weaknesses and strengths. Now they could be revealed in beautiful captured gas—ancient words in a new medium, presented for observation and thought, not preaching.

Bruce says he's uncomfortable thinking without a pencil; he loves the tactile aspects of making art. He went home and put together his proposal, which arrived as a large beautiful drawing in watercolor with pencil. There would be seven sets of words. Each vice would be paired with a virtue, and the two words would be superimposed on each other in five-foot letters, using a double strip of neon tubes in two different colors for each word. The virtues would be in straight, or roman, block letters, and the words would flash on and off in a sequence running clockwise around the building, as if turning with the rotation of the earth. The vices would be written in slanted, italic letters, which would illuminate counter-clockwise, against the norm, at a slightly different rate. The system was devised to display every possible combination of vice

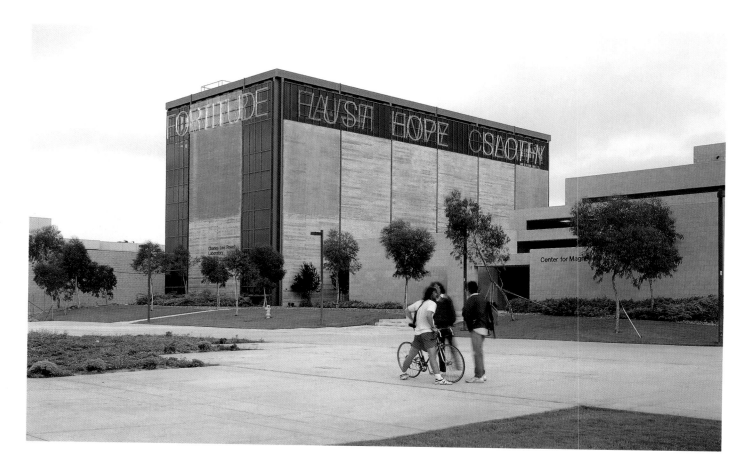

and virtue, and occasionally all fourteen words would light up at the same time. The neon would be controlled with a light-sensitive timer to go on in the mid-afternoon and off at midnight. The virtues had slightly more airtime, a feature I used later when trying to make arguments on the work's behalf.

Recognizing that *Vices and Virtues* could be controversial, I decided to talk it over with the chancellor. He was hesitant at first, but was persuaded to give the go-ahead for a quiet effort to build support in the community. Bruce sent a set of large working drawings in watercolor and collage. The then chair of the Department of Theater Arts and I went to see Mandell Weiss, then over eighty years of age, and a key benefactor of the theater named for him. His support would be crucial; initially quizzical, he soon responded with considerable enthusiasm and humor. Because the building lies in the territory of the Coastal Commission (a state agency overseeing the California coast), an environmental-impact study would be required. We continued low-key efforts to gather support, but were disappointed by a meeting with other key theater people who were concerned about the possibility that controversy over a giant neon work would hinder fund-raising efforts in their fragile second season. We were also surprised by their lack of enthusiasm for *Vices and Virtues*, which they seemed to predict would interfere with their program and confuse their audience, rather than augment their image and clarify their purpose.

We agreed to lay low for a while. There were other concerns: university officials had been working on a potentially controversial project to develop property adjacent to the campus for condominiums and a conference center. They were at the peak of their efforts to win city council approval, and asked me to avoid discussing the Nauman proposal publicly until approval had been received.

We tried to proceed with the Environmental Impact Report (EIR), even though there was apparently no precedent for a report about the impact of neon artworks. In a fit of hope,

Mathieu and I went to Las Vegas to conduct neon research. We set up appointments with several companies and also looked up the artist Robert Irwin, who lived in Las Vegas then. He spent an evening teaching us how to improve our casino skills. Over the weekend that we were gone, a *Los Angeles Times* reporter (for the San Diego edition) heard about the Nauman proposal and published an inflammatory article. A colorful debate ensued. I was told by a reporter that a La Jolla representative to the San Diego City Council called a press conference at the site to announce that if "the university was allowed to put LUST up there in neon, it would incite infidelity in the community." When this reporter asked for my response, I was perplexed, and answered with a question: "Why, when there were fourteen to choose from, did he pick lust?" A professor suggested that since the work would be visible from a number of spots in La Jolla, someone would have to be posted near it at all times to explain to La Jollans which of the words were indeed vices and which were virtues, and the difference between them.

Over a year had passed, so, to spur things on, I requested an administrative review. In preparation for its possible result, Bruce returned to the campus to consider other buildings as possibilities. We decided to take the position that there were no viable alternative sites—that the theater was physically and conceptually so well adapted to the project that it would be wrong to compromise, especially without the EIR. Should a negative decision come down from the administration, Bruce would deliver an altogether new proposal.

An amiable and wise senior UCSD planner with community experience, Pat Collum (now Aguilar), was designated to help me present the project. Together we set up a virtual tornado of public appearances and strategic meetings with various campus and community groups. We tried to use the opportunity not only to present the Nauman piece but to educate a lot of people about the goals and value of the Stuart Collection. We made some progress, but the main opposition came from the university's immediate neighborhood, where the neon would be quite visible at night. A petition against the project was forwarded to the chancellor. The local paper published a favorable editorial, but it didn't seem to change the minds of opponents.

In early 1985 we sent out a request for bids on the EIR: cost estimates came in high. We agreed not to proceed during the La Jolla Playhouse season, then not to proceed until after the launch of UCSD's twenty-fifth-anniversary fund-raising drive. In December the university asked for an indefinite postponement in consideration of higher priorities. This we found unacceptable, so Mathieu and I launched a search for a new building. The Powell Structures Laboratory was under construction at the time, a space where research into earthquake-resistant building and retrofitting was to be carried out. Here, in one of only two such buildings in the world, engineers would build sections of bridges, columns, and the like; the structures would then be stressed, repaired, and stressed again to test their durability. The building was to be larger than the Weiss Theatre, the configuration seemed suitable—plus the location would

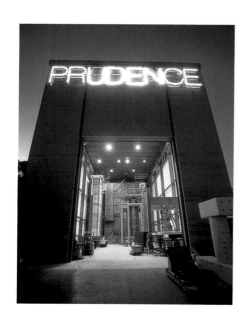

Inside the Powell Structures
Laboratory, UCSD

not require an EIR. The truly significant fact, however, was that Lea Rudee, then dean of
engineering and also a photographer and adventuresome supporter of the arts, came to us to
suggest the possibility of using this building. He proclaimed genuine enthusiasm, arguing that
the vices and virtues were just as important and as pervasive as engineering. This was unbeliev-
ably helpful.

The Advisory Committee agreed to give the go-ahead to the new site, assuming Nauman
approved it. Bruce returned to the campus and found the building not only acceptable but bet-
ter on several counts: it is higher than the Weiss Theatre, going up six stories; it has a rectangu-
lar footprint; the interiors are clear and open, and clerestory windows run all the way around
the top ten feet. These windows would allow the viewer to see that the work continued around
the entire perimeter, like a frieze, and would reveal the three-dimensionality of the building.
Also, because the windows are ten feet high, the letters would need to be larger to fill this
frame—seven feet high, rather than the five-foot letters that would have gone on the theater.
Finally, although the connection between a theater and a neon list of vices and virtues was obvi-
ous and strong, putting such a list on a building like this one, though perhaps more risky, also
opened up the work to more ways of thinking, making it richer and more mysterious. Bruce
seemed pleased and so were we.

We conducted tests to find out whether neon would emit radio waves that would interfere
with sensitive equipment in the area. No negative results. Approvals went through on all levels.
Bruce and the Stuart Foundation signed a contract without fuss, but the contract that finally
went out to California Neon in San Diego took another year to work out, and ended up over
sixty pages long. A separate contract was signed with San Diego Stage and Lighting for the
microprocessor controls that would flash the neon on and off. Bruce came back in the summer
of 1987 to approve four test letters: TO/RA. There were delays: California Neon had other,
bigger jobs to build, with more serious deadlines.

Finally *Vices and Virtues* was turned on, in September of 1988, but Bruce was not to see it
until October, when he came for the opening. I was anxious that he be pleased, and nervous as
we killed time until it was dark enough to see the colorful words flashing into the atmosphere.
During the day, before the light comes on and color is visible in the letters, the barely legible
words seem like a rather cryptic drawing. As night falls they get stronger and stronger, and truly
spectacular. As we approached, Bruce, as always, was cool and matter-of-fact, but he put his
arm around my shoulders and said, "What a weird idea. How'd we get away with this, Mary?"

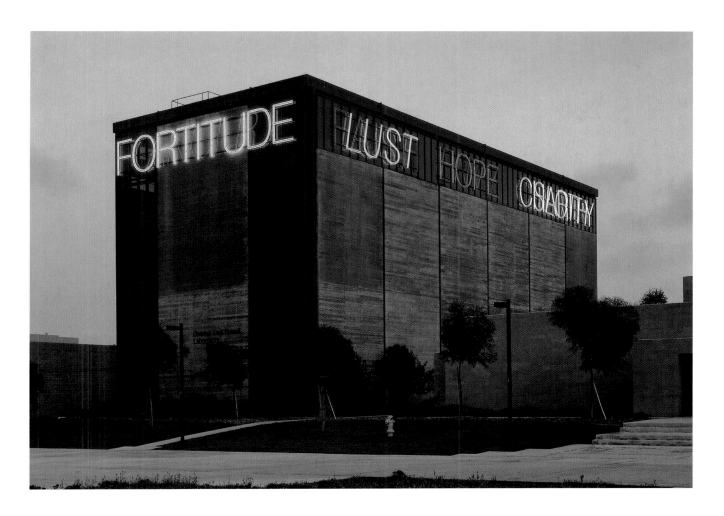

I knew he was happy, and so was I.

The project had turned into a win-win situation. The building is deeper into the campus than the theater, so the upset neighbors were mollified—the university community would be more exposed to the words than they would. The view of *Vices and Virtues* from the village of La Jolla was lost, but it can be seen from some points off campus. "ANGER" and "FORTITUDE" shine toward Scripps Memorial Hospital, as though, if the one got you in, the other would get you out. It also might remind us that anger can help with a certain kind of fortitude–if you're angry you can sometimes be braver—but they are separate and very different. "GLUTTONY" and "TEMPERANCE" can be barely discerned from a nearby shopping center. But to view the work you really have to walk around the entire building. There is no beginning and no end. There are reflections in other buildings' windows. The work expands into a lot of space without taking up physical territory.

Now more buildings are filling in the area, but every night the vices and virtues come on in all their permutations. There is a tension between the beautiful colors, and an impossible game in trying to make up stories from the insistently recombinant words: narratives begin to suggest themselves, but before you can connect them into coherence, new words have flashed. You can't get a grip, the work refuses to be logical, it's frustrating. Like life—you can't quite keep up, everything constantly changes, nothing is absolute, but it's hypnotic and beautiful—you don't want it to end.

—*MLB*

1. The theater is shared by the UCSD Theatre Department and the La Jolla Playhouse, a professional regional theater company.

interview

bruce nauman

JOAN SIMON: *Your project was first proposed to the Stuart Collection in 1983 and was completed in 1988. What happened in-between?*

BRUCE NAUMAN: It took a long time, but dealing with Mary and her staff was very good. The whole thing was well thought out; they made it easy for the artist to work. Dealing with institutions isn't always that straightforward. In my experience these things do take years. That was a long time, but I think it's probably not unusual.

The original proposal was to install the piece on the theater building, and we ran into some problems with that. I think most people thought it was okay, but some people connected with the theater didn't like the idea.

JS: *Do you know the reason?*

BN: No. Just didn't want it on the building. Then the back of the theater faces off-campus, and people who could see the back of the theater objected to the neon. We did all kinds of stuff—it would be turned off at 10 o'clock or 11, stuff like that—but it didn't fly.

Then a guy who was in charge of the building it's on now, this earthquake testing lab, basically volunteered the building. It was a new building at the time, they were just finishing it. He said, "Why don't you put it on my building, I'd like it." So at that point, given that this thing had been going on for a couple years by then, on and off, we figured that was going to be the best way to do it. That's how the piece got over there. My idea was that it would go around the top of the theater building; it made sense there. It doesn't have a reason to be on the lab building.

JS: *The reason for it being on the theater?*

BN: It was about human attributes that actors would have to deal with. It had a kind of theatrical function. But it didn't have a reason to be on the lab building, other than the fact that it was the only building where anybody wanted it and it could fit. There were a lot of politics that went on, and the thing about Mary was—at a certain point, in my experience with anybody else they would have given up. But she just kept going. Once she wants to do something it's hard to stop her.

JS: *Once the decision was made, how far along was the lab? Was it being built? Already built?*

BN: I think it was just barely finished when I first saw it.

JS: *This was the second big neon piece you'd put on the outside of a building, and like the first one,* Violins Violence Silence (Exterior Version) *[1981–82] in Baltimore, it was initially conceived for a different site—but this piece is different, in that while the Baltimore piece is mounted on two solid exterior walls, this one is mounted so that it can be seen from all four sides, and from inside as well as outside the building.*

BN: Right. All around the top the building is basically a big glass box. What they do in

there is build structures and then stress them until they break, to figure out what it is that broke and how to build stronger, more earthquake-proof structures. It has to be a pretty big building so they can build sections of buildings inside it.

JS: The letters are seven feet high and six stories up.

BN: You can see them from the inside because of the glass, but you can also see them from the outside. You can see all the way through the building, so you can see the front side and the back side of the letters.

JS: You can see the words on opposite sides of the building at the same time. You've used the vices and virtues in a number of projects—was this the first?

BN: It was, in fact. We got a graduate student to do research, because when I started thinking about the seven vices and the seven virtues, I thought, it's got to be written down somewhere exactly what they are, probably in the Bible. But it's not, at least not in that form. There are places where you can find a list of vices and virtues, but they're not even called that. They're all kind of different. The earliest written stuff is probably Jewish, at least the ones we could find. So there are lists like that, but they don't necessarily follow the ones that we think of.

JS: How did you finally pick the ones for your project?

BN: Well, we kind of did what seemed to be the more modern amalgamation. Maybe Mary still has some files that show how we finally got a list.

The other thing we tried to find—because I thought, well, green is envy, everybody knows that one—was that maybe someplace, maybe during the Middle Ages, there would have been some kind of codification of the colors with the various vices and virtues. There didn't seem to be any list of those things either, except for a couple; I thought that's got to be there, that sort of medieval iconography, but it's not. I used associations where I could find them, but otherwise they're kind of arbitrary.

JS: Did you do the initial search for these words because you were looking for a text specifically for the theater building? Or did you have them in mind completely separate from that building, and before it became a potential site.

BN: No, I had the idea of doing some sort of frieze on a building. I looked at the library because it's not uncommon to have authors' names there. And on theaters you'd have playwrights' names. I thought it would be interesting to use these descriptions of human traits, rather than authors.

JS: The vices move in a counter clockwise direction around the building and the virtues—

BN: —go clockwise—

JS: —and they go slower.

BN: Yeah, they have a different rate, so that the combinations differ. Random pairs appear. And at some point they all go on together.

JS: I don't remember this kind of ribboning before—your neons have advanced with the technology of the industry. The '60s and early-'70s works have comparatively simple on-off configurations. Then when you returned to the medium after the Baltimore Museum survey of the neon works in '82, the switching systems became mechanically quite complex, and by the end of the '80s you were using a computer system.

BN: Yeah. Boy.

Bruce Nauman
Violins Violence Silence, 1982
Neon tubing with clear glass tubing
suspension frame
Collection The Baltimore Museum of Art

JS: What kind of system now runs the synchronization, the pattern, the dance of these letters?

BN: It's fairly simple; it's electronic switches. Neon really went out of style for a long time. When I first started to do it again, all that was really available was mechanical switches, which would always go out of sync and wear out, break, and stuff like that. Then when neon began to get popular again, all that electronic stuff was available. It was so much simpler. You could do very complicated stuff and basically just program it with the chip in there. It didn't get out of sync, it kept time, and you could do all that. It made it a lot simpler, a lot more precise. I was able to use all this stuff without sitting around with a screwdriver adjusting everything all the time.

JS: The Stuart Collection Vices and Virtues *has the computerized electronics?*

BN: Yeah.

JS: Even before the Baltimore neon piece came a proposal to mount a neon sign around a building for your first retrospective, in '72, at the L.A. County Museum of Art. Both the Baltimore project and the L.A. project were rejected along the way.

BN: Which one was the one in L.A.?

JS: La Brea/Art Tips/Rat Spit/Tar Pits. *The proposal was for a sign that could be seen from the nearby La Brea tar pits. The wordplay uses the name of that site for an anagrammatic art-world commentary, and the words themselves were supposed to encircle the L.A. County Museum building.*

BN: And I did a proposal for, which school was it? It was for a new music building, a concert hall.

JS: That concert hall was supposed to be for Long Beach State College, and got canceled after it had been fairly—

BN: We got pretty far along with that before they decided they didn't want to do it. The entrance lobby had glass on the exterior, big glass windows. That proposal [*Violins Violence Silence*] was to hang in the window, and you would be able to see it from the inside and the outside. It did get built that way.

JS: Only later, at the time of the Baltimore survey of neons. In a way, the relationship of the words to the concert hall in that work, and then the change to the art museum, is something like the relationship of the words to the theater at UCSD, and then the switch to a different building where the words had no context. When you installed the piece in Baltimore, the triangular format had changed, and you put it up—

BN: —on a horizontal.

JS: And on two walls. Rather than making the words encircle the building, you superimposed them,

as well as executing one set backward (in mirror writing, to be clearer), and the other set "normally"— written forward.

BN: Yeah, reversed. Because the initial conception was that it would be hanging in a window, so you'd see it from both sides and have that confusion of forward and backward.

JS: You gave the Stuart Collection a set of drawings to consider as your proposal. Do you remember those, or what you were trying to indicate in them?

BN: They were scale drawings of the words. In one or two drawings I drew the building and how the words would be placed, on which sides of the building. It was like a plan view of the building and then the words were drawn on each side, or next to each side.

JS: Subsequently you've done variations of Vices and Virtues—*in stone, in drawings; in English and also in German.*

BN: There was a small-scale neon [*Seven Vices and Seven Virtues*, 1983]. I think the letters were a foot or ten inches high. That was meant to go around the inside of a room, installed up high, near the ceiling. Then there was a stone version. Then there was a German stone version. Then the full-scale drawings of that.

JS: In the past two years you have again been working almost exclusively on public, outdoor, commissioned works. These public pieces seem to have a pattern of being rejected before being built—how have the recent ones gone?

BN: Well, the one at Bellingham actually went quite well. But that one was [originally] for the University of New Mexico in Albuquerque, and got rejected [*Stadium*, 1983]. It sort of sat around in various guises for a long time and got rethought.

JS: The other public piece you've recently completed is a staircase, but I think it was developed specifically for its site.

BN: The one at Steve and Nancy Oliver's. That's pretty different, dealing with an individual or a couple like that. You don't have anyone else to deal with; once you agree to go ahead, it just goes.

JS: You worked in neon and video in the late '60s and early '70s, and after about a ten-year hiatus returned to both. You returned to video again in the '90s, but not neon. Are you thinking about any neon works right now?

BN: No. The last one that almost came up was the piece I did, *Partial Truth*, when Konrad [Fischer] was dying. It was the year that Susan [Rothenberg] and I had sublet a loft in New York. Konrad had heard about that. He called and said, "Bruce, I hear you're moving to New York." I said, "No, well maybe partly. This is partly true." And he said, "This is a piece. We'll make this piece." So I didn't really think about it very much, but I did make a drawing. By the time I'd made a drawing, he'd already made plans to have it made in neon. Then he died before anything got done. I didn't really want to do it in neon; it seemed appropriate to do it in stone. That was the last tiny thing that almost got done in neon.

JS: Are there other public projects you're thinking about at the moment?

BN: No.

JS: What are you doing?

BN: I've been videotaping various locations in the studio with infrared light and tracking

the mice and the cat. I've got about forty hours of tape of them now. My working title is *Fat Chance, John Cage.*

JS: I remember where that came from [laughter]—the invitation to participate in a memorial exhibition for John Cage, and your faxed response, which was your participation.[1]

BN: It's interesting, the mice and the cat. So far I've never gotten a picture of the cat catching a mouse. I have had a picture of the cat in the frame at the same time as there was a mouse in the frame, but they saw each other at the same time and the mouse got away. So, we'll see.

JS: What are you going to do with it?

BN: I don't know. My intention right now would be to get about six hours in six locations and then it would be a continuous, life-size or larger-than-life-size projection of each location for six hours. I guess you could sit there for six hours and watch the cat and the mice come and go, or hear the dogs barking outside and the coyotes once in a while. Or you could come and go, whatever.

JS: What does the infrared light make it look like?

BN: Sort of a gray-green color. Not very green, but greenish. Which I might start altering, I don't know. It's kind of a restful color. The other thing it does, the way this camera works, in order to get enough light to have some brightness and clearness to the picture, it's almost like a stop action. What it does is it stacks up six, seven images, and then you view it. So you get this strange kind of stop-action deal.

JS: What's the camera?

BN: It's a little digital camera you can buy that's built to pick up infrared.

JS: What would it usually be used for?

BN: I don't know why they put that on there.

JS: Why would somebody be taking infrared pictures if they weren't looking for mice and cats at night?

BN: I don't know. It lets you take pictures in what they call the dark. You don't need any other light. It's got a little infrared light on it, you can't see it, so you can shoot in the dark.

JS: Actually it reminds me of the flashing neons in the dark—the words catching up with each other in Vices and Virtues—*and also of your early photos in the dark, where you twirled a flashlight and captured the image. You called them light traps.*

BN: Yeah.

JS: The cat-and-mouse game sounds great.

BN: It's very amusing, kind of pretty. Every night I shoot an hour and then I view it. I've been taking notes, writing down the times when the mouse appears and disappears. Sometimes there are only two or three events an hour, sometimes there are flurries of activity where there's a mouse in and out of the picture every minute for half an hour. I've got a logbook with all this stuff.

1. Bruce Nauman's response to an invitation to participate in a memorial John Cage exhibition at the Anthony d'Offay Gallery, London, in 1992, was a witty fax that, honoring the master of chance operations, said: "Fat Chance." This typical Nauman wordplay was his contribution to the show, and was not—as one might interpret it if taking the words at face value—a refusal to participate.

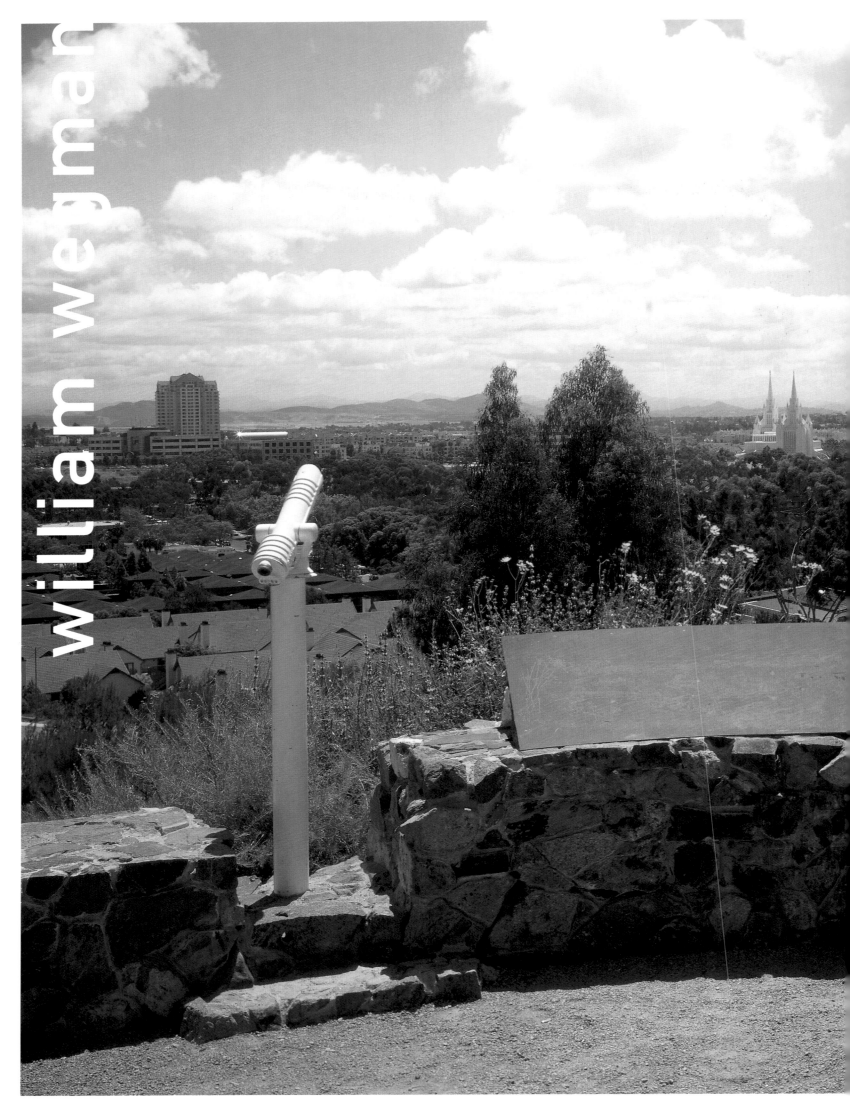

william wegman

william wegman

LA JOLLA
VISTA VIEW
1988

WILLIAM WEGMAN IS WIDELY KNOWN FOR THE WITTY photographs and videos he has made of his compliant and handsome Weimaraner dogs—Man Ray, Fay, Battina, Chundo, and Chippy. For many years and to growing popular acclaim, Bill has dressed these dogs in costumes and photographed them in highly amusing situations, sometimes using the resulting images in sequences that illustrate fairy stories, in "lessons" for public television's *Sesame Street*, and more recently in mass media corporate advertisements. He also produces drawings, packed with visual and verbal puns and double meanings, casual and playful in appearance. Bill is a painter as well as a photographer, and when we ran into each other at a Los Angeles party in 1985, he announced that he'd been thinking about sculpture too. It turned out he was joking, but the Advisory Committee knew that his thinking about art went far beyond photography.

Bill came to La Jolla from his New York home in the summer of 1985. Walking around the campus, he was virtually bubbling with ideas. A memorable one was an embellishment for the rather bland concrete fountain in Revelle Plaza—a circular pond set within the square frame made by a low, sitting-height wall, with spigots around the perimeter gushing water into the center. Bill thought we should replace each spigot with a new one in the shape of a little fireman using a hose to spray a tiny burning house in the fountain's middle. Such droll but captivating additions were amusing to think about but with so much more to explore we kept on walking, eventually reaching the very southern edge of the campus.

There we came upon a small bluff above La Jolla Village Drive, behind the Mandell Weiss Theatre—a place of palm trees, a huge and beautiful old Torrey pine tree, and chaparral. A few metal chairs stood around, apparently hauled out for the occasional lunch crowd, dramatic brainstorming, or a simple tête-à-tête. We sat, and immediately became absorbed in the scenario stretching out to the east and south—a view of highways, condos, and shopping centers,

William Wegman
Study for *La Jolla Vista View*, 1986
Color photo-collage with notations
11" x 45"

including La Jolla Village Square and University Towne Centre. This was the "Golden Triangle," a rapidly expanding region of sprawling suburban development immediately adjacent to the university campus. As we watched, we became fascinated by the little narratives that arose: a flat tire, a fender-bender, a man walking his dog across a footbridge, a window cleaner at work. The whole scene felt like a photo opportunity, a grand vista just waiting for someone to walk up and take a picture but also with many smaller events taking place within it. The content of the picture was banal, the picturesque ocean was behind us and out of view, but the idea of a historic landmark, or the type of scenic overlook you see by the side of a highway, started to emerge, sharpened by Bill's heightened sense of catching the photographic moment.

As we talked, the idea developed: a semicircular stone wall would support a bas-relief loosely mapping and identifying the area and the mountains beyond. Seating would be necessary. Binoculars would be mounted for close viewing of points in the landscape. Later, with Mathieu, we talked about making a road with a pull-over for parking spots. We wondered about San Diego history—whether local historical references or characters might be introduced. A drinking fountain, a table and benches, and a bike rack all seemed possibilities and eventually found their way into the final project.

Bill did a dozen or so loose watercolors in his witty cartoonlike style. These formed the proposal that went to the Advisory Committee, and was approved. In order to get things rolling we sent extensive photographs of the site to Bill in New York; he returned to study the place, visit local parks and overlooks, and think. We began to discuss the plaque and what it should look like. Since a bas-relief was one of the considerations, we investigated bronze, but decided that a relief in this material would be difficult to construct and harder to "read." On a visit to a volcano park in Hawaii, however, he saw a drawing etched into a bronze explanatory plaque.

This seemed the ideal solution, and we went with a plan for a large drawing to be etched into a bronze plate.

Mathieu and I met with staff and faculty of the UCSD Theatre Department and the La Jolla Playhouse (a professional regional theater company in residence at UCSD) to go over their plans for the area. We talked about pathways, places to sit, and general usage—the creation of a place. Their enthusiasm helped work our project smoothly into their plans. We agreed upon the exact and fairly extensive site.

In the spring of 1986 Bill returned a number of times to work on the drawing for the "map," which was to be quite large—three feet by twelve. He included supposed points of interest discernible from the overlook, and wrote in wry comments: "coming attraction," "lost development," "obvious development," "now leashing" (one of several sly references to his dogs), "student testing site," "food smells." He would eventually work in our shed, using photographs and a grid system, but at first he sat out on the side of the hill in the intense sun and drew on-site. I regularly wandered out there, and would always be welcomed with enthusiasm and sometimes with a slightly panicked plea for advice that I felt completely inadequate to give. Bill has an infectious spirit of fun, and he made this project a sometimes hilarious adventure into new territory.

The proposal had been loose; the work got real by looking at nearby parks and scenic overlooks. The materials selected were native plants and rocks. Visiting the Cabrillo National Monument, Bill decided he wanted to use the local stone that appeared in the WPA-era walls there. The use of native materials was deliberate, the opposite of the choices made in the fast-track development below the site, where chaparral was being replaced by roads, parking lots, office complexes, shopping malls, condos, and lawns—in fact by the scene depicted in the drawing. Bill later remembered getting somewhat "preservational" about his project.

Because Bill made his drawing from the hillside before we bulldozed a promontory with a flat area for the site, he looked out from a point slightly lower than the final outlook itself. It turned out that the center of his drawing was not weighted to the center of the view. This seemed to skew things uncomfortably. What could be done to avoid redoing the whole drawing, which had taken many trips and many days to make? Bill had to get back to New York, so we made a plan to build a plywood mock-up of potential elements for the entire piece. We would then be able to use them in order to determine the exact placement, contours, and layout. When he returned we moved these plywood shapes around on the site, testing many potential arrangements. He discovered that if the binoculars were moved off-center and the right side of the site

View through telescope on site of
Wegman's *La Jolla Vista View*

was weighted with more stone benches, the slight dislocation of the drawing became less dis-
turbing and probably quite acceptable. People might not even notice it.

Once the overall structure had been resolved, execution of the plaque went forward. The
plate was etched at Anadite, a company in Orange County; at the time, it was the largest in the
company's experience. The pedestal was built with local stone. Then several more benches
and steps were built as Bill altered and extended his plan. The new hillside was planted with a
few more Torrey pines and hydroseeded with native plants. Mathieu built a wooden table with
benches to go under the largest palm. A modest drinking fountain similar to one in a local
coastal preserve, Torrey Pines State Reserve Park, went in. The binoculars were placed, the
landscaping was finished, and the etched bronze plaque was installed.

It was time for a title. We brainstormed, then went out to the site late one afternoon to
choose the phrase that felt best. Going down the list, we came to *La Jolla Vista View*, and just at
that moment a great horned owl flew out of the high palm and crossed right in front of us to
some eucalyptus down the hill. We took this as a signal that we had found the right name, so *La
Jolla Vista View* became a play on words to go with the play on site. Given Bill's photographs, in
which man's best friends become surrogate players in the human comedy, the only thing still
missing was a dog. So Bill made a delightful drawing of one, looking out, as if over a landscape,
at an owl swooping by. This became a smaller bronze plaque set on a bench to commemorate
our experience.

Bill had never been associated with site-specific work. He told me that he had done some in
graduate school, but then went as far away from it as possible, because he "couldn't get anyone

View from Wegman's
La Jolla Vista View in 1987

View from Wegman's
La Jolla Vista View in 2000

William Wegman
Revolutionary Skating, 1987
Oil and acrylic on canvas
30" x 84"
Private collection

to specifically go" to his sites. Instead he made photographs, which simply take their site with them wherever they go. This project, however, turned out to be totally site generated and site connected. It is entirely about where you are standing on the UCSD campus and what you are seeing from it, and could not be moved to any other place.

Rather ironically, *La Jolla Vista View* is almost impossible to photograph. It can't be easily understood or appreciated from photographs; even when you are there, in fact, you have to enter the world of the drawing in the bronze plaque. It is important that visitors naturally and easily walk into the work and feel the connection between the plaque and the scene it describes. We encouraged this by setting up the elements of the place so that one is inclined to walk first to the left side of the plaque, then across to the right as one reads.

While working on *La Jolla Vista View*, Bill began making large panoramic paintings. Perhaps his experience at UCSD had a reciprocal function as a laboratory for extending ideas and generating new ones—past into site, site into future.

In 1995, the dance program received the go-ahead to erect a dance building in the UCSD "theater district" on campus near the scenic overlook. This would become a striking Antoine Predock building nestled into the eucalyptus grove immediately adjacent to the Wegman site. The construction created something of a mess at the site for a while, but we worked with land-scape architects, and on the completion of the new building, in 1997, the approach and access to Bill's piece were improved. In the next few years, new theaters and offices are planned for the area, so we expect the feeling to change a bit but the usage to increase greatly. Below the out-look the land has already been sufficiently developed so that it will change far less dramatically in the future, but the bronze will always record a moment in time—how it all looked in 1986.

La Jolla Vista View uses a device usually involved in celebrating America's grandeur to poke fun at its pretense. Many of the sites marked on Bill's bronze map are temporary—buildings being constructed, birds in flight, a group of people walking their dogs. The inclusion of these immediately superseded points of interest asks viewers to contemplate the rapidity of change in American life, and the resulting, and constant, revision of history. The new buildings that have gone up since the drawing was done become markers of time as well as of place. Defamiliarizing the ordinary world by transforming it into a scenic overlook, Bill encourages visitors to view their surroundings with fresh and newly critical eyes.

—*MLB*

Detail from etched-bronze plaque

interview

william wegman

JOAN SIMON: You're probably the most unlikely person chosen to make a commissioned sculpture for the Stuart Collection.

WILLIAM WEGMAN: Yeah, but not really. I do a lot of different things. I ran into Mary Beebe at an opening at MoCA in L.A., and she asked me if I had ever thought of doing a sculpture. I said "Yes!" But I'm not sure how true this was. I might have twenty years before; back in the late '6os, before the photo pieces, I was a sculptor. Everyone was a sculptor then, even painters. So it didn't seem unlikely to me.

JS: Did Mary know your early work?

WW: I don't know. Maybe. I was in one international exhibition in 1969 called "When Attitudes Become Form." I was doing minimal floor pieces with screen, a little like Keith Sonnier or Alan Saret. A little like everyone else.

JS: How did the idea for UCSD take shape?

WW: I visited Mary at the campus. We wandered around the possible sites and I got a couple of different ideas. One was for a fountain in the center of the campus—a circle of fireman figures holding water hoses spraying into the middle of a pool. Other ideas came and went. We walked and talked some more. Every day we ended up at this particular site at the edge of the campus overlooking the freeway and sprawling development—condo, mall, and on and on. It was a natural place to stop and look. After a few visits I got the idea for the scenic overlook, like one of those "photo-opportunity" sites. Really the place gave me the idea.

JS: Had you visited many of those places, as a kid or as an adult?

WW: You can't avoid them. Everything leads you there on trips. The funny thing is I really thought I knew what it would look like but when I started to work it out I realized I hadn't a clue. I had to do some research.

JS: Your research?

WW: I went to Hawaii [laughs]. I went to a national park at an active volcanic area. There were information plaques, etchings on bronze plates. I got the idea to do a line drawing. I was going to do a relief model of the area, but I realized that would be my life's work. I figured I could make a big panoramic drawing of the view.

JS: The first stage was the drawing.

WW: I did more research before I started the drawing. I met Mathieu Gregoire, a sculptor who was assigned to work with me on the project, and we talked about it as we drove around and explored the interior of the view. I made notes. Mathieu, Mary, and I also examined other park sites around San Diego to get ideas about the installation. Then I photographed the vista from the site and pieced it together into the panorama. Mathieu helped me set up a drawing

William Wegman
Study for *La Jolla Vista View*, 1986
Pencil and watercolor on paper
14" x 17"

Details from etched-bronze plaque

studio in a shed on campus, and I started the drawing—ink on a big piece of acetate. I actually made two drawings but I abandoned one. I drew from the photos for a few days and went back to New York. I came back a month later and the view from the site had changed a lot. I took new photos to keep up with it. I spent a lot of time at the site just looking at the view. I came back from New York several times. A Michael Graves project sprouted up during the drawing, and a lot of other construction too. Mounds of dirt would be there and then not.

JS: What was the Graves project?

WW: I don't know, a hotel and restaurant complex. It's in the upper-left-hand area of the drawing. Once in a while you could see a range of mountains in the distance. With a map you could see what various peaks were called.

JS: And so you wrote the names on these things, such as the mountains—Fortuna Mt., McGinty Mt., Cowles Mt., Mt. Helix. In addition to the mapping, you made a number of other notations—the words "birds" and "planes" near their renderings; in other places the notes "rare birds," "rare planes." You noted the less remarkable as well as the remarkable.

WW: An insubordinate reaction to the tedium of drawing all those condos.

JS: I saw "mystery dirt," the note "food smells," "Tijuana—watch your step." And a store with the sign "Now Leashing," as well as the "Tree of Lost Dream Lost Dog."

WW: I had fun sneaking those things in. Even though the view was not scenic in a conventional sense, it was fun to look at. There's a lot of things for your eye in this site.

JS: You worked from photographs as well as direct observation.

WW: Which were way too contrasty and hard to really see, so I'd have to be there too.

JS: When you were there, were you looking at the vista with your naked eye, or through the lens of your camera, or through one of those pivoting telescope machines you often find at such sites—drop in a quarter and the view opens up. I'm not sure what those machines are called.

WW: They're called pivoting telescope machines. We installed the telescope last.

JS: Have you looked at many nineteenth-century panoramic photos?

WW: I liked them, yeah, but I didn't look at a lot—no more than, say, another above-average person like myself [laughs].

JS: Steffan Schmidt wrote in an exhibition catalogue that "along with video and photography, Wegman has always worked with drawings, constructed along a conceptual pattern of"—quoting you—"always one idea per page.[1]" Your proposal to the Stuart Collection included eight drawings, and I'm wondering how you meant these to be used, as they introduce several characters and references to the site.

WW: Drawing is what I'm most comfortable doing. I'm much happier with a pen or a pencil in my hand than with a camera. Drawing for me is like writing, and writing is like thinking. I don't consider drawings studies, however. They're more like a warm-up to the main attraction.

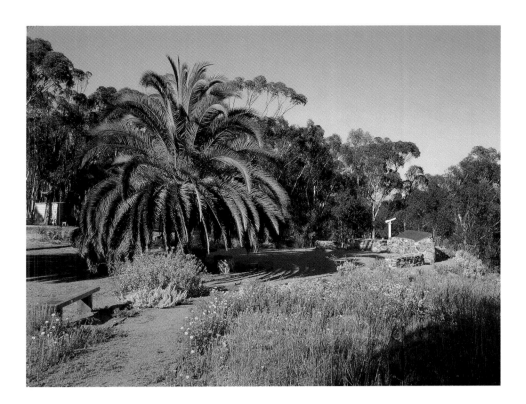

JS: There's the note "Mary Mariott stayed in Mariott Hotel in 46," for example, and a fellow named McGinty: "McGinty, b. 1792 d.—climbed McGinty Mt in 1831." Did you make up these characters?

WW: I felt like a tourist in La Jolla, and I became fond of all these new place-names that were floating in my head. They had the effect of literally adding character to the work. The site became kind of a stage for these events and characters that were new to me. It made it come more alive.

JS: The project went on for about three years.

WW: It got to be my regular job. Sort of fun.

JS: In your early videos you were pointing things out, giving demonstrations of or taking a head-on look at what was right in front of you. Showing how to make things, not exactly as a parody but in a way dead earnest, deadpan, as Bruce Nauman also had in his '60s films and photos. La Jolla Vista View continues to follow this conceptually pragmatic, seriously comic vein. A parody without being a parody.

WW: When you become really involved in something, then it becomes the real thing. The parody aspect was the point of departure, but it really dropped back.

JS: Is your Field Guide to North America—*a book of yours from 1993 that collages various collected materials, as well as observations and commentaries on the American landscape—related to* La Jolla Vista View? *And what about the landscape paintings you've long done?*

WW: The *Field Guide* is a book project that Robert Shapazian at Lapis Press inspired me to pursue. I was really fascinated by nineteenth-century nature writing—all those grandiose allegories about the eternal. Also the aspect of gender in botanical writings strikes me as perplexing and amusing as it gets tangled with feminist issues. There's something about outdated information that I find can be useful in my work. In that sense the playful misinformation that I smuggled into *La Jolla Vista View* relates to the *Field Guide*, and probably influenced it. And certainly my paintings of the mid-to-late '80s got a boost from the La Jolla piece, in the scale of it. My paintings became larger and more densely populated.

JS: You said when we began talking that this project became something different from what you first thought it would be. Are there things you would now see differently?

WW: I don't know—I imagined it being better than it turned out. But I don't really know what I mean . . . just . . . well, just the materialness of it all. The stone and the composition of the walkways was problematic; the stone wall that supports it looks a little stodgy. I haven't seen it for a while, maybe it will improve with age. The landscaping came out well; Mathieu and Mary and [artist and San Diego resident] Kim MacConnel were all a big part of it. Kim was a huge help with the planting, he knew what type of plants were indigenous to the area and we spent a lot of time together at the site. I'm at a loss in that field. He was my guide. Mathieu was indispensable in the building of the site and the etching of the drawing. He did a lot of invaluable research. He really got it together. And Mary. There is certainly something about Mary—she's a great instigator. I believe she provoked the humor that crept into the work.

I like that the piece is kind of quiet. It doesn't confront you like so much art in the environment does. I'm pretty happy with the drawing and the way it translated to the bronze. I wonder if it's still legible now, or still serves as a point of comparison.

JS: Yes, it's legible, and serves as a point of comparison—maybe even more so today, a dozen years later, when so much more of the vista has changed.

The whole idea of the self-conscious amateur is not foreign to your nonphotographic work; it's the distinctive voice and style of your drawing and painting. Do you think that sense of putting the lookout together yourself, with your colleagues, has contributed to the fact that it feels like a site indigenous to the place—as if it had been used as a lookout for years without being officially marked as such? Perhaps others too have become prominent or "official" because they were used, rather than because they were built anew.

WW: Well, probably if we had had a real company do it, it would have had more of the look of a real kind of a place, which I really don't like. I hate the Park Service stuff—all those conventional signs.

Did you like the piece?

JS: Yes, I did.

WW: What do you think would have made it better?

William Wegman
Study for *La Jolla Vista View*, 1986
Pencil and watercolor on paper
14″ x 17″

JS: Nothing. I just wanted to stay there.

WW: It seemed like a spot that was already chosen.

JS: I also found your asides of names and places mixed into the drawing on the plaque very funny, and telling. The invented ones and the real ones.

WW: I think we could have done a little more with the side plaques.

JS: I only saw one.

WW: There was an owl that came to visit us, so we made it our mascot.

JS: Actually that plaque seems to be the marker, the bronze that names the piece—

WW: Yeah, *La Jolla Vista View—*

JS:—but the figure that's looking up toward the swooping owl is neither you nor Mary. It's a dog.

WW: I didn't have a dog at the time. Ray had been gone five years and Fay came to me a year later. I must have had a yearning.

JS: I see. Your choice of this spot for the project, while obvious in some ways, is also a bit contrarian. It doesn't help visitors to orient themselves on campus, by north-south-east-west, or by the names of the colleges, or by the distinguishing features of the surrounding topography. I also find myself noticing that the spot is not only at the edge of the campus, as you've said, but at the edge opposite the edge that faces the campus's most traditionally "scenic" view—the one toward the ocean.

WW: That's right. Isn't it ironic.

JS: Have you been tempted to update the big drawing on the bronze plaque? Have you wanted to go back, and maybe at different points in time make overlays to compare the ever-changing landmarks seen from this lookout?

WW: I could become the artist known for that, the guy with the lookout instead of the guy with the dog. I used to think, I'll be getting a call any day now from Cleveland or Gary, Indiana. But none of these phone calls happened. So I got another dog, and started taking her picture.[2]

1. Steffan Schmidt, "William Wegman: Doesn't Fit—Fits," in *William Wegman*, exh. cat. (Malmö: Rooseum—Center for Contemporary Art, 1998), p. 35 and notes 14, 15.

2. Wegman has written of Man Ray, the weimaraner who, with his grace and talent before the camera, "changed the way I thought about my work": "Man Ray died in 1982, late in his eleventh year. I was devastated and vowed that I would never get another dog. I didn't know Fay Ray as a puppy. She was six months old and almost fully grown when I met her in April 1986." William Wegman, *Puppies* (New York: Hyperion, 1997), n.p. Fay Ray, who died in 1995, was the grande dame of Wegman's players, and he continues to work with her progeny: Chundo, Crooky, and especially Battina, who in her seriousness assumed Fay's place, and who begat Batty, who begat Chip.

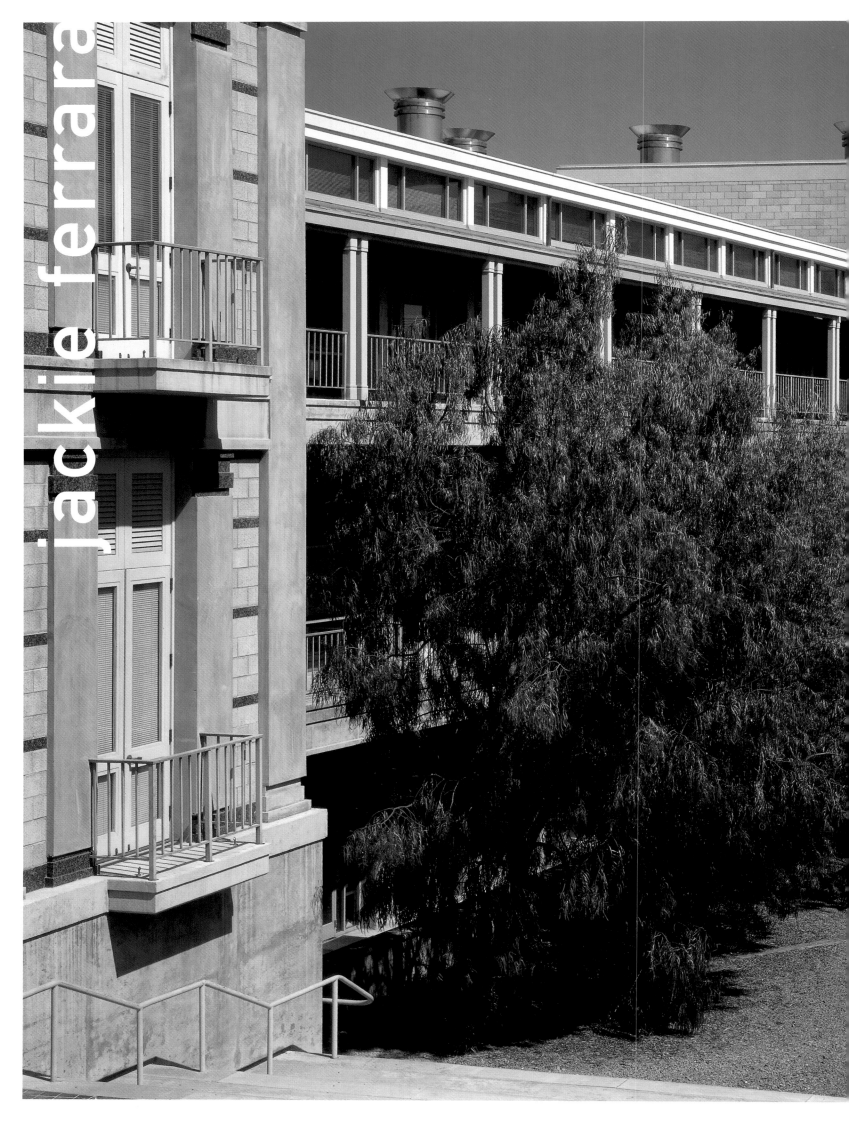

jackie ferrara

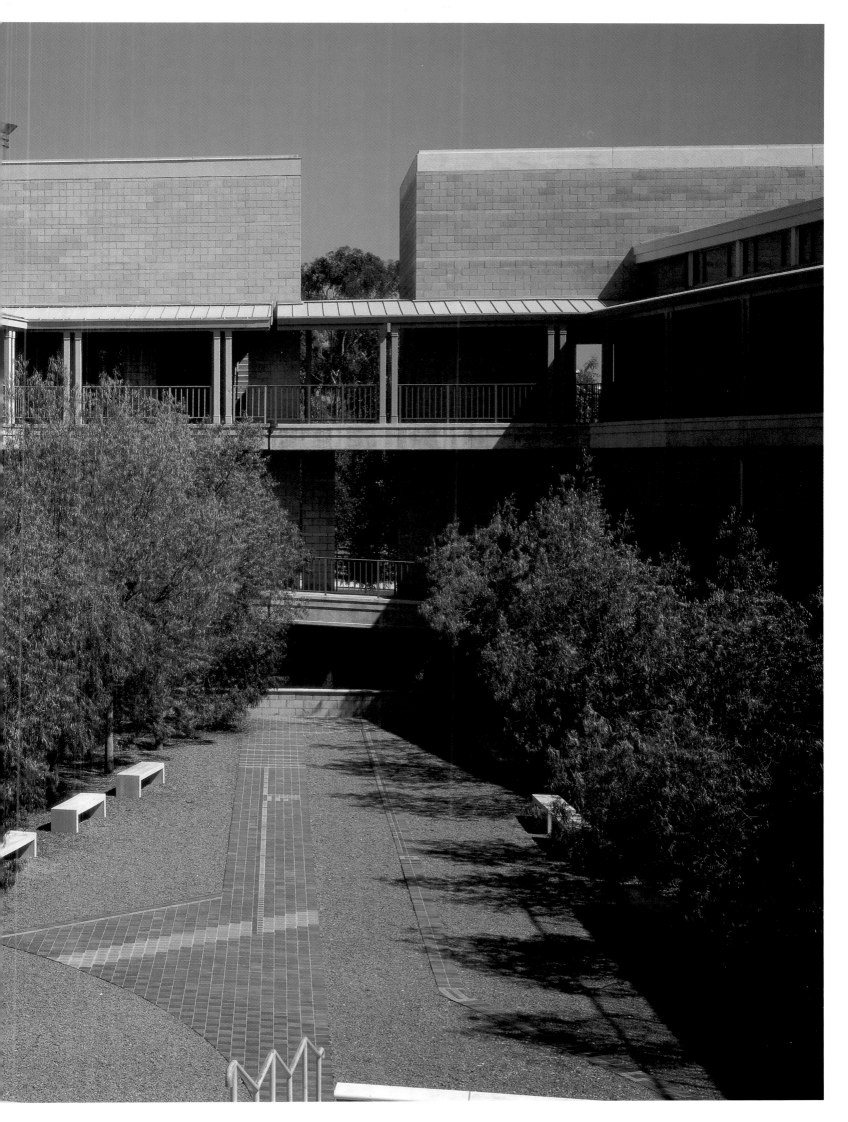

TERRACE
1991

IN 1986, WHEN THE UCSD SCHOOL OF MEDICINE was reaching the design phase of its new Cellular and Molecular Medicine Facility, its associate dean, Ruth Covell, asked us if we knew of an artist who thought about courtyards and terraces and who might like to collaborate with their architects. The Advisory Committee had designated a few artists as a design pool for consideration on such occasions, and one of these was Jackie Ferrara, a New York artist who had been designing and building courtyards, terraces, and architecture-like structures since the early 1970s. Jackie was the clear choice to join the project's team—the architects Moore Ruble Yudell and the San Diego landscape architects Land Studio.

Jackie is one of several artists of her generation, emergent in the 1970s, who used forms and materials generally associated with architecture both to enrich the definition of sculpture and to challenge the assumptions and conventions of the typical built environment. She had been attracted to the idea of dealing with architecture early on, and was influenced by artist friends Robert Smithson, Eva Hesse, Sol LeWitt, and others. Later she became fascinated by the relationship of buildings to the landscape. At the top of her list of places to visit on her trip to La Jolla was the Salk Institute, one of the most important buildings of the American architect Louis Kahn, and masterfully integrated with its site above the sea.

Jackie had recently completed two works in Minneapolis: a large, open cedar structure in the outdoor sculpture garden of the Walker Art Center, and a beautiful courtyard in pale-yellow and off-white local limestone at the General Mills Headquarters. In the 1960's, when she first moved to New York (having grown up in Detroit), she had been more involved with dance and theater than with art, and one senses this influence in the General Mills courtyard, which feels like an outdoor theater that invites one to play or dance on its "stage." Music was another early influence, and Jackie's work generally has a methodical musical rhythm, being built on repeti-

tive gestures and clearly graspable mathematical formulas. She sees herself as a carpenter and builder as much as a sculptor; she goes to more movies than art exhibitions. *Blade Runner* is a particular favorite, because of its mix of the old and crumbling and the sci-fi new. Jackie aims for work that is ahistorical—not of a particular time, but timeless. Her interests range from classical pyramids to contemporary design.

Jackie's visit to La Jolla was her first trip to Southern California. She arrived in Los Angeles, where we met with Charles Moore, the lead architect at Moore Ruble Yudell. The two had met before—at the Max Protetch Gallery, New York, some years earlier, when his drawings and her work were exhibited together—and the conversation clicked right along. Both of them had a great sense of humor. It was a good match.

Jackie next went to the Sea Ranch, a community on the coast north of San Francisco, for a retreat-cum-charrette with the whole design team. There was a lot of give-and-take and ideas began to take shape. The three-story building—mainly funded by the Howard Hughes Medical Institute, historically a funder of well-designed research facilities across the country—was to wrap halfway around a pair of terraces on two levels, with a grand staircase at the juncture. The shape of the terraces emerged from the footprint of the building. Another building, to be added later, would fill the terraces' other side, making the larger, lower, northern one of them in particular into an enclosed courtyard. The School of Medicine faculty wanted a quiet, secluded place to gather, not a busy public promenade. Jackie has always liked enclosed spaces, which may be public but have a feeling of being private—inner courtyards, sanctuaries, to be discovered. For the terraces she had a vision of a stone "garden"—a landscape of slate tile, in red, black, and a gray-green that would subtly enliven muted grays and greens in the surfaces of the buildings. Set in gravel, the tiles would become pathways, with patterns contradicting or

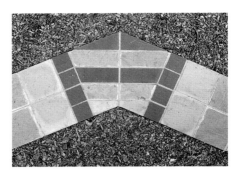

emphasizing the buildings' shapes. Lines of trees would echo the diagonal vectors made by the buildings' facades.

The Stuart Collection paid Jackie a proposal fee and agreed to underwrite her artist's fee and expenses. The terraces themselves, however, became parts of the building's construction contract and landscape budget. The first cost estimates were higher than anticipated; budget cuts were deemed necessary, and the process became difficult for everyone, especially in light of the Stuart Collection staff's pride in giving artists full backing to make their projects work and be true to their vision. This was the first of our projects, and remains the only one, on which we did not oversee the construction or the design process. We made reviews and requests, but did not determine budgets or contractors. Challenges were encountered as always, but budget cuts were the most difficult and led to some compromises. First the grand staircase was reduced; other cutbacks followed. The School of Medicine indicated that it would help raise additional money, and Jackie, with her usual calm and grace, decided that the integrity of her work would survive.

The construction of the first building began in February of 1988, with an estimated completion date in the summer of 1989. The terraces of course had to wait until the building was fairly far along. When work was to start, Jackie came back from New York. On-site we soon discovered that the tile that had been delivered was the wrong size. Jackie's work is exactly crafted, and this mistake could have thrown everything off, but she is an accomplished collaborator with architects and craftspeople and she negotiated brilliantly. A solution was figured out by slightly adjusting the space between the tiles, and she returned to New York while the tile was recut. Unfortunately there were more compromises to come when she returned a few weeks later: the north terrace, the larger and lower of the two, was underway, and she was mostly pleased with the workmanship, but the wall had been built six inches shorter than she had requested. She

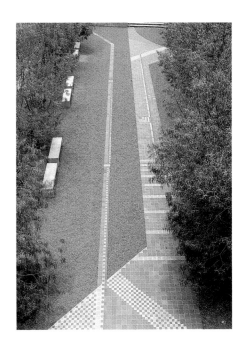

wanted a wall that was easy to sit on. We obtained a commitment to add a layer of eight-inch brick, so in the end the wall was two inches higher than originally planned but still reasonably comfortable. Yet another problem had been solved. She and I retreated to the desert for a restoring respite.

Jackie wanted trees that she described as "soft and droopy." The willows that were her first choice would eventually grow too large for the space, but she searched around with the landscape architect, Andy Spurlock, and they discovered Australian willows, a smaller species that would work beautifully. Maple benches were constructed, like her other work, by a process of stacking layers without joints, and placed in line with the trees. In December 1991 we had a grand opening celebration. The headline in the San Diego Union-Tribune, the local newspaper, said "N.Y. Artist Helps Wed UCSD Lab to Setting."

Construction of the second building, which was to enclose the larger terrace, began in the summer of 1993. Trees were removed and part of the terrace was torn up. Jackie took all challenges in stride; I was the anxious one. It was dust and chaos until 1995, when the terrace was returned to its previous state, its tiles repaired and scrubbed. The maple benches had not weathered well and in 1995 were replaced with concrete benches in an identical shape. Ribbons were cut and another completion was celebrated. Jackie had been incredibly patient and good-natured—but that's the way she is, calm, confident, and completely unassuming.

The buildings remain one of the most appealing complexes on campus. Cutting-edge research adjoins light and air. The labs look out onto the enclosed north terrace, with its feeling of quiet seclusion, of sanctuary. The trees have grown tall and light filters through. The magic of the place lies in its musicality, its sense of measure, the quiet progression and integration of its forms and shapes. A mathematical scheme underlies the arrangement of pathways and trees, and one feels its rhythmic beat. Although there is a complexity to the grid-based patterns, there is also an underlying simplicity from which the work gains strength. Occasional breaches in the established geometry make their own contribution. Jackie has articulated the motifs of the architecture, incorporating them into a very special and human place—serene, ordered, but sensual, with moments of spontaneous imperfection.

—*MLB*

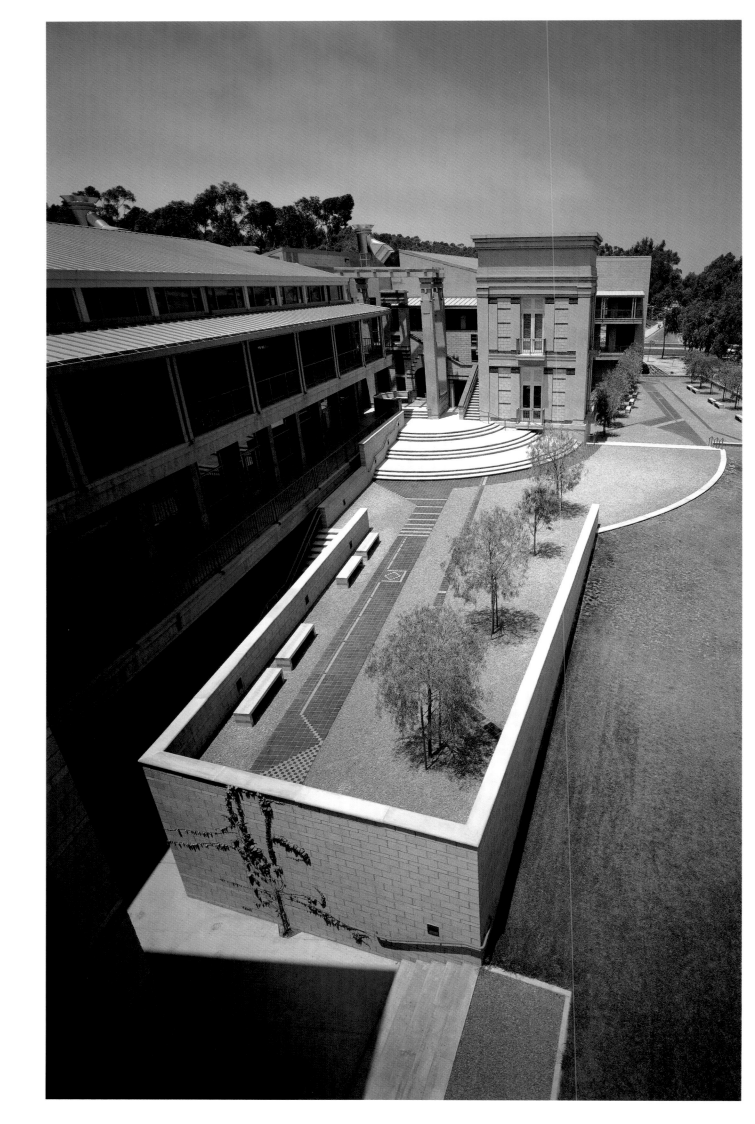

interview

jackie ferrara

JOAN SIMON: *Yours was an unusual situation within the open-ended context of the Stuart Collection: you were offered a particular site, the Cellular and Molecular Medicine Facility, which was being built by the UCSD School of Medicine.*

JACKIE FERRARA: It was specifically that building. Charles Moore was the architect, and he knew my work. Before I even looked at the site, I met Mary in L.A. and we went to their office, and then had dinner with Moore that evening.

JS: At that point was the scheme for two buildings?

JF: I knew that was going to happen. I knew the space was going to be enclosed. And when I saw the site I thought about doing a terrace.

JS: How did you proceed?

JF: I met with the architect, then we drove back to La Jolla and looked at the site. Then I made a proposal. When I brought my plan, Moore liked the idea. He asked me one question about the plan: who drew it. And I said I drew it all except for the trees. I never went to art school. I'm better now, but then I wasn't very good—I just couldn't draw trees, even though I planned to have trees. So a friend of mine drew the trees.

I probably had a small section of the paving pattern. Originally it was going to be a concrete surface—because of financial constrictions we switched to gravel. It was always going to have the slate paths and the lines of trees and benches. I was following the site plan I had been given, which showed the outline of the new building—the one that was about to be built—and the projected building [that would follow later], which was a mirror image of the other building's facade. So here was a clearly delineated enclosed space between two buildings.

JS: The terrace has several parts.

JF: There's a north terrace and a south terrace, and then there's the middle curve. And one terrace is much bigger than the other.

JS: What kinds of changes came into play?

JF: I had the stairway going into the building as almost a rectangle shape. In fact one of the things that was hard for me back then was that the shape wasn't a real rectangle, it got narrow at one end, and that irregular shape was difficult to figure out on my graph paper. I mean, the only way I could make the steps was to make them a rectangle shape; I couldn't draw circles. But Moore suggested the curve, and I thought that was great. Much better.

The other change was the benches. I wanted to use teak for the benches, and teak is very costly. It was decided to use maple, and the maple didn't last—very quickly, it pulled away, got unglued, twisted, did all kinds of things. When I first made the proposal for the benches, I made a concrete version and a wood version. I really wanted to use teak, but the second choice would

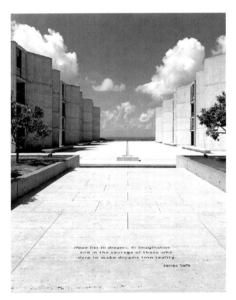

Salk Institute, La Jolla, California

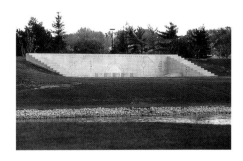

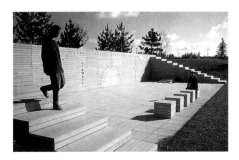

Jackie Ferrara
Stone Court, 1988
Limestone
8′ x 65′ x 24′
General Mills Art Collection,
Minneapolis, Minnesota

have been concrete. So they went back later, used my drawings for the concrete benches, and made those.

The surface of the terrace really looks nice with the gravel. Ultimately I was happy about it, but when it was first happening I was worried about having gravel. I felt it was going to make dust when people walked on it. I thought it was really terrible for anyone wearing high heels. But it's a very nice look, and as it turns out nobody's going there much in high heels anyway.

JS: You were hired as part of the landscape-architecture team—did you help choose the trees, the plantings?

JF: Yes, but I worked with a local landscape architect, Andy Spurlock. We went driving around to look at trees. I wanted some kind of willow. He subsequently sent me photographs of Australian willows. They were perfect because they weren't too big.

JS: The site is between two buildings (one constructed some time after the other) and is not very public. You have said elsewhere that the scientists who were to work in these buildings wanted a secluded, private place.

JF: I met with a couple of people from the building, and they wanted to maintain a low profile. So I conceived of this as a meditative, private space. I'm sorry the two buildings didn't get built together, because the trees on one side have grown taller than the others. When they added the other building, they took the trees out from that side of the terrace and put them in boxes until the building was finished and the trees could be replanted. During that time they didn't grow, they just stayed the way they were. Meanwhile the trees on the other side continued to grow. I suppose the lower ones will catch up at some point, but I'm sure for now it's awkward-looking.

JS: Did the scientists say how they wanted to use this garden?

JF: Not a whole lot. They were very busy. They were all excited about their new building. They weren't really much interested in what I was going to do, and I was just sort of feeling them out, because I wanted to make something they would find appealing. It was during the discussion with them that I first called the space a meditative garden. They were very receptive, and then I never met with them again. And I always wondered—because so much of the terraces is about mathematical progressions—did they go out on the balcony and notice? I have no idea. The trees were meant to give shade, because it can get hot there. I don't even know how much the space is used. Were there people there when you were on campus?

JS: When we were there, no. It had the feeling of being a quiet pocket, off somewhere.

JF: The Salk Institute [in La Jolla] is one of my favorite buildings—I'm a big admirer of [the architect Louis] Kahn's—and when I was there, I never saw anybody on that plaza either. Maybe scientists just don't sit outside and schmooze.

JS: I'm interested in how you got from your early sculpture to this kind of public work. In the early

'50s you worked in ceramics, and your first solo show, in 1961, was of bronze figures cast when you lived in Italy. After that you suspended works from the ceiling—

JF: —they were rope things—

JS: —with feathers and flax. Then you moved into a new loft in August 1971, and it was after renovating this loft, in '71 to '72, that you changed the way you worked. You started to use construction materials and architectural forms.

JF: The ceramics thing started out as a hobby. I lived in a neighborhood where there were a lot of settlement houses, and there were all kinds of evening classes for adults. This was the Lower East Side, New York City. So I made the pottery, and that evolved into clay sculpture. Eventually I started making things that looked like mummies, and I would put them in beds of feathers or flax. Then I started hanging flax and feather shapes from chains. And when I came here—to the loft where I still live—I had all this stuff hanging from the ceiling while I was renovating the place. Doing the loft really took me a year, and it's almost insidious what started to happen after I finished. The first things I made were simple forms, canvas shapes that were still hanging from the ceiling with chain. And then it just started to evolve into things that were like stairways, and then the stairways became pyramids. I was using wood, at first materials I found on the street.

JS: Those early wood ones used repetitions of the same-size pieces of the same type of wood.

JF: I was always consistent with what I used. If it were Masonite, they would all be quarter-inch thickness or eighth-inch thickness. It was all material I could buy at the lumberyard.

JS: And you always used a process of systematic placement for these units.

JF: Yes, and it would be figured out in advance. Because I'd have to know how much to buy.

JS: You did the figuring on graph paper?

JF: On graph paper. I still use graph paper.

JS: How did your mathematical thinking match your handling of these wood pieces?

JF: I was just using all these systems. Later I learned things like the Fibonacci series. I was always good in math—I loved algebra, I loved geometry. I'm a big game player, and they were like games. I know other people hate math, but I thought it was fun. So on the graph paper, it was all done with steps. At first it was straight angles. After a while I learned that if I increased

each step a little more than the one before, I would get a curve. And that's how it all evolved.

JS: The geometry quickly turned into architectural form. Early on you began to get into pattern, not just in the wood but in the negative spaces.

JF: I was using little openings to make a diagonal on the facade. At some point I called it drawing on the surface.

JS: You pretty quickly went from small works to freestanding sculptures that referred to architecture but had a human presence.

JF: I'm not sure how fast that happened. I was doing pieces in Masonite and plywood, and because of the way I was making the work, nothing ever got much taller than four feet. I could make them long—it's weird what I could do—but I couldn't make them high. Or at least I would have had to use so much wood to make them high that it put me off. That's when I started to use one-by-twos, like regular building lumber. But that probably took eight years. A really early one, from '73, is just stacked blocks. They're all four feet long, and the first layer is say twenty-four blocks, the next one is twenty-three, the next one is twenty-two, and then the top is one. So that made a simple pyramid of cedar.

Then people started asking me to do wooden outdoor pieces. Some of them were only supposed to be temporary, but because I was using big thick wood—four-by-sixes—they lasted.

JS: At what point did you go from building these structures outdoors to working with spaces where—

JF: —where I was thinking about it as a space? Well, in a way it started with one at the Minneapolis College of Art and Design, in '78. While we were building it we were inside it, because it was easier to build it that way. And at some point we had to get out—we couldn't stay in there forever—but I thought it was wonderful what was going on inside. So I made one in '81, at Laumeier Sculpture Park in St. Louis, where you could walk into and through it. There was a room inside it.

At that point I was making studio works that were places, and I was calling them that, thinking of them as that. They were tabletop works in my studio.

JS: One of your inspirations for Terrace *is a courtyard in a building on the Lower East Side of Manhattan.*

JF: It's wonderful. It's just three stories, an early housing project with I think the International Ladies Garment Workers Union. It's at 504 Grand Street—a brick building with corbelling, designs made in the brick by either recessing it or bringing it a little bit forward. That was unusual for something built as a low-income housing project. And you walk through a doorway and end up in an inner courtyard where there's a pool—which probably no longer has water in it, but it used to have water lilies—and there's an exit through a long arched tunnel. I love it. When I first saw it I couldn't get over it, I couldn't believe there was this hidden inner courtyard.

JS: The slate in Terrace, *the gray-green, black, and red tiles—*

JF: —Those are the colors it comes in.

JS: You went to slate for the color, for the dimensions, for its use in your system, for its cost. Would you have picked another stone if, say, the budget had been different?

JF: The only other stone would have been granite, which would have cost a whole lot more.

See, this slate already existed in six-inch squares. I also needed smaller ones, which had to be cut on site; I was using three-inch squares and six-inch squares.

JS: Are budget restrictions useful in coming to good solutions—valuable in the process of working things out? Or is that a rationalization.

JF: Sometimes you have no choice if you want to do something.

JS: What's the difference for you between placing sculptures in existing spaces and working with architects to create spaces?

JF: There's an enormous difference. For one thing, the sculptures placed in spaces—I don't even do that any more. It's all about working it out in the studio, and it has nothing to do with where it's going to go. It's an object. Sometimes, because it's a big object, it can go outside, and it can even stand in front of a building. But that's not the same thing as interacting with a space. And I find the concept of making a place far more interesting.

JS: Are independent objects and contextual projects parallel tracks for you?

JF: If I work in the studio, I'm creating places that are imaginary. Almost everything I make in the studio now is a tabletop size, but every now and then I'll make a floor piece that's a tower. I've done that periodically.

JS: And when you're working on-site outdoors?

JF: I'm creating places outdoors too. But I don't always get a commission to do one outdoors, so then I'm inventing them in my studio.

JS: Is there something that you think should in particular be said about Terrace, *or that may have gone missing from some of the prior discussion and writing?*

JF: The only thing I would say, and this may be very apparent anyway, is that when I was working everything out, I was having the trees follow one line (which had to do with the building), and the path following another line, and then there was the line of benches. I was very conscious of all that happening, of the lines interacting with each other and being skewed with each other.

JS: Are there aspects you might rethink at this point?

JF: No. And once the dwarfed trees catch up to the others, the terrace will be as I planned.

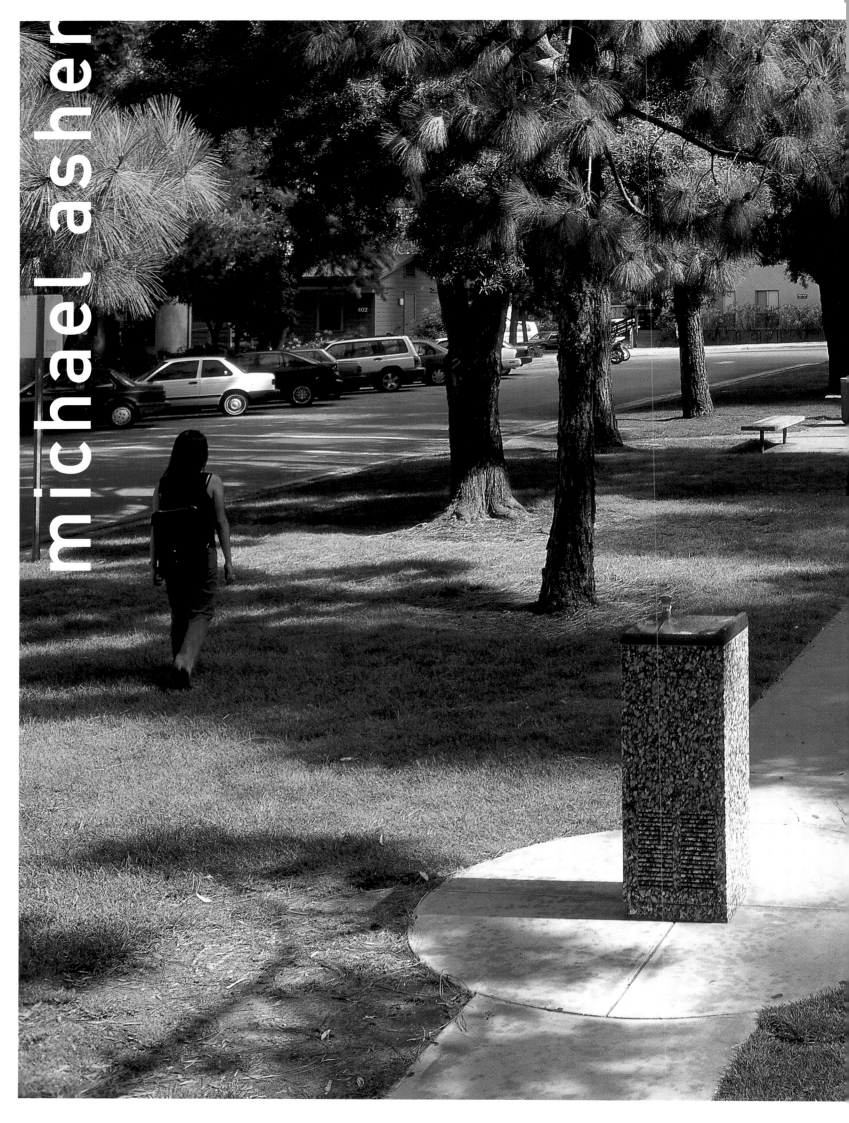

michael asher

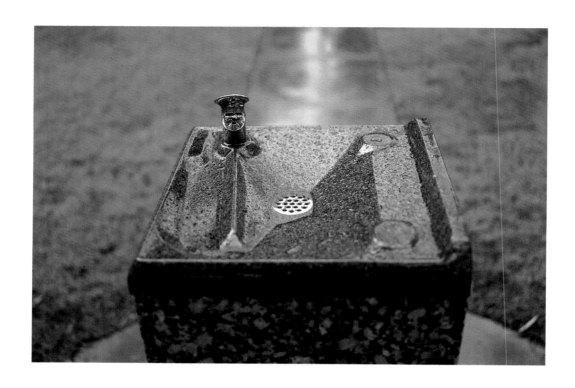

UNTITLED
1991

FOR MICHAEL ASHER, CONTEXT IS ALL. His work comments on function and often invisible systems. One of the leading Conceptual artists, based in Los Angeles but showing mostly in Europe, he points to architecture and institutional procedures or systems that influence our understanding of things without our necessarily being particularly aware of them. His work is fused with and comments on its setting, sensitizing us to its history. UCSD, with its beginnings as a military training ground, seemed a perfect place for him to explore and consider. Although highly recognized and often commissioned for exhibition projects, he had no permanent public work in this country, which was surprising given the recent focus on place, history, and dependence on site. He was high on the Advisory Committee's list and responded enthusiastically when I called.

Michael first visited the university in 1984. On an extensive tour, two things sparked his interest: the campus signage, which was in great need of clarity and help, and the possibility of turning a small yellow-brick building near the Gilman entrance into a visitors' information center. The building, once an electrical switching station, was unused and neglected. Upon reflection and inquiry, Michael decided that the size and complexity of the campus signage made it a less attractive challenge. He abandoned that pursuit. His interest in graphics, however, became an opportunity: in addition to producing a project, he wanted to redesign the Stuart Foundation's stationery—an offbeat and typically subversive idea. He did a superb job with a difficult assignment and we still use a version of his design today.

In the meantime the yellow-brick building was slated for destruction to make way for the new Molecular and Cellular Biology Building, science winning out over history. We urged Michael not to give up, and he returned many times over the next four years. Combing the campus and taking extensive notes, he considered and thought through many interventions. On an

extended visit in 1988 he discovered a site near the chancellor's office that he felt could be essential to an understanding of the university as both a place and an organization with a history.

This area is a median strip about 300 feet long and 55 feet wide, a small grassy island surrounded by road and parking. In the center is a high flagpole that flies the American flag, and on the south end a stone landmark, placed in 1962, with metal plaques commemorating the training of "rifle shooters" that used to take place there and the transfer of the campus land from the military to the university. The land that the campus occupies had earlier been Camp Matthews, a World War II training center and rifle range. Michael was intrigued and happy to learn that this site had been the camp's center. We immediately went to the UCSD Physical Planning Office to find out about any intentions for the area, and were given tentative clearance.

Michael would add a drinking fountain, a working granite reproduction of the familiar, 1950s-style, vertical-box-shaped stainless steel drinking fountain used widely in offices, factories, and schools. He proceeded with development and drawings, sending a long, detailed written proposal, as conceptual as it was specific, as philosophical as it was revealing of the socioeconomic history of the site and of contemporary land- and water-use issues. Reviewing the proposal at a meeting in January 1989, the Advisory Committee was very enthusiastic. Certain members of the Campus Community Planning Committee, however, voiced serious concerns. There was support for the idea of a work of art in this central location, but not for a drinking fountain that some of them thought purported to be a major expression of artistic values and the symbol of UCSD. It was thought that a fountain might be an appropriate representation of the tradition of culture, education, and research for which the university should stand, but a grand, civic fountain, not a small drinking fountain. The opposers claimed that an

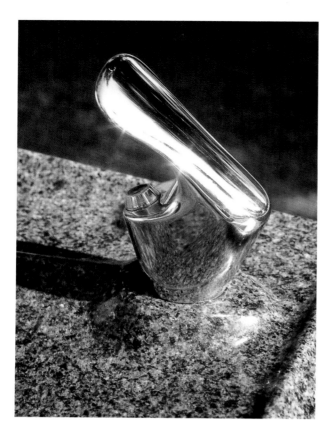

identifi-cation sign would be necessary for most people to recognize a granite-clad drinking fountain as art. Even then, they said, most wouldn't believe it. This was the "epitome of a bad idea." There was a vigorous protest, most of which arrived in the form of a letter.

We worked on a response, which stated in part,

As you have probably noticed, many of the Stuart Collection works are not clearly and immediately recognizable as art. . . . This is part of their intention. The notion that art is a part of life and about the act of thinking rather than memorializing, or of being identi-fied as art, is essential to aesthetic development in the 20th century, and it is one of the strengths of the Visual Arts faculty here at UCSD. We think this is an important aspect of the collection and a part of the reason for its placement throughout the campus rather than being confined to a "garden" area where one's expectations would be different.

The purpose of the Stuart Collection is not "tasteful design" or cosmetic beauty, but thoughtful composition and integration with surroundings (among other considerations). We are not for a moment proposing that Asher's fountain "become the central expression of artistic values on this campus, the symbol of UCSD." Asher's work does represent tradition, culture, education, and research, but it does not announce itself as Art. It acknowledges and includes its surrounds. It has many levels of meaning which can be dis-covered with some effort. Although one looks toward the flag when actually drinking, this granite drinking fountain has nothing to do with "bowing one's head" to the flag; indeed, it places itself in opposition to ideas of monumentality and nationalism. I hope that you will present this work to your colleagues and students in this light rather than as "the central artistic symbol of UCSD." . . .

Although the Stuart Collection is meant to be an educational tool, individual works do not necessarily promote the virtues of education or of institutions of education. One might compare them to books in the library, in that we hope to have a significant range of

ideas represented. . . . A great deal of work and thought has gone into these proposals and
we hope the Committee will recommend them to the Chancellor.

This letter elicited a positive response and the project went forward.

Michael proceeded with excruciating deliberateness. We built a wood model. He agonized
for days over many samples of granite. The base of the fountain and the top were to be of two
different colors: the top, which is stainless steel or chrome in the office-equipment model, would
be darker; the base, which is often painted a light brown in office models, would be lighter.
Considering handicap modifications, Michael slightly lowered the height of the fountain, and
adjusted the placement of the spigot and the button.

The granite parts of the fountain were fabricated to exact specifications at Cold Spring
Granite in Minnesota. The metal bubbler is stainless steel, beautifully produced in the machine
shop of the UCSD Scripps Institution of Oceanography, which fabricates specialized equip-
ment for oceanographic and atmospheric experiments. An extension of the sidewalk was laid,
linking the fountain to the flagpole. The fountain was installed in December of 1991. It became
a wonderfully elegant yet low-key addition to a rather ordinary site. It has an air of mystery.

When one is drinking from the fountain, one's body is aligned in an evenly balanced
arrangement made out of the triad of the fountain, the flagpole, and the stone commemorating
the military history of the place. Remembering that this was once a shooting range, one might
imagine the flagpole as a sight aiming one's vision on the monument, so that the work perhaps
makes reference to the connections that still exist between the university and the military. The
work is not a monument, it is the opposite of monumental—a somewhat incongruous, small,
functional fountain, as much fountain as it is art. Whether as fountain or art, it asks us to ques-
tion how we use our resources—both human resources and natural resources such as water.
This water is cooled and filtered.

Before the opening celebration Michael seemed happily awed by the completed project; he
said it made him a little weak in the knees. He gave a slide talk about his work and the opening
followed. TV news reporters came, against our wishes—in my experience they generally use
such occasions to make fun of the art, which is what they did with this piece, an obvious target.
But the fountain stands oblivious to its critics and has many admirers, not to mention frequent
imbibers of a refreshing sip of water. Although it does not announce itself as art, it is droll
enough to have been discovered by students, who, labeling its output "smart water," have
instituted a legend about its secret powers, and often come to drink at it before an exam—and
perhaps to think about why it's there.

—MLB

PROJECT PROPOSAL FOR STUART COLLECTION
by
Michael Asher

The outdoor sculpture I propose for the Stuart Collection at the University of California, San Diego consists of a granite drinking fountain in the form of a commercial indoor water cooler, and similar to those found on numerous school campuses, city buildings, and businesses. It is approximately forty-four inches tall, fifteen inches wide, fifteen inches deep, and constructed of a light and dark colored granite. The base of the sculpture will contain a refrigeration unit for the water.

This project is to be situated on the island which forms a parkway in the center of Myers Drive. This median strip is located between the Political Science Building #412 and Academic Affairs Building #105 within the Matthews Complex. The Sculpture will be placed on the path through the parkway at a point equidistant north of the central flagpole, as the Camp Calvin B. Matthews landmark is placed south of the flagpole. A circular pad of cement will be poured for the sculpture which is the same size diameter as that of the landmark's foundation.

The size of the sculpture makes it a similar scale as the Camp Matthews landmark. Its position on the parkway will visually balance the arrangement of all the elements placed there and inherently give the site a certain visual continuity. Yet, the introduction of the sculpture is meant to reveal some clues produced by the landmark which might otherwise be read as representing a closed chapter in ucsd history. In this juxtaposition, the sculpture functions as a model containing numerous cultural references.

For example, the artwork I propose can be read as a fountain, if only due to its object status outdoors, yet it distributes water rather than circulating it, plus its appearance refers to the industrial designs of objects for institutional use. On another level, it carries the baggage which allows it to be an artwork on modernist terms with its aesthetic dimension having the characteristics of sculptural representation and its integration of appropriation within its production as a formal strategy. But the reference to the modernist paradigm begins to disintegrate as soon as the operation of the sculpture has been realized as having the potential to bring together the viewing subject and the object for something other than transcendent renew-

al. The sculpture also bears a relationship to a monument in its similarities of material construction and its iconic status, but as a monument, the sculpture lacks the same reference to a specific event.

Further, operating as a model to open up this important landmark to a contemporary reading, this project subtly disturbs the relationships that exist between requirements of natural resources and requirements of state policy. Within the terrain of use value, the sculpture represents a distribution point for one of the most essential material requirements (water) for our body without which we could not live. The water cooler describes an area where we can take a break in our daily routine for refreshment and regeneration, as well as social discourse. On the other hand, the landmark chronicles a short history regarding the use and transfer of government land from the military to education in order to meet future requirements in the construction and maintenance of state policy. In communicating this message, we are given a sense that this fundamental shift in land use possibly represents a shift in the state's concerns for growth of the individual, through education, to prepare for the demands of civilian life. Therefore, within this juxtaposition, the sculpture meets the needs of our bodies' requirements of state policy to meet our future political and economic needs. But neither object on the Myers Drive parkway directly reflects upon portions of its current status which define their existence. The sculpture does not reflect upon the complex networks of pumps and pipes which make it possible to distribute water as a drinking fountain just as the landmark does not reflect upon the degree to which education is at the service of the military, and so on. Within the disturbance which is created by this juxtaposition is hopefully enough cause for the public to become adequately stimulated to develop these problematic issues and continually ask thoughtful questions about these two very different objects.

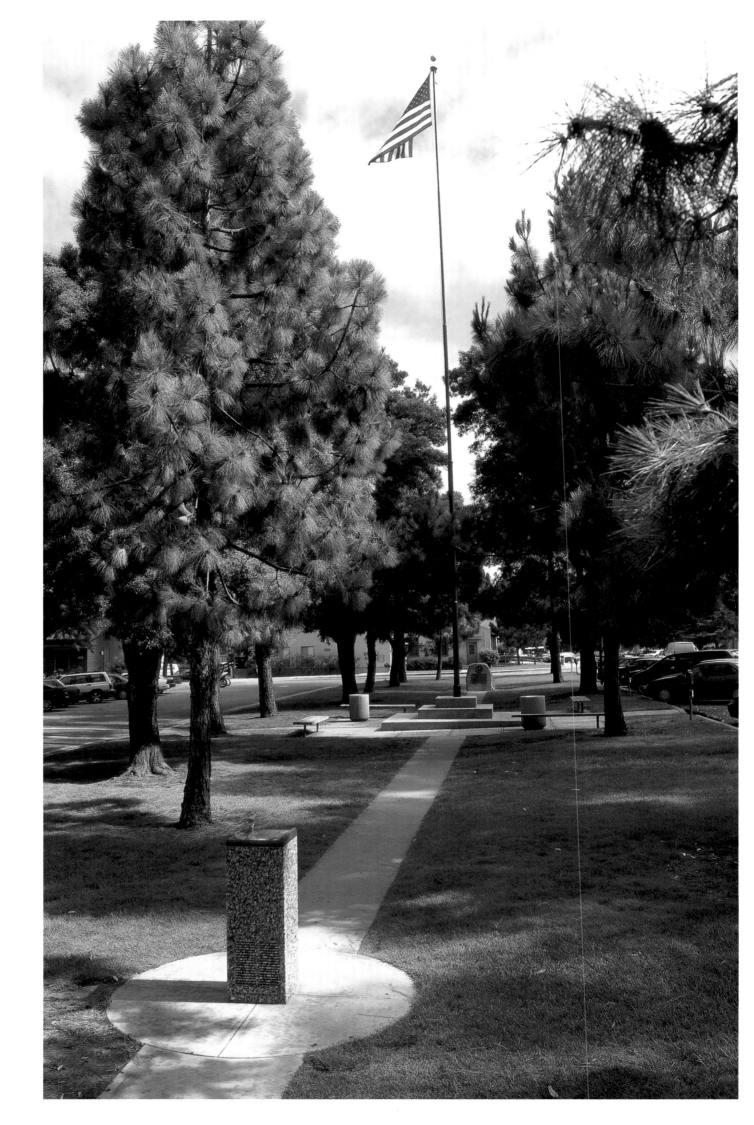

interview

michael asher

JOAN SIMON: Why did you pick this site?

MICHAEL ASHER: Let's see if I can answer this very clearly. It wasn't that I had an object in mind that I wanted to install, but there was a problem, or problems plural, that I could perhaps describe, at this particular point. One of the most significant was to produce comparative relations—one of the forms of logic that keeps coming back to me, and that I use to learn by, as well as utilize quite often in my own work and in teaching.

JS: In picking a site, you kept looking for something that had the potential for you to trigger this thinking. I know you went to the campus many times.

MA: My notes start with that, because I just had the hardest time finding anything that would function for this logic. Finding a site became almost impossible, compared to projects prior to and after this artwork, where the specific site is designated and the problem is defined from that point. This way of working returned when I finally found the place where the artwork would be placed.

JS: What was it that crystallized for you that you did have some ideas, and the correct site in which to work them? The place you chose has and, I assume, already had in place the memorial marker, the boulder.

MA: That was perhaps one of the key reasons. The plaque on the boulder explained how the area was once a shooting range for the Marines and then was deeded to the university.

JS: Why don't you talk about encountering that for the first time, and what your response was.

MA: Actually, that's in here, in my notes. I usually write about each one of my works right after I do it. But for some reason—I think it was because I was moving very quickly at this point in my life—I never compiled notes [for the UCSD project]. I did have a lot of notes in my notebooks that I used every time I went down there, but those were more in reference to ideas that I could possibly do at one place or the next place—I would always check them off because I wasn't happy with them.

JS: Can you talk about any of the ideas that you rejected?

MA: No, the retrospective notes I did compile come from the few notes I already had that seemed relevant to what I finally did. I asked myself, you know, what was I thinking at the time. I retraced my steps.

In regards to locating a place for a project, many situations would not have been usable since they weren't for multiuse, and were not trafficked by large groups of the college community. Other situations already raised questions due to the juxtapositions the campus designers produced. These questions were not so significant to me.

JS: You were drawn to the center of the campus. Could you describe the site as you first found it?

MA: There was a parkway with a road around it. On the grass, there was just a path, a flagpole with benches, and a rock monument from the Marines. If you looked at it just visually and formally, it was fascinating, because it was structured to be symmetrical but the symmetry wasn't complete, since nothing balanced the memorial. It also appeared to be designed to symbolically give the visitor a sense of stability. This was likely due to the offices that were represented on the parkway

JS: Then how did you begin to address what the problem would be, and what your intervention would be? You did alter the site, adding something to it, but passersby may not necessarily realize this.

MA: I wanted to complete the symmetry, in order to produce questions about preexisting elements. I noted, "I didn't want the object to have the presence of a new marker which must first be identified as part of an autonomous practice." I thought that idea of the autonomous practice could come later. The idea of the marker—I wanted that to remain the large boulder and the flagpole. Also I wanted to offer some sort of contradistinction to the other projects in the Stuart Collection.

JS: Maybe you should read me the first of your notes, so that I have a sense of how you make them.

MA: One was, "I made intermittent trips from L.A. to San Diego over a period of X number of years." Number two, "For the longest time I thought an idea would be impossible."

JS: And number three?

MA: "I wanted to bring together ideas and objects that were very familiar." That becomes a problem that I had in general with most outdoor sculpture; I didn't want to represent abstract forms that would immediately individuate my work in public space.

JS: The things that were preexisting were the flagpole, which you didn't change—

MA: Not at all.

JS: —And the boulder, and you didn't change that either. The boulder commemorated Camp Matthews, which was a World War II training center, a rifle range.

MA: I can read you what [the plaque on the boulder] says: "The United States Marine Corps occupied this site known as Camp Calvin B. Matthews from 1917 to 1964. Over a million Marines and other shooters received their rifle marksmanship training here. This site was deeded to the University at San Diego on the 6th of October 1964 for the pursuit of higher education."

JS: That's a lot packed into one plaque on one rock.

MA: It's quite incredible, and I mention this point also in my notes. One of the things that one can't help think of is the military research that might be going on at the university.

JS: The dates of the camp seem to be from the end of World War I—actually from the beginning, I think, of U.S. involvement, in 1917—to the Vietnam War era.

MA: Perhaps the Marines deeded the land because they knew it would be more beneficial to them as a research facility to which they would have access.

I'll go on with my fifth point. "The project that I finally decided on and was accepted was the installation of a granite water cooler on a parkway where students could traverse or remain and meet other students." So that's around the flagpole area. Then my sixth point is, "The parkway was like an island, defined by a road which turned around it, and parking places which met

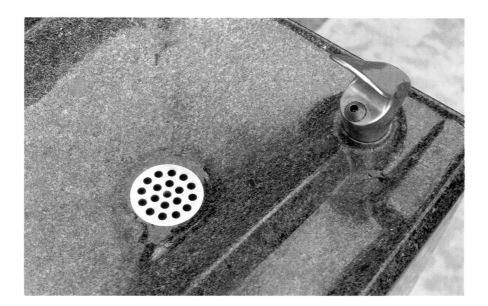

its curb." The seventh point is, "The trees and grass in it were similar to the trees and grass on the surrounding campus." I say similar because quite a bit of the campus has eucalyptus, but there's a part of the campus just east of the parkway that has pine trees. It mirrors that situation. Going on to number eight, "What made the parkway different was that rather than having any building on it, it had been dedicated to what one might call a historical/patriotic function. And then number nine: "In the center was a flagpole with the American flag with benches around it. South of the flagpole and close to the end is a large granite boulder with a bronze plaque fixed to it which faces the flagpole. And on the plaque is inscribed the following"—and that's what I read to you.

JS: Before you did your piece, what was on the opposite side of the flagpole?

MA: Nothing but that walkway, which went all the way lengthwise through the middle of the parkway. Otherwise it was just grass and trees.

JS: So you made the pairing complete.

MA: The symmetrical connection, yeah [laughter].

JS: Why a water fountain?

MA: I'll get into that. It's a tool, like I say, for comparisons. "An equal distance north of the flagpole is where I installed the granite water fountain." The granite water cooler that I had fabricated is a copy of one of the most popular I could find. I started looking on different campuses and started noting, not only in industrial buildings but even in office buildings, what was most popular. I tried to figure it out. Actually it's one model, which I think was designed maybe in the '50s, maybe the '60s, and it's meant to be placed up against a wall. Oddly enough, the one that I had produced doesn't usually go in the middle of a space.

Anyway I go on to say that "the precise likeness of the granite cooler to the original manufactured one was a good measure of the care that Mathieu Gregoire had been taking in the production of my project." And I mention him because all the way along, he was just so careful, and would not compromise on anything. And I really appreciated working with him. I go on, "The cooler had a pump so it could be used for drinking." And then number fourteen, "Additionally, a pump filter and refrigeration unit was purchased from the company that manufactured this model and placed into the unit." Because it would fit exactly, I went to the original manufacturer of the unit that I copied and got all that. Then number fifteen: "The granite monument, the flagpole and the water cooler," as I already mentioned, "are all situated on the center of the one path which goes lengthwise through the parkway." And I don't know if this is par-

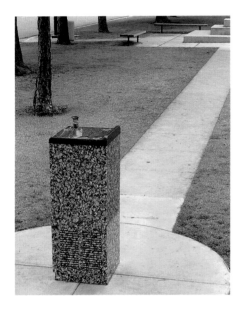

ticularly important, but when you take a drink of water the flagpole bisects the plaque as if it were in the sight of a gun.

JS: When visitors lean to take a drink, they get a glimpse of the pole as if it were the vertical line in the cross-hairs of a gun sight?

MA: Viewers are not using any sort of mechanical device in front of their eyes to line up anything other than what was there.

OK, so I go on more directly to your question: "Due to producing an artwork for a school setting, I wanted to demonstrate one of the most fundamental tools to my own learning and that was an object and the way of experiencing which could be then used for comparative thought." Then I go on, taking the most superficial characteristics first: "Visually the granite monument is rough, and its large size makes it immobile, while the cooler is highly polished." "It had to be assembled from separate parts. It was light enough to be handled." "The cooler is designed to code so it can be used as any object for architectural installation while the granite boulder is rather arbitrary and could have been any number of sizes, while its presence is massive and overwhelming to the viewer."

Then twenty, "The design of the cooler is a copy of one which has been infinitely repro-duced. For the boulder, it is impossible to conceive that another like it exists." "The cooler was designed to meet a very specific necessity. The rock was selected due to someone's taste." I go on to say, twenty-two, "The boulder is to remind us not only of the legacy, the connection the land had with helping the war effort, but also can't help remind us of the campus and its involvement in defense research," which I've already mentioned. And twenty-three, "Hopefully the cooler underscores the campus as a resource tool for those who are interested in education and humanity." I go on to say that some of the questioning turns around how we use our resources, both human and natural, and what's at stake.

JS: There are two pieces of yours that I've always wanted to ask you about. One of them was at the Clocktower in New York over twenty years ago—you took the windows out. For me it was extraordinary. It was in one sense such a simple gesture and yet so complicated, and it made the space so full and clear. The room looked the same yet was experienced so differently, the light so much brighter, the sense of air palpable, circulating. That was part of a body of work that you were doing in the '70s.

MA: Yes, 1976.

JS: How were those interventions different, if they were, from these later ones? In some ways it was working with the same vocabulary that you still use to amplify a structure.

MA: Generally speaking, the later ones take on more political and social questions than the earlier interventions. They are structured more as a tool with which the viewing public can work on the problems I am describing or outlining.

JS: It seems in many ways you keep returning to the revelation of systems specific to a structure, an institution.

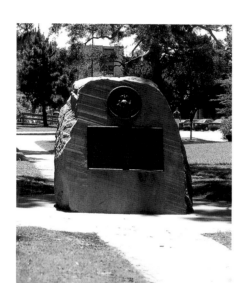

MA: Yes, I'm still very much involved in that—for instance in The Museum of Modern Art work I did on listing the deaccessions.

JS: That was the second of the pieces I was going to ask you about.

MA: It's the same thing, just in a different way. The collection of the Modern represents the canon of modernism that I had come to understand in school. I assumed that everything they brought in was very specific to that canon, and they would never want to get rid of anything. On the other hand, when I started to learn more about The Museum of Modern Art, I came across an article about something they might have gotten rid of. At some point I began to realize that the objects which were treasures were also quite transferable. The catalogue is left as a list for the viewer to further inquire about what changes take place once the deaccessions are made.

JS: What about the flip side of that, the idea of making something that's rock permanent—of making an outdoor sculpture? The Stuart Collection piece was your first of these in the United States.

MA: You're right. It is granite, a traditional material. I decided to go all the way and see if the same material could operate in completely the opposite way from the original monument, and could this become a tool to reevaluate how the representations of different institutions are displayed in public.

JS: It was pointed out to me while I was on campus—I'm not sure I would have noticed on my own—that there is a "signature" of sorts, or at least a plaque, identifying your work. But it's ankle high, on the curbstone facing the parking places.

MA: Well, I did want to take responsibility for it. I didn't want it to be totally anonymous. I wanted to account for the fact that it would be on the Stuart Collection map and that it was a work of art. Similarly, I wanted there to be a person's intent clearly registered behind my artwork, rather than having an institutional origin as the other marker on the parkway. I think if our artworks were truly public and the community helped conceive and fabricate our projects, there would be no need to claim authorship. On the other hand, you might want to ask how we can claim authorship when most of our ideas for artworks come from the public domain.

JS: And why, to play devil's advocate, shouldn't the author of a work of art be in the foreground?

MA: I think he or she should. Absolutely. It's just in this particular situation, where one is almost involved in making monuments—not monuments, these markers, which are part of autonomous production—I would prefer that that be secondary. It's a little like my trailers in the Münster sculpture exhibition, which I've done three times.

JS: You're referring to the trailer or caravan you parked at different outdoor locations at the 1977, 1987, and 1997 editions of the "Skulptur. Projekte in Münster" exhibitions.

MA: Yes. There, actually, you only find out about the author, who the author is, by going to the museum and picking up a slip about where the piece is. My artwork in the Stuart Collection is very similar to that in a way; well, it's sort of similar.

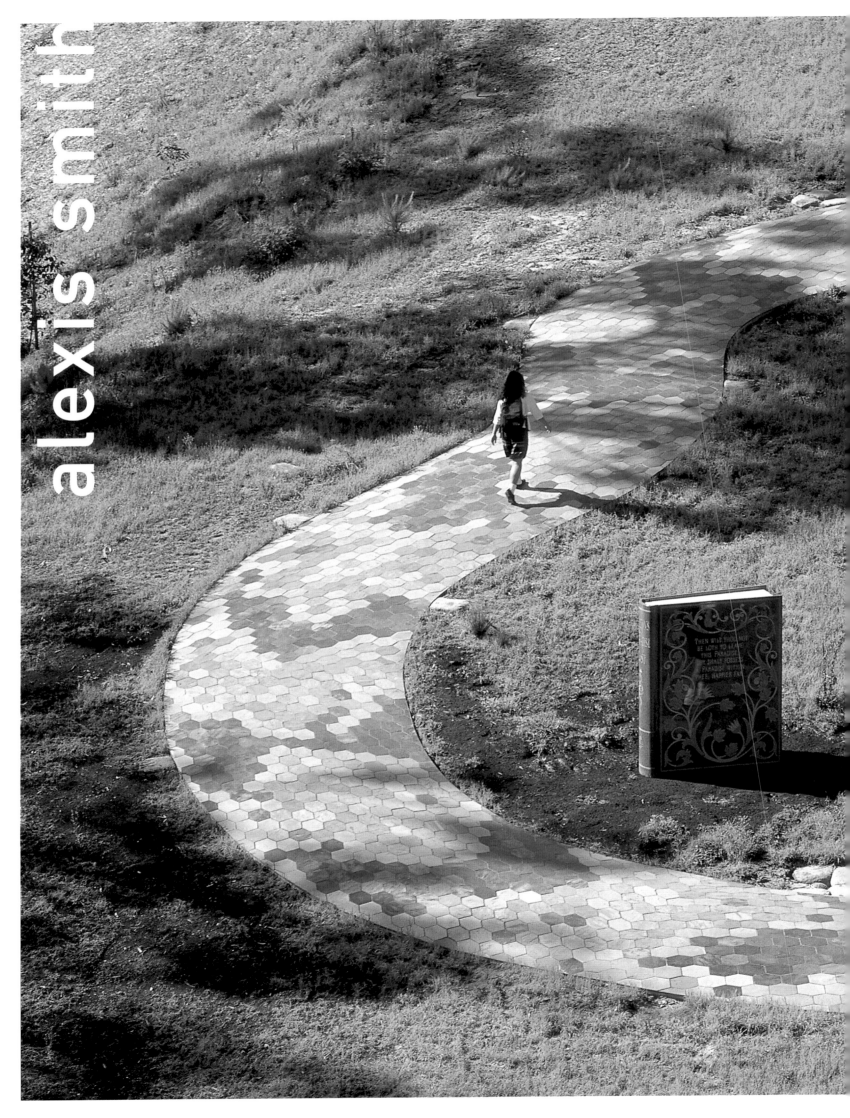

SNAKE PATH
1992

LOS ANGELES ARTIST ALEXIS SMITH mines America's soul, our psyche and mythology. In the 1980s she was known for innovative collages combining fragments from popular culture—magazine covers, 1940s dust jackets, a wide range of kitsch and found objects—and playing on our nostalgia for the recent past, works that she sometimes organized into sequences implying a narrative. She also painted large murals directly onto the wall, hanging smaller framed images over these painted backdrops; which effectively transformed the entire space into a collage. In the 1980s Alexis moved into a new domain, with larger-scale public projects that required all kinds of collaboration. In 1983, she transformed an entire two-story theater lobby in Grand Rapids, Michigan, into a narrative drama, using images derived from local history and from the Art Deco style of the building. A project of 1986 helped to revitalize Los Angeles's MacArthur Park through an installation of sculptural elements playing off and remarking on the history of the area. So it was not surprising that her name came up in an Advisory Committee meeting in 1986.

In April of that year, Alexis came to UCSD and we walked around the campus together. At the time, she was winding up a series of works related to Paradise with a huge 22-by-65-foot mural for the lobby of the Brooklyn Museum. This mural, painted in a style evoking old fruit-crate labels and California postcards, depicts a vast orange grove with giant fruits and blooms receding into a purple-hued expanse of mountains. Running through the grove is a disturbingly vacant highway that metamorphoses in the foreground into a monstrous snake—this Eden is in trouble. Set over the whole picture at viewer height is a series of collages incorporating quotations from Jack Kerouac's beat epic *On the Road*, where in the end, the odyssey is everything. The snake is poking his forked tongue at this series of images. Kerouac thought of the road as a metaphor for life and Americans' quest for the Promised Land. Alexis thought a snake path

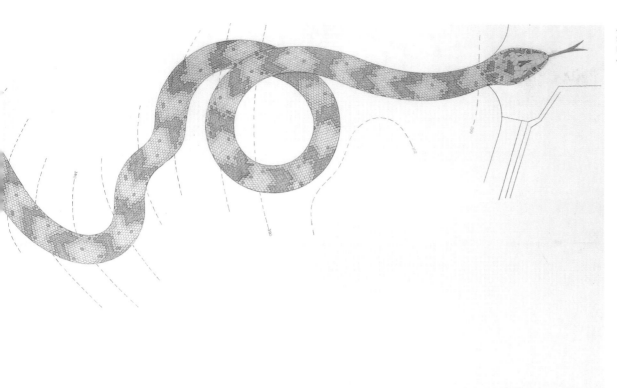

Alexis Smith
Study for *Snake Path*, 1988
Pencil on vellum
4'6" x 12'

could be, in addition to a real pedestrian route, a metaphor both for a real highway and a kind of information highway, a path to knowledge and self-awareness—the tempting serpent of knowledge from the Garden of Eden.

As it happened, the Central Library was about to undergo expansion, and there was an architectural model of the building proposal on display in the lobby. Looking at the model, Alexis immediately saw an opportunity. By January of 1988, she had made a wonderful preliminary drawing of a path in the shape of a snake, extending from the engineering mall up the steep hill to the library terrace. At the base of the slope, the tail of the snake wrapped around a concrete path. Next it wound up the hill, passing a large granite book along the way; encircled a small garden at the top; and then the head, tongue extended, pointed on to the library terrace.

We met with the Library Administration and the Building Committee, and both were enthusiastic. It was unusual for the Stuart Collection to meet with such excitement, but our timing was fortuitous, coinciding with the library expansion. Alexis and Mathieu studied library plans, met with landscape architects, and made revisions and adjustments. UCSD agreed to let us prepare the contour plan for the hillside, and also agreed to underwrite the basic concrete substrate under the tile, as well as items of infrastructure such as electrical service and irrigation.

The plan was presented to the Stuart Collection Advisory Committee in January of 1989. Some members were ambivalent; foundation resources were running low, and money was becoming a real concern. It was also felt that if the path weren't fully resolved, it could end up being quaint. We assured the Committee that we felt it could be carefully done, and after a lengthy discussion they agreed to go ahead.

In 1991, the Mandeville Gallery (now the University Gallery) mounted an exhibition

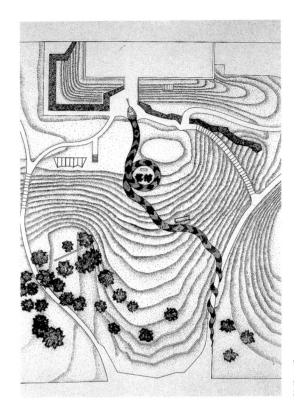

Site study for *Snake Path*,
1988
Schematic drawing
30¹/₂" x 24"

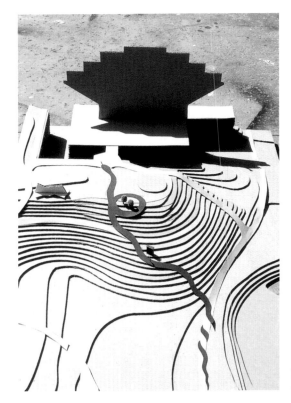

Snake Path site
model, 1988
Cardboard

entitled "Alexis Smith Public Works." The critic Hunter Drohojowska-Philp wrote an insightful essay for the catalogue. This popular show proved a successful way to introduce Alexis and her work to the university and to the community. But as enthusiasm for the project grew, the cost estimates also went up. The size of the path was dictated by the site, and the form could not be reduced without looking ridiculous. It had to be a believable snake. We debated eliminating the book. The tile contract was pared to the minimum. In March of 1991, I rather sheepishly wrote to the Committee that *Snake Path* had taken on a life of its own and "was coming along beautifully. . . . We just haven't figured out how we will pay for it all."

It's not unusual to arrive at a crisis of confidence during the process of commissioning a work. You know that if the work turns out to be fabulous, all will be forgiven, but if it doesn't, you could lose everyone's confidence, including your own. You believe it will be wonderful, but of course you can't see it yet; you can only guess. You know you can't afford to compromise the project for lack of money—preserving the integrity of the work is always foremost in the struggle—but you don't know how to pay to make it the best way either. Torture. I remember pleading with Alexis, by now a good friend, "Please, oh please, make sure it's really good." Of course I knew my pleas were pointless; she would do her best under any circumstances. I was simply trying to unburden myself. But after many fruitless efforts to raise additional funds, we began to feel that the project was a priority for us alone. As often happens in projects of this scale, there comes a point when you just have to get going, with or without the full commitment of monies, and hope that once you start, the momentum will bring in the rest of the funding. Before we completely despaired, Jim DeSilva agreed that we should proceed and came through with additional funds.

A boost to the project came in November 1991, when a major Alexis Smith retrospective opened at the Whitney Museum of American Art, New York, curated by Richard Armstrong. There was some speculation about how New York would take to this West Coast artist's decidedly maverick work, but the opening was buoyant, the reviews were positive, and we naturally hoped that some of the national recognition would rub off onto our project. Although the construction of *Snake Path* had not yet begun, Armstrong had included a drawing of it in both the

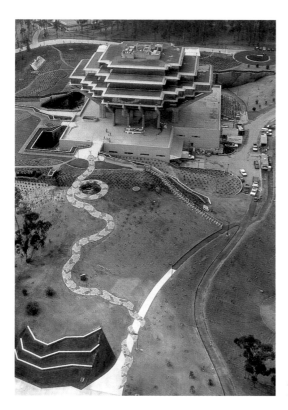

exhibition and the extensive catalogue. The exhibition came to Los Angeles's Museum of
Contemporary Art in 1992, raising the visibility of our efforts.

After much interviewing and extensive contract negotiations, Klaser Tile Company was
chosen and hired. Selections and decisions were made and we were on the way. By December
I was able to write the Advisory Committee that contracts had been signed and *Snake Path* was
under construction. Delays would have increased costs and caused problems. The path had to
be open by the time the expanded library was ready.

This was not a project that could be built and critiqued in the studio. As we proceeded, on-
site adjustments were deemed necessary. The snake as designed proved too long and circuitous;
when we transferred it from a paper plan to the ground, we could see that it wasn't practical.
People would make short cuts, so-called "desire paths." So a new set of working drawings was
created: Alexis cut forty feet out of the length, which meant that the colored tiles representing
the skin had to be entirely reconfigured to make the pattern "flow." A tile shape for the "scales"
needed to be devised that could be somewhat "directional," to make the snake's body believable
as it wound its way up the hill. Mathieu figured some of this out on the computer. He oversaw
the operation on a day-to-day basis and Alexis came down from Los Angeles every week or two.
On several occasions we gathered fellow gardeners and went to nurseries to select plants and
"forbidden-fruit trees" for the Garden of Eden.

When the contractor began the work of laying the multicolored slate tiles, people could
see the creature growing and excitement picked up. The workers also seemed to enjoy a job that
was completely different from anything in their previous experience. One day they arrived
sporting T-shirts printed with "Team Snake."

Jim DeSilva and others saw *Snake Path* as a turning point in the collection's history. It estab-
lished a critical mass in terms of the number of works. It became possible to see the path as cele-
brating the library and learning; the project made a leap in relating the collection to the univer-
sity. The academic community grasped the work's literary references, and also linked it to Bruce
Nauman's *Vices and Virtues*, which is visible from it at night—a serendipitous occurence. I like to
think that when students come out of the library after dark, with both newfound knowledge and

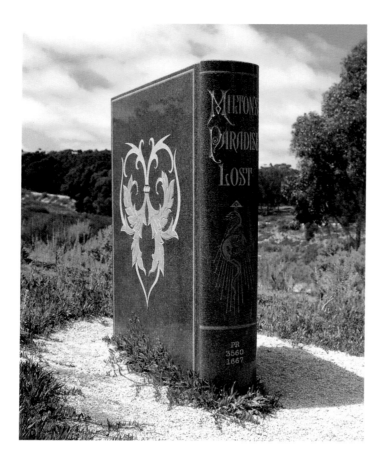
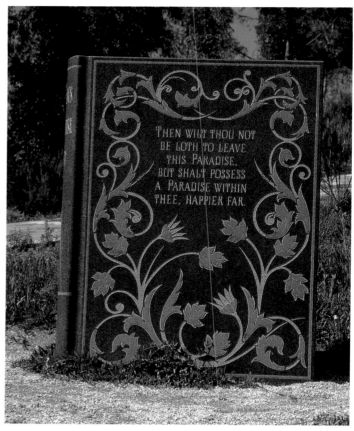

newly lost innocence, to venture down *Snake Path*, they can see just ahead, flashing in the night, the forces they will encounter outside Paradise in the real world—vices and virtues, human strengths and failings, battles of conscience against tempestuous urges.

In 1992, thanks largely to the publicity and good reviews that came out of Alexis's retrospective, CBS did a wonderful story on her for *Sunday Morning with Charles Kuralt*. She was shown foraging for material in flea markets, searching out the castoff stuff of former dreams and desires, which she then rewove, recast, and torqued into a new light and a new context. The program showed *Snake Path* in the works. As a result, CBS reporter Betsy Aaron came to visit the Stuart Collection, and her enthusiasm led to another *Sunday Morning with Charles Kuralt* program, aired in August of 1993. We felt this was a major publicity triumph. Aaron was intelligent and inquisitive; talking with students and faculty, she conveyed a real sense of the impact the art had made on campus.

We were soon to plant the trees in the Garden of Eden: a pomegranate—etymologically a seedy kind of apple, a "*pomme grenate*"; a fig tree; a date palm; and an orange tree (and now an apple). These were to stand for the fruits of temptation and desire that may have lured Adam and Eve from innocence into a state of awareness and knowledge. A reminder of this innocence appears on a granite garden bench, on top of which is engraved a quotation from Thomas Gray's poem "Ode on a Distant Prospect of Eton College": "Yet ah why should they know their fate / When sorrow never comes too late, / And happiness too swiftly flies / Thought would destroy their Paradise / No more, where ignorance is bliss, tis folly to be wise." Look carefully to one side of this inscription and you will see an etched scene of Adam and Eve in the garden, taken from an early print; on the other side is a snake. Looking east from the garden out over the canyons toward the distant mountains, with the huge lunar-lander-shaped library behind, one is reminded of one's small but important place in the universe.

The book was the last element to be added to this grand scenario, but it is the first to be encountered on one's pilgrim's progress up to the library.[1] It is inscribed with Art Deco designs taken from a copy of Milton's *Paradise Lost*. It also has the correct library call number on the spine, just in case a visitor on the way to the library might want to read more than the quote on the front: "Then wilt thou not be loth to leave this Paradise, but shalt possess a Paradise within thee, happier far." This is the Archangel Michael consoling Adam and Eve as they are being expelled from the Garden of Eden. The first touchstone one encounters on the way up the path, the book sets up the metaphor of the university as a paradise from which students will eventually be cast forth, like Adam and Eve from the Garden, to find—or make—a paradise of their own, one made far happier with the knowledge they have gained. The concept of finding sanctuary within oneself—outside the idealistic and protected confines of the university—might speak directly to the student on the verge of entering the "real world." Alexis has taken a cultural myth, so-called classical knowledge, and given it new meaning by casting it into a new context.

The physical experience of walking this 560-foot-long and 10-foot-wide path is critical: the path's surface is crowned, that is, it is convex, the center being raised as a snake's round back would be. (This brilliant idea was initiated by the landscape architects Spurlock-Poirier.) It feels quite different from the usual flat path. The pattern, colors, and sheen of the slate are also snakelike, and the way the path slopes with the hillside—it is not banked for easy walking—makes it difficult even for skateboarders. This seems appropriate for, as we all know, the path to knowledge can be uncertain and uneven—perhaps risky and dangerous. It doesn't take long to figure out that this is a reptile of significant proportions. We are lucky that the slate tile doesn't get slick with the rains, and as it happens, the red tile is shedding slightly, like a snakeskin. In the landscape, off *Snake Path*, we hydroseeded a combination of native plants to match the canyons below, and planted additional larger bushes and several pomegranate trees. Alexis wanted it to be as if the snake had come up out of the canyon, where several species of snakes, including rattlers, actually live. As far as we know, they haven't ventured far enough to visit their over-sized cousin.

The opening was changed from spring 1992 to October. It had been six years since we started on this journey. The American Institute of Architects gave *Snake Path* an Orchid, an annual award for the best in San Diego's planned and built environment. Alexis gave a lecture about her *Snake Path* experience, sharing great insight and a lot of asides. Afterward, a few of us were able to go up in a helicopter to get an aerial view of *Snake Path*. Alexis exclaimed, "Why, it looks just like the drawing." For a brief moment we were back at the beginning.

—*MLB*

1. Mathieu oversaw the making of the large granite book and garden bench at the Cold Spring Granite Company, outside

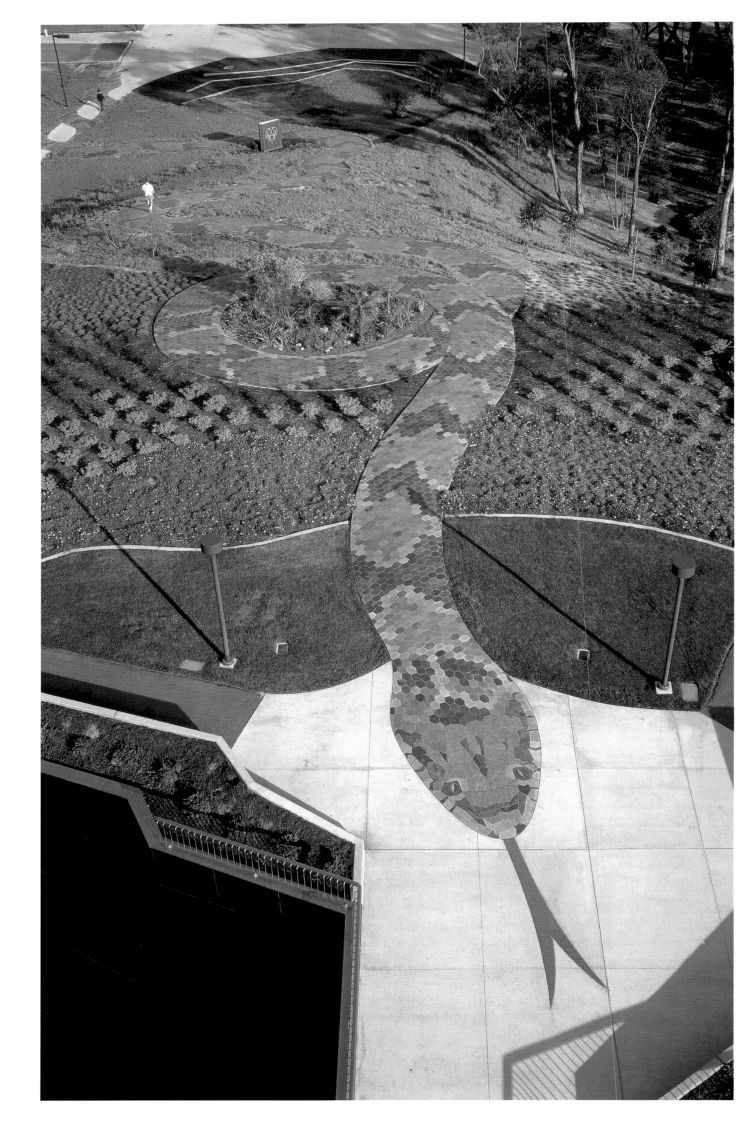

interview

alexis smith

JOAN SIMON: *Though you've used snake images before—in your 1987* Sidewinder *necklace and your 1990 mixed-media collage* Jack, *to name but two—the serpent in your Stuart Collection project seems to come directly from the one in your 1987 installation at the Brooklyn Museum,* Same Old Paradise.

ALEXIS SMITH: It did, actually. While I was installing the piece in Brooklyn, I had a dream of a snake you could walk on. It was obviously related to the piece in Brooklyn, but it was the first time I had ever considered the possibility of making a big snake for the Stuart Collection. Mary Beebe had asked me to do something; there was a possibility of doing some kind of plaza, or something for one of the science buildings. I had come down and looked around, but it hadn't really gelled, I hadn't figured out what I wanted to do. I don't remember whether I already knew about the library site or not. They were going to do an underground addition to the main library and they were going to create an artificial hillside over the top of it, which eventually became the site of the snake. It was a perfect site, of course, because of the biblical idea of the snake and the tree of knowledge, and because the idea of the snake winding down the hill was much better than if it was just going over something flat.

JS: *The scale of the image in that Brooklyn piece is also related to* Snake Path.

AS: It's actually a road that becomes a snake, so it wasn't a very big leap. And it's also big— sixty-six feet wide, twenty-two feet tall. It was painted in the scenic shop at the University of California, Los Angeles. They have these enormous frames, and you can staple huge pieces of canvas onto them, then press a button so that the whole thing goes down into the floor. You can work at the top without standing on a ladder. It was a fabulous facility for doing that piece.

JS: *How do the many "snake" works relate to* Snake Path?

AS: Once I start thinking about some particular image, or even some particular text, it's easy for me to reuse it, because the more I think about it, the more I can see different things it could mean or ways I could use it. It's hard to say what drew me so much to the snake image. I used it initially as the train that becomes a snake [*Sidewinder*, 1987].

I guess I was initially drawn to the sinuous shape of the snake just as a thing in the world, its serpentine nature. That was the first draw. Then I got interested in the scale part—the surface texture. I used it in conjunction with tire treads a few times. They were parallel in a visceral way. First, I used bicycle-tire treads as a printing device for the snake outline in *Asphalt Jungle* [1985], and then truck treads formed a slash across the snake in *Jack. The Holy Road* [1988] had little snakes in it, and tire treads carved into the frame. Then for *Same Old Paradise*, the road actually becomes the snake.

JS: *You've talked elsewhere about* Same Old Paradise *deriving from Jack Kerouac's novel* On the Road.

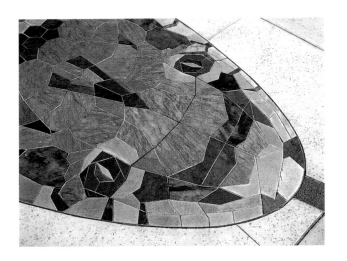

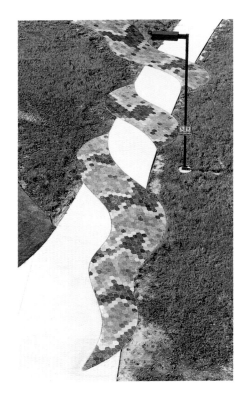

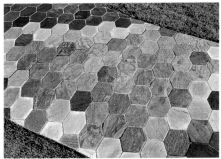

AS: Yes. There's a huge body of work from 1987 to 1990 based on *On the Road*—actually all of my work for almost four years was based on that book. *On the Road* congealed a lot of ideas about American sensibility for me. The whole idea of manifest destiny, keeping moving, constantly westward—those ideas are talked about in a really poetic way in *On the Road*, a book where everything is going to get better, you just have to keep moving. It is a very overt metaphorical use of that idea. The main character is Salvadore Paradise, and the title *Same Old Paradise* is a quote from *On the Road*, and refers to that character. The piece has a giant collage in it, and it's my eight-sentence capsulized version of Kerouac's whole book: California is Eden. There's the idea of moving west, moving toward some kind of promised land, toward paradise. It's a timeless myth, a biblical myth. I personally, curiously enough, am a Buddhist, and I was just getting interested in Zen at that time, which is apropos of nothing but so was Kerouac, and when he was working on *On the Road* he was particularly enthusiastic about it. The book has a spiritual aspect—that your life is the road, and there's nowhere to get to.

JS: If you start your journey along Snake Path *at the bottom of the hill, you soon come upon a monumental granite book, with a quotation on the cover.*

AS: It's Milton's *Paradise Lost*. "Then wilt thou not be loth to leave this Paradise, but shalt possess a Paradise within thee, happier far"—which I take to mean that as consolation for leaving Eden, and for the inevitable loss of innocence and protection that goes with that departure, you have this knowledge that you take with you, which keeps you in good stead for the things that happen to you in life.

JS: At seven feet high, the book is startlingly out of scale.

AS: The thing about it is that everything is out of scale. It's a formal choice. I couldn't have put a little tiny granite book there without having it look like a cemetery.

Actually I don't see you starting at the bottom of the path—I think of you starting at the top, because the research library was the original piece of architecture, and that was unchanged. For me, the piece probably starts at the head. But I don't really think of it having a beginning or an end. It goes both ways.

JS: Paradise Lost *was given to you by the artist Italo Scanga, who teaches at UCSD.*

AS: As a wedding present. I actually took a lot of details from that book. The curling serpent on the spine comes from the Scanga book, and also the Gustave Doré etching of Adam and Eve, which I used on the bench. The Dewey decimal number is the one from the research library, although I don't think they use this number anymore. And then there's the loop.

JS: The snake curls around itself midway up the path and encloses a separate garden, which you have planted as a Garden of Eden.

AS: The loop is as close as we could come to treating the Garden of Eden literally, as they

Alexis Smith
Same Old Paradise
Mixed media installation
20' x 60'
The Brooklyn Museum
October 1987–January 1988

did in the Middle Ages, as if it was a real place. We researched what people thought was in the Garden of Eden. In the original biblical conception it was pomegranates, not apples. Apples were a European perversion; they couldn't grow pomegranates in Europe, because it wasn't warm enough. Anyway, there is a pomegranate tree in my Garden of Eden.

JS: There is also a marble bench, inscribed with the Doré image of Adam and Eve and also with a quotation from another poem.

AS: That's the "ignorance is bliss" text—the flip side of the Milton quote, another country heard from, and it's from Thomas Gray. It reads:

Yet ah! why should they know their fate?
Since sorrow never comes too late,
And happiness too swiftly flies
Thought would destroy their paradise.
No more; where ignorance is bliss,
'Tis folly to be wise.

JS: The Stuart Collection works are referred to as commissioned sculptures, and for this book, appropriately I think, as "landmarks."

AS: They are not traditional sculptures in the sense you usually think of—a sculpture as a big thing that's attached to a base, whether the base is a plaza, at the sculpture's most grandiose, or an actual base. I think that's what most people think sculpture is. I don't know what you'd call things that exist in space if you don't call them "sculpture." I think if you want to qualify it and call it "installation sculpture," that's always fine.

JS: How you structured the snake, its skin, is crucial to the experience of walking the path.

AS: The snake's skin is made out of three colors of slate. Each of the scales, or tiles, is cut

Details of etched bench top in
Snake Path garden

out of a twelve-inch square. In order to make those shapes, you have to make seven more cuts. There are 7,000 tiles and so there are 49,000 cuts just to make the snake scales. The thing about the path is that the imagery only functions at the macro level. When you get to making things like that, the how-to-make-it is way more important than the what-it-is. If you're a conceptual artist and you're making photographs, the what-it-is or the material form is way less than the idea of it. But when you're making something that has to fit into the master plan of the university, and that's 10 feet wide and 600-and-some feet long, that has to be in a nonrepeating pattern, then you're talking about something where the idea is the broad-strokes part. The actual physical making of it, and the process, getting over all the hurdles, that's the hard part.

I'm actually really good at imagining things large. I'm one of those people who thinks that if it looks good small, it'll look really good large. That's just my theory of public art. If it fits into the plan, and really fits in so seamlessly and is so custom-made that it can't be off by a centimeter, then when you actually make it, it'll be so integrated that it'll blow people's minds—perfectly part of your experience of where you are. It has to be a perfectly chosen image, it has to be the right thing for the right place. Every little detail has to be worked out of in terms of the physical making. That's where I put my attention. I don't put my attention toward how the metaphor functions, or the conceptual details, or any of that, which is weird because in my studio work I do all these small things, and those little nuances are really important to me. But when you do this really big stuff, the emphasis shifts to how wonderful the physical experience is, because that's the thing that you care about when you're walking on it. The fact that you could put it in the metaphorical context of the university, and understand how the image works and what it means, that makes it a work of art. It takes brain work to figure that out. That part takes five minutes. The other part, the physical realization, takes six years.

JS: You've said that the piece was interesting for you because "the form and content are the same."

AS: We made the hill. The hill was graded to fit the snake; the snake was then adjusted to fit

the hill. The scales are in a nonrepeating pattern, and one of the hardest things about it was that I couldn't do the snake until I found the tile shape. I finally found the shape in a math book about tiling, which is basically how different shapes fit together—the history of tile shapes. And the only kind of tile that would work for me was a tile that looks kind of like a snake scale. That ruled out 90 percent of the tiles. The second thing I needed was a tile that could change direction, in order to get the zigzag of the curves. These gave you a niche so you could lay them on a diagonal. That made the snake. Until I could change direction, I couldn't do the piece.

JS: When you walk the path, you feel each scale underfoot, and especially become aware of how the snake back rises in the center. The middle of the path is higher than the edges.

AS: It's crowned. That wasn't actually my idea, it was the landscape architect's—Andy Spurlock and his partner Marty Poirier—and it was a brilliant idea. As soon as he said we could crown it, I knew that was right.

JS: Six years is long, even given the fluidity of the Stuart Collection's programming.

AS: These public-art things go on for a long time. If it's small enough to just be insinuated into a building—and believe me, "insinuation" is the right way to think about these things—then fewer people have to sign on to it. But in something like this, it has to be in the master plan of the university. It has to be tied in. The piece wraps around the sidewalk and goes into the plaza. It has to be part of the sidewalk, and be part of the circulation for the whole campus. Every one of those things represents a battle. I wanted the head to be inlaid into concrete, but the landscape architect didn't. Or—after the snake was accepted by the university, and it was part of the master plan, there was a time when the landscape architects for the library suggested that my snake tail wrap around an amphitheater, and I said, "Forget it." It may have taken as much as a year to resolve whether there'd be an amphitheater or a snake. And then there was the issue of wheelchair access, which turned out not to be a requirement since the path leads to the building's terrace, not an entrance.

It's a cross between politics, architecture, and art. A hybrid. It's not like working in your studio. I don't even know how to describe it—so little of it is the idea, and so much of it is about not only the implementation but also the tenacity, on my part and the Stuart Collection's, to establish the limits. Either we're going to do it this way or we're not going to do it, and trying to win every little battle. It has to be this way or it won't look good. That's it.

JS: UCSD is a relatively new university, and a part of the statewide university system. I know you went to UC Irvine when it first opened, and its newness and open-endedness were very important to you.

AS: It was a mudhole when I went there; it was brand new. But I always think of that as part of the attraction. I mean, like America versus Europe—there's the attraction of a place where change is still possible. Where the things that are there are not so important that new things can't supplant them. And that's the attraction of the New World versus the Old, the West Coast versus the East. It's very hard to change things where everything is wonderful, and has a tradition.

JS: You have said of Irvine that such a young university, without significant facilities, brought in the best faculty they could—working artists, visiting critics. In some ways I think of the artists working on-site at UCSD in a relatedly vital way.

AS: That was one of the most fateful and luckiest nondecisions that I ever made. For absolutely no reason, on a whim, I went to Irvine, and it turned out to be the most important decision I ever made in my life.

Bob Irwin and Vija Celmins were my teachers, but I also had Ed Moses and Bruce Nauman. It was a crucible for young artists.

Bob Irwin was probably my most important teacher. A lifelong friend. He has consistently been there. The support was most useful when I was young and weird compared to everybody else, incredibly unfashionable in the years of Minimalism.

JS: Nauman and Irwin are now your colleagues in the Stuart Collection.

AS: Yes, and Bob is a colleague of mine at the Getty Center too. I did a big painted mural at the Getty. The theme of the piece is the convergence of conceptual and aesthetic taste. I used the image of an apple—as presumably the first taste, the first instance of behaviorial tasteless-ness. A fragmentary part of *Snake Path* extended into the Getty.

JS: Some of the Stuart Collection artists I've been interviewing have discussed things that might have gone differently, or changes they'd still like to see.

AS: We have redone the garden, so I actually don't have to have hindsight.

Snake Path under construction, 1991

JS: What changed?

AS: Some of the plant choices. The garden needed to have somebody to maintain it in a more hands-on way. We reassessed the plantings. They were fine at the beginning, and they were kind of metaphorically chosen, but they don't address the maintenance difficulties. We now know how people use the path, and the way they cut across means that we have to plant things and put rocks in some areas so that people don't cause erosion. There's nothing I could have done that would have changed that, but I needed to go back and fix it.

JS: You followed Snake Path *with a number of large-scale permanent installations. Are they related in any way?*

AS: One of the important things about my really big-scale pieces—this piece, and the L.A. Convention Center, and now my piece for the Schottenstein Center in Ohio—is that you can't see them all at one time. They're so large you can never get back and see the whole image. That's a perversity of architecture, of big-scale projects: though you can see snatches, each is in too big a scale for you to take all of it in from one place. You can't ever deal with it the way you deal with a painting or a drawing. There's a level of physical frustration, and you have to extrapolate what the whole thing is like from your experience of the pieces you can perceive.

JS: It seems there are places in the the library, for example, from which you can see Snake Path *in its entirety, if not experience it kinetically.*

AS: *Snake Path* more than the Convention Center or the arena. I think if you go up to the top of the library you can see most of it—there are photographs shot from there. I remember the day it opened, the DeSilvas took me up in a helicopter. And I just could not get over how much it looked like the drawing. It was the weirdest experience, because I was seeing it small again, like my first conception of it.

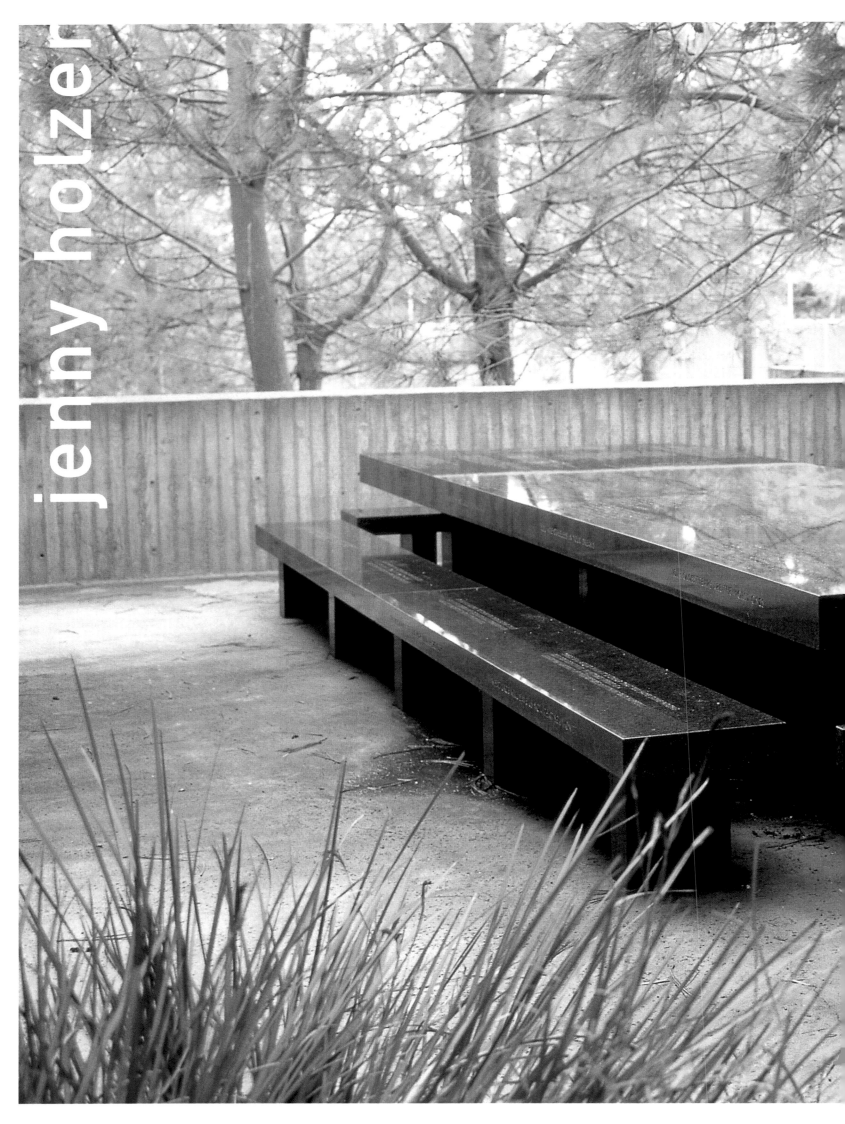

jenny holzer

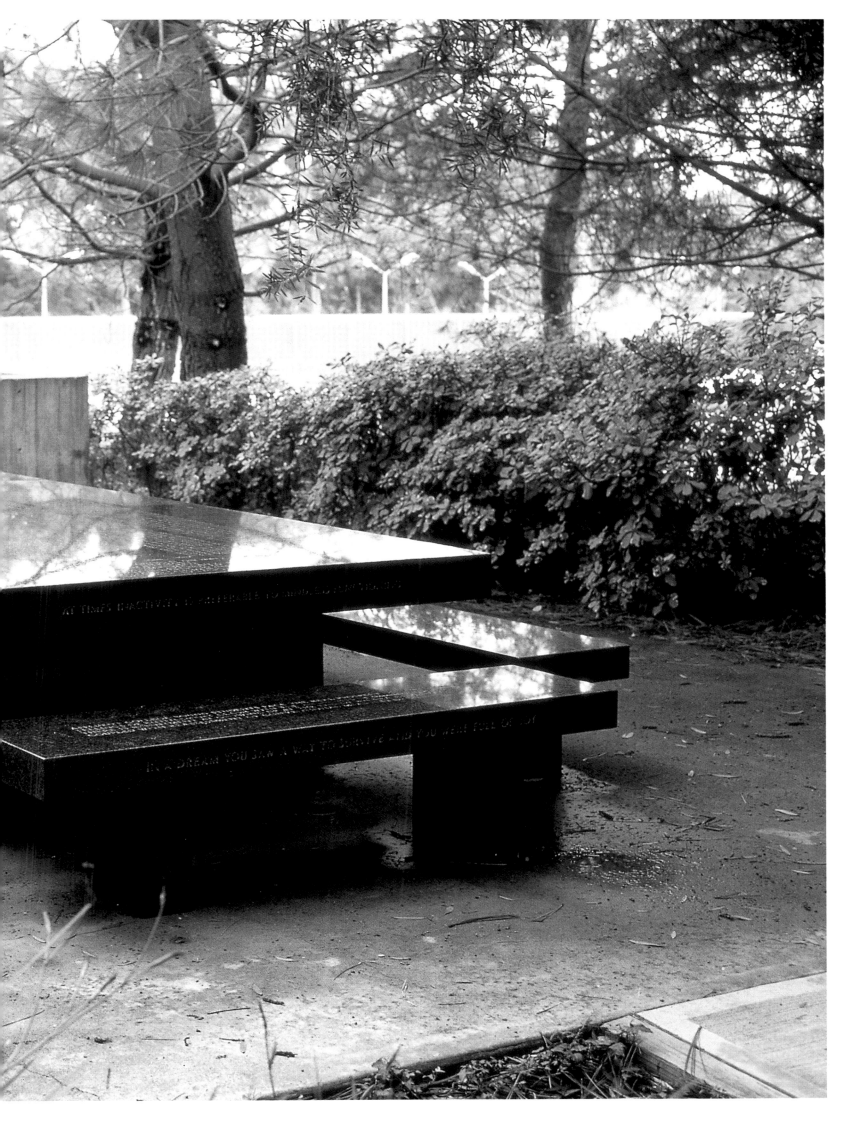

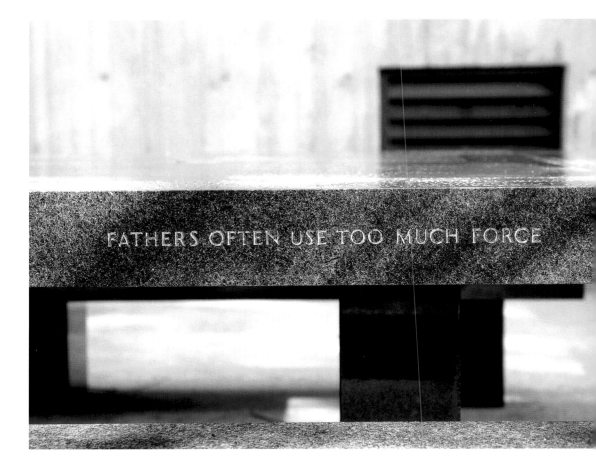

GREEN TABLE
1992

IN TALKING ABOUT ARTISTS WHO WORK with language, the Advisory Committee found the names of Bruce Nauman and Jenny Holzer rising to the top of the list. Bruce first visited in 1983 and Jenny came for the first time in early 1984, when her husband, Mike Glier, had a powerful exhibition of wall drawings at what was then called the La Jolla Museum of Contemporary Art (now the Museum of Contemporary Art, San Diego).

During this first visit Jenny had the idea of saturating the campus for sixty days with her writings—on plaques, in computers, on LED (light-emitting diode) display boards, and on posters. The plaques and one prominent LED machine above the entrance to the Central Library were to remain as permanent elements of the Stuart Collection. At that time the library's computerized catalogue and data base, known as Melvyl, was fairly new, and served seven campus libraries in addition to the Central Library (renamed the Geisel Library in 1995). It occurred to us that Jenny might be able to plug her writings into the Melvyl system so that they would come up at random while the user was waiting for requested material. We felt that the fledgling Stuart Collection had already created an expectation of substance, surprise, and intelligent discourse, and that Jenny's project would be a good vehicle for expanding into new territory.

University and library administrators agreed, some nervously, and the proposal was well received by the Advisory Committee, so Jenny visited again. Meanwhile the library was in the throes of planning for a major expansion, so the idea of locating an LED machine at the entrance was ruled out. A site in the Muir quadrangle arose as a good possibility.

Time passed. At the Stuart Collection we were working on several projects. In 1988 Jenny had a daughter, Lili, and was also busy preparing for a major exhibition at the Solomon R. Guggenheim Museum, New York, to open in December 1989, for which she would transform

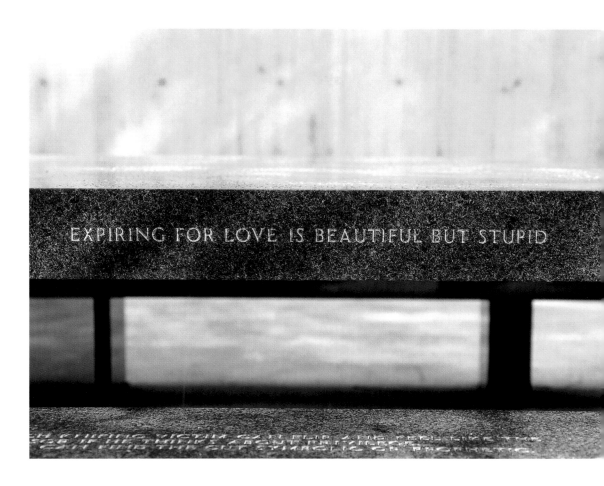

the space with a moving spiral of ascending electronic information. She was then selected to represent the United States at the 1990 Venice Biennale, where her extraordinary installation in the U.S. Pavilion won the show's highest honor, the Golden Lion. She had become a prominent art world figure. Her thinking had moved into new realms, including furniture and entire installations that engage the architecture of particular sites. For La Jolla, in addition to the temporary projects, she now proposed a "garden" of stone tables and benches inscribed with her words.

An absence of arbitrary deadlines and a flexibility in dealing with timetables and priorities are important factors at the Stuart Collection. The conditions we provide often give artists opportunities to think things through in more than one way, and usually mean not having to make decisions under pressure. So when Jenny returned to the campus, in 1990, to determine the layout of the tables and benches, we spent more time on the site. We discussed a number of new options, including a floor in which half of the paving stones would be replaced with inscribed granite slabs. Another idea was a spiral-shaped table, also with writing; and Jenny struggled for a while with the idea of making a coherent work out of ten small tables. Finally, though, she decided these might feel more like isolated obstacles than like a comfortable and inviting place to sit. Monumentalizing an ordinary functional object, she settled on making a single giant table—in fact, she said, "the mother of tables, covered from head to toe with writing like a tattooed lady."

The table—Jenny's first—was to stand on the concrete pad (approximately thirty feet by fifteen) adjacent to a six-story concrete building which is part of the John Muir College Campus. This pad covered utilities for the building, and had always sat bare. One side of the site was bounded by a wall, the other was landscaped with Torrey pines, eucalyptus, and low

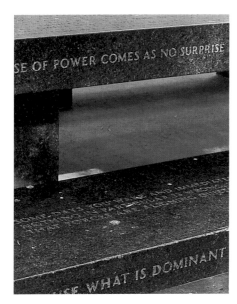

bushes. This area served as an extension of the small Muir quadrangle, which was planted with melaleuca trees whose spongy, peeling gray bark and pale green leaves added a gentle note to the place, softening this setting between the building's severe concrete wall and the garden atmosphere of the areas around.

The table Jenny proposed putting here was of a familiar kind, a refectory or picnic table—but a huge one, twenty feet by six, to fit the size of the pad. The stone, six inches thick, would be durable granite, and a selection of her writings would be incised into the top and sides of the table and into benches on all four sides. A table has many connotations: we come to it to eat, to negotiate, to play, to debate. This would be a table with an added dimension: a table with content to be discussed.

Jenny chose writings from various series: Truisms, Survival, Laments, Mother and Child, Inflammatory Essays, and Under a Rock—sentences that could live together, and perhaps fight from time to time. Most important, they were chosen to be of interest to students, covering many moods from which a sitter could choose. The messages seemed to have been written in various frames of mind—left, right, sad, hot, ridiculous—and addressed AIDS, coming of age, anger with the world, and other emotional subjects. This would be a table filled with a perplexing universe of possibilities, and with that universe's absurdity. Jenny feels that her use of text in her art allows her to treat subject matter directly in a way that many artistic approaches cannot. Her writing differs from poetry in that it is intended to be embedded in an object or sign, and to be set in a specific location.

Although Jenny's writings are often droll, the prospect of a permanent installation of these resonant writings on campus made some university officials uncomfortable: there seemed to be a vague fear of negativity and anger. Some members of the Campus Community Planning Committee wanted veto power over the writing, arguing that their purview was "the environment," which Jenny's text would affect. I responded with concerns about the dangers of censorship at a university, and tried to reassure them that the chancellor, after all, would have final say over the entire project, including the writing. Another argument made was that a stone table would retain the cold, and would therefore be uncomfortable. I replied that the stone would also retain heat from the sun, staying warm. The site was approved.

Now another issue arose: the Office for Students with Disabilities wanted a person in a wheelchair to be able to move directly up to the table. This would have required removing or

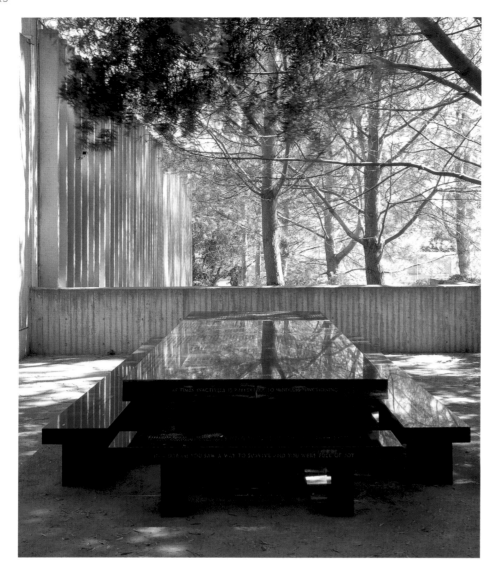

shortening one of the four benches, a compromise that was unacceptable to Jenny. She stood firm, arguing that the work was art first and a table second. Mathieu and I met with vice-chancellors who dealt with these issues in campus building and construction, and who worried that her position could create a serious legal problem. We made the case that art could work with boundaries, but at what point did the boundary take precedence? Granted, even if the piece was intended to take you into your private mind, it would be a public work. But a wheelchair could in fact get all the way around the perimeter, and its occupant could read most of the text, could feel the surface, and could participate in events around the table. We agreed with Jenny that experiencing the work didn't necessarily mean sitting at the table, and that the work's symmetry and integrity would be compromised by eliminating one of the benches or reducing its size. University officials agreed, and even decided they could back us up if it came to a legal challenge. Although not completely happily, the Office for Students with Disabilities also agreed, accepting the argument that this was a work of art first and furniture second.

Even furniture, of course, has to meet engineering standards. Tests were done to make sure that the cement pad could support the eight-to-ten-ton table, and that it would be stable. Jenny selected a dark Canadian granite called Prairie Green. She sent the writings to draftsmen, who first made a paper version of the layout, then transferred it to a rubber mat to be used as a stencil in the sandblasting of the type. The spacing of the letters was carefully manipulated, and there was proofreading at every step of the way. Jenny works with Rutland Marble and Granite, which is based in Vermont. They took over for the actual sandblasting. The finished stones were

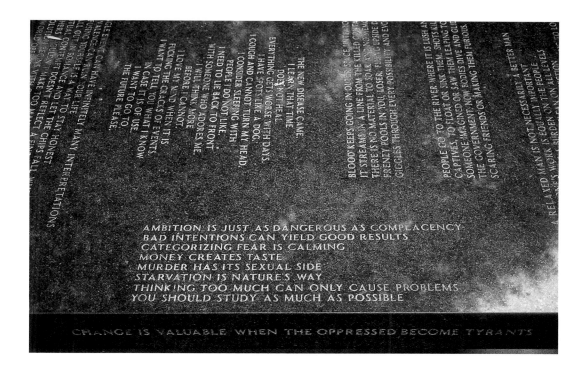

trucked across the country. When Jenny visited in late 1992 for the work's installation, one of her first comments was, "Weren't we young when we started this, Mary?" I had to agree that it had been a long time coming. We set an opening in March 1993 and Jenny returned to New York.

The Russell Foundation was a major donor to *Green Table*, for its board felt that this bold work, with its multiple frames of mind, embodied the spirit of both Jenny and the adventurous art proponent Betty Russell: inviting and provocative, challenging and comfortable, intense and humorous, sensitive and bold, private and public. Jenny returned for the opening, and in order to carry out her original idea of "saturation," we were able, with the help of the Lannan Foundation, to sponsor TV spots, posters, plaques, and LEDs. Truisms appeared anonymously and periodically on ABC-TV and on Cox Cable television for two weeks. We covered several university walls with posters, including one large one in the foyer of the Central Library [now the Geisel Library]. On the UCSD Libraries' main computer catalogues—Melvyl and the newer Roger—daily "messages" appeared on one's screen as one chose a data base. This was to go on for a month or so, but the volume of response to the Truisms became so overwhelming that the libraries' webmaster had to post new Truisms less frequently. LEDs in various places on campus, including shuttle buses, were programmed with sporadic messages. There were signs of Jenny everywhere; for a while, people were continually coming across her subversive texts in unexpected ways.

Jenny's messages are decidedly unusual: they use a voice of authority, the delivery system of advertising and public address, but their apparently straightforward language is deceptive, for the messages speak to complex and compelling life issues. "Protect Me from What I Want" is not exactly a sales pitch. *Green Table* has become a gathering place of faces and moods, a site of questioning and debate as of quiet study, of informal conversation as of festive parties. People hold meetings here, play cards and chess, eat and drink, contemplate. A nice surprise for Jenny and for all of us was the reflection of the trees in the polished stone surface of the table. Also, when these trees produce their pale yellow pollen in the spring, it falls on the table and collects in the grooves of the letters, highlighting them in a beautiful gentle way, as if harsh facts and anxious voices could be tempered for a moment by time and the seasons.
—*MLB*

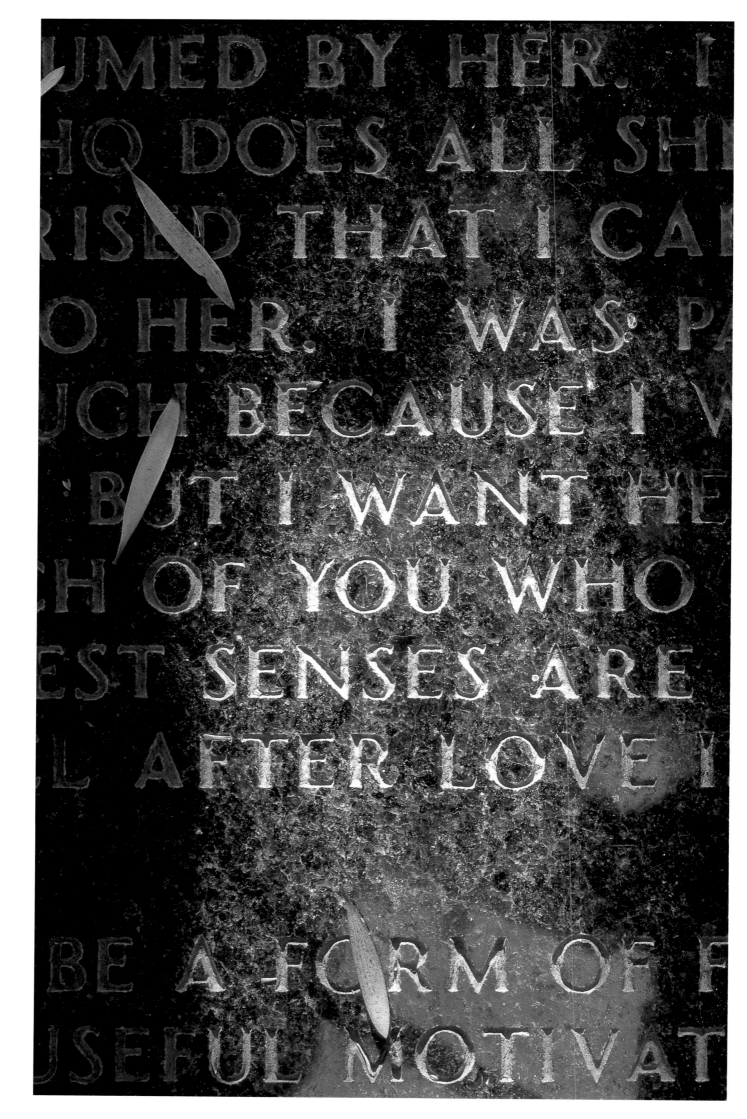

interview

jenny holzer

JOAN SIMON: *What was your reaction to the idea of developing a piece for the Stuart Collection?*

JENNY HOLZER: I was curious, because I was told that Irwin had done something. That was enough to get me there. I also liked the idea of making work at a university.

JS: What had you heard about the Irwin? And about the school?

JH: I heard the Irwin dealt with the sublime, in this case, right under the trees and sky, and I wondered if that possibly could be true. I'd looked at some of his indoor scrim pieces, so I wanted to see what he could build outside. I couldn't quite imagine what he had constructed.

JS: Why were you intrigued by the idea of the school?

JH: Because I'm sophomoric [laughter].

JS: How did the question get popped to you?

JH: Early on, Mary Beebe and I talked, which I enjoyed very much. She's a reason I went there many times. I also admired the DeSilva family, which had much to do with the founding of the Stuart Collection. They seemed happy to meet artists and this isn't always the case. It is relatively rare for Americans to support public art, plus this extended family did things for the common good, such as taking in babies in trouble. After the initial meeting, the DeSilva holiday card has been the first to arrive every year, so this project has had pleasant side-effects.

JS: What did you and Mary talk about?

JH: Art, and the mission of the foundation.

JS: Which was?

JH: To fill the campus with art.

JS: How did you develop the proposal, and when did you first visit the site?

JH: I made several site visits, beginning in the mid-1980s, and had a number of ideas. Once I thought of putting an electronic sign on the library, and I considered having benches under pine trees. I kept coming back, though, to the place I eventually chose, the spot where people might gather.

JS: When I was visiting the campus, someone pointed out that the patio you picked was always there, but no one really knew why it was there. It was a kind of nonzone behind a building.

JH: The fact that food was available nearby led me to the french-fry crowd, and had me hope that they would come to the art, lunch in hand.

JS: It was french fries that led to the idea for a table?

JH: Yes, the idea of a refectory table, for eating and maybe some reading.

JS: That concept has echoes of a monastery, where eating was at times accompanied by texts read aloud. And also to your first room-scaled installation employing the benches, at the Barbara Gladstone Gallery, New York, in 1986, where they were placed like seating in a chapel.[1]

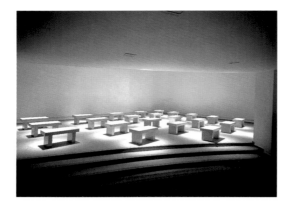

JH: I think my first visit to UCSD wasn't long after that show. The piece for San Diego was the first table.

JS: You decided to do the table. Then what?

JH: I figured out how much text I could jam onto it. I made a tattooed lady: I wanted to cover the entire surface. I went through most every series I'd written by then to find texts for the table and for the bench tops and sides.

JS: How did you make your selections? Were they chosen specifically for the audience you envisioned on campus?

JH: I did try to make the text work for everyone—students, professors, maintenance crews, parents.

JS: The first texts you see as you approach the table head-on seem almost banners, or extended head-lines—three sets of key thoughts for students. Centered on the table edge is the phrase "AT TIMES IN ACTIVITY IS PREFERABLE TO MINDLESS FUNCTIONING"; centered on the bench-top edge, "IN A DREAM YOU SAW A WAY TO SURVIVE AND YOU WERE FULL OF JOY"; and centered on the bench top, "AFFLUENT COLLEGE-BOUND STUDENTS FACE THE REAL PROSPECT OF DOWNWARD MOBILITY / FEELINGS OF ENTITLEMENT CLASH WITH THE AWARENESS OF IMMINENT SCARCITY / THERE IS RESENTMENT AT GROWING UP AT THE END OF AN ERA OF PLENTY / COUPLED WITH REASSESSMENT OF CONVENTIONAL MEASURES OF SUCCESS."

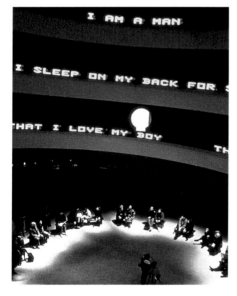

Jenny Holzer
Installation views of *Jenny Holzer* at the
Solomon R. Guggenheim Museum, New York,
December 12, 1989–February 25, 1990

Before you came to the decision to make the stone refectory table, you had at one point an idea for cafe tables and chairs.

JH: First I thought I'd dot tables all through that courtyard. I believed that would animate the zone. Then I went to the idea of a long table, because I felt that, with luck, people would sit there contemplating one another. Another piece that was social, that oriented viewers to each other, was the circle of benches at the Guggenheim.[2] Visitors sat in the round, mostly facing the center. After glancing up to the spiraling sign and the ramp walkers, they might stare across the circle to see others looking back at them.

JS: Visitors to the campus now, in the year 2000—eight years after Green Table *was fixed in its place—would not necessarily know that when this permanent commission was first installed, there was also a temporary part of your project: the many signs that were spotted in various places around campus, as posters, small bronze plaques, and electronic LED machines, all bearing your writings. Your anonymous, idiomatic clichés also surfaced, apparently randomly, as information on the library's computers, and also as fake ads punctuating commercial breaks on television. How did these relate to* Green Table?

JH: I was dripping language around in as many places as I could. I was particularly interested by the chance to insert my text into the library's computer system. The piece was set up so that when somebody went to the library and used a computer, a message would pop up for a short time, hopefully not so long as to irritate. My messages were not attributed, and I wanted this anonymity, and the content to be engaging.

TRUISMS 1977–79

A LITTLE KNOWLEDGE CAN GO A LONG WAY

A LOT OF PROFESSIONALS ARE CRACKPOTS

A MAN CAN'T KNOW WHAT IT'S LIKE TO BE A MOTHER

A NAME MEANS A LOT JUST BY ITSELF

A POSITIVE ATTITUDE MAKES ALL THE DIFFERENCE IN THE WORLD

A RELAXED MAN IS NOT NECESSARILY A BETTER MAN

A SENSE OF TIMING IS THE MARK OF GENIUS

A SINCERE EFFORT IS ALL YOU CAN ASK

A SINGLE EVENT CAN HAVE INFINITELY MANY INTERPRETATIONS

A SOLID HOME BASE BUILDS A SENSE OF SELF

A STRONG SENSE OF DUTY IMPRISONS YOU

ABSOLUTE SUBMISSION CAN BE A FORM OF FREEDOM

ABSTRACTION IS A TYPE OF DECADENCE

ABUSE OF POWER COMES AS NO SURPRISE

ACTION CAUSES MORE TROUBLE THAN THOUGHT

ALIENATION PRODUCES ECCENTRICS OR REVOLUTIONARIES

ALL THINGS ARE DELICATELY INTERCONNECTED

AMBITION IS JUST AS DANGEROUS AS COMPLACENCY

AMBIVALENCE CAN RUIN YOUR LIFE

AN ELITE IS INEVITABLE

ANGER OR HATE CAN BE A USEFUL MOTIVATING FORCE

ANIMALISM IS PERFECTLY HEALTHY

ANY SURPLUS IS IMMORAL

ANYTHING IS A LEGITIMATE AREA OF INVESTIGATION

ARTIFICIAL DESIRES ARE DESPOILING THE EARTH

AT TIMES INACTIVITY IS PREFERABLE TO MINDLESS FUNCTIONING

AT TIMES YOUR UNCONSCIOUS IS TRUER THAN YOUR CONSCIOUS MIND

AUTOMATION IS DEADLY

AWFUL PUNISHMENT AWAITS REALLY BAD PEOPLE

BAD INTENTIONS CAN YIELD GOOD RESULTS

BEING ALONE WITH YOURSELF IS INCREASINGLY UNPOPULAR

BEING HAPPY IS MORE IMPORTANT THAN ANYTHING ELSE

BEING JUDGMENTAL IS A SIGN OF LIFE

BEING SURE OF YOURSELF MEANS YOU'RE A FOOL

BELIEVING IN REBIRTH IS THE SAME AS ADMITTING DEFEAT

BOREDOM MAKES YOU DO CRAZY THINGS

CALM IS MORE CONDUCIVE TO CREATIVITY THAN IS ANXIETY

CATEGORIZING FEAR IS CALMING

CHANGE IS VALUABLE WHEN THE OPPRESSED BECOME TYRANTS

CHASING THE NEW IS DANGEROUS TO SOCIETY

CHILDREN ARE THE HOPE OF THE FUTURE

CHILDREN ARE THE MOST CRUEL OF ALL

CLASS ACTION IS A NICE IDEA WITH NO SUBSTANCE

CLASS STRUCTURE IS AS ARTIFICIAL AS PLASTIC

CONFUSING YOURSELF IS A WAY TO STAY HONEST

CRIME AGAINST PROPERTY IS RELATIVELY UNIMPORTANT

DECADENCE CAN BE AN END IN ITSELF

DECENCY IS A RELATIVE THING

JS: Which texts were on the computers, and did they relate to those on Green Table *and its benches?*

JH: I chose from a variety of texts, mostly short ones, especially the Truisms, so there was some overlap with the table. I was hoping that by placing a lot of writing around campus in many different ways, there would be a cumulative, larger effect, because I can't do narrative.

JS: If there was anything about Green Table *you would rethink or change, what might that be?*

JH: The table's setting is pretty homely, but I feel decent about the work because it's packed with content, and it is functional furniture after all. Although the library-computer piece was not fully developed, I would have liked the texts to stay on the system in some way shape or form. That would have been a good balance, the stone table sculpture in its deli spot, and writing on the computers everywhere.

JS: Were the material processes unusual for you in any way?

JH: We did earthquake-proofing. Not only was it my first table, it was my first artwork that had to withstand tremors. A structural engineer and others were consulted. This was a useful exercise, and began to get me ready for later complicated projects such as the one for the Reichstag, the German parliament [in 1999], for which I made plans with draftspeople, engineers, and architects. Early on I'd been accustomed to making things out of the air, or from paper and wheat paste. The UCSD earthquake engineering was different.

JS: Who shepherded this part of Green Table's *fabrication?*

JH: I worked with my good stone collaborator John Socinski, of Rutland Marble and Granite, who worked with Mathieu Gregoire.

JS: How do you work with the stone collaborator? What kind of preparatory materials do you give him? How do you select a particular stone, the positioning, the lettering, the style of the carving? There are so many factors to consider—how the angles of the cuts for the letters reveal the light; the coloration of the stone's interior, especially in relation to its surface treatment.

JH: Once I've chosen the writing, which has to do with meaning and how many letters will fit, I try to create logical and decent-looking placement and pattern. I need people to be able to read from where they sit, and I want the general appearance of the text to be appealing. Because the table was stone, I chose a dignified serif font called Government, one of my favorites because if I can't be a government, I can look like one. I took the Prairie Green granite over other options because it's dark and figured enough to absorb ketchup and still be lovely. Prairie is a good color since it is nearly black in some conditions and a deep green in others. I was thinking that the green brought something of the landscaping of the quad into the cement plateau. I had the table polished because this repels stains and creates a mirrorlike surface that reflects people and clouds—you can call it an instant O'Keeffe. Once the writing is cut, the stone within the letters is a different color from the surface, and this plus the depth of the cut yields greater legibility.

JS: I know there was a good amount of discussion with Mary Beebe about your ideas for the form of the table, and also about possibilities for its siting.

JH: We went back and forth. There was one idea for a poetic table in a grove of trees. I can't recall what happened to that one, but I remember it was pretty. I think we finally decided the place wasn't trafficked enough.

Jenny Holzer working on text for
Green Table at Rutland Marble
and Granite, 1991

JS: Any other thoughts about how Green Table *turned out?*

JH: I liked when the trees dropped pollen on the table. Everything covered with yellow.

JS: Your "anonymous" voice is still heard in the selection of writings carved into Green Table, *but the work is no longer anonymous in the way it was when you used to wheat-paste unsigned printed posters of your writings around New York in the late '70s, or when you had your texts pop up, unsigned, on the UCSD library computers. There is a plaque near the table acknowledging it as your work.*

JH: My voice in the writing on the table is something like anonymous, because the texts are not attributed, and many of the sentences are in conflict with one another. My point of view, or self, is not quickly available. But you are completely right that the table is not anonymous in the way the street posters were. No one was thinking about art, or about me, when they saw those posters; few had a clue who was speaking or why. The Stuart Collection plaque, on the other hand, identifies the table as art. It's reasonable to identify the table as a piece in a unique collection, and so support the idea and study of public work, but the table would be more mysterious and the sentences would operate more like the originals, at least for the uninitiated, if there were no plaque.

JS: With Green Table *you've made a place to eat, a place where people could, if they wanted, gather in the same place very day. Your table talks to them, giving them a concretization of "food for thought." What about the command "and organize them"? Who is doing this in this new context? You've obviously organized the seating, but is political organizing anyone's job in this situation?*

JH: I provide a place to sit, read books, talk, and eat, plus I supply some byte-sized chunks of ideology, confessions, accounts of awful real-world consequences, and a few laughs. What happens next in politics or in personal life is up to the students. I can be uncomfortable telling people what to do. Dictating usually doesn't work and is lousy. I am more able to say what people should not do, such as rape and murder. I want to believe that most people will attempt the right thing, given a chance, the setting, and enough french fries.

1. These first stone benches, made in 1986, were incised with the texts of Holzer's Under a Rock series.
2. The exhibition "Jenny Holzer" was on view at the Solomon R. Guggenheim Museum, New York, from December 12, 1989, to February 25, 1990. A 530-foot-long LED sign spiraled the Guggenheim parapet, and seventeen Indian Red granite benches, inscribed with Holzer's Survival series, formed a circle on the rotunda floor.

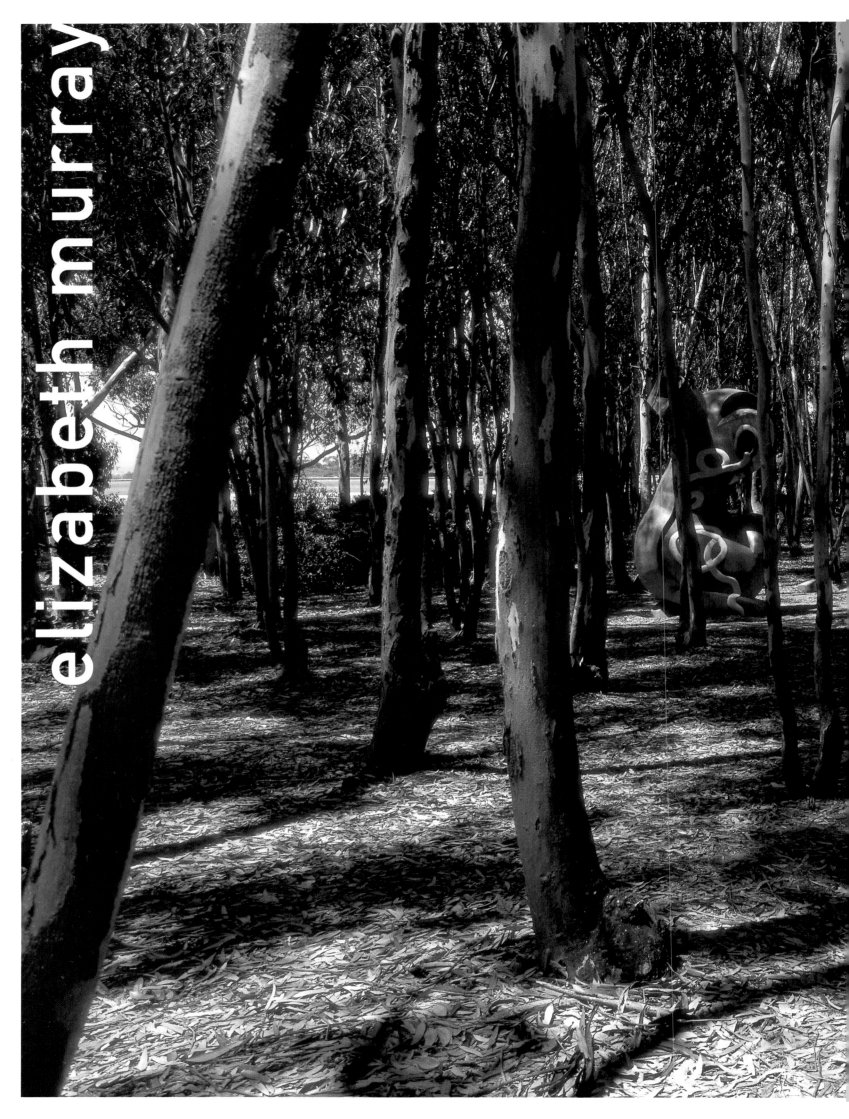

elizabeth murray

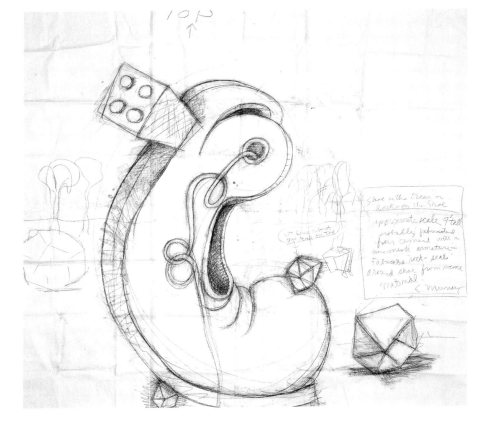

RED SHOE
1996

THE IDEA OF LOOKING TO PAINTERS and introducing evidence of the hand of the artist appealed to us, and in the early 1990s we began thinking about artists who might be willing to lead us into this new territory. Elizabeth Murray, an important American painter, had made some freestanding work early on, but she really hadn't pursued this path. Her powerful paintings, however, had become more torqued and shaped and sculptural. Both physically and conceptually, they were close to coming off the wall; their three-dimensional contours were critical. Elizabeth was challenging the boundaries of traditional painting with compelling passion. Nonetheless, she wasn't exactly a predictable choice for an outdoor environmental-sculpture collection.

Elizabeth first visited in early 1994. We walked around the campus so she could see the existing projects and think about whether this was something in which she would be willing to participate. It's always a pleasure to take artists around the Stuart Collection; they invariably respond very thoughtfully. In Elizabeth's case, her intelligence, warmth, and positive outlook came through—she liked what she saw (particularly Nam June Paik's antimonumental stance in *Something Pacific*) and was inspired to give sculpture a try. Elizabeth seems truly to enjoy the tension of taking on something new and untried, something she's not sure she can actually do. She is an artist who just gets in there and wrestles with it. She has a playful spirit that is part of her creative process.

Elizabeth's paintings most often show domestic objects, such as tables, chairs, beds, shoes, and cups—the things in our lives that are normally stable and calm. But she imbues these things with motion, emotion, energy, and mystery, so that they mutate into strange, nearly abstract wild beings, bursting forth in time and space. At UCSD, Elizabeth immediately thought of a shoe. Having given life to many shoes in her paintings, she now visualized an outsized one run-

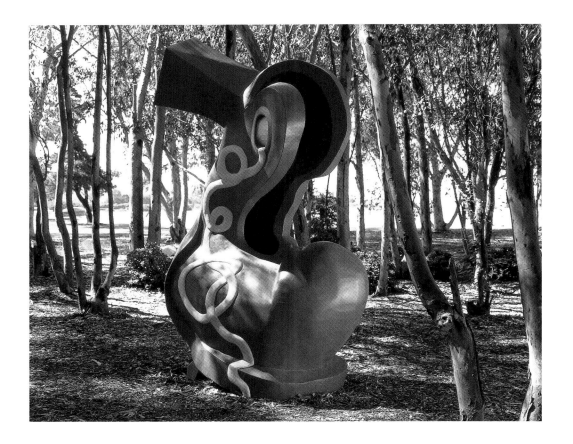

ning through a eucalyptus grove on the edge of the campus. She found the perfect place in a grove between Torrey Pines Road and the Mandel Weiss Theatre, at the campus's southwestern corner. It is a grove that has never been watered, so the trees are small and spindly—perfect for making the shoe feel even bigger. There is an asphalt path, but this is definitely the edge of the university's territory. The shoe would be visible from the road and as one approached the theaters.

Elizabeth later had other ideas, one of which, she said, was a dress "falling up one of the buildings, a dress shape that would have kept it a more two-dimensional relieflike thing without it being a sculpture." Interestingly, she was also about to embark on an extraordinary public artwork for the New York subway system: gracing an interior of the 59th Street station are glass mosaic walls showing a giant tree in a whirlwind, crazy beautiful women's shoes with ribbons soaring, and flying cups. And for us it was to be a giant red shoe up on its toe and running through the woods, with gemlike "stones" strewn in its path. Mother Goose, Disney cartoons, and animated films have all been important sources for Elizabeth; she diagrams fantasy in action, puts image into motion. She gives her domestic objects new life, and an original chaotic humor that enlivens their dramas.

Elizabeth decided to stick to the shoe idea. As in her paintings, in making the object physical she would contrive to knit together conflicting forces: motion and stasis, male and female. Materials were considered and debated. Fiberglass was eliminated because it wouldn't have the sense of touch she was seeking. Mathieu made some stucco samples. Elizabeth visited again in July 1994, with her studio assistant, Warren Kloner. She thought again about construction and considered the possibility of using a twisted eucalyptus branch as a shoelace. Back in New York, contemplating, she decided that painted or colored concrete or stucco would not have the sense

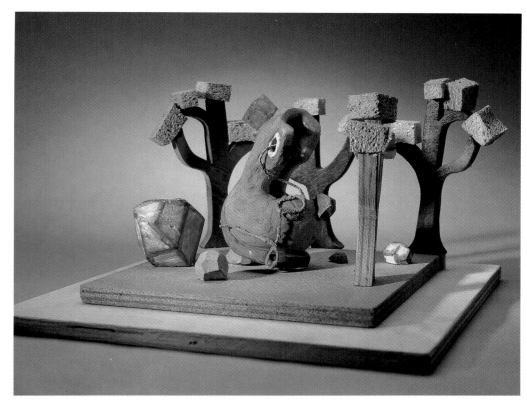

Elizabeth Murray
Study model for *Red Shoe*, 1994
Mixed media

of touch that she wanted either. She started thinking about making the shoe out of wood.

She was already familiar with the medium, since her three-dimensional wall paintings were painted on shaped forms built up out of plywood with canvas stretched over them. Wood has a life of its own—being organic, it would crack like old shoe leather, shrinking and expanding with the effects of temperature. Like a shoe it would wear and get old; it would accrue a history. Elizabeth thought about carving the wood. It could be stained or painted. She was concerned about the quality of the color, and the feel of it. Her paintings brim with sensuality and action; she struggled to bring that feeling to this shoe. So many decisions: we saw that the shoe would develop as she went along, just like her paintings. It would be more a product of its making than a description of something.

Elizabeth sent us a charcoal drawing on taped-together sheets of bond paper. Made to scale, it was eleven feet high. She had done it standing on a ladder in her studio, and you could feel her stretching and reaching—feel her pleasure in the act of drawing the voluptuous forms of this very round shoe. It already felt alive and afoot. She also sent a little carved and painted maquette, with awkward wood-and-sponge trees to represent the copse of eucalyptus. There was one of the "gemstones" sitting on the toe of the shoe; it later went to the ground, where it was joined by several others.

We chose cedar as the most durable and pliable wood. As Elizabeth didn't like any of the stucco- or epoxy-type materials, the shoe would be wood, glue, and nails. It would be as high as she could make it in her studio—nearly twelve feet. Warren would do the construction, using the same technique of building up layers of wood that he used to make the grounds for her paintings. Once the strips of cedar were laminated they would be carved. The outside of the sculpture would be smooth and softly contoured, the interior, which would be left open for small children to climb into, would be rough and unfinished, revealing the history of the construction process. The work took a long time, and Elizabeth got somewhat frustrated. Mathieu and I visited her in New York: this monster was taking over her studio. It was a struggle. We

waited in California and tried to provide both moral and physical support. When Elizabeth came back to Los Angeles several times to work on a print series at Gemini, I went up to visit and watch; it seemed clear that these prints were more fun than the troublesome shoe. She hired someone to help Warren.

At last the shoe shaped up, emerging as a full-blown dynamic red creature. The truck picked it up from the studio in early 1996. Once it was delivered, Elizabeth came out to finalize its placement. Electricity was installed to provide night lighting. Elizabeth returned for the actual installation and the opening. The crane operator thought the shoe looked like a duck; from a certain angle it did. It is both abstract and real—at first sight you aren't sure what it is, but you know it's something. There is something quite sexual about it, and also romantic—something to do with its combination of a private, hidden space and a public and participatory role.

Red Shoe looks strange and mysterious from Torrey Pines Road. Audiences coming and going from the Mandel Weiss Theatre will catch glimpses of it—relevant for both tragedies and comedies. It is lit, but not strongly, and unless you know, you can't quite figure out what that peculiar red object in the woods is. The nearby asphalt path is mostly traveled in the mornings and evenings as people enter and leave the campus.

The shoe has become a favorite for children of all ages. Little ones can climb on top or into the interior, which becomes a nest, a fort, or a boat, where the making is revealed. It's just a bit scary, but the Mother Goose quality evokes thoughts of childhood rhymes and animated films. Questions arise: where is it going? Where is its mate? It seems to be running away, but from what? There is both a certain angst and a sweet humanity. As *Red Shoe* has aged, slight cracks have appeared. Some have been repaired and repainted, but the piece still feels a touch worn, maybe even sad. It has a life. You can sense that there is a story here, with more to come—a story that will play out in a range of dramas.

—MLB

interview

elizabeth murray

JOAN SIMON: It was probably a surprise to you for someone to ask you to make a sculpture, but maybe not a surprise to anyone who's watched your work. First your shapes were burgeoning to break loose from the canvas, and then the shaped canvases themselves started to come off the wall.

ELIZABETH MURRAY: Was it a surprise to you?

JS: Not really. Sooner or later I thought they were going to totally break out. The ballooning forms and fragmented planes might move fully into 3-D, become free-standing, or become some kind of suspended animation. One day I thought it could happen. What about you?

EM: I never seriously thought about it, and when Mary talked to me about it, I just immediately thought "Yeah—I'm going to do this, no matter what." I just sort of intuitively wanted to. And I liked Mary. I went out there and saw the collection, which I think is one of the most interesting sculpture collections—or whatever it is. I looked at what she had done, and looked at the campus, and the whole thing.

Of course the campus is ugly—to me. I guess there are a few interesting buildings. But to me, what was amazing, which I don't think anybody's talked about really, is that the whole thing is transformed architecturally and spatially by what has been done by the artists in the collection—who are not all sculptors. A lot of the stuff there I think is more like installation than sculpture, like Alexis Smith's piece, which I think is one of the high points. I don't know if I would call Bruce's [Bruce Nauman's] piece on the building—another really good one—a sculpture. There's just really very little traditional sculpture around. So I felt completely excited by that. Whatever I did, I just knew I could think about it in any way I wanted. I thought more about environment, and I found this spot in the eucalyptus trees, sort of on the edge there, which maybe says something about how I felt about making sculpture [laughs]. It just seemed right. So I made a little model and I did it.

JS: You fixed on this particular grove, which is in an odd spot.

EM: Yes, it is in an odd spot. It's in an ugly spot, really. It's close to the theaters, but it's not related to any building. And it's definitely in a place where you can go in and out of the campus. It's right close to the edge of the campus, the outer boundary.

JS: The model you made is fascinating—

EM:—The model's the best part, I think [laughs]—

JS:—the way you used, for example, cut-up chunks of kitchen sponges for the tree foliage.

EM: It was fun. It was like being back in grade school, which was really sort of how I approached the whole thing.

JS: How did you proceed once you'd picked the site?

EM: Right away I got the shoe image in my mind—of putting a walking shoe in the forest.

Elizabeth Murray working on
Red Shoe in her studio

It seemed a good thing. And that was what I stuck with the whole time. Once they liked the model, the project went forward, which was really different for me, I have to say. The problem I had with it was that once it was decided it would be this shoe, and I did all the planning, it was not organic like a painting. For me anyway. Maybe because it was the first time I worked in sculpture. I mean there were changes I made once it got going, but the thing about a painting is that at any time you can scrape the paint off and you can start over again, which is what I do. I can change how the work gets painted, or I can move a shape, or I can take it apart. And this was harder to change radically, partly because, this was what we had agreed upon. This was how it would look, they liked it, and so forth and so on.

JS: Once the form was fixed, the idea was approved, then what happened?

EM: I always thought that I'd make it in wood, and that Warren [Kloner], my assistant, would make the structure for me. They were giving me a certain amount of money to do it, and—well actually, I take it all back. My first thought, what I really wanted to do, was make it in stone. Have it made in pink granite [laughs]. That was what I wanted. Without any coloration at all except the granite.

JS: No painting by you.

EM: No painting by me. Just to really do a sculpture. And then it turned out that that seemed to be way beyond the budget—that it would cost twice as much. So I just dropped that idea and went to the wood. And Warren said, "Oh, piece of cake, no problem." But it was extremely difficult to figure out. And it turned out to take a long time. Once it reached a certain place, it was very hard to go back into it and change it. It took a number of tries. It had to be dismantled, and we hired a second person to help do it. Building that piece in wood was a real exercise in wood engineering. I felt committed to do it, and I really wanted to see it built. I found out later that if I had been computer savvy, or if Warren had, we could have really figured it out on the computer. But I didn't have any idea, really—I guess it occurred to me along the way, you know, "Would that be possible?"—but I didn't follow through. Now I know we could have figured it out, and probably even have made it in granite, for the price. But this is what it became. The wooden shoe.

JS: You finally constructed a wood shape that visitors could look into. The open, shifting form was fixed. But did you, at the last stages, and also typically for you, work and rework the painted surface?

EM: No. The surface was very worked and sanded, but the surface was unlike my paintings. I didn't paint on it at all the way I paint my paintings; I covered it in paint the way a house painter would cover a house with paint.

JS: In terms of the palette, you've talked in the past about the kinds of paints you pick, and how you can get different tones of colors from different qualities of paint. The more expensive oils, for example, have more pigment in them, the less expensive have less, are duller, and tend to fade. What is the paint on this thing?

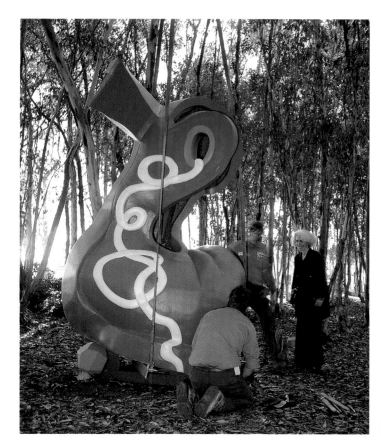

Elizabeth Murray during the
installation of *Red Shoe*

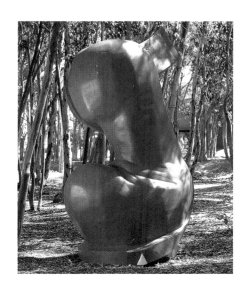

EM: The paint on it is a very high-quality Benjamin Moore latex paint because, here's the thing, in California they have strict environmental rules about what kind of paint can be used. You can't go out there with a bucket of oil-based enamel anymore and paint something, especially on a university campus. I had to think about—and Mathieu Gregoire (who is great, by the way, he was fabulous to work with) had to think about—a way it could be repainted whenever it needed it. I'm not sure how many times it's been repainted, but it has been repainted at least once, I think. I wanted it to be very simple—they would just go out there when it got scuffed up and slap a coat of paint on it. The best part for me is how that paint is going to thicken it and change the lines in it. So I picked a house paint that they could use.

JS: That's also why there is none of your painterly surface handling on it. Someone could repeat what you'd done with this overall coat of house paint.

EM: Yeah. I never imagined there would be surface handling on it. That wasn't a desire that I had for it. I wanted it to be a really basic, simple sculpture. A thing.

JS: This thing is a shoe, an image you've used many times before.

EM: Yeah. And many times since.

JS: What was it about this shoe landing in the middle of a grove?

EM: I guess it seemed romantic to me, and pleasant. And like a little walk through the eucalyptus grove.

JS: Something that's hard to see in photographs, and that I didn't know was part of the piece until I visited the site, was a set of what someone called—and I'm not sure if you call them this—"jewels" scattered about. The sculpture is not just a single shoe.

EM: There are three rocks, I think.

JS: What's the relation of those to the shoe, and when did they come into your overall scheme?

EM: I guess they're not in the model. At one point I was going to have a different kind of shoelace, which was going to extend and fly away from the shoe. And then Mathieu kind of said, "Forget about it. Because somebody is going to break it off. It's going to be a constant problem."

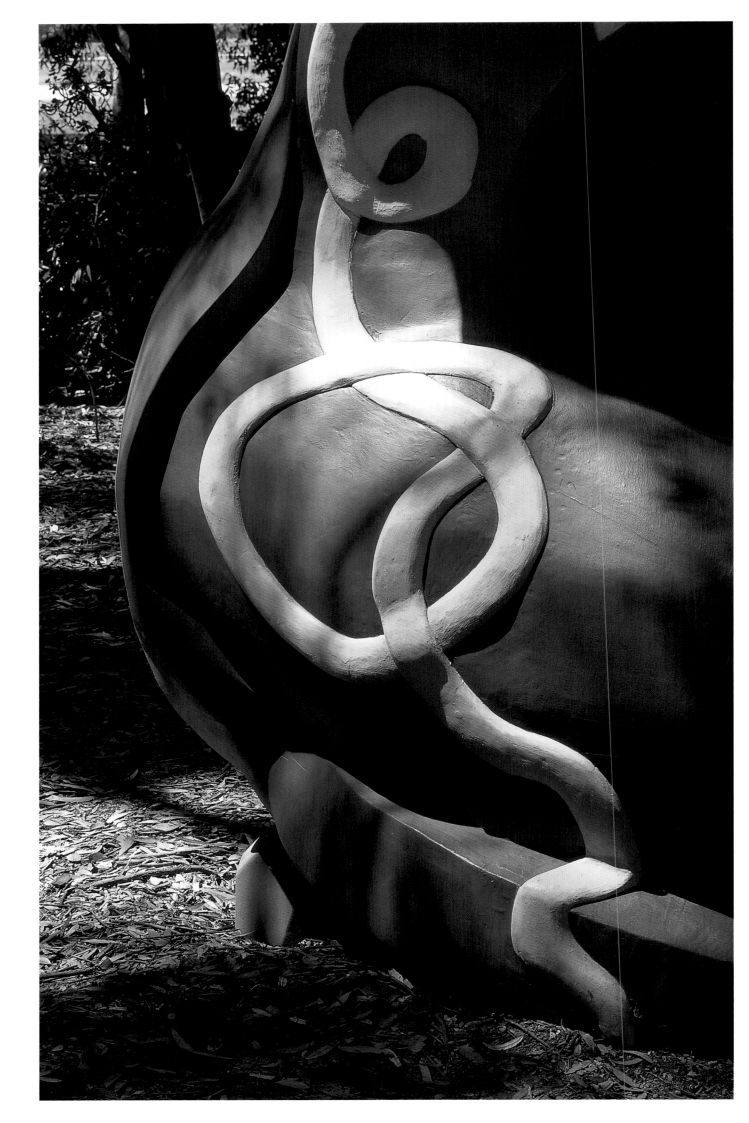

So I put the lace against the shoe and just built it out in relief. But the rocks seem like places to sit around the shoe. Or just a way to transform that very sterile ground with something. It's kind of silly. The part I like best is that there is something silly and funny about it, and that I think feels real. I haven't seen it for a long time, but I know people crawl on it. And it activates that little part of the space there on the campus.

JS: In a 1999 interview you talked about the relationship of your work to dreams. You said, "I hardly ever dream about painting. But I think my paintings are a kind of dream, and about dreaming."[1] Your images do seem dreamlike, changing, shape-shifting. Not stable forms.

EM: In terms of the shoe?

JS: This shoe is more animated, more twisted around itself, more distorted, than some of your other shoes.

EM: It's more contorted. The toe is more bulbous and sexual—really phallic—and the opening is really female. When I saw that, it felt more cartoony than I wanted it to be, but there it is. It's interesting to have something out there—because I've never felt this way about a painting—that you feel kind of uncomfortable about, and that you can't really do anything about.

JS: Is this because it was a new form for you, or because of the process?

EM: I think it was a new form. And I didn't really understand all the possibilities. I work very spontaneously, and when they accepted the idea, and really liked it, I sort of went on ahead with it really quickly. But I think that's what everybody does, I don't know.

JS: Part of the process at the Stuart Collection is that there is a good amount of time between that immediacy of finding the idea and finally building the work. How long did it take you?

EM: It was a couple of years.

JS: You've talked before about your spectrum of sources, or how your images come up—from the immediate domestic or studio landscape, which includes cups and saucers and shoes, to particular historical references, whether van Gogh's boots or Philip Guston's clodhoppers.

EM: Well, I think there's that. I didn't really think about it. Those kinds of shapes were just in my work. It would be hard say how I arrived at feeling like I wanted to paint a big shoe, but once I had done it, and made the painting, I immediately related it to Guston. But, you know, there it is. It just seemed like a very compelling image to me. I think emotionally and symbolically the shoe refers to masculinity. It's a father image, or, according to Freud anyway, it's phallic. So there's that. But I don't know how much of that is there. Consciously that's not the least bit what compels me about it. It's just an interesting image, a set of shapes to arrange.

JS: Would you want to make another—

EM:—sculpture? I don't know. I guess I would like another crack at it. But I'm not out there looking for it [laughs]. If I could do anything like sculpture right now, I'd go back to Mary Beebe and do another piece there. I'd take a couple of pieces of plywood and cut them out in several forms kind of like a dress shape and slap it up against a very ugly building and let some ivy crawl up it, and paint it—with thousands of coats of Benjamin Moore.

1. "Turquoise All Along: Elizabeth Murray Interviewed by Bob Holman," in *Elizabeth Murray: Recent Paintings*, exh. cat. (New York: PaceWildenstein, 1999), p. 6.

kiki smith

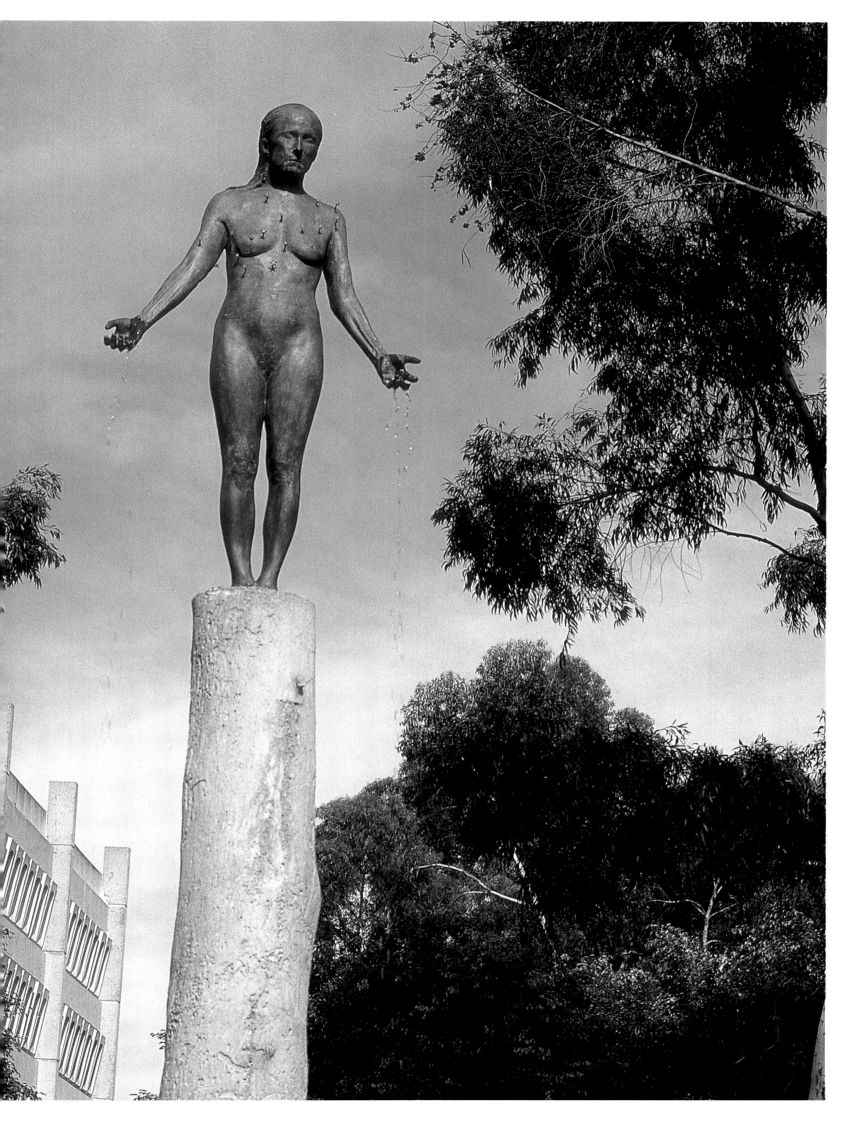

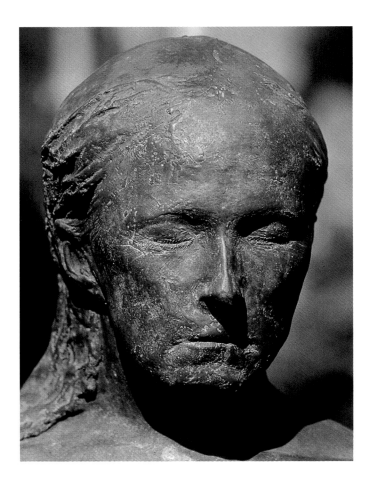

STANDING
1998

IN 1992, AT THE FAWBUSH GALLERY IN NEW YORK, I saw a truly haunting exhibition by Kiki Smith. There were the most delicate aluminum fairies dancing across a wall, and figures: a white plaster torso with bluish glass branches for arms, representing Daphne, who, in classical myth, hid from Apollo by turning into a laurel tree; the biblical Lot's wife, made from plaster and salt; and a flayed Virgin Mary with veins of silver. Kiki made the stories of these women mortal and spiritual in a tactile and gripping way. The work was brutal and tender; it used the physicality of the body to talk about other things—about how the body functions socially, how we experience it. The exhibition was unforgettable and I felt we had to invite Kiki to look around the campus. Her work was so fresh, and totally new territory for the Stuart Collection. The Advisory Committee agreed.

Kiki visited in September of 1993. Thinking about what she might propose, we were excited, intensely curious, and, to be honest, mildly anxious. Her focus on the body—its strength and its fragility—as a vehicle for ideas about life and death suggested the School of Medicine as the obvious territory. Kiki was quiet as we walked. She has a somewhat distracted and sometimes fragile air about her as she moves through the world, sensing details that she usually keeps to herself for some time. Then her words can come out like a string of beads. Completely uncensored and candid in her responses, she is also determined and single-minded when it comes to the bigger picture. In this she is rather like her work, which is often oddly delicate and ethereal in its details but cuts right to the core of an extraordinary idea with awesome and sometimes disturbing poignancy.

Mathieu had made a discovery that we were eager to show Kiki: in a classroom he had found some very old papier-mâché models, écorchés, probably made in India and still used for anatomy lessons. They were constructed with overlays that could be peeled away to reveal lay-

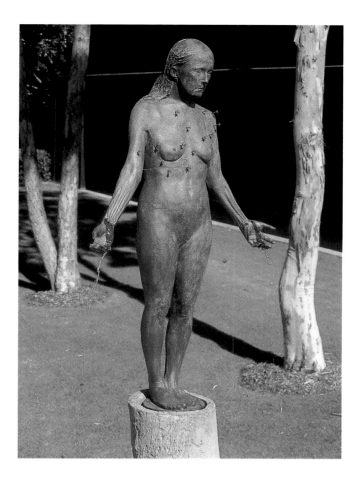

ers of skin, muscle, organs, nerves, and bone. Beautifully hand colored, they were also bug-eaten and full of holes, which just seemed to add to their story. Because Kiki's work on paper has a vulnerable and revealing surface or skin, we thought she would love seeing them, and she did.

A large portion of the School of Medicine takes the form of a group of clinics and hospitals located in Hillcrest, a neighborhood near downtown San Diego, far from the La Jolla campus. We, of course, preferred to stay on the main part of the campus, but inspiration about a site was slow to come. Kiki did not want any of the obvious places for a sculpture, she wanted something intimate—a place to be discovered. We wandered and explored; no location felt quite right. I dejectedly wondered if it was hopeless. Kiki probably did too.

Some months later Kiki sent us a simple and rather crude drawing on two small sheets of odd-sized paper pasted together. What she proposed was a "traditional" sculpture: a female nude atop an eighteen-foot column. The column, made of steel, was perhaps fluted, and felt Indian or Persian. The figure was made of anodized aluminum. She had no skin, so that her musculature showed, and she stood with her palms facing outward, the common pose of statues of the Madonna. From the hands fell red veins, like maypole ribbons. The work was definitely visceral. Vines grew up the column, perhaps green in spring and summer, red in the fall, losing leaves in winter—changing with the seasons.

In early 1994, without identifying a site, we presented this proposal to the Advisory Committee. I noted at the meeting that the work had "both a very beautiful, triumphant, celebratory sense as well as a quieter, almost painful one." We discussed its connection to the Hermetic tradition, to the Christian tradition, to civic monuments such as Egyptian obelisks, and to heroic ones such as the statue of Admiral Nelson in London's Trafalgar Square. The committee members also talked about the pose of the martyr Saint Ursula, and even of the

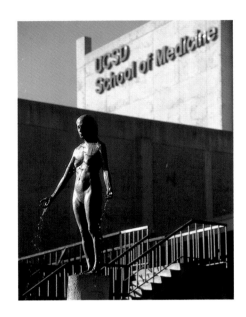

stylites who, in the fifth-century Middle East, spent years living and preaching on top of pillars. The committee saw a powerful possibility and a strong move on Kiki's part.

We discussed and suggested locations. The committee saw Kiki's proposal as a move away from site-specific works, and something of a change in philosophy for the collection. Were we just placing monuments? What was the work's relationship to its context, and how would it enter into a dialogue with the university setting? The final sense, though, was that this was a great project and would support whatever philosophical adjustments were necessary.

When Kiki returned in the fall we were determined to find a site. Scouring the School of Medicine, Mathieu and Kiki came across a path with a strange kidney-shaped island in the middle of it. This appealed to Kiki. It was a nondescript place between the three-story concrete-and-stucco Basic Sciences Building and the smaller, lower, brown-wood Medical Teaching Facility. It was a left-over space mitigated by a few eucalyptus trees. Sloping lawns opened into a wider lawn area bordered by a road that led to a cluster of outpatient clinics and parking lots. The spot seemed to have the quiet intimacy and sense of seclusion that Kiki was seeking. The work would be seen from the road, but at a distance; the area was busy between classes but quiet at other times, when people sat on the lawns to rest or eat, or played the occasional Frisbee game. These contrasts of private and public were just right for an artist whose work explores the differences between self and other, the social and the personal, what we can control and what we cannot. Kiki left with a sense that she had found her site, and we set about the necessary groundwork with a feeling of relief and possibility.

I went to see the associate dean of the School of Medicine, Ruth Covell, who had been supportive of the Stuart Collection. I explained what Kiki wanted to do; that she was an important artist on the rise; and that her work was about the body, and so was appropriate for a medical school. Ruth was hesitantly enthusiastic, but anticipated some resistance. She took me to see the dean of students, whose blessing she thought would be important, but who expressed serious reservations—especially about the figure's nudity, which she felt could create negative response. This was surprising to me, since her students were obviously learning as much as they could about the human body; maybe Kiki's work would promote some healthy discussion. The dean of the School of Medicine, John Alksne, meanwhile had a genuine curiosity that seemed to propel his interest and support.

We next went to a School of Medicine Faculty Council meeting, bringing with us photomontages showing the sculpture in the site we were proposing. I explained that the work would be in the mode of a classical figure, but since it was to be cast from life, it would not be idealized, in the style of classical or Renaissance statuary, but a real-life figure—the kind they tried to heal every day. With this open and generous gesture, Kiki seemed to be saying that one can endure vulnerability with dignity and without being diminished. I also noted that she was still contemplating the exact look of the column and deciding whether the figure would rotate

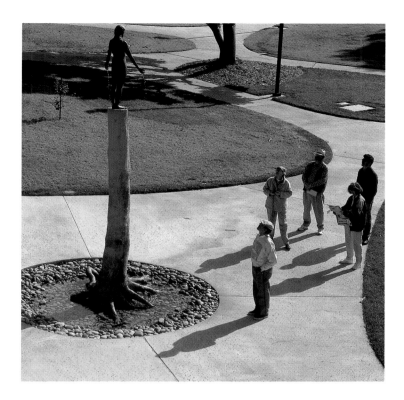

(an idea she considered for a while). The council asked a few questions but expressed absolutely no objections; one might even say there was enthusiasm. The group was nearly all men. I left feeling elated, but wondering whether, if Kiki had wanted to make a male nude figure, things would have been different.

Kiki was to figure out the work's artistic aspects, Mathieu the technical and mechanical aspects; I was faced with finding the funds. The Stuart Foundation was nearly depleted. We calculated an estimated construction budget and secured contributions from friends and past donors, but it wasn't enough and we struggled for the next few years.

The piece was cast at the Art Foundry in Santa Fe, from the body of Peg Wood, a friend of many artists in the town. Peg was a small woman in her mid-forties, with a lovely modest body, but not a young one. She was sick with cancer at the time, and subsequently died. Kiki was sensitive to Peg but understandably didn't want the fountain to be a memorial; the figure was meant to be more of an Everywoman. I visited Kiki at the foundry and saw the first pieces of the bronze figure, which was truly beautiful—dignified, serene, ageless, not smiling but serious and perhaps in certain lights even dour, with a touch of melancholy, not sexualized in any way. The Madonna-like pose brought suffering to mind—part and parcel of human existence, either one triumphs over it or one doesn't, but one's response to it is crucial. Here we were contemplating life and destiny.

I suspected Kiki would do something more with the figure, but there was no telling what that might be. Her first idea had been for a fountain with three figures, one peeing, one vomiting, and one with milk spewing from its breasts. The orifices of the body, the places where the world passes into and out of us, had always played a prominent role in her work, which, however, was now turning away from the body to the wider world of flora, fauna, and celestial phenomena. Her approach to art—and to this project—seemed to be to experiment, to move on.

Now Kiki decided that the column should take the form of a tree trunk. We embraced this idea and set about looking for a dead tree in a good shape. Mathieu found several and took photographs from which Kiki, now back in New York, made a selection. She returned to confirm her choice. The tree was then dug up, roots and all, and delivered to San Diego Precast

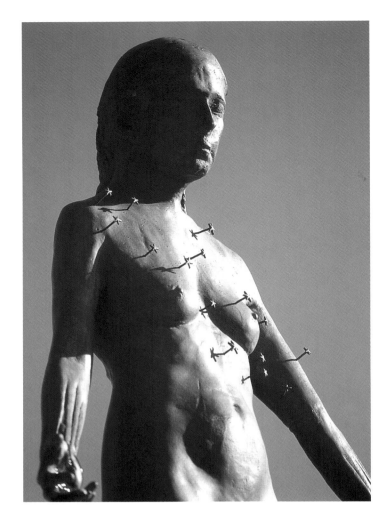

Concrete, where, not surprisingly, no one had ever cast a tree before. They put the project in the hands of their expert mold-maker, who set about the long and delicate process of making the mold, spraying layers and layers of green rubber well into the summer. This took longer than expected; once it was finished, there would be only one chance for the pour. The pressure was on. We couldn't afford any mistakes because we had set the opening knowing that our construction "window" had to be either Christmas vacation or summer, when there were fewer people around. The School of Medicine wanted as little disturbance as possible but we had to dig some major holes and disrupt the flow of foot traffic. When the pour finally came, there were fears at first that it hadn't gone well. But the concrete set, the mold came off, and a few patches later all was well. Great sighs of relief.

The veins falling from the statue's hands in Kiki's original drawing were to be realized as steady trickles of water dropping into a pool at the base of the column. Contracts had been negotiated for this pool, and things were well underway. Mathieu made all the construction drawings for the intricate details of the water system, and met with Kiki to test them. The internal pipes had to be configured in such a way that the water didn't spurt out as if from a ruptured vein. We were also concerned about splashing and wind. Some of this had to be worked out ahead of the actual installation.

The figure was carefully patinated, and was finally ready for the Art Foundry to ship. I spoke with Kiki by telephone just before they sent it off, and she said "Mary, I've made a little surprise for you. I thought she needed something pretty." From the beginning I had wondered when this moment would arrive—when Kiki's edge would enter the picture. When our beautiful bronze lady reached San Diego, we saw that Kiki's craft sensibility had come forth: she had added little bronze stars, cast from starfish, pinned like an elaborate necklace across the figure's chest. The starfish were placed in the shape of the constellation Virgo, which Kiki had some-

where seen depicted as a woman pouring a jug of water. They were incredibly poignant, a bit disturbing—stabbing, puncturing like needles, suggesting acupuncture or tattooing or pinning a butterfly—and so vulnerable. Once again the skin is fragile, it protects, but only so much. At the same time, a great cosmic connection is made—a tie among the earth (trees), the heavens (stars), and the ocean (fish). The figure stands, her strength drawn through the tree from the water, which returns, constantly replaced—a life cycle. She becomes both celestial and earthly. The starfish are hard to make out from the ground, and some people see them as nails. They may add a touch of violence, but also a mystery.

On the appointed day, the concrete tree was craned into place and the figure was hoisted to its top. The water was turned on and the figure looked as if she'd been there forever. During the installation a number of people expressed how deeply moving they found the sculpture to be. (A few others were not so pleased.)

We had refined and reconfigured the pathways around the site to extend the arterial imagery. We had also planted more eucalyptus trees on the sloping lawns. It is amazing how the cast-concrete tree embraces them, the nonliving tree making you notice the living ones. The exposed roots look like arteries. The molding is sufficiently sensitive to show beetle trails in the surface of the original tree (which the beetles had probably killed), and these become a kind of memory of that insect life, and seem like veins or capillaries as well. At the public opening, Kiki sat on the grass, shoes off, blithe and relaxed. This being her first public work, she was amazed at the strength of people's responses, and was thrilled to see hummingbirds drinking from the sculpture's streams of water. *Standing* had taken its place at the School of Medicine, and Kiki was eager to do more outdoor public sculpture.

—*MLB*

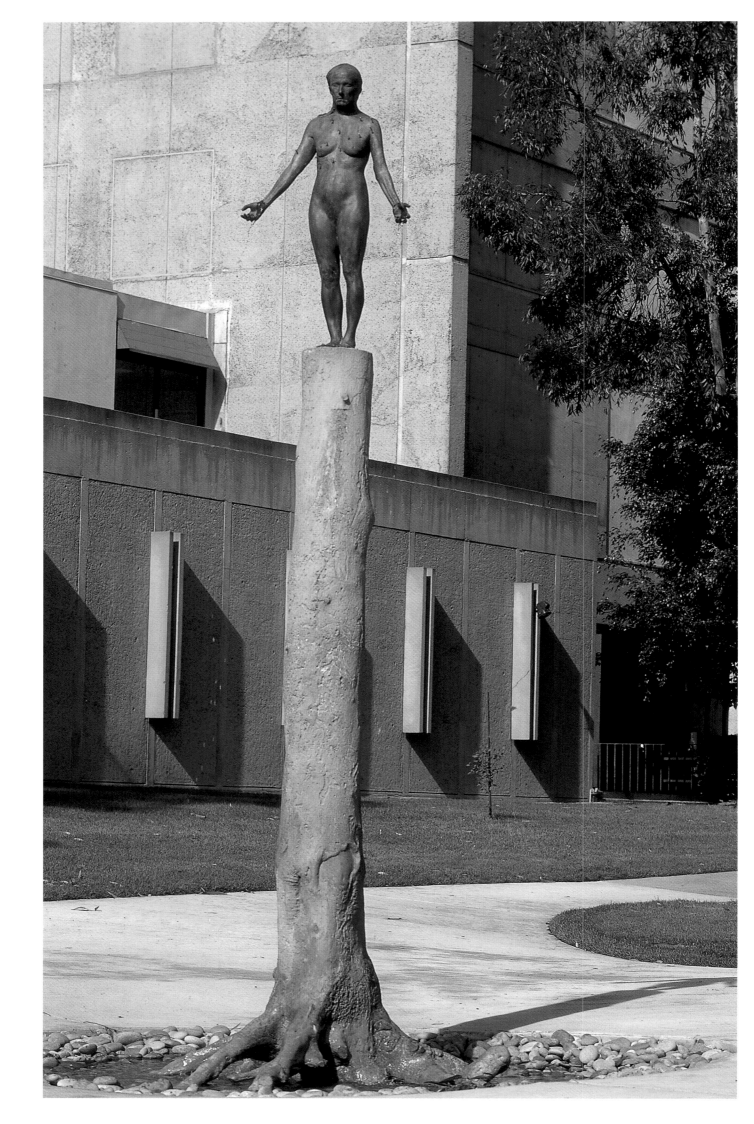

kiki smith

JOAN SIMON: Is Standing *your first permanent public sculpture?*

KIKI SMITH: Theoretically, yes. I made something once for an outdoor park, but it was temporary. Mary Beebe called me up and asked me if I wanted to make something. I said OK. Then I went and saw the collection. Probably for me Bruce's [Bruce Nauman's] piece and Nam June Paik's pieces were my favorites; I really liked the Nam June Paik piece—how modest it was. In any case we visited the medical school and inside the school was an écorché, an anatomical model of a body in India-made papier-mâché. It was a beautiful crafted model of a man in an elegant pose, and it was carefully hinged to open and reveal the internal organs. It had small holes in it from bugs. It was no longer being used, and it was going to be given away. I recently made three color etchings from an image of the head. The écorché had been used for a medical teaching model; I thought I'd make something in relation to it.

JS: Was this decision made after you picked the site near the medical school?

KS: No, I picked the site later, because it was so anonymous. It was just a pathway from the parking lot between buildings. I first saw the écorché, then went back to visit the campus twice. The second time we picked the actual space.

JS: Then what?

KS: Then I made the figure, in New Mexico. I was making a lot of Virgin Mary sculptures based on the écorché tradition at the time—you know, like a woman standing with her arms open, in a generous stance. I was also looking at a book, maybe it was Mongol sculpture, and there was a large basalt column. I thought that was nice, a column space. And I had been in Berlin, at Charlottenburg, in the garden of a Schloss. There was a row of trees broken by small sculptures on top of columns. The sculptures were smaller than life-size. The columns were about six feet high, maybe less, and the figures were smaller. Normally when people make outdoor sculptures on columns or on buildings they tend to make them larger than life. I thought when I saw this to go the opposite way. I always like making people smaller than myself, because their forms then seem more abstract .

I thought I'd cast a woman who was about five feet tall. In the process of casting, things shrink. Through each process you have shrinkage. I wanted her bleeding out of the veins, like rays coming out of her hands. We improved the design of the pathways. They weren't really integrated with one another, they were kind of cumbersome and klutzy. And so I worked with Mary and with Mathieu [Gregoire]. We improved the design of the pathways, and tried to design a path with better flow. That was very satisfying.

We used a tree as a column. We picked it from some of the dead eucalyptus in the vicinity. And we used river stones underneath it, so that the water drips into a stone basin and it's recycled.

Kiki Smith
Honeywax, 1995
Beeswax
15½" x 36" x 20"
Collection Milwaukee Museum of Art

Écorché papier mâché model
UCSD School of Medicine

JS: The Virgin Mary sculptures you were making at the same time, were they specifically religious or spiritual figures? Or are you talking about the stance itself.

KS: I'm interested in physiological stances—the idea that in taking poses, poses make, inform, the psyche. That it's a dialogue back and forth, so that if you open your arms out, in a sense you open your body, you expose your body, you open your body. It's a revealing and encompassing stance. It makes one vulnerable.

JS: In this sculpture you're also revealing what's under the skin.

KS: That was from the écorché. I had also done this with the Virgin Mary sculptures, showing the flesh beneath the skin, the muscle structure. I just made it very subtle: I slightly carved on the wrists and on the backs of the calves to the ankles. I showed a slight understructure.

JS: You carved into—

KS: —the wax. First I made a cast off someone's body. Then I made a wax of that. Then I manipulated that wax and I made another mold off of that. And then I manipulated that wax. And then I cast it.

JS: Standing also in a sense embodies a memorial to the specific woman who was the model for the sculpture. It's not something someone would know coming upon the work on campus, and I only learned about it in talking with Juliet Myers, who lives in New Mexico and was an intimate friend of this person for many years.

KS: The woman I used as a model I would have used anyway, because I had used her several times before. She was forty-eight when she died, and this was less than a year before that. She was a person studying to be a social worker. I had met her in New Mexico, and I liked her looks very much. She was physically a very strong person but a very quiet, plain-looking person, or quiet-looking person. And she was sort of small, which I liked. She was very attrac-

tive to me as a model. I used her several times and then she got sick. And then, in a way, I thought it was nice to use her because she was dying, and it was nice immortalizing someone in another material. When she was modeling for this one, she knew she was dying. There is a poignancy in doing that. She died of lymph cancer.

The last time we worked, when we cast her body, it was too much for her to cast her head, because she didn't have hair and she was just too sensitive. We ended up using a head from another sculpture cast from her, which is moving in a different gravity, so it makes her mouth go down slightly, but I liked that.

JS: What were some of the other sculptures she modeled for?

KS: One was called *Honey Wax* [1995]. That cast was also used for a piece called *Scalpel Body* [1995]. And then I made bronze heads with coins attached [*CoinHead*, 1998]. I don't know what else besides that. When my sister died I made death masks of her, and it made me realize how you have an attachment to people's bodies, which are the physical form of their spiritual life, or their personalities, or whatever. One has attachments to different shapes of bodies, or forms of bodies, or specific bodies that are separate, and that can exist. You can have the affection for them just in the form. Maybe that's why people like figurative sculpture, because you can have that same sort of sentiment to the form as to the actual living people.

JS: Did you ever study anatomy?

KS: In a home-made version. For about ten years, I looked at *Gray's Anatomy* and other things every day. I also studied once to be an emergency medical technician, out of curiosity. That's how I studied anatomy. I've never studied it seriously.

JS: The last thing you did to the Standing *sculpture was to add—*

KS: —In the end I added constellations to the surface. It took a long time to make the

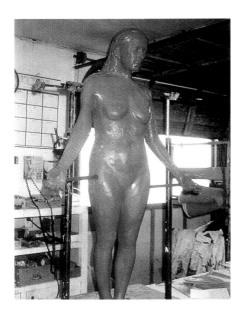

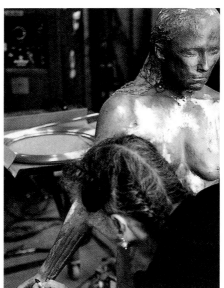

Top: Wax model at foundry
Kiki Smith working at the
Art Foundry, Santa Fe,
New Mexico, 1997

piece—I got a vision of what I would do, but then they had to do fund-raising and permission-getting and all the different bureaucratic things of making something. So it took, really, about four or five years. And by the time I was making it, I was into making these other pieces, the constellations. And so, as an afterthought, I thought I'd put them on the figure, like tattoos. I was also having myself tattooed with constellations, and I thought I'd like to add tattoos to this figure, as a kind of private joke. I was also making casts of small starfish. So I put those on the surface of her body.

JS: Why did you position them like that—raised above the surface? They're used like the heads of pins. Each pin is tacked into the body, creating a point-to-point mapping, a cluster of starfish.

KS: First I did the constellations seen from the northern hemisphere, and stamped them into the surface of the body, but it was too subtle. You couldn't see it from more than a foot away. So then I did these. I just chose off the top of my head, "Well, make it Virgo, for the Virgin, because she's like a Virgin." It was funny, because it was her sign actually—the astrological sign of Peg [Wood, the model]. So it's the Virgo constellation on the surface.

JS: What about the rootedness of the work—you found a dead tree, recast it, and anchored the sculpture into the ground through its roots. It's an incredible way to work the bottom of the base—

KS: —To expose the roots, so you see them growing down. I suppose you could say I used two dead things to make a live sculpture, and reanimated them with the water. The tree was dead. Peg Wood was dead. Both are reanimated by the motion of water. The water is not a big cascade, it's more like a drip. Lots of my work I acknowledge is about the reanimation of dead things.

JS: When did you decide that the sculpture would be a fountain?

KS: Someplace halfway through. Whether somebody else had the idea, or I got interested myself, I don't really know. I know I made one other fountain, a tooth fountain—the top palate of the mouth turned upside down, so you can see the nasal cavity and then the teeth.

JS: Other sculptures of yours have involved leakages from the body: in one piece glass beads that suggest a trail of blood, in another glass tears.

KS: Which I like. I like oozing out over the world. Mathieu figured out the technical aspects that would make it work.

JS: For example?

KS: How the tree should be cast. Getting engineers to figure out the water. Figuring out what was possible in rerouting the paths to be more economical and graceful. He helped with every aspect of it.

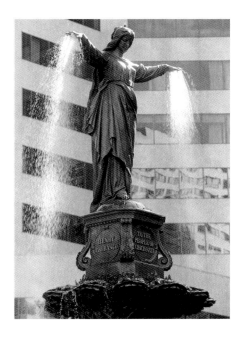

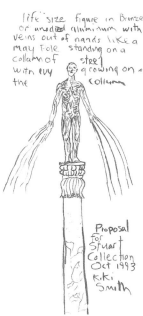

Top: August von Kreling
Tyler Davidson Fountain, 1871
Bronze and granite
Fountain Square, Cincinnati, Ohio

Bottom: Proposal for *Standing*, 1993
Watercolor and pencil
19" x 8½"

JS: Is there anything you would have done differently?

KS: I don't know. I thought maybe I would have put it someplace even more inconspicuous, but in a way it gave life to a dull place. I went to Guatemala about ten years ago, and I remember thinking that water is the center of towns—in the center of the towns were wells—and that women in general show up in the world moving water around. Water activates spaces. It makes a space a real space. The site I chose is a slope where people can sit and study. I thought, What do you have to do to activate or enliven a transit space so that it becomes a pleasant place for people to hang out? I don't know if that happened or not, because I don't live there. And I know some people thought the piece was morbid—like a suicide, or your life oozing out of you. I know that's part of my work—I'm a morbid person. I like the ambivalence of things, that there can be a lot of different connotations.

JS: Each aspect of it works, down to the timing of the drips. Slow, intermittent.

KS: At first I thought, Oh, it's a sin to make a fountain in Southern California. Ecologically it doesn't make sense. And then I was seduced by my ego or something to see what it would look like. Also there's a fountain in Cincinnati that played a part. It's a very large fountain downtown, something like a Virgin Mary or a Diana, I don't know what, with water sprouting out. The idea for *Standing* came out of that also.

JS: The groves of trees are the signal of this campus. Robert Irwin's piece stands high within a grove, becoming one with it. Terry Allen reused and resurfaced eucalyptus trees, animated them with word and song. You made a concrete cast of a tree. A visitor wouldn't necessarily know that your column is cast from actual—

KS: —But it is. From actual nature.

JS: And from the immediate landscape. Like Terry Allen's, your project is made using a dead eucalyptus tree found on campus.

KS: Terry is coming from the desert, I'm coming from the East Coast. What you notice is different. The eucalyptus tree is a strange thing. It fits into all these ecological arguments: it's not an indigenous plant, it was very invasive in California. It has shallow roots, so it's delicate. It's fast growing but doesn't last long as a tree. If you go someplace you don't have a relationship to, it's interesting to see what you pick up on, what you notice.

JS: The trees you and Terry Allen used had died and then were salvaged.

KS: Maybe in a sense this is my Catholic reliquary, which maybe comes from earlier ideas of, yes, saving the dead, keeping the dead around. Trying to immortalize the dead, to give life to the dead, regenerate the dead.

JS: Is there anything I've neglected to ask you that you'd like noted about Standing?

KS: No. Thank you. I'd forgotten why I made it and this reminded me of some of the reasons.

WRITE THINK DREAM

john baldessari

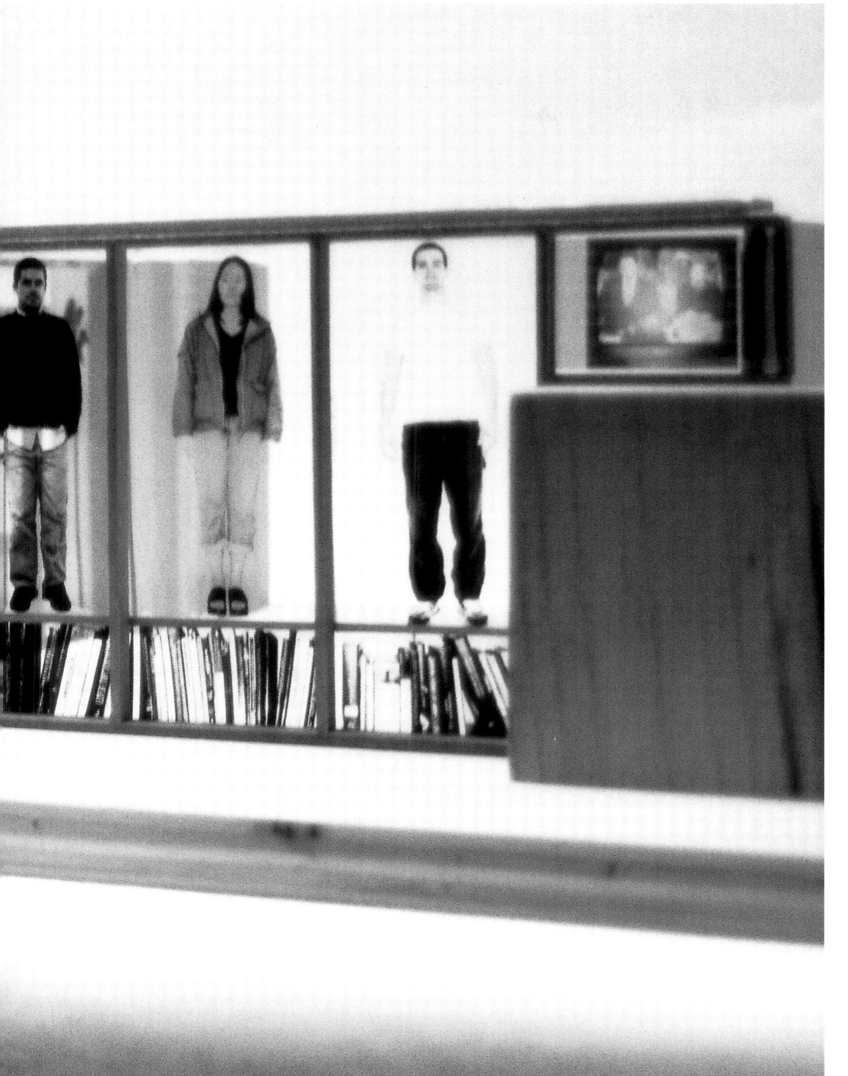

READ/WRITE/
THINK/DREAM
2001

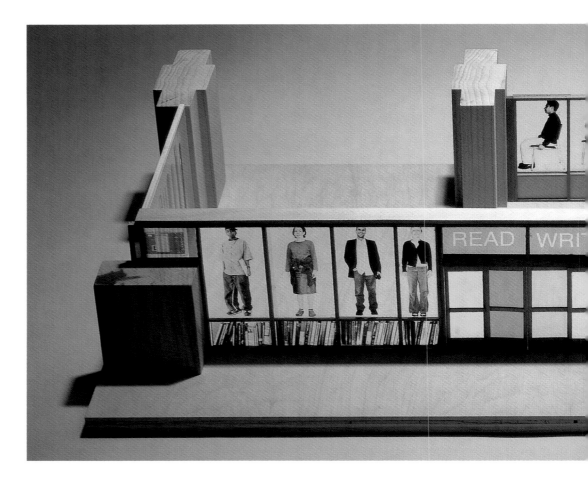

JOHN BALDESSARI IS AN IMPRESSIVE FIGURE—very tall, a lot of white hair, and an amiable demeanor. He can't be missed at the openings and art events that he faithfully attends, more than any artist I know, out of curiosity and friendship. John is not known for outdoor public work; he is internationally respected as a conceptual artist who often works with images taken from old Hollywood black and white movie stills. He has also been an influential teacher, encouraging the breaking of rules for over thirty years.

John grew up in National City, just south of San Diego, and taught at UCSD and other local schools and institutions before moving to Los Angeles to teach at the California Institute of the Arts and UCLA. Having invented a completely new approach to photography, he had been on the Advisory Committee's list for some time. A 1971 work consisted of writing on canvas again and again, as if in punishment, the pledge "I will not make any more boring art." Before he made this phrase an artwork it was a challenge he posed to his students, who, in 1971, wrote it all over gallery walls for an exhibition of a new and different kind. We knew John was a good candidate for the Stuart Collection.

Even so, John isn't a sculptor. When I first called him, in 1994, he sounded surprised. But he agreed to make a visit, and came with doors in mind. He had thought a lot about Ghiberti's famous fifteenth-century bronze doors for the Baptistry in Florence, which render Bible stories in high relief, teaching the moral lessons of the day. John's work too involves lessons, but they are questions rather than answers; through surprising combinations of pictures he prods the viewer into open-ended puzzles. In thinking about a project for the Stuart Collection, John was considering (as he always does) the acquisition of knowledge in our own day, and how he might address that subject by translating images from movie stills into bronze.

We searched the campus for significant doors. UCSD architecture, however, is varied but

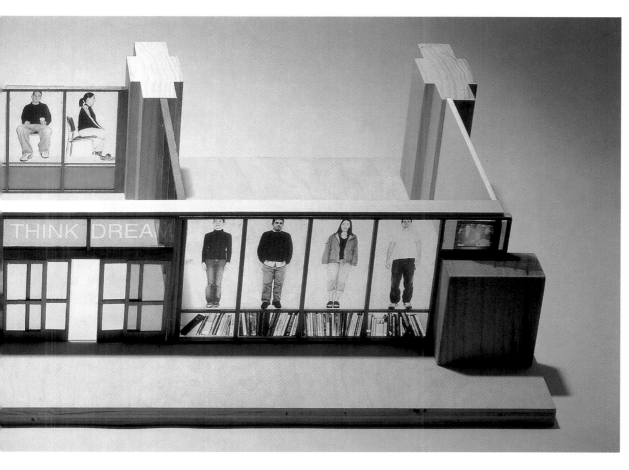

John Baldessari
Study model for
READ/WRITE/THINK/DREAM, 2000
Mixed media

practical, and clearly influenced by the California setting, where the climate is conducive to being outdoors rather than needing indoor lobbies and grand entrances. The most notable doors we found were in the entrance to the university's main repository of books, the Geisel Library, a landmark building designed in the late 1960s by the California architect William Pereira (who designed a number of buildings for University of California campuses), with a 1992 expansion by Gunnar Birkerts. The library administration was intrigued by the possibility of an artwork that could transform their entrance and foyer into a more provocative and interesting space.

John and Mathieu struggled for some time with the challenge of making photographic images legible in bronze. They considered relief, digitizing, and other methods, none of which worked to anyone's satisfaction. John thought that maybe he could hire an artist to do this. There were additional problems of weight and cost. John had exhibitions in Europe and the United States coming up, and we were still working on Elizabeth Murray's shoe and Kiki Smith's fountain. It all came to a standstill for a while. With plenty of time to mull things over, though, new possibilities arose: we suggested to John the idea of putting images on glass, and this caught his interest. By 1998 we were back in the business of figuring out solutions and researching glassworkers and companies in the region. Meanwhile John had started thinking about not just the doors but the whole lobby space of the library. He was also thinking of taking the students themselves as his subject.

By early 2000, Mathieu had samples of treated glass in hand, and we had checked out the potential limits and licenses that might affect us: colored doors are legal, mullions can be changed, security signs cannot be removed, the view from the reception desk cannot be blocked, et cetera. Mathieu made a model of the space for John to use. In February, John called

to say he had something for us to look at and wanted feedback. In a state of eager anticipation, Mathieu and I drove to his Santa Monica studio, and were surprised and delighted with what he had devised.

The entrance to the library comprises a wall of eight ten-foot-high glass panels flanking two pairs of sliding electronic doors. Through these doors is an unassuming lobby that is twenty-one by forty-four feet. To the right is a four-panel glass wall; straight ahead are four more glass panels, and security gates leading into the library itself; and to the left is a concrete structural wall.

What John had done was combine each of the eight glass panels flanking the doors with a photographic image of a student standing atop a row of shelved books. Etched on glass and made part of an architectural structure, the students will become caryatids, the books their bases. Flesh and blood and literature are equated to concrete and steel in supporting the library, its massive tower contrasting sharply with the glass images. The dress and diversity of the students reflect the time—now, today, early-twenty-first-century San Diego. By bringing students front and forward, John reminds us that they are central to the university's educational mission.

In the electronic doors, John proposed to replace clear glass with glass in primary colors, perhaps suggesting primary sources of information. When the doors slide open and closed, these colored glass panes will cross over each other, visually mixing into new colors. Above the doors are four more glass panes, and here John wanted to etch the words "read," "write," "think," and "dream"—a challenge to all who enter, and a reminder that along with the day-to-day grind of studying for exams comes the real possibility of learning something unexpected, life-changing, or fun.

The four glass wall panels inside the foyer, and ahead of you as you come in, were to be etched with images of seated students. In front of them would go an actual bench for real students to sit on, doubling the images preserved on the glass. The wall of four glass panels to the

right was to be etched with images of the tall slender palm trees seen throughout Southern California. Beyond this line of palm trees, but visible through its glass support on the wall beyond it (outside the actual lobby), would be a photomural showing beachfront and sea, with a few boats on the water. On the concrete wall to the left of the entrance John planned a photomural of vertical pens and pencils lined up neatly in a row. Pens and pencils mirror palm trees, metaphorically become them. Palm trees lead you to the sea, a reference to the library's larger site in San Diego, at this lower, seaside corner of California.

This is here and now. John, once again, had absorbed the culture around him, using the latest techniques to create a collage juxtaposing photographs, words, and colors, which all loop back on each other to spark associations and thoughts. Entering the library is a daily routine for the university population, but even so, perhaps the building's visitors will notice and slow down a little as they go in.

We presented John's model to the library administration and staff. They were guardedly enthusiastic, if a little worried about how this might impact usage. We assured them that John would not impose a precious, untouchable artwork; that he would address their needs; and that his piece would use found images and ordinary forms. Despite his interest in Hollywood, he would seek not glamour but truth, with gentle irony and humor. They were also concerned that if his work were to run through the entire lobby, it would be hard for them to put up the necessary signage and notices currently posted there. We agreed that some signage could be placed discreetly on the doors. John may design a kiosk for notes and notices. The coloring of the glass for the doors provided a challenge: for safety, they have to be made of tempered glass, which can't be tinted. To achieve the effect, a slice of transparent color will be laminated between two sheets of the tempered glass.

In March of 2000, friends were invited to a gala evening to meet John and see the model. That night witnessed a great sense of excitement and enthusiasm. Fund-raising began and was propelled by the leadership of the Friends' Council. Audrey Geisel, San Diego's great patron of the library and of the arts, thought the words above the door should be "read," "write," "think," "sleep," as that's what students really do there. We will stick to John's plan. The work is under construction as this book, our first, is being produced. We will soon be on to the next project.

—MLB

interview

john baldessari

JOAN SIMON: Of the Stuart Collection commissions documented here, yours is the only one not yet built. How did you pick the site?

JOHN BALDESSARI: Well, I can even back up a little bit further. Mary had approached me many times over the years, and my reply would always be, I'm not a sculptor. She would say, Well, think of something. And finally I had this idea that I wanted to do something like the bronze doors of the baptistery in Florence—make some doors with some sort of pictorial narrative, but using details from movie stills. These stills would be translated into low relief.

We did a site visit with Mary and Mathieu, trying to find some appropriate doors on the campus. And there were none. Most doors were not the statuesque or impressive kind that I was hoping for. Most of them were glass doors, International Style heritage, I suppose. But in our tour we did go to the main library on campus and either Mary or Mathieu had the idea, Why don't you do the whole facade, which includes sliding glass doors, two pairs of them, but it's all glass where you enter.

The problem then became to deal with the glass in some way. The idea of etched glass seemed a reasonable solution. I had to go back and completely rethink what I was doing. In the meantime we had the idea of doing not only the facade to the library but also the foyer. You go through the front doors and there's another barrier you go through and then walls left and right. Then it became more ambitious. What I elected to do was—because I've taught pretty much all my life, as a means to support myself—and I thought, Why don't I, instead of using elements taken out of movies, deal with students. Then they could be used very architecturally, vertically, in terms of the architecture, as post and lintel, and configuring it.

That's pretty much what I did. Students either standing or sitting, frontal or side view, left and right. Those are elements. And then other elements on the left and right inner walls are repetitions of the vertical: on the left wall a series of different pens and pencils, in color, arranged according to the spectrum of the color wheel, and then on the right, palm trees.

JS: The pens and pencils are the same height as the palm trees.

JB: They'll all be the same height, but what really shifts is the subject matter. Then the doors, since they were sliding, I decided to make use of that and make them translucent colors, so that when one slides over another you'll get a different color. A yellow and a red will give you an orange, or a blue and yellow will give you a green, as they slide. Then I think there are two other subject-matter elements. On the top register on the entrance, there are horizontal panes of glass, and those are devoted to text: read, write, think, dream. And on the far left and far right, there are two kind of squarish elements. One will be a computer screen and the other will be a TV screen.

JS: Those are images, or actual working machines? What will they show?

JB: Photo-etched on glass. What's on the monitors I've yet to decide. I'll put in something generic.

JS: The element you haven't yet spoken of on the facade is that flanking the doors left and right are four vertical panels on each side. Each of these will show a student, and each image will "stand" on a smaller rectangular panel, a base, showing a shelf of books.

JB: Oh right, I forgot about that. Pedestals as shelves of books. The kinds of titles on the spines—and whether they'll even show up or not I don't know. I've left the choices open depending on what kind of results we get with the glass etching.

JS: Is this the first commission of this scale that you've done?

JB: Yes, this is the largest to date. I don't ordinarily do them because I just don't like to get involved with committees and architects and that sort of thing. On the other hand, Claes Oldenburg and Coosje van Bruggen are close friends of mine, so they've been influential. I've done a few commissions, but not many.

The first one was rather modest; it was for the California Arts Commission in Sacramento, in an entrance to one of their auditoriums. Then I did one for the Seattle Arts Commission. Then I did a lot of little things in Europe, mostly billboards and that sort of thing, and projects in museums. I don't think those count—I think of those as artist's projects. Then just recently I did a large piece for the atrium of the Creative Arts Agency building here in Los Angeles.

JS: In terms of developing your commission for the Stuart Collection, the method, subject, and approach go back to your National City works of the late '60s, which were phototext works on canvas— conceptual projects using photo blowups and lettering rendered by a commercial sign-painter. These projects were often very funny, translated as paintings, and used as subject matter your hometown of National City, not far from San Diego. About them you said, "Why not give people what they understand most, which is the written word and the photograph."[1] In its overall scheme, your La Jolla project really works from the architecture to do the same thing.

JB: It's very much like a Greek temple, using the figures as columns.

JS: With the other artists in the collection, the discussion of course followed what was finally built, as well as what might have been. In this case, of course, you don't really know yet how yours is going to turn out.

JB: It's obviously going to evolve, and Mathieu is sort of the one who figures out how to do things. I've got to say the two of them have been splendid to work with. All my fears of some-body all of a sudden saying, You can't do that because we're going to have a heating duct there, or whatever, or we don't like this, we don't like that—Mary has been quite amazing. And actually at one point my plans for the right-hand side with the palm trees were voided—well, some-what voided, but Mary now says it's possible. In fact it's possible that you would see through the etched-glass palm trees and behind that there would be a seascape, with sailboats and so on. So actually things have gotten better, not worse.

JS: Though Niki de Saint Phalle and Robert Irwin now live in San Diego, you're the only native son. You grew up nearby, in the area.

JB: I grew up in National City, but I'm probably the only one who taught at UCSD.[2]

Site at Giesel Library for
READ/WRITE/THINK/DREAM

JS: Also probably the only whose early subject matter includes the San Diego area, specifically National City. It was for you the place in which, to quote one of your paintings, you "LOOK AT THE SUBJECT AS IF YOU HAVE NEVER SEEN IT BEFORE." You found generic sites–the donut shop, traffic intersections–and captioned them banally and straightforwardly. What was it like working there?

JB: Basically, art people never came to San Diego—they would pass through it on the way to Tijuana maybe, but that was the end of it. I remember driving Henry Geldzahler around San Diego and taking him down to Tijuana, that sort of thing. I would get visits from people I knew, but they were always combined with a trip to Mexico. The university wasn't there. The city wasn't a cultural hot spot, or even a watering hole. But that was fortunate for me, because I had gone to school in L.A., and I had painted for a while in L.A., and I decided to leave because I thought I would get infected by whatever current aesthetic was operative. And so I went back and taught in high school and then painted. I had a studio with no windows. I had to reinvent myself by questioning everything, all the received wisdom I had gotten over the years from reading and listening to people. So it was good not to have anybody around me, any influences. It was like Christ's forty days in the desert, so to speak [laughter]. I don't mean to align myself with Christ, but you know what I mean. I isolated myself.

I was miserable at the time, but looking back it was probably the best thing that ever happened to me because I was really able to think everything through. And it's funny, while I'm talking I'm thinking of Bob Irwin. He went to Las Vegas to purge himself. I don't know what Bob's attraction to Las Vegas was, but for me in San Diego the attraction was that there were no attractions. Having nothing seductive around, I could just start from the ground up.

JS: Recognizing that you're still midway in the process, is there anything in particular you would like documented about your Stuart Collection piece as it's taking shape?

JB: Anything I would say would be tentative. I'm very excited about it. I might even make changes as new things become possible—talking to Mathieu and so on, I certainly have already made changes. So, who knows? I have no idea. I like that it's not yet set in stone, or set in glass, or whatever [laughs]. It could still be somewhat malleable.

JS: I'm looking at color photocopies of the model.

JB: My fear is that it's kind of going to look like a Gap ad. On the other hand, I like that teetering quality between high and low culture.

JS: Who are the young people in these photos, students? Professional models? They look like they could be either.

JB: Conceptually it shouldn't make any difference, but in the finished work they will be students from UCSD. And it's interesting that you brought up the National City stuff: I used almost the same aesthetic. I said, Just stand, let me photograph you. Now sit. It was almost like mug shots or I.D. shots. I wasn't trying to make them artful; I just wanted them to be students, I wanted them not to pose.

JS: One question that's come up, I'm told, is whether the student pictures taken in 1999 will look "dated" years ahead.

JB: I think it would be interesting to change the photos at times. I don't know how often fashions change on campus. At some agreed-upon time increment—say every two years, or

every five years—we could take one out and pop in a new one in. It's kind of practical too. You wouldn't have sweeping costs replacing all of the students; you'd just replace one or two.

JS: It would also be something that could be built into the conservation program for the work. Some day a pane of glass might have to be changed, I would imagine—it could break, or need to be upgraded to some new construction standard. One can't anticipate specific changes, but one knows, with public commissions, that conditions change, and deterioration is a possibility given weather, light, and climate. Questions of stability and replacement often come into play when photographic processes are being used. What is the scale of these photographs?

JB: That's an interesting question. I'm ball-parking it here. If you take away the pedestal of the bookcase, I think they're about eight feet each, maybe seven feet or something like that. Maybe smaller.

JS: Will the panels be illuminated from the back at night?

JB: Again, these are all iffy things. How late is the library open? When it closes do the lights go out? It's a good question. I hadn't thought about it.

JS: Will they be artificially lit by day?

JB: I have no idea. It's all iffy. The closest we've gotten so far is, Mathieu made some small test panels. We tried looking at them from different angles, and so on, and it's all very subtle, which I kind of like. It's not hugely dramatic.

JS: What is the process for transferring the photos to glass?

JB: Mathieu and I went through so many samples. I think we've eliminated the photoetching. I think what it is right now is a silkscreen, some sort of printing process on the glass, so there's a black silkscreen that filters the glass. Mathieu is doing more research.

JS: It looks like the target date for completion of your project is the spring of 2001. That's the most recent update I've received from the Stuart Collection.

JB: I'm moderately superstitious—my choice would be June 17 (my birthday) or 2001 ½ (end of June) (my address).

1. John Baldessari, quoted in Hugh M. Davies, "John The Baldessari: Prophetic Works," in *John Baldessari: National City*, ed. Davies and Andrea Hales (San Diego: Museum of Contemporary Art, 1996), p. 6.
2. Baldessari taught at UCSD in 1968–70; Alexis Smith also taught at UCSD in 1977–78.

terry allen

Born 1943, Wichita, Kansas. Lives in Santa Fe, New Mexico.

Trees, 1986
Three lead-covered eucalyptus trees, each c. 40´ high, two with 24-hour intermittent recorded sound

Funding provided by the Stuart Foundation with additional support from the National Endowment for the Arts

michael asher

Born 1943, Los Angeles, California. Lives in Los Angeles, California.

Untitled, 1991
Granite and stainless steel drinking fountain, 39˝ high, site c. 300 x 55´, with extant elements including flag-pole, military landmark, paths, and benches

Funding provided by the Stuart Foundation with additional support from the National Endowment for the Arts

john baldessari

Born 1931, National City, California. Lives in Los Angeles, California.

READ/ WRITE/ THINK/ DREAM, 2001
Ceramic enamel on glass windows and large-format color prints mounted on walls in Geisel Library entrance lobby, lobby 10 x 65 x 21´

Funding provided by Audrey Geisel, San Diego Foundation Dr. Seuss Fund, Joan and Irwin Jacobs, The Looker Foundation, the Friends of the Stuart Collection, Susan Ramsey Crutchfield, the Colleagues of the Stuart Foundation, the Redducs Foundation, the Friends of the Library at UCSD, Peter and Peggy Preuss, James and Mary Berglund, Chris and Eloisa Haudenschild, Steven and Nancy Oliver, Fred and Erika Torri, and numerous others

jackie ferrara

Born 1929, Detroit, Michigan. Lives in New York City, New York.

Terrace, 1991
Slate tiles, gravel, benches, and Australian willows, 110´ long, 270´ wide, site c. ⅓-acre

Funding provided by the UCSD School of Medicine Associates and the Stuart Foundation

ian hamilton finlay

Born 1925, Nassau, Bahamas. Lives in Lanark, Scotland.

UNDA, 1987
English limestone, five stones, each 30˝ high and 44˝ deep by an overall width of c. 37´

Funding provided by the Stuart Foundation

richard fleischner

Born 1944, New York City, New York. Lives in Providence, Rhode Island.

La Jolla Project, 1984
Pink and gray granite elements, site c. 1½ acres

Funding provided by the Stuart Foundation

jenny holzer

Born 1950, Gallipolis, Ohio. Lives in Hoosick Falls, New York.

Green Table, 1992
Prairie Green granite, table 32˝ x 6´ x 20´, with four matching benches, each 18½˝ high

Funding provided by the Russell Foundation with additional support from the Lannan Foundation, the National Endowment for the Arts, and the Stuart Foundation

robert irwin

Born 1928, Long Beach, California. Lives in San Diego, California.

Two Running Violet V Forms, 1983
Plastic-coated fencing, stainless steel poles, and iceplant, two V-shaped forms each c. 28′ high and 196′ long, poles 5″ diameter, site c. 3,000 square feet

Funding provided by the Stuart Foundation with additional support from the MacArthur Foundation

elizabeth murray

Born 1940, Chicago, Illinois. Lives in New York City, New York.

Red Shoe, 1996
Laminated and painted cedar, shoe 10′ 6″ high with five smaller elements, site c. 55 x 80′

Funding provided by the Stuart Foundation with additional support from the National Endowment for the Arts

bruce nauman

Born 1941, Fort Wayne, Indiana. Lives in Galisteo, New Mexico.

Vices and Virtues, 1988
Neon tubing and clear glass tubing mounted on aluminum support grid, letters 7′ high, building 64 x 52 x 124′

Funding provided by the Stuart Foundation with additional support from the National Endowment for the Arts

nam june paik

Born 1932, Seoul, Korea. Lives in New York City, New York.

Something Pacific, 1986
Mixed media installation, six outdoor elements, indoor bank of twenty-four live interactive television sets

Funding provided by the Stuart Foundation

niki de saint phalle

Born 1930, Neuilly-sur-Seine, France. Lives in La Jolla, California.

Sun God, 1983
Painted fiberglass with gold leaf, steel armature, on concrete arch, 29 x 18 x 11′

Funding provided by the Stuart Foundation

alexis smith

Born 1949, Los Angeles, California. Lives in Venice, California.

Snake Path, 1992
Slate tile and concrete path, granite book and bench, garden plantings, path 10′ wide x 560′ long

Funding provided by the Stuart Foundation, Rea and Lela (Jackie) Axline, Colleagues of the Stuart Collection, the National Endowment for the Arts, the Russell Foundation, the California Arts Council and numerous individuals

kiki smith

Born 1954, Nuremberg, Germany. Lives in New York City, New York.

Standing, 1998
Bronze, concrete, and mixed media, figure 4′ 10″ high, tree 12′ 6″ high, set in pool with stones, 13′ diameter

Funding provided by the Lucille A. and Ronald L. Neeley Foundation, Robert and Mary Looker, the National Endowment for the Arts, the Stuart Foundation, the Friends of the Stuart Collection, the Penny McCall Foundation, the Ansley I. Graham Trust, and numerous others

william wegman

Born 1943, Holyoke, Massachusetts. Lives in New York City, New York.

La Jolla Vista View, 1988
Mixed media, including telescope, etched-bronze plaques, stone walls and benches, wooden table and benches, drinking fountain, and indigenous plantings, site c. 2,000 square feet

Funding provided by the Stuart Foundation with additional support from the National Endowment for the Arts

Many projects in the Stuart Collection have required alterations to the landscape as part of the overall installations, including the addition and/or replacement of trees, plantings, and other materials.

Many of the Stuart Collection artists made drawings, watercolors, collages, photographs, or maquettes as proposals or studies for their permanent commissions. These works are part of the Stuart Collection Archive.

Richard Serra, Jim DeSilva and
Amnon Barzel at the opening of
the Gori Collection in Pistoia, Italy,
June 1982

1960

- University of California, San Diego (UCSD), chartered
 by the university's Board of Regents.

1964

- UCSD enrolls its first class.

1978

- Envisioning a project focusing on outdoor sculpture,
 James Stuart DeSilva establishes the Stuart Foundation.

1980

Richard C. Atkinson

Stuart Foundation Advisory Committee:
Allan Kaprow, Newton Harrison, Anne
d'Harnoncourt and Pontus Hulten

- Richard C. Atkinson named fifth chancellor of UCSD.
- Regents of the University of California approve concept
 for agreement with the Stuart Foundation for "Proposed
 Sculpture Collection, San Diego Campus."
- First meeting of the Stuart Foundation Advisory
 Committee: Jim DeSilva, Jim Demetrion, Anne
 d'Harnoncourt, Patricia Fuller, Newton Harrison,
 Pontus Hulten, Allan Kaprow, Patrick Ledden, Pierre
 Restany, and George Segal.
- Second Stuart Foundation Advisory Committee
 meeting.
- Long-term planning begins for a twentieth-century
 sculpture collection.

1981

Mary Beebe

- Niki de Saint Phalle invited to create proposal.
- Mary Livingstone Beebe hired as director of the Stuart
 Collection.
- Mandeville Gallery at UCSD presents exhibition, "Niki
 de Saint Phalle: Monumental Projects," featuring
 maquettes, drawings, and photographs.
- Robert Irwin invited to create proposal.
- Niki de Saint Phalle proposal approved.

Mary Beebe and Jim DeSilva

Dance troupe rehearsing on Fleischner's *La Jolla Project*

Mathieu Gregoire and Robert Irwin

Stuart Foundation Advisory Committee: Jim DeSilva, Patricia Fuller, Anne d'Harnoncourt, Pierre Restany and Mary Beebe

1982

- October 5: Final agreement signed between the Regents of the University of California and the Stuart Foundation. "The Stuart Collection at the University of California, San Diego" adopted as name.
- Construction begins on Niki de Saint Phalle's *Sun God*.
- Mathieu Gregoire hired as project consultant for the Stuart Collection.
- Robert Irwin proposal approved.
- Richard Fleischner invited to create proposal.
- Stuart Foundation Advisory Committee meeting.
- Construction begins on Robert Irwin's *Two Running Violet V Forms*.

Jim DeSilva, Niki de Saint Phalle and Pat Ledden

1983

- Stuart Foundation Advisory Committee meeting: Richard Fleischner proposal approved.
- Bruce Nauman invited to create proposal.
- Inauguration of Niki de Saint Phalle's *Sun God*.
- Inauguration of Robert Irwin's *Two Running Violet V Forms*.
- Terry Allen invited to create proposal.
- Construction begins on Richard Fleischner's *La Jolla Project*.

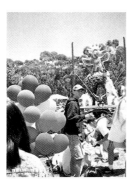

Sun God Festival

Robert Irwin and Richard Fleischner at inauguration of *La Jolla Project*

1984

- Jenny Holzer invited to create proposal.
- Inauguration of Richard Fleischner's *La Jolla Project*.
- Stuart Foundation Advisory Committee meeting: Terry Allen proposal approved; Jenny Holzer proposal approved; Bruce Nauman proposal approved.
- Bruce Nauman proposal, *Vices and Virtues*, generates community controversy.
- Michael Asher invited to create proposal.
- First Sun God Festival, sponsored by the Associated Students of UCSD.

Friends of the Stuart
Collection trip

Ian Hamilton Finlay

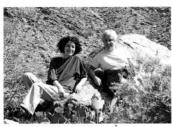

Jackie Ferrara and Mary Beebe

1985

- Ian Hamilton Finlay invited to create proposal. Mandeville Gallery at UCSD presents first exhibition of Stuart Collection proposals.
- Construction begins on Terry Allen's *Trees*.
- Jackie Ferrara invited to create proposal in collaboration with UCSD School of Medicine and Moore Ruble Yudell Architects & Planners.
- William Wegman invited to create proposal.
- Nam June Paik invited to create proposal.

above left: Marne DeSilva,
Terry Allen, Jo Harvey Allen,
Joan Tewkesbury and Jim
DeSilva
bottom left: Hugh Davies,
Mary Beebe, Jim DeSilva, Italo
Scanga, Anne d'Harnoncourt
and James Demetrion
above: Nam June Paik, Jim
Smith, Shikego Kubota and
Sherman George

1986

- Stuart Foundation Advisory Committee meeting: Jackie Ferrara proposal approved; Ian Hamilton Finlay proposal approved; Nam June Paik proposal approved; William Wegman proposal approved.
- Inauguration of Terry Allen's *Trees*.
- Construction begins on Nam June Paik's *Something Pacific*.
- Alexis Smith invited to create proposal.
- Bruce Nauman's *Vices and Virtues*, proposed for Mandell Weiss Theatre, relocated to Charles Lee Powell Structural Systems Laboratory.
- Inauguration of Nam June Paik's *Something Pacific*.
- Construction begins on Bruce Nauman's *Vices and Virtues*.

William Wegman and Mathieu Gregoire

1987

- Construction begins on Ian Hamilton Finlay's *UNDA*.
- Inauguration of Ian Hamilton Finlay's *UNDA*.
- Plans for new faculty club adjusted to preserve eucalyptus-grove site of Robert Irwin and Terry Allen projects.
- Construction begins on William Wegman's *La Jolla Vista View*.

CLOSE TO HOME By John McPherson
12-14

"The intern who worked on me was an art major
before going to med school."

Close to Home ©1995
John McPherson

Nina MacConnel,
Paul Mahalik and
Alexis Smith

Peter Lodato, Juliet Myers,
Mary Beebe and Bruce Nauman

1988

- Terry Allen updates tapes for *Trees*.
- Inauguration of Bruce Nauman's *Vices and Virtues*.
- Inauguration of William Wegman's *La Jolla Vista View*.

1989

Pat Ledden, Pierre Restany,
and Giuseppe Panza

Stuart Foundation Advisory
Committee touring campus

- Stuart Foundation Advisory Committee meeting:
 Michael Asher proposal approved; Alexis Smith
 proposal approved.
- Colleagues of the Stuart Collection support group
 formed.
- Construction begins on Jackie Ferrara's *Terrace*.
- Construction begins on Michael Asher's *Untitled*
 drinking fountain.
- Bruce Nauman's *Vices and Virtues* on cover of *Art in
 America* (December).
- Niki de Saint Phalle's *Sun God* temporarily shrouded for
 Day Without Art.
- Neon in Bruce Nauman's *Vices and Virtues* temporarily
 turned off for Day Without Art.

1990

Stuart Foundation Advisory Committee:
Mary Beebe, Giovanna Panza, Pierre
Restany, Patricia Fuller, Jim DeSilva
and Giuseppe Panza

- Terry Allen's silent tree stored during expansion of
 Geisel Library.
- James DeSilva receives Chancellor's Associates Award
 for Distinguished Service to UCSD.

1991

Julia Kindy and Kiki Smith

Alexis Smith on site

- Mandeville Gallery at UCSD presents exhibition
 "Alexis Smith: Public Projects."
- Inauguration of Jackie Ferrara's *Terrace*.
- New Mandell Weiss Forum building plans adjusted to
 preserve site of Richard Fleischner's *La Jolla Project*.
- Julia Kindy hired as Program Representative for the
 Stuart Collection.
- Terry Allen updates tapes for *Trees*.
- Construction begins on Jenny Holzer's *Green Table*.
- Construction begins on Alexis Smith's *Snake Path*.

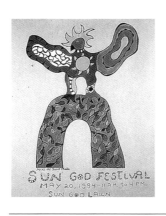

Sun God Festival poster

Michael Asher

1992

- Inauguration of Michael Asher's *Untitled*.
- Inauguration of Alexis Smith's *Snake Path*.

Pat Ledden and Jenny Holzer

Betsy Aaron & crew gather for
CBS's *Sunday Morning with
Charles Kuralt*

1993

- James DeSilva receives Revelle Medal for Distinguished and Sustained Service, UCSD's highest honor.
- Inauguration of Jenny Holzer's *Green Table*.
- Terry Allen's silent tree reinstalled at entrance to Geisel Library.
- Stuart Collection featured on *Sunday Morning with Charles Kuralt*, on CBS TV.
- Elizabeth Murray invited to create proposal.
- Restoration of Niki de Saint Phalle's *Sun God*.
- Restoration of Nam June Paik's *Something Pacific*.
- Kiki Smith invited to create proposal.

John Baldessari and
Mathieu Gregoire

Robert Conn, Jim and Marne DeSilva and
Kiki Smith at inauguration of *Standing*

1994

- John Baldessari invited to create proposal.
- Stuart Collection Web page launched, at stuartcollection.ucsd.edu.
- American Institute of Architects presents Institute Honor award to Stuart Collection.
- Stuart Foundation Advisory Committee meeting: John Baldessari proposal approved; Elizabeth Murray proposal approved; Kiki Smith proposal approved.

Mary Beebe, Niki de Saint
Phalle, and Julia Kindy

Richard Atkinson, Jim DeSilva,
and Pat Ledden

1995

- University of California Regents and Stuart Foundation extend their agreement to 2009.
- Richard C. Atkinson named President, University of California.
- Construction begins on Elizabeth Murray's *Red Shoe*.

Friends of the Stuart Collection trip to Napa Valley, California

below: Elizabeth Murray and Mary Beebe
above right: Robert C. Dynes
below right: Jim Langley, Marsha Chandler and Robert C. Dynes

1996

- Inauguration of Elizabeth Murray's *Red Shoe*.
- Robert C. Dynes named sixth chancellor of UCSD.

1997

- "Scholars and Sculpture" documentary on Stuart Collection airs on UCSD-TV and nationally on UCTV cable television.
- President William Jefferson Clinton delivers UCSD commencement address.
- Stuart Collection and insite97 host public art conference at UCSD.
- Construction begins on Kiki Smith's *Standing*.

1998

- Athenaeum Music and Arts Library, La Jolla presents an exhibition of Stuart Collection proposals.
- UC Libraries at UCSD present "Before It's Built," an exhibition of Stuart Collection proposals.
- James DeSilva receives UC San Diego Foundation Civis Universitatis award in Recognition of Leadership and Dedication to UCSD.
- Friends of the Stuart Collection support group founded with Joan Jacobs and Peggy Preuss as co-chairs.
- Inauguration of Kiki Smith's *Standing*.

Friends of the Stuart Collection trip to Santa Barbara, California

1999

- Restoration of Niki de Saint Phalle's *Sun God*.

2000

- Restoration of Alexis Smith's *Snake Path* garden.
- Construction begins on John Baldessari's *READ/WRITE/THINK/DREAM* for the Geisel Library.

2001

- Inauguration of John Baldessari's *READ/WRITE/THINK/DREAM*

John Walsh, Mary Beebe and Hugh Davies

THE VOYAGE OF THE STUART COLLECTION covers considerable territory and the journey has taken cooperation, support, and sustenance from a prodigious variety and number of individuals and institutions. One must start with James Stuart DeSilva. His vision motivated the University of California, San Diego, to join him in this unique collaboration to integrate an exemplary collection of contemporary art into the life and fabric of a major university campus. To Jim, and to his wife, Marne, we owe most profound thanks for their conviction, their generosity, and their faith in our efforts to make their hope a reality. It was a proud moment in 1993 when Jim was given the Revelle Medal, one of three awards he has received from the university: the Revelle Medal is UCSD'S highest honor. Besides Marne, his wife of fifty-eight years, other members of the DeSilva family deserve recognition: Jim and Marne's son, Peter, and daughter, Dede Grant, along with their spouses, Madelyn Naylor and Bob Grant, deserve deep thanks for standing by Jim and Marne.

Richard C. Atkinson, President of the University of California and earlier the fifth Chancellor of UCSD, made launching the Stuart Collection one of his first acts. His leadership through the years has shown both endurance and real courage. There can be great enthusiasm for the idea of art, but the reality of much contemporary work weakens the resolve of many public leaders. This endeavor would not have been possible without Atkinson's pivotal early support and unflagging commitment. Patrick J. Ledden, Assistant Chancellor early on and now Provost of Muir College, has been an inspired and loyal shepherd. Robert C. Dynes, sixth Chancellor of UCSD, together with his Senior Vice Chancellor, Marsha Chandler, have continued the earlier administration's support with confidence and strength. Their defense of the integrity of the collection has taken a measure of fortitude and prudence for which we are grateful.

We owe thanks to the Regents of the University of California, who had the foresight to give the original endorsement to a newly formulated plan in 1982. We hope to have produced a model of possibilities for other universities.

The Stuart Foundation Board and Advisory Committee members past and present— Hugh M. Davies, James Demetrion, Peter DeSilva, Patricia Fuller, Anne d'Harnoncourt, Pontus Hulten, Newton Harrison, Robert Irwin, Allan Kaprow, Patrick Ledden, Count Giuseppe Panza di Biumo, Italo Scanga, Pierre Restany, George Segal, and John Walsh—have brought their expertise, knowledge, and wisdom to guide the form and life of the collection. Even though some of the choices and decisions have been difficult, the meetings have been a great pleasure and they have kept us on a straight and clear path.

The Stuart Foundation and the University have been the financial keystones to the collection, but we wish to extend our deep gratitude to the other donors who have contributed so generously to these projects. Many names are included elsewhere in this volume, but I especially want to recognize the major support of the Friends of the Stuart Collection, the Russell Foundation, Lela (Jackie) and Rea Axline, Joan and Irwin Jacobs, Audrey Geisel, the Lucille A. and Ronald L. Neeley Foundation, Robert and Mary Looker, the Lannan Foundation, the Penny McCall Foundation, the Redducs Foundation, the MacArthur Foundation and the Ansley I. Graham Trust. The National Endowment for the Arts deserves special mention and

thanks for grants toward eight of the fifteen works in the collection. These grants provided not only financial support but also critical validation, a significant help in establishing credibility in the early days. The Colleagues of the Stuart Foundation, begun in the early 90s and founded by Emmy Coté, have also helped with contributions and participation from many in the community.

Who would expect to find two Deans of Engineering as major pillars of support for contemporary art? Yet that has been the case at UCSD. Unpredictable linkages can happen at a great university. Lea Rudee, dean at the time of the Bruce Nauman project, was eager to see *Vices and Virtues* on a new laboratory. A photographer, Lea has been a strong force for the arts at UCSD and in the community. Robert Conn, dean since Rudee's retirement in late 1994, and an avid and daring collector of contemporary art, has led the amazing growth of the Engineering Department. In 1998, he chaired a committee that did an extensive review of the Stuart Collection, which highlighted the value of the collection to the university, provided the basis for increased administrative support, and called for the formation of the Friends of the Stuart Collection. To these two for their insight and friendship, and to the members of that committee—Georgios Anagnostopoulos, Louis Hock, and Adele Shank—we owe particular gratitude. The Dean of Arts and Humanities, Frantisek Deak, initiated the review and has given generous financial support for this book from his office.

Joan Jacobs and Peggy Preuss, both great friends and patrons of the university, stepped forward to help found the Friends of the Stuart Collection in 1998. Their leadership has immeasurably extended and increased our base of support in the community and beyond. With Cree Scudder, Elly Kadie, Madelyn Naylor, and Erika Torri, they also formed the Council of the Friends. The members of the International Advisory Committee to the Friends of the Stuart Collection have generously lent their prestige and distinction as well.

Many colleagues at the university deserve special mention. Sterling advice has come from James M. Langley, Vice Chancellor External Relations, and the Office of External Relations has provided funds for this book. The friendship and enthusiasm of Lynda Claassen, Director of Special Collections for the University Libraries, has led to several exhibitions of Stuart Collection artists' proposals in the Geisel Library. Sherman George, Director of the Media Center, together with Jim Smith and Bill Campagna, have carefully overseen the collection's audio, visual, and media needs.

We are grateful to all members of the Visual Arts Faculty for their input and their support of our efforts. Special thanks go to David Antin, Eleanor Antin, Manny Farber, Newton and Helen Harrison, Louis Hock, Allan Kaprow, Chip Lord, Jean Lowe, Kim MacConnel, Sheldon Nodelman, Patricia Patterson, Moira Roth, Jerome Rothenberg, Italo Scanga, Ernest Silva, Susan Smith, Jehanne Teilheit-Fisk, and John Welchman.

Others at UCSD who have provided expertise and support through the years include Pat Aguilar, John Alksne, Richard Attiyeh, Larry Barrett, Diana Bergen, Maudie Bobbitt, Tom Bond, Nada Borsa, Lynn Burnstan, Margerie Caserio, Stan Chodorow, Ruth Covell, Win Cox, Ann Craig, Bruce Darling, Gigi Doerr, Julie Dunn, Julia Engstrom, Dorothy Gregor, Boone Hellmann, Bonnie Horstmann, Jack Hug, Steve Ilott, Pam Jenkinson, Wayne Kennedy,

Jerry Lowell, Cecil Lytle, Nancy Mah, Gerry McAllister, Lindy Nagata, Lynne Peterson, V. S. Ramachandran, Ray Ramseyer, Steven W. Relyea, Jerry Schneider, Brian Schottlaender, Jeff Steindorf, John Sturla, Mary Walshok, Joe Watson, and John Woods. We are grateful to the many faculty who have assigned papers or projects involving the Stuart Collection and who have supported the process. Numerous graduate students have been helpful over the years, but special thanks go to Frank Cole, David Jurist, and Matthew Hincman. For those I may have overlooked, please know that my thoughts and appreciation are not lessened by my faulty memory.

Hugh M. Davies came to be director of the Museum of Contemporary Art, San Diego, right after I arrived in La Jolla. His support as a member of the Stuart Foundation Advisory Committee, the Stuart Foundation Board of Directors, an articulate scholar, and a fine friend have made working here a great pleasure. MCA Director of Development Anne Farrell and museum curators Lynda Forsha, Ron Onorato, and Elizabeth Armstrong have added to the expertise and accomplishments of the Stuart Collection. Erika Torri, director of the Athenaeum Music and Arts Library, has been a true colleague. The Athenaeum's 1998 exhibition of the Stuart Collection expanded our base of friends and increased community knowledge of the collection.

Others in the area deserve great thanks, especially Sally Yard at the University of San Diego for her scholarship and her initiatives with UCSD graduate students. We thank friends and collaborators Michael Krichman and Carmen Cuenca, Directors of insITE, the pioneering binational San Diego/Tijuana exhibition/project; Mark and Anna Quint of Quint Contemporary Art; and Margaret Porter of the Porter-Troupe Gallery. We wish to thank Margo Leavin and Wendy Brandow of the Margo Leavin Gallery in Los Angeles.

This book took on a life of its own a number of years ago, but it never would have happened without the expert vision, clear thinking, and voice of wisdom of Lynda Forsha, our publication director, who has brought the project forward on every level. This is a far better book because of her unflagging involvement: she has been a stalwart and esteemed friend through many years. We are grateful to Christopher Lyon at Rizzoli International Publications, Inc., for his courage in undertaking this endeavor, and to Isabel Venero for continuing his efforts. We hoped for someone of renown and distinction to draw together the many threads of the Stuart Collection; Robert Storr has done this with extraordinary insight and intelligence. Joan Simon we thank for her knowledge and understanding in producing the interviews with the artists. She has contributed extensively on many levels. We are enormously grateful to David Frankel, an editor of profound finesse, clarity, and patience. Graphic designer Simon Johnston has pulled all this together with a purity and precision true to each artist. He understood our goals from the beginning and has produced a beautiful, elegant, and experiential book that communicates the value we place on the art itself.

Photographers have made outstanding pictures of the Stuart Collection for many years. We are especially grateful to Becky Cohen, Phillipp Scholz Rittermann and John Fitchen for their many inspired contributions. Liz Sisco and Lisa Boulanger have also been very helpful.

Over the years, many others too numerous to name here have contributed in various ways

to the welfare of the Stuart Collection. Without pretending to be totally inclusive, I would particularly like to mention: Betsy Aaron, Leslie Abrams, John Alexander, Larry Alvarez, Paule Anglim, Richard Armstrong, Steven Ausbury, Bill Benton, Robin Brailsford, Jack Brogan, Susan Caldwell, Dagny Corcoran, Jon DePriest, Larry Doherty, Laura Donnelley-Morton, Jennifer Dowley, Julia Engstrom, Enniss Enterprises, Sid Felsen, Arnold Glimcher, Pnina Goldberg, Elyse and Stanley Grinstein, Dwight Hackett, Pat JaCoby, Amy Jorgensen, Susan Jurist, Dorothy Lichtenstein, Robert MacDonald, Christine Madsen, David Malmberg, Debbie McGraw, Roy McMakin, Daniel McNaughton, Juliet Myers, Lane Myers, Mark Ninteman, Stephen O'Riordan, Vickie O'Riordan, Robert Orton, Steve Pyle, Leah Roshke, Adele Santos, Stephanie Scanga, Frieder Seible, Marlene Shaver, Mort Shayegan, Leslie Simon, Andrew Spurlock, Wayne Takesugi, Quincy Troupe, Phyllis Van Doren, Julisa Voinche, Philip Yenawine, and Jane Zwerneman Lam.

The Stuart Collection team has put forth their all, as always, and not only for the book. The whole collection never could have happened without the help, intelligence, and loyalty of Mathieu Gregoire, a genuine partner in every aspect of the collection from the beginning. Julia Kindy tolerated and even embraced the many vicissitudes of such an undertaking for over nine years, adding insight and energy to the team. Working with them both has brought great pleasure, joy, and growth.

Deepest gratitude goes to my family, and most especially my husband, Charles Reilly. His generous and wise advice, his faith and his fortitude, his love and forbearance have made this effort possible.

Obviously this book, this collection, this story, would not exist without the artists who have completed works for the Stuart Collection. They have been magnanimous, courageous, tolerant, and awesome, and we owe them the greatest thanks. I treasure these friendships. Each of the works is an extraordinary gift. Many other artists put in a great deal of time and energy on a possibility, a proposal, for the Stuart Collection. Not all of these efforts have come to fruition, but every one of them has truly enriched the experience and the process and we are most grateful. I would like to take this opportunity to thank all the artists through the years who have made my life so full and rewarding. To them goes the real credit for making the world a place of discovery where we can acquire a vastly deeper sense of ourselves, our history, our capabilities, and our possibilities.

—*Mary Beebe*

Terry Allen
Drawing sent to Mary Beebe, Mathieu Gregoire,
Julisa Voinche and Jim DeSilva in 1986.

authors

Mary Livingstone Beebe has been the director of the Stuart Collection since it began in 1981. From 1972 until 1981, she was Director of the Portland Center for the Visual Arts (PCVA) in Portland, Oregon. Prior to that she worked at the Fogg Museum, Harvard University; the Museum of Fine Arts, Boston; and the Museum of Art in Portland, Oregon. She lectures extensively throughout this country and in Europe, and serves as a spokesperson on panels, juries, and advisory committees.

Joan Simon is a writer, editor, curator, and arts administrator specializing in contemporary art, working independently for museums, foundations, and publishers in the United States and Europe. Her publications include books and catalogs devoted to artists such as Ann Hamilton, Susan Rothenberg, Joan Jonas, Jenny Holzer, Gordon Matta-Clark, and Bruce Nauman, including serving as General Editor of the Bruce Nauman catalogue raisonné. Since 1990, Simon has divided her time between Paris and New York.

Robert Storr is an artist and critic, and a Senior Curator in the Department of Painting and Sculpture at The Museum of Modern Art, New York. He most recently curated an exhibition of Gerhard Richter's *October 18, 1977* paintings at The Modern, and authored a catalog in conjunction with the show (*Gerhard Richter: October 18, 1977*). He has also co-organized *Making Choices* (1920-1960), the second cycle of MoMA 2000, for which his curatorial projects include *The Dream of Utopia/ Utopia of the Dream, How Simple Can You Get?, Modern Art despite Modernism, New York Salon, Paris Salon, The Raw and the Cooked*, and *War*.

photography credits